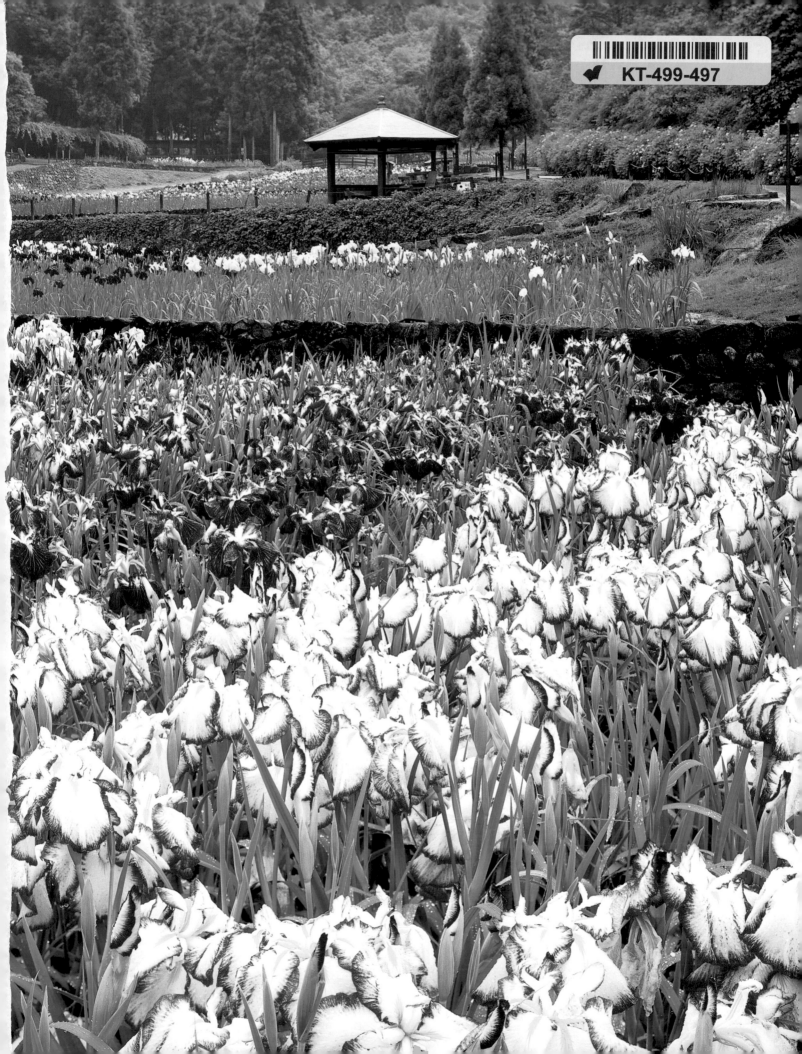

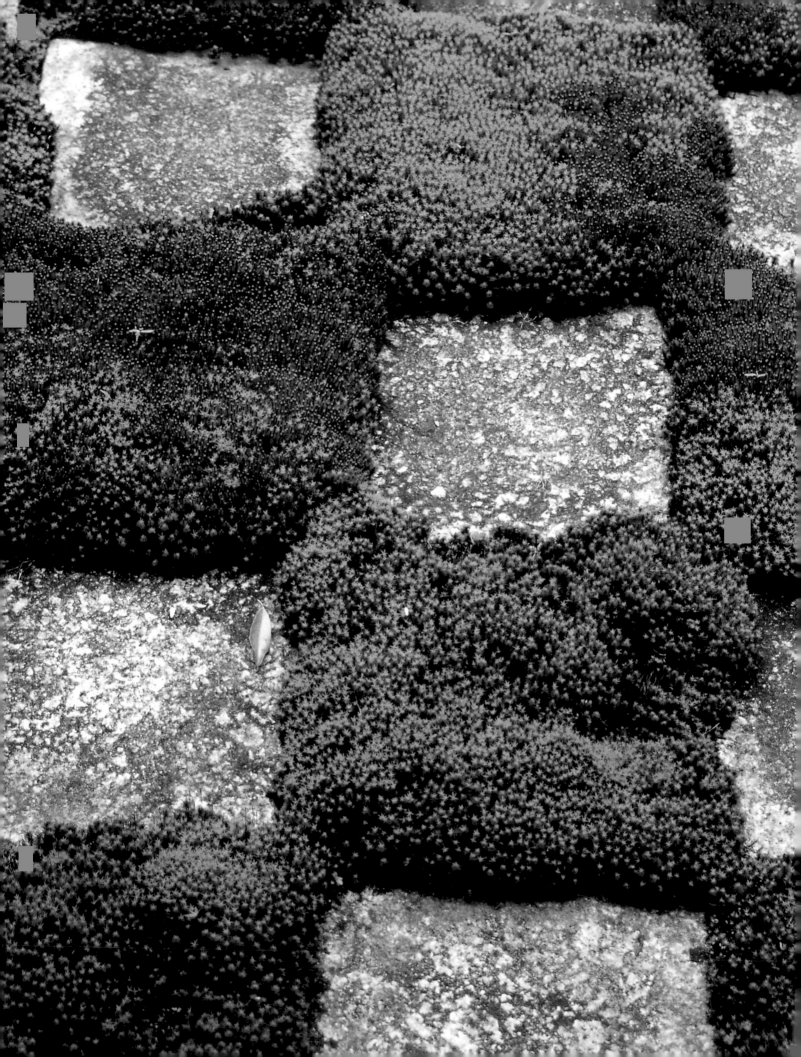

The Art of the
Japanese Garden

David and Michiko Young

Photography by
David and Michiko Young
Ben Simmons
Keystone

Illustrations by
Tan Hong Yew

TUTTLE

Published in 2005 by Tuttle Publishing, an imprint of Periplus Editions (HK) Ltd, with editorial offices at 364 Innovation Drive, North Clarendon, VT 05759-9436, and 130 Joo Seng Road, #06-01/03 Singapore 368357.

Library of Congress Control Number
2004114426
ISBN 0 8048 3598 5

Printed in Singapore

Distributors

North America, Latin America and Europe
Tuttle Publishing, 364 Innovation Drive,
North Clarendon, VT 05759-9436, USA.
Tel: (802) 773 8930; Fax: (802) 773 6993
E-mail: info@tuttlepublishing.com
http://www.tuttlepublishing.com

Japan
Tuttle Publishing, Yaekari Building, 3F,
5-4-12 Osaki, Shinagawa-ku; Tokyo 141-0032.
Tel: (803) 5437 0171; Fax: (813) 5437 0755
E-mail: tuttle-sales@gol.com

Asia Pacific
Berkeley Books Pte Ltd, 130 Joo Seng Road
#06-01/03, Singapore 368357.
Tel (65) 6280 1330; Fax (65) 6280 6290
E-mail: inquiries@periplus.com.sg
http://www.periplus.co

09 08 07 06 05
6 5 4 3 2 1

Page 1: Irises in bloom at Banshū Yamazaki Hana Shōbuen in Hyogo Prefecture.

Pages 2–3: Moss and stone checkerboard pattern in the North Garden of Tōfukuji Temple's Hōjō Garden, Kyoto (page 164).

Pages 4–5: View of the pond and Kotoji stone lantern at Kenrokuen, a large stroll garden in Kanazawa City (pages 148–53).

Page 6: Cherry blossoms at Ryōanji Temple, Kyoto (pages 108–9).

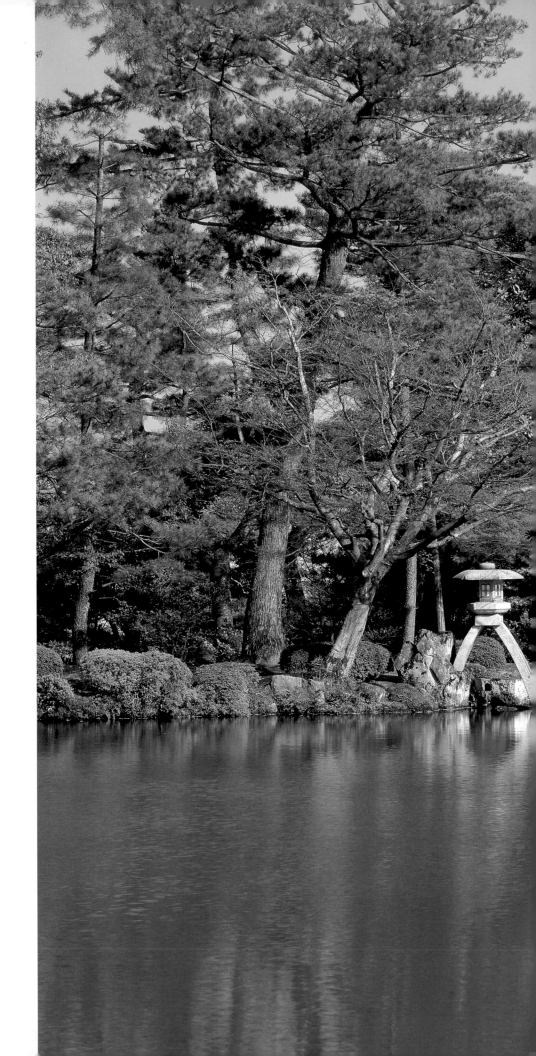

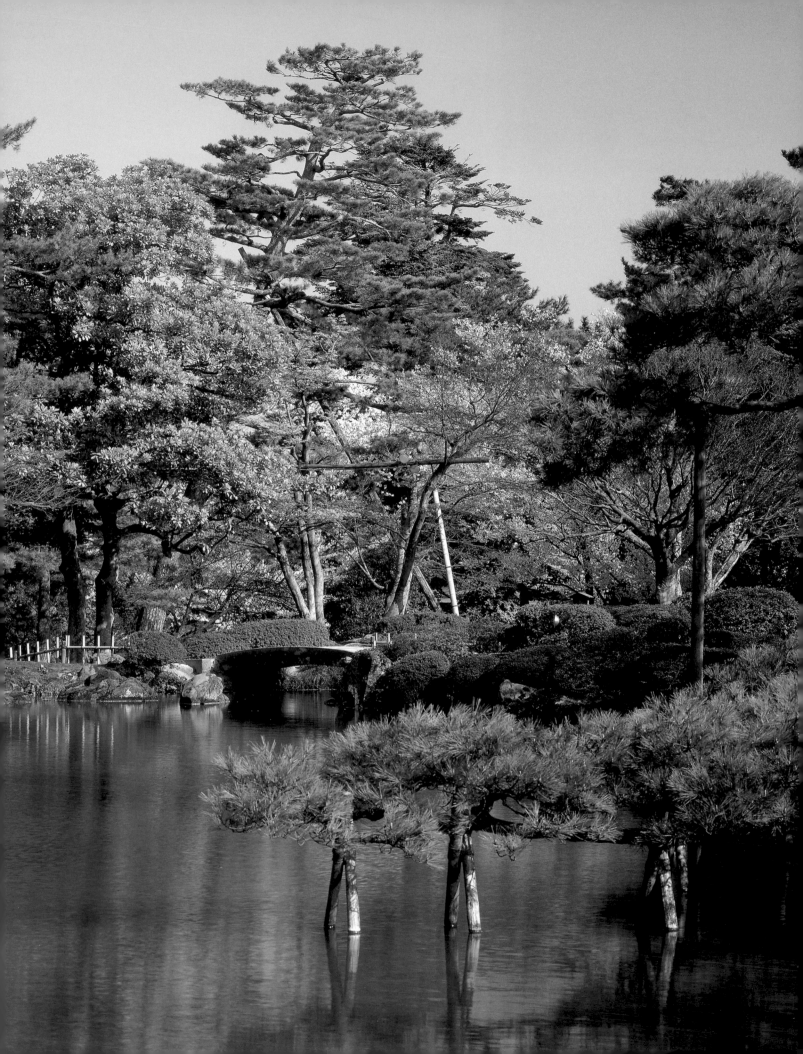

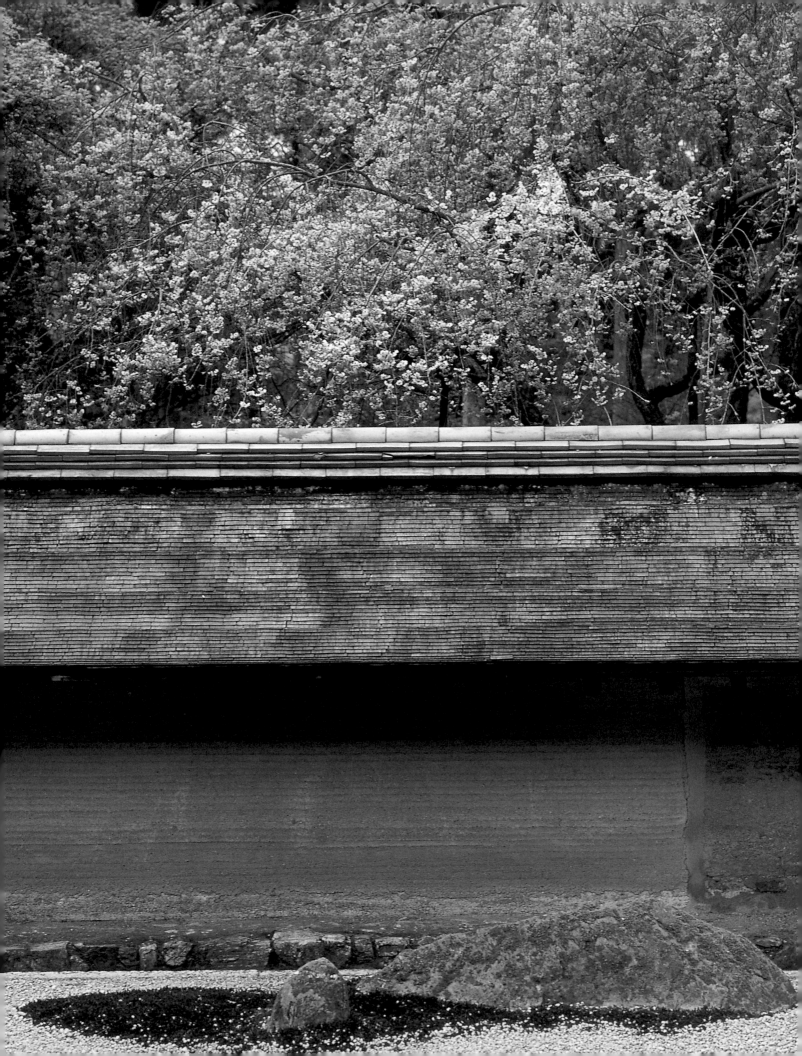

Contents

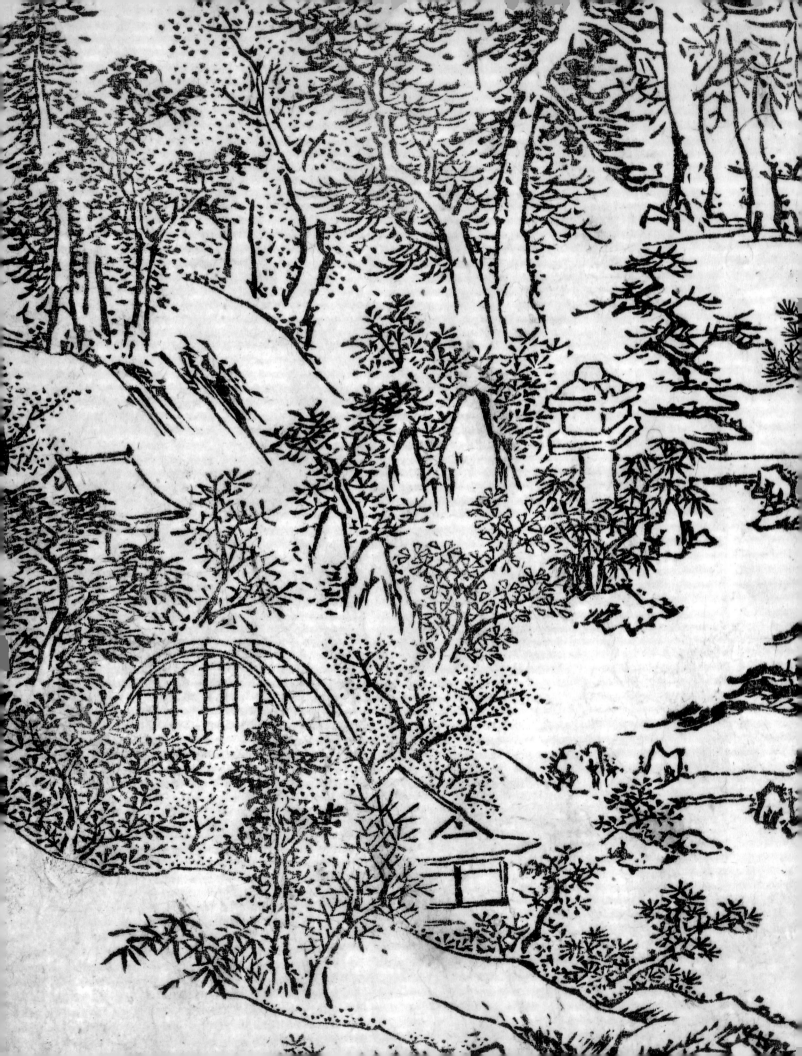

An Ancient Art Form

In Japan, gardening is an art form that has developed over thousands of years, beginning with simple pebbled covered plots on the beach or in the forest, created for ceremonies honoring spirits believed to have come from the heavens or across the sea. Pebbled plots later developed into the graveled courtyards associated with prehistoric chiefs' houses and Shinto shrines. This early indigenous tradition was joined by beliefs and practices from China and Korea, beginning in the third century BCE and culminating with the introduction of advanced civilization in the sixth and seventh centuries CE. This latter wave of influence brought writing, Buddhism and continental style gardens organized around a pond.

Indigenous and continental traditions continued to interact over the centuries and often were integrated in a variety of ways to serve the needs of royalty, aristocrats, temples and shrines, and eventually also commoners. In the process, Japan created some of the most beautiful and sophisticated gardens in the world. Today, Japanese gardening practices have been adapted to the needs of modern society and exert a major influence upon gardens in other countries of the world.

Historical Overview

Pages 8–9: Detail from a garden design depicted in the 1735 edition of the Edo Period gardening manual *Tsukiyama Teizōden* (Building Mountains and Making Gardens).

Opposite: Lantern on an island in the Sawa-no-ike Pond at Kōrakuen Garden, Okayama City (pages 154–5).

Pages 12–13: Kinkaku (Golden Pavilion), situated on the northeastern edge of Kyōkochi Pond at Kinkakuji Temple, Kyoto (pages 102–5).

Some time before the end of the Pleistocene epoch people entered Japan from various parts of Asia. Some came from the north through the island of Sakhalin; some came from China via Korea; others appear to have come from the south by boat. Not much is known about these early people except that they were Paleolithic hunters and gatherers who employed sophisticated stone tools.

During the Jōmon Period (10000–300 BCE), pottery was invented and, towards the end of the period, people began experimenting with wet rice agriculture on a small scale. People lived in pit houses, but grain was stored in elevated structures. In the Yayoi Period (300 BCE–300 CE), new cultural influences and people arrived from the mainland to bring a more settled way of life with large villages supported by irrigation agriculture. It was during this period that the indigenous religion developed into what came to be known as Shinto.

Development of a Unified State

Beginning in the late Yayoi Period, burial mounds were created for clan leaders and other important persons. The Tomb Mound Period, beginning around 300 CE, was a time when Japan was struggling to overcome centuries of conflict between rival clans and to develop a unified state under the leadership of the Yamato clan, from which the present imperial house is descended. Buddhism was introduced to Japan in the sixth century from Korea. The period between the arrival of Buddhism and the Taika Reform of 645 is known as the Asuka Period (538–645), which takes its name from the Asuka area near Nara. During the Asuka Period, Japan underwent great transformation as it came under the influence of continental culture.

Dominance of Continental Culture

The Taika Reform of 645, which marks the beginning of the Hakuhō Period (645–710), created a central government and a legislative structure based upon the model of the Tang Dynasty in China. The first real capital was established at Fujiwarakyō in 694. Official interchange with China was established for the first time and continental culture spread from the court to the provinces. In 710, the capital was moved from Fujiwarakyō to Heijōkyō, near present-day Nara, to usher in the Nara Period, which lasted from 710 to 794. Major Buddhist denominations established their headquarters in the new capital. The great flowering of architecture and the arts that ensued marks the high point of Buddhist culture in Japan, and the maturation of Japan into a nation state. The capital was moved again in 794 to Heiankyō

(present-day Kyoto), where it remained for over 1000 years until Edo (present-day Tokyo) became the capital at the time of the Meiji Restoration of 1868. The Heian Period (794–1185), which derives its name from Heiankyō, saw continued borrowing from Tang China. Eventually, Japan reduced contact with the continent and assimilated what it had learned to produce a distinctive culture of its own.

Feudalism

Towards the end of the Heian Period, a series of wars between the Taira and Minamoto clans resulted in victory for the Minamoto. Partly to escape the influence of the imperial court in Kyoto, the victorious clan established a military system of government known as the *bakufu* in Kamakura, near present-day Tokyo. This marks the beginning of the Kamakura Period (1185–1333). Japan had become a feudal society, with a shogun as its head, governed by the principles of *bushidō*—the Way of the Warrior. The Kamakura shogunate, weakened by Mongol invasions, was replaced by the Ashikaga family, which moved the military capital back to Kyoto, to begin the Muromachi (Ashikaga) Period (1333–1573). In the Muromachi Period, there was a great flowering of Zen-inspired arts such as black ink painting, calligraphy, flower arranging, the tea ceremony, Noh drama, the martial arts and landscape gardening. Eventually, the Ashikaga shogunate waned in power and more than a decade of clan warfare (the Ōnin War) reduced much of the capital to rubble. Japan was reunified in the Momoyama Period (1573–1600) by a succession of three great military leaders: Oda Nobunaga, Toyotomi Hideyoshi and Tokugawa Ieyasu. The Tokugawa family moved the military capital from Kyoto to Edo (present-day Tokyo) in 1600, to begin the Edo (Tokugawa) Period (1600–1868), characterized by two and a half centuries of relative peace and stability, as well as isolation from the West.

Early Modern Japan

Dissatisfaction with the Edo rulers grew as Japan fell behind the West in technology and many feared the growing threat of colonization. The Meiji Restoration of 1868 abolished the shogunate and samurai class and restored the emperor to power, at least in theory. Japan became a constitutional monarchy and embarked upon the road to rapid modernization, industrialization and urbanization. With these developments came a growing militarism that eventually led Japan to defeat in World War II and occupation. Japan rebuilt rapidly after the war and soon became an important economic force in the modern world.

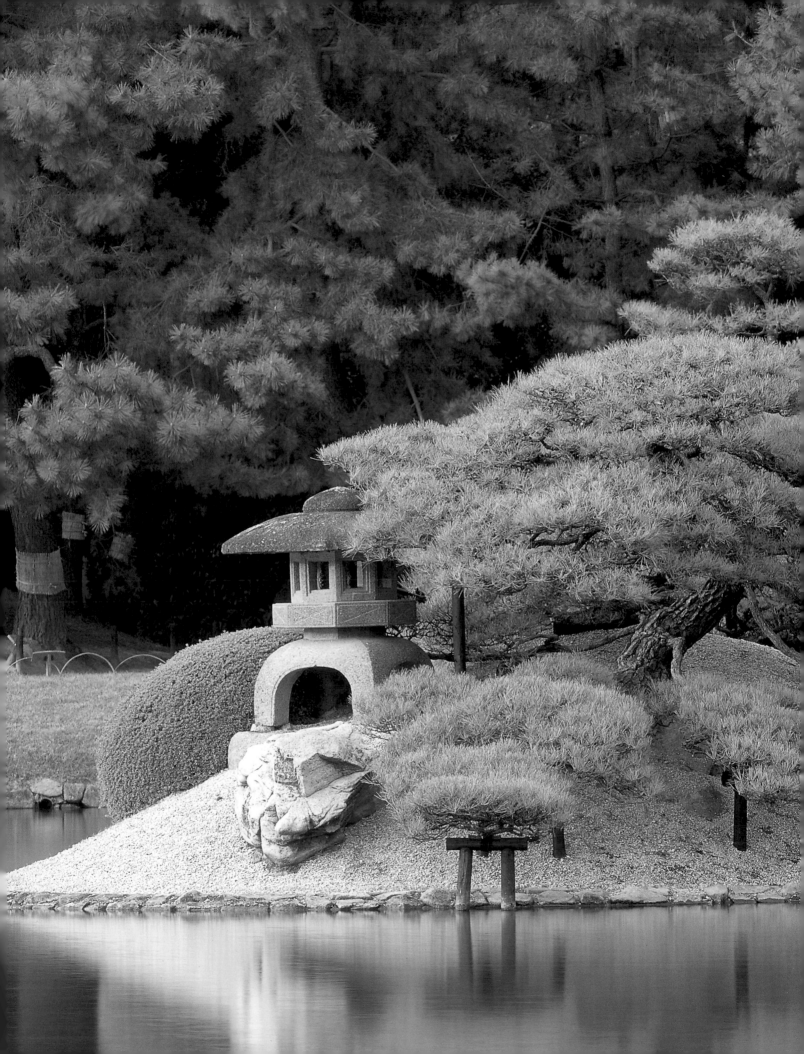

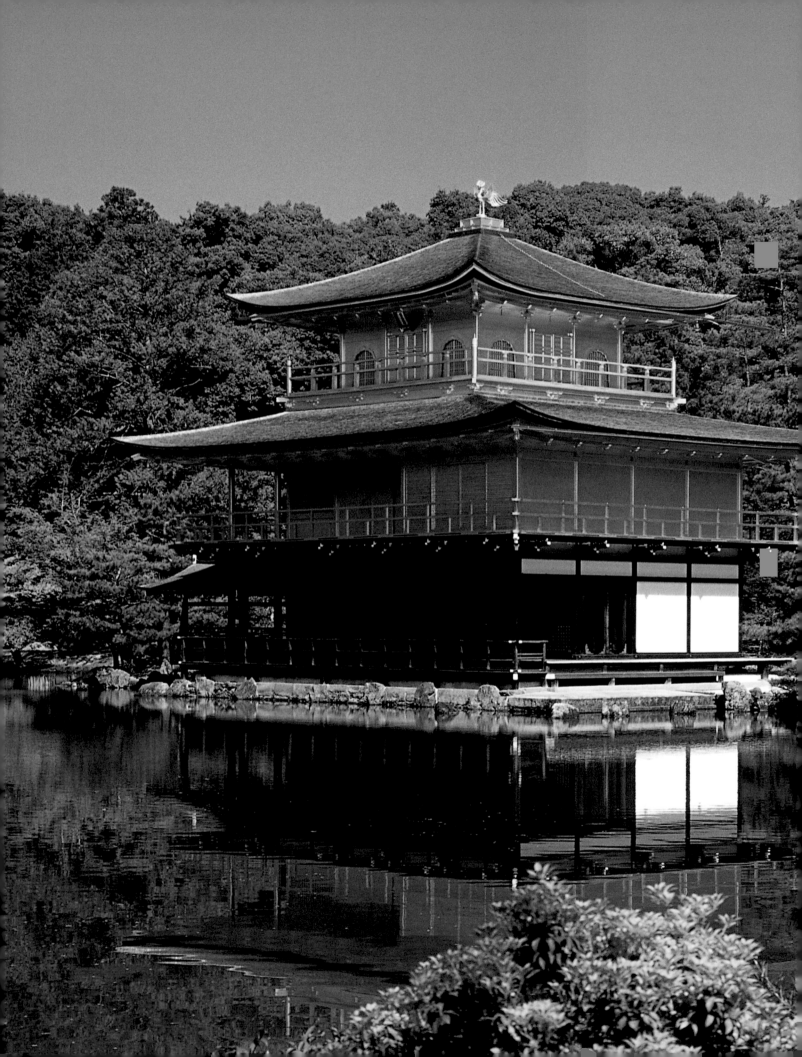

Chronology of Japanese Gardens

HISTORICAL PERIODS

FOREIGN INFLUENCES

JŌMON
10000–300 BCE

YAYOI
300 BCE–300 CE

TOMB MOUND
300–710 (overlaps
with later periods)

ASUKA
538–645

HAKUHŌ
645–710

NARA
710–794

HEIAN
794–1185

KAMAKURA
1185–1333

MUROMACHI
1333–1573

MOMOYAMA
1573–1600

EDO
1600–1868

MEIJI
1868–1912

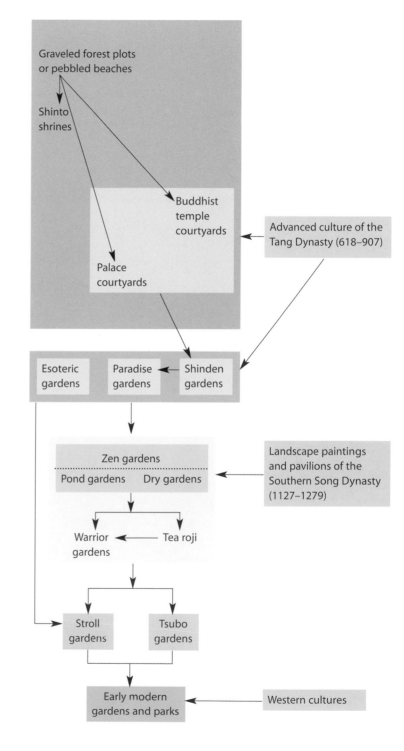

Graveled forest plots
or pebbled beaches

Shinto
shrines

Buddhist
temple
courtyards

Palace
courtyards

Advanced culture of the
Tang Dynasty (618–907)

Esoteric
gardens

Paradise
gardens

Shinden
gardens

Zen gardens

Pond gardens Dry gardens

Landscape paintings
and pavilions of the
Southern Song Dynasty
(1127–1279)

Warrior
gardens

Tea roji

Stroll
gardens

Tsubo
gardens

Early modern
gardens and parks

Western cultures

Development of Japanese Gardens

In Western societies whose cultures are fundamentally European in origin, the word "garden" means a place where things are grown, as in "vegetable garden," "flower garden" or a formal garden where flowers, shrubs and trees are artistically arranged and managed to provide aesthetic enjoyment. In Japan, this definition is too narrow since many gardens, being composed entirely of rocks and gravel, do not have vegetation.

The Concept of Teien

The modern Japanese term for garden is *teien*, a compound word composed of the characters for *niwa* and *sono*. In prehistoric times, the term *niwa* referred to places where specific activities were carried out, such as ceremonies dedicated to *kami*, spirits believed to have descended from the heavens or to have come from across the sea. These special places may have included areas around sacred objects such as trees, rocks, waterfalls, naturally pebbled beaches or plots in the forest that were covered with gravel. After the development of agriculture, the term *niwa* was used to refer to the bare clay-packed area in front of a farmhouse for conducting activities such as daily chores and ceremoniously seeing off guests.

With the spread of agriculture around 300 BCE, the word *sono* was employed to describe plots that were shaped into paddies and flooded for the planting of rice. Wet rice agriculture involved extensive modification of the surroundings. In addition to clearing trees, fields had to be leveled; in some cases terraces were constructed; retaining walls were built around each field to retain the water; and irrigation systems were constructed to distribute water among the numerous fields. The importance of water is also seen in the sacred ponds and purification rites of early Shinto.

In brief, *niwa* were areas that were graveled or covered with clay in preparation for activities such as ceremonies, whereas *sono* were areas in which things were planted and watered. Both of these early roots were retained in the term *teien*.

Sacred versus Secular

To help clarify the relationship between graveling and planting, it is useful to make a distinction between "sacred" and "secular"—terms that form two ends of a continuum. At the sacred end are compounds dedicated to spiritual entities and activities, including individuals with "divine" origins, such as the emperor. In the ancient tradition, these compounds are austere graveled areas adjacent to or surrounding buildings such as important shrines and temples, or the imperial palace. A good example is provided by the graveled courtyards of the shrines at Ise Jingū, long associated with the imperial family. Though graveled courtyards often are not included in books on Japanese gardens, such courtyards are the heirs to an indigenous tradition that has had a considerable impact upon the concept of *teien*.

At the secular end of the continuum are spaces dedicated to entertainment and aesthetic enjoyment, such as gardens constructed for mansions and villas. Such gardens are generally larger, have a pond and are planted with trees, shrubs and flowers. This complexity is further enriched with a variety of visual stimuli such as rocks, lanterns and pavilions. A good example is the Naritasan Shinshōji garden in the town of Narita near Tokyo.

In the middle of the continuum are gardens that combine aesthetic pleasure with a feeling of philosophical or religious profundity, as in the Katsura Rikyū Detached Palace garden in Kyoto, said by some to be the high point of garden and palace architecture in Japan. A little more towards the sacred end from this mid-point is the austere Zen meditation garden, Ryōanji, in Kyoto, composed entirely of white gravel and rocks; and a little more towards the secular end is the Saihōji Temple garden in Kyoto, popularly known as Kokedera (Moss Temple), which is famous for its lush green mosses and stately trees. Many would consider the gardens in this middle portion of the continuum to be Japan's finest.

Opposite: View of the Kikugetsutei (Moon-scooping Pavilion), a teahouse on the north shore of South Lake at Ritsurin Kōen, Takamatsu City (pages 142–7).

Below: China had a major influence on Japanese gardens at various times in its history. Shown here is the Yoen (Jp.) pond garden in Shanghai, constructed in the Ming Period (1368–1644).

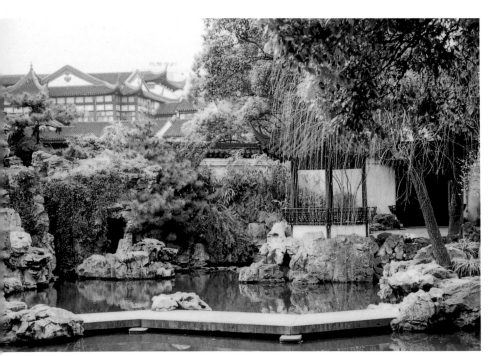

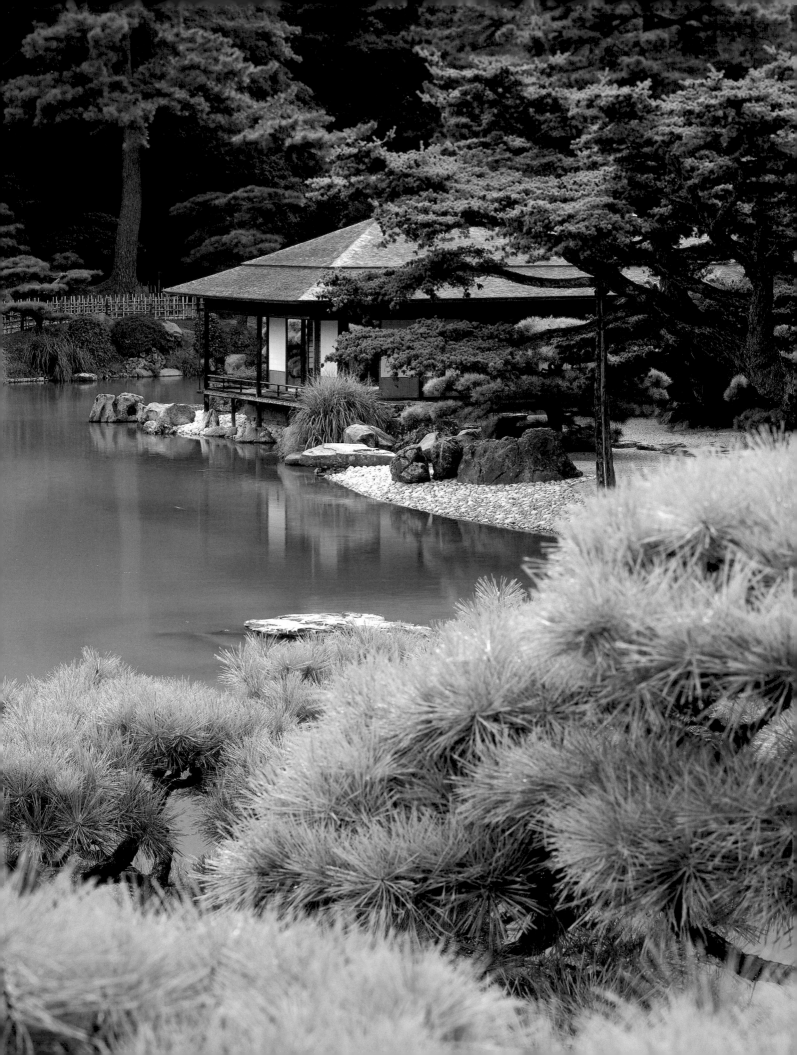

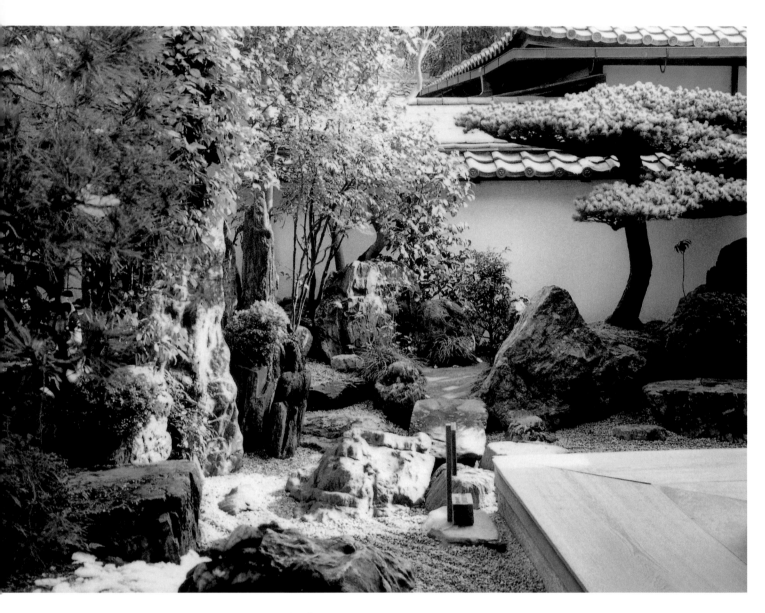

Above: *Karesansui* (dry landscape) garden of Daisenin, a sub-temple of Daitokuji, a major Zen monastery in Kyoto (pages 110–11). This style of garden became popular in the Muromachi and Momoyama periods.

Opposite: The Naritasan Shinshōji garden near Tokyo is a good example of a secular stroll garden from the Edo Period. Most stroll gardens were attached to villas and palaces. The Naritasan Shinshōji garden, however, is attached to a Buddhist temple in the town of Narita.

Continental Influences

Japanese gardens did not develop in isolation. Though rooted in ancient prehistoric traditions, they were influenced by new cultural waves coming from the continent, beginning in the third century BCE and culminating in the sixth and seventh centuries CE when the advanced civilization of the Tang Dynasty was at its height. In 607, Ono-no-Imoko, the leader of the first Japanese diplomatic mission to China, returned to Japan with detailed observations on Chinese gardening methods. In 612, Michiko-no-Takumi arrived from Korea to construct for Empress Suiko a garden inspired by mythical Mount Sumeru, mentioned in Buddhist scriptures. Complete with

an artificial lake and an island, this continental model was quite different from the earlier graveled courtyard model indigenous to Japan. Both models were destined to play an important role in the development of Japanese gardens.

Organization of the Book

The sacred/secular continuum described above could be used to organize the book as a whole. To do so, however, would require making subjective judgments about the position on the continuum occupied by each garden discussed in the book. This is simply not practical.

Traditionally, Japanese gardens have been organized into three types: natural scenery (*shizen*

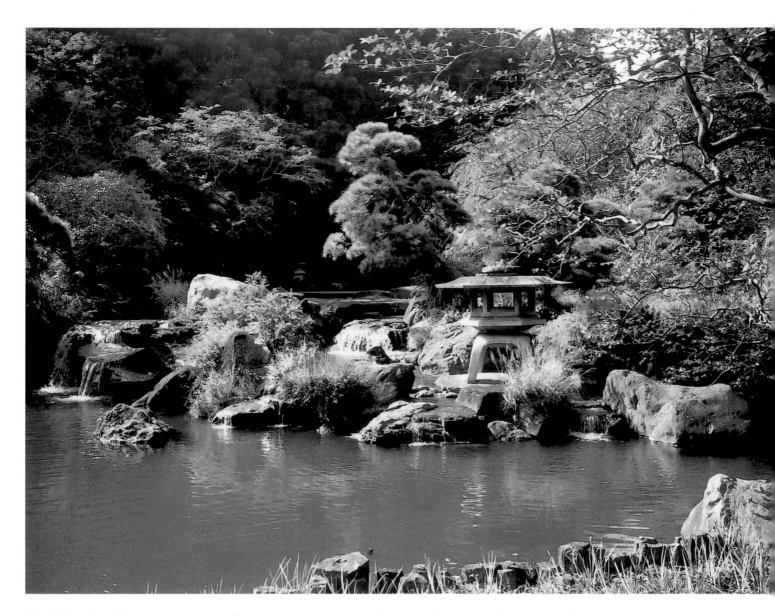

fūkeishiki) gardens that represent nature with artificial ponds and hills, stones and vegetation; dry landscape (*karesansui*) gardens that suggest natural scenes with stones, gravel and sand; and tea ceremony gardens (*chaniwa*) that consist of landscaped paths (*roji*) leading to a teahouse. This classification scheme also could be used to organize the book. It is, however, overly simplified. Instead, Japanese gardens will be described in this book in terms of their historical development. The value of this approach is that it provides a basis for understanding how Japanese gardens were influenced by broader cultural forces, and how early gardens evolved into, or influenced, later types, including gardens in other countries.

Austere and simple	Visually rich and complex
← Sacred	Secular →
Cleared and graveled	Contoured and planted

Though there are exceptions, gardens that evoke religious feelings and philosophical insights tend to be towards the austere end of the continuum, whereas gardens that stimulate a sensual aesthetic response are towards the secular end. Many of Japan's finest gardens lie in the middle of the continuum.

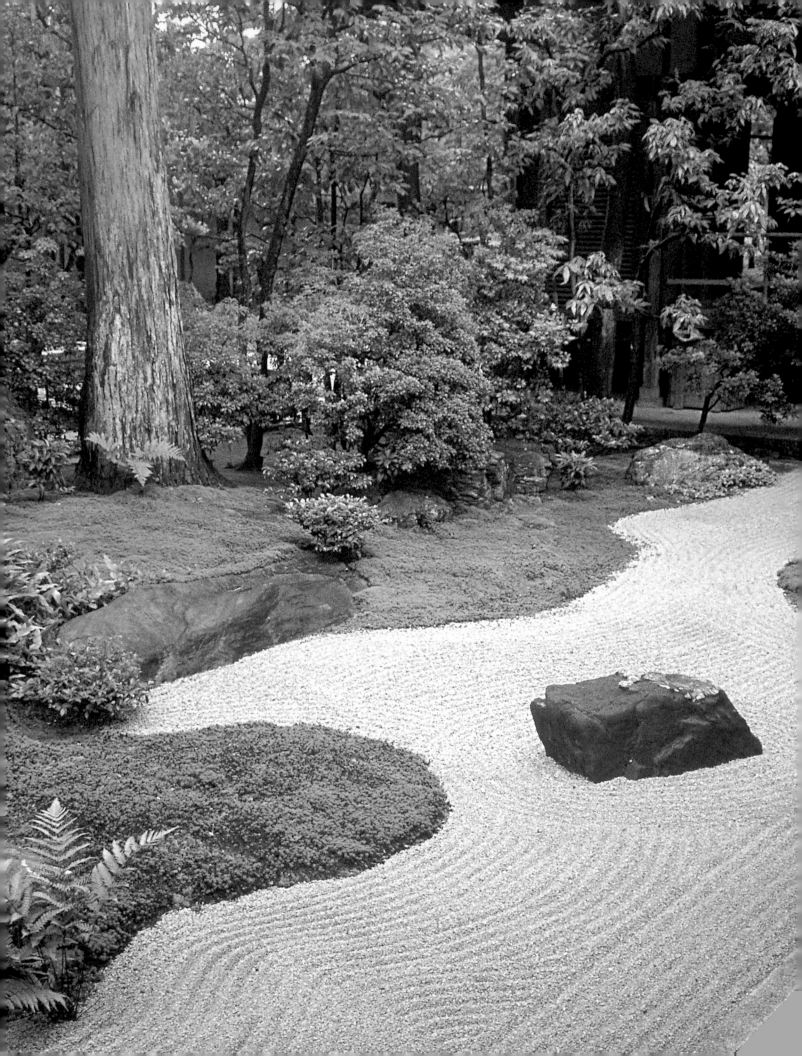

Basic Elements and Principles

Japanese gardening, like other art forms, is a skill in which the artist, to use a linguistic analogy, employs a grammar to express an idea in tangible form. The basic building blocks (or "words") of this gardening grammar are elements such as rocks, vegetation, water and stone lanterns; and the syntax (rules for combining basic units into a meaningful expression) are principles governing the use of different shapes, sizes and colors to create a balanced and pleasing composition.

Just as languages have dialects, Japanese gardening is not a uniform body of techniques and practices. The grammar employed depends upon the style of gardening. For example, the designer of a stroll garden has access to the full range of basic elements, whereas the designer of a dry landscape garden is much more limited in the vocabulary used. This does not mean that the stroll garden is any more highly developed than the dry landscape garden, but it is different in terms of the resulting "feeling tone." Moreover, like languages, gardening grammars and styles change over time, depending partly upon internal trends, such as a trend towards increasing complexity, and partly upon external cultural, social and political factors.

This section explores the grammar of Japanese gardening in preparation for a description of specific gardens in the following section.

Above: Basic structural elements in a Japanese garden: water, rocks and vegetation.

Pages 18–19: Raked gravel used to create a dry landscape stream at Daishinin, a sub-temple at Myōshinji Temple in Kyoto.

Opposite: Many of the basic elements of a Japanese garden are shown in this 1735 edition of the gardening manual *Tsukiyama Teizōden* (Building Mountains and Making Gardens).

Basic Elements

The most important elements are structural features. Rocks are arranged into compositions that represent mountains, waterfalls and rugged seascapes. Contrasts between mountain slopes, meadows and valleys are indicated by different species of trees and shrubs that are pruned, clipped and trained into a variety of shapes. Trees and shrubs also are used to connect and provide transitions between the different scenes in a garden. Soil is piled up to create artificial hills; and water is channeled to feed streams, ponds and waterfalls.

Additional structural features are the frames provided by fences and walls, as well as the paths and bridges that are used in "entry-style" gardens to guide the visitor along a predetermined course.

Next in terms of importance are more decorative elements such as stone lanterns, water basins, flowers, carp and the occasional boat. The function of such features is to augment and fill out the basic design, as well as to provide color and interest.

Some large gardens also include small buildings such as teahouses, pavilions and shrines. Sometimes there is a transitional device between a main building and its garden, such as a deck where one can sit to contemplate the garden, rather than wandering through it.

Basic Principles

A basic principle of Japanese gardening is miniaturization, in which elements such as rocks and ponds are used to represent large-scale landscapes. Related to miniaturization is the use of various techniques to make spaces appear larger than they really are. One of these techniques is altered perspective. For example, if rocks and trees in the foreground are larger than those in the background, the result is an illusion of distance.

A second technique is *miegakure* (hide-and-reveal)—arranging the garden in such a way that not everything can be seen at once. For example, in entry-style gardens, vegetation, fences and structures are employed to block long-range views.

A third technique is *shakkei* (borrowed scenery) in which mountains and buildings (such as castles) that lie outside the garden are incorporated into the design of the garden.

Another basic principle is asymmetry. In asymmetric forms and compositions, no single element is dominant. If there is a focal point, it should be off-center. For example, rocks and trees usually are arranged into triangular compositions that balance horizontal, vertical and diagonal forces. Another example is to arrange the rooms of the main building (such as a villa) to which the garden is attached in a diagonal, overlapping pattern, sometimes referred to as "geese in flight." This staggered arrangement creates interesting garden spaces and helps integrate a building into its natural surroundings.

Not all gardens are designed to be entered. Some are to be viewed from inside a building or from a deck, in which case the entire composition may be seen at once. This requires a different set of principles involving the need to create a balance between structural stability and a type of dynamism in which the eye is enticed to trace an interesting route as it moves from one element to another, thereby drawing the viewer into the creative process.

At the root of all such basic principles is the understanding that a garden is a work of art. Though inspired by nature, it is an interpretation rather than a copy; it should appear to be natural but it is not wild. A primary challenge to the designer is to bring out the intrinsic nature of a landscape scene in such a way that it is beautiful in all seasons of the year.

Basic Themes

Basic elements and principles vary depending upon the type of garden. There are certain themes, however, that are found in many different types of gardens. A large rock, sometimes placed on an islet, often symbolizes Buddhism's Mount Sumeru or Taoism's legendary mountain peak of the immortals, known as Mount Hōrai. Another frequently occurring theme is a pair of basic elements, such as rocks, islets or trees, to represent the tortoise and crane—traditional symbols of longevity. The crane is always the higher of the two elements in the dyad. Other common themes are natural landmarks such as Mount Fuji or famous landscape scenes in China or Japan.

Landscape Manuals

The basic elements, principles and themes of Japanese landscape gardening were described in early gardening manuals. The first of these was *Sakuteiki* (Notes on Garden Making). Written in the middle of the Heian Period (794–1185), the *Sakuteiki* attempted to adapt Chinese gardening principles to Japanese conditions and tastes. Later manuals included the fifteenth-century *Senzui Narabi ni Yagyō no Zu* (Illustrations for Designing Mountain, Water and Hillside Field Landscapes) and the eighteenth-century *Tsukiyama Teizōden* (Building Mountains and Making Gardens). Manuals such as these are still studied today.

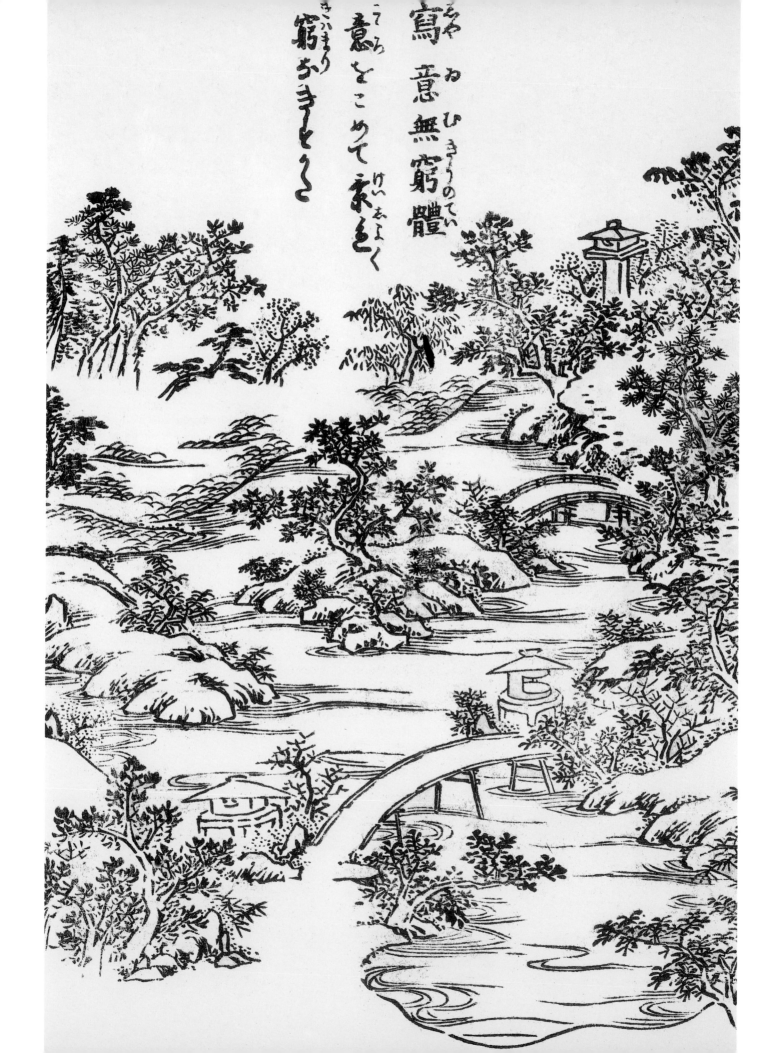

寫意無窮體

やゑひきうのてい

こゑ　けいをよく
意をこめて家を

さふまり
窮ちきとる

Rocks, Sand and Gravel

Above: *Ying–yang* rocks placed along a stream on the outskirts of Yuishinzan Hill at Okayama Kōrakuen (pages 154–5) represent male and female sex organs. Fertility was a favorite theme of Warrior gardens during the Edo Period since the fief was repossessed by the shogun if a *daimyō* did not pass it on to a son.

Opposite: A monk rakes gravel into water patterns at Zuihōin, a sub-temple of the Zen monastery Daito-kuji in Kyoto. Such patterns become disturbed by rain and wind, as well as cluttered with leaves or other debris, and must be re-established on a regular basis.

Variables to be considered in the selection of rocks, sand and gravel include shape, size, color and texture. Rocks are among the most important structural elements of a garden since they can be used to represent mountains, rugged shorelines and waterfalls. Sand and gravel also are important as they can be raked into patterns that are suggestive of flowing elements such as clouds and streams.

Types of Rocks

Landscape gardens normally use natural rocks found in the mountains, at the seashore or along rivers. These can be classified into three kinds: *suisei-gan* (sedimentary rocks), *kasei-gan* (igneous rocks) and *hensei-gan* (metamorphic rocks). Rocks of the first type are usually smooth and round due to the action of water. They are used on the edges of ponds and as stepping stones. Rocks of the second type are produced by volcanic activity and are usually rough in shape and texture. They are used as stepping stones or to provide a highlight, such as a mountain peak. Because rocks of the third type are very hard, they are normally used around waterfalls and streams. Cut rocks (*kiriishi*) also have become popular in recent times. Sedimentary rocks are generally used for this purpose since they are relatively soft and easy to handle. Cut rocks are used for bridges, water basins and stone lanterns.

Rock Selection

When rocks are selected for a garden, it is particularly important to consider shape and size. Rugged mountain peaks require large rocks with sharp, angular planes, whereas weathered hills require the gentler shapes of water-worn rocks. Another consideration is the surface patina of a rock. Some compositions call for rocks covered with moss or lichens, in which case they must be collected and handled with great care. On the other hand, a recently broken rock may be suitable to represent a high mountain peak. Even so, care must be taken to not leave scratches on the surface.

Sometimes rocks are selected because of an interesting or unusual shape, or because they resemble animals, birds or human artifacts. This practice has precedents in China, where the mountainous dwellings of the immortals often were depicted by unusual rocks or where an entire garden, especially in the Ming Dynasty (1368–1644), could consist of an elaborate assemblage of fancifully shaped stones. The Chinese emphasis on selecting rocks for their representational or fanciful qualities has long had an influence on Japanese gardens, as in the boat-shaped rock at Daisenin Temple in the great Zen monastery complex of Daitokuji in Kyoto (page 110), the rocks used to represent heads and tails in the turtle and crane islands common in large stroll gardens, or in the unusual rocks often found in Warrior gardens. In general, however, Japanese have preferred asymmetrical, natural shapes to representational or fanciful ones, and have placed more emphasis upon the integration of rocks into the composition than upon the uniqueness of individual rocks.

Composition and Placement

Traditionally, rocks were classified according to shape: tall vertical, low vertical, arching, reclining and flat. There also are classifications for the number of rocks in a composition: two, three, five or seven. An arrangement of three rocks is the most common. There are two types of rock triads: one in which three rocks are arranged horizontally to form a triangle when viewed from above (*hinbonseki*), and one in which three rocks are arranged to form a triangle, with its base resting on the ground, when viewed from the side (*sanzonseki*). The latter, the vertical triad, probably dates back to the Nara Period when it was known as a Buddha triad, with the large rock in the middle representing a Buddha and the two flanking rocks representing Bodhisattva attendants. An entire garden can often be analyzed in terms of the relationship between horizontal and vertical rock triads.

Some basic rock shapes.

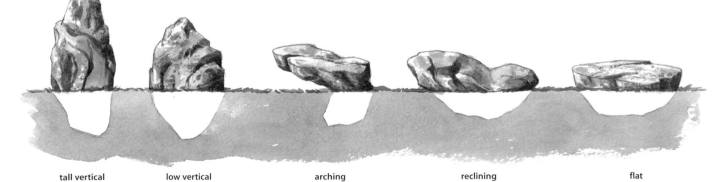

tall vertical low vertical arching reclining flat

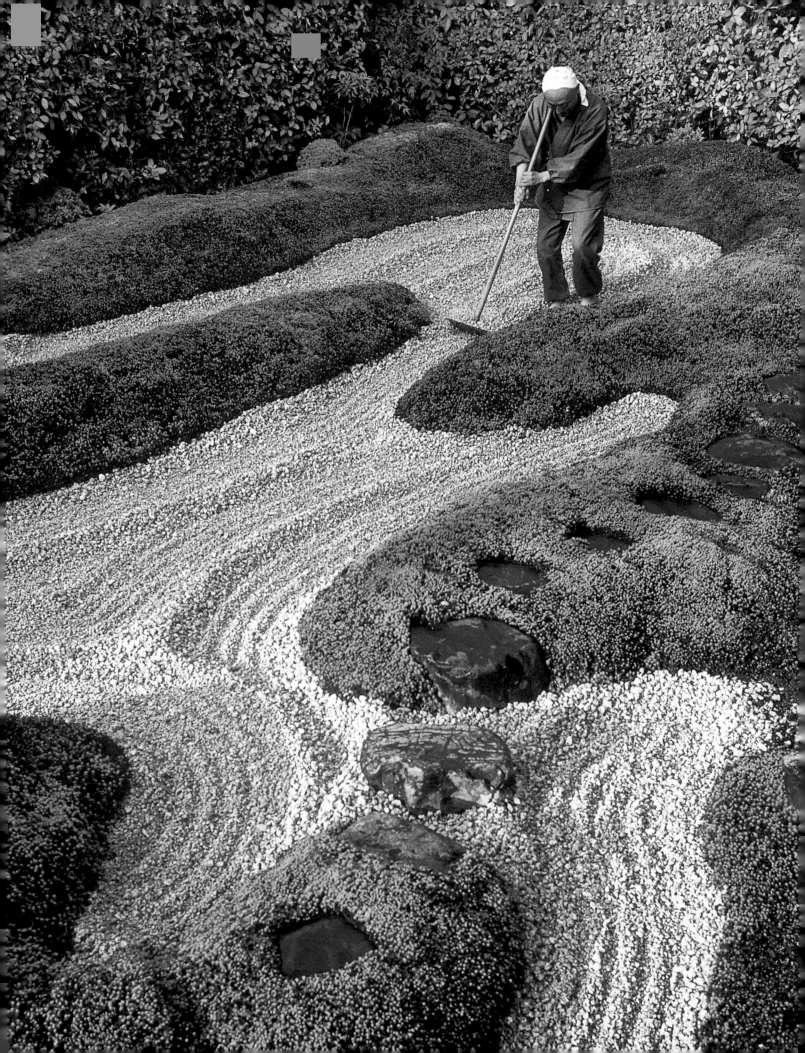

Some basic rock combinations.

tall vertical and reclining

tall vertical, short vertical and reclining

short vertical and flat

tall vertical, flat and reclining
(an example of the basic triad)

tall vertical, arching, short vertical,
flat and reclining

Above right: The *karesansui* garden
at Ginkakuji Temple (pages 106–7). The
long furrows of raked sand resemble
waves in the moonlight, hence the
name Ginsadan (Sea of Silver Sand).
The sand mound at back is called
Kōgetsudai (Moon-viewing Dais).

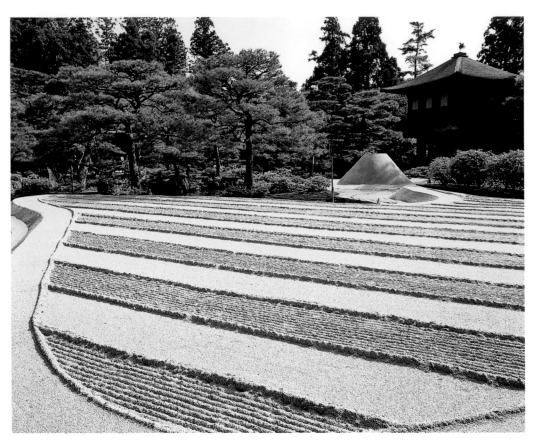

The use of three components, one large, one small and one medium, to create a dynamic balance of odd numbers is not limited to garden architecture but is a basic principle in other arts, such as flower arranging, where the tallest (vertical) element in the arrangement (such as a flower, wild grass or branch) represents heaven; the shortest (diagonal) element represents earth; and the medium-size (horizontal) element represents humanity—the bridge between heaven and earth.

Other Design Considerations

Generally, a rock should be set into the ground far enough to provide a feeling of stability and a sense that the rock has been there for some time. The number and size of rocks included in a garden have a major impact upon the general impression created. As mentioned earlier, Warrior gardens tended to include numerous rocks of large size, suggesting power and authority. In contrast, Zen gardens generally employ few rocks, to create a more austere and contemplative environment.

An important design consideration is to select rocks that vary in terms of color, shape and size. Within an individual rock, however, too much variation can be distracting. If strata or veining are evident, they should be oriented in the same direction. The same is true of color. A rock with too many strongly contrasting colors lacks subtlety.

An interesting design principle introduced at the end of the Edo Period was the seemingly random placement of one or more rocks to provide an element of spontaneity. Such rocks are referred to as *suteishi*—"discarded" or "nameless" rocks. This "artless" use of rocks nevertheless has to be done skillfully if it is to achieve the desired effect.

Sand and Gravel

Sand (*suna*) and gravel (*jari*) have characterized sacred plots in the forest or on beaches since ancient times (pages 64–5). Much later, sand from eroded granite was popular in dry landscape (*karesansui*) gardens because it can be raked into patterns that represent flowing water. By implying movement, sand patterns rely upon the power of suggestion to entice observers to participate in the creative process and to enter into the very fabric of the garden itself. The dynamism of sand patterns also complements the static nature of rocks. To use an organic analogy, if rocks provide the skeleton, sand patterns provide the soft tissue and blood.

Used together, rocks and sand patterns suggest various contrasts important in both continental and Japanese cosmology, such as the contrast between *yin* and *yang* (*in* and *yō* in Japanese), or the contrast between the eternal principles of the universe and their constant manifestation in the ongoing processes of nature.

Sand and Gravel Patterns

In creating sand patterns in dry landscape gardens, the size of the grain is important. If the grain is too small, it is easily disturbed by wind and rain; if the grain is too large, it is difficult to rake. Color is also important. White sand carries connotations of purity and can be dazzling in the sunlight, whereas darker colors, such as gray or brown to bluish black, are said to convey feelings of tranquility. The best white sand comes from the Shirakawa area of Kyoto, where it has been used in gardening for centuries. The Tokyo area produces some of the best colored sands.

Sand is ideal for gardens that are meant only to be viewed, but it is not suitable for courtyards in which activities take place, such as those of Buddhist temples or Shinden style mansions. Such courtyards employ larger grained gravel or small pebbles that are more apt to stay in place under the trampling of feet. Some courtyards, such as those at Ise Jingū, which are not normally walked upon, are covered with rounded, water-worn pebbles and small rocks, reminiscent of a river beach.

straight

paving stone

flower (or some other plant)

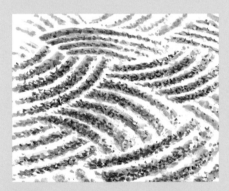

woven

whirlpool eddy in foreground; straight in back (note how the "straight" lines curve around the rocks)

piled sand

ocean waves

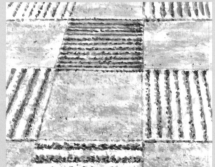

checkerboard (the main difference between the checkerboard and paving stone designs is in the size of the squares)

curves

Walls, Fences and Paths

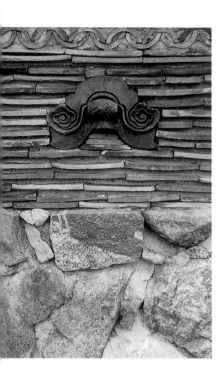

Walls and fences are used to enclose a garden, thereby ensuring privacy and keeping out unwanted intruders. They also are frames that allow a garden to be viewed as a work of art, somewhat detached from its surroundings. The importance of paths is that they guide visitors through a garden in such a way that the composition unfolds as intended by the designer.

Walls and Fences

In addition to framing what is on the inside, walls and fences can be used, in conjunction with trees, shrubs and hedges, to frame distant scenes and incorporate them into the garden—an example of "borrowed scenery." Fences are also used within a garden to screen a view or to encourage visitors to look or move in a particular direction. The choice of whether to use a wall or fence when creating an outside boundary depends largely upon the type of buildings and gardens enclosed, as well as upon the intended effect. A substantial wall is well suited to the large buildings and grounds of a Buddhist temple, whereas a twig fence is more appropriate for Sukiya style mansions and gardens. Walls and fences must, of course, have appropriate gates. For example, a twig fence may be interrupted by a small grass-covered pole gate, whereas a garden surrounded by a substantial clay wall with a tile roof requires a more impressive entrance.

Above: Detail of a wall constructed of ceramic tiles and clay, resting on a stone foundation.

Below: Bamboo fence at Kōetsuji Temple, Kyoto.

Materials and Construction Methods

Walls are generally distinguished by their construction methods. Temples and palaces are enclosed by very substantial walls constructed of a mixture of clay and straw (*shikkui*), covered with a coat of plaster that is painted white or a pastel color such as tan or beige. Sometimes tiles are embedded in the clay. Clay walls are supported by a timber framework and covered with a tile roof. Sometimes the wall is erected on a stone base. A common type of enclosure for early Shinden style gardens and mansions in the Nara and Heian periods was a substantial wooden wall with a wooden roof. Because such walls were easily damaged by wind and rain, they were mostly abandoned after the Heian Period, though board fences continued to be used.

Fencing materials and construction methods vary widely. In addition to the use of boards, some of the most common materials are bundled twigs, bamboo, reeds and bark. Flexible materials such as reeds and split bamboo can be fastened by cords and vines to a sturdy frame constructed of horizontal poles attached to vertical members sunk in the ground. They also can be fastened to each other and hung from a horizontal top pole, or in the case of strips of bark, woven together and attached to the frame. More sturdy materials such as bamboo poles can be widely spaced and interlaced on the diagonal, leaving diamond-shaped spaces between the poles. Twig fences in which the tops are not trimmed are known as "nightingale fences." These are only a few of the many fence alternatives open to the garden designer.

Paths

Paths are generally constructed of beaten earth that can be left plain or covered with sand or fine gravel, on top of which are placed stepping stones. Irregular flat stepping stones were used in tea *roji* to guide the participant towards the teahouse and to keep his or her feet clean. Later, stepping stones were incorporated into other types of gardens. The most commonly used materials are slate, schist, flint and granite, left as natural slabs or shaped into more regular forms. In most traditional gardens, stepping stones are of different sizes and are arranged in a variety of patterns, with several inches between stones so the bare spaces can easily be cleaned. In other cases, cut rocks can be arranged in a close-fitting geometric pattern to create a type of stone pavement. Most paths serve a practical function, but the material and style employed serve an aesthetic function by contributing to the degree of formality desired by the garden designer.

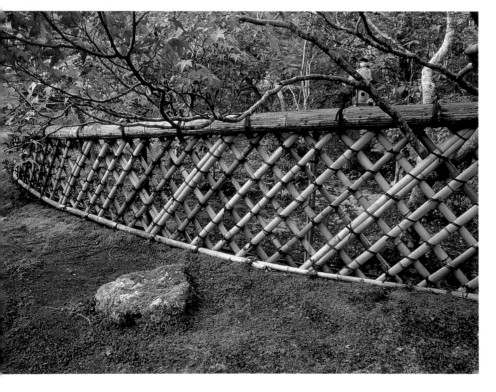

Wing Fences

Screen or wing fences are short ornamental fences, slightly narrower than tall, that are attached to buildings in order to control the view of the garden from the veranda or to conceal some object in the garden. They are usually made of brushwood (*shiba*) and split bamboo. Considerable effort is expended to turn wing fences into works of art. The drawings below are based largely upon the drawings of Josiah Condor, an English architect who lived in Japan in the Meiji Period.

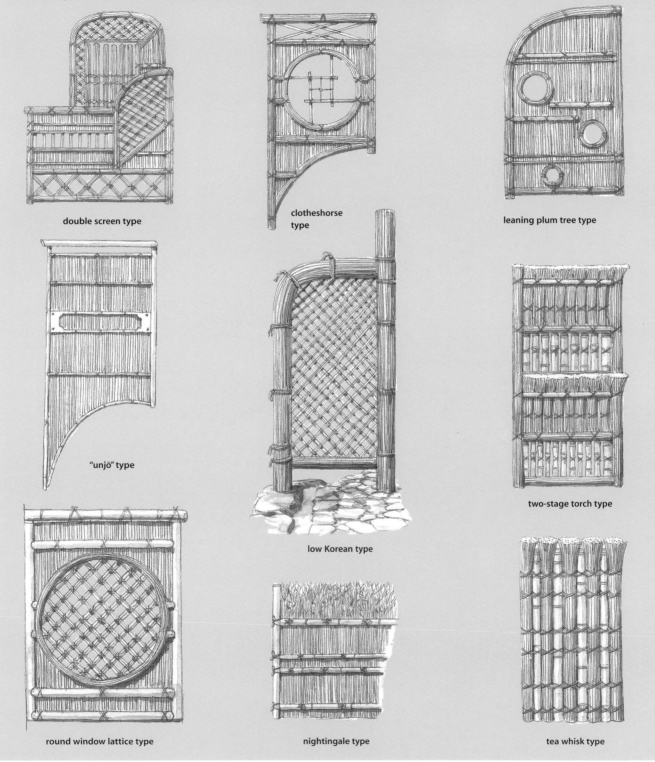

double screen type

clotheshorse type

leaning plum tree type

"unjō" type

low Korean type

two-stage torch type

round window lattice type

nightingale type

tea whisk type

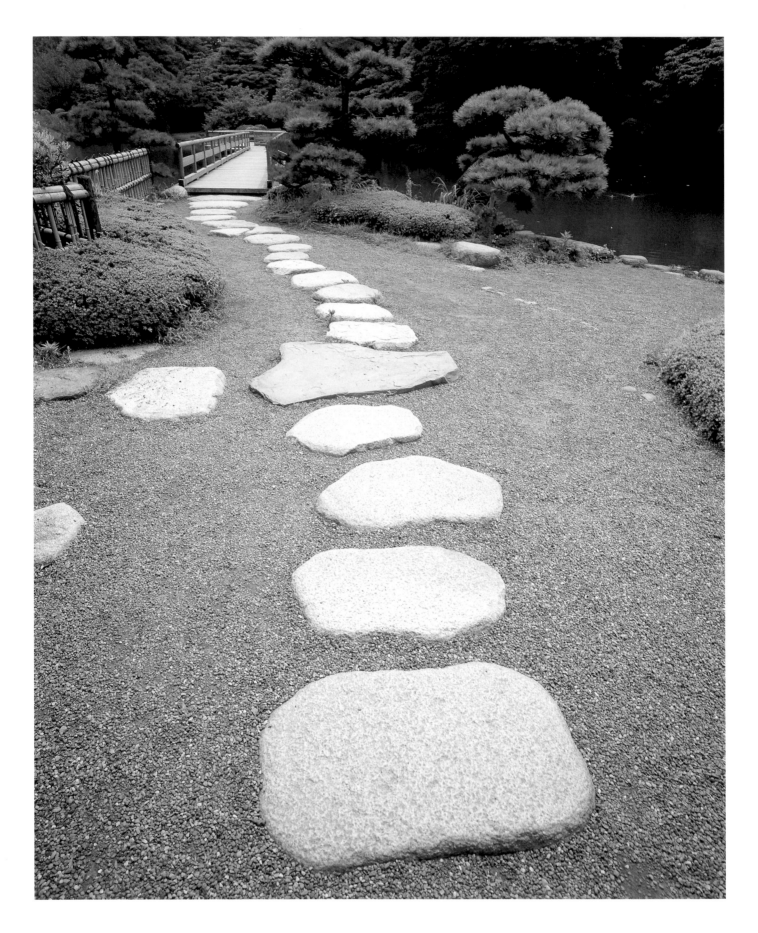

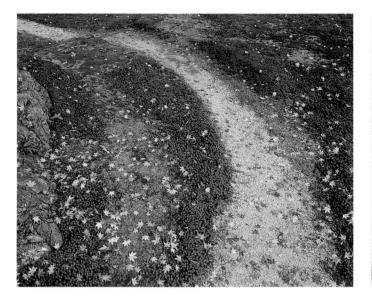

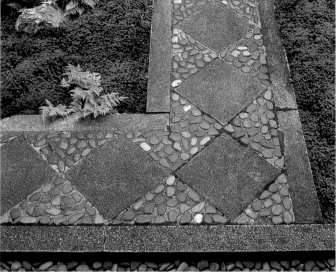

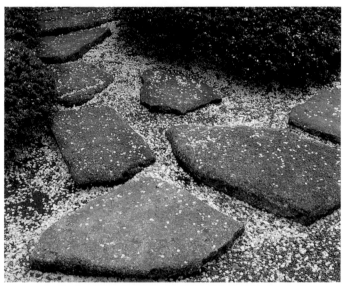

Opposite: Widely spaced natural stepping stones surrounded by gravel (*sō*: informal style). A larger stepping stone is used where two paths join.

Clockwise from top left: Earthen path covered with gravel.

Geometric cut stones surrounded by natural pebbles and cut stone border (*shin*: formal style).

Closely spaced natural pebbles, classified as formal (*shin*) because of the regular effect achieved by the use of pebbles similar in size and shape.

Closely spaced natural stones, irregular in size and shape, enclosed by a cut stone border (*gyō*: semiformal).

Informal stepping stones (*sō*).

Ponds, Waterfalls and Bridges

Above: Detail of a river emptying into a pond, from the gardening manual *Tsukiyama Teizōden* (Building Mountains and Making Gardens).

Opposite: View from the west bank of an artificial pond looking towards Rinuntei pavilion at the Shūgakuin Detached Palace (pages 132–7), at the base of Kyoto City's northeastern mountains.

Oceans and rivers have always been a major source of sustenance for the Japanese. It is therefore not at all surprising that water played a critical role in Shinto purification ceremonies. This indigenous emphasis upon water was strengthened in the sixth century when continental culture introduced gardens that included ponds, streams and waterfalls. Bridges are used to provide access to islands situated in ponds or to cross streams running through the garden.

Ponds and Streams

Ponds were created in a variety of shapes, sometimes based upon Chinese characters, such as the characters for water, heart or dragon. An important design principle was to avoid geometric forms such as rectangles and circles, except in very small domestic gardens. In a landscape garden, the pond should look natural with an irregular shoreline and different "arms," sometimes partially separated by narrows. Rocks and polished stones were often used to create a rugged coastline or a pebbly beach.

Whenever possible, ponds were fed by natural streams or springs, or by water that was piped in, sometimes from a considerable distance. In Kyoto, where most of Japan's famous gardens are located, there were numerous springs until the mid-Heian Period. Streams also can be employed in gardens that have no ponds to represent tumbling mountain brooks or rivers flowing through a plain. In the former case, streams are narrow, twisting and rocky. In the latter case, they tend to be broader, straighter and lined with wild grasses and flowers.

Waterfalls

Waterfalls are used to indicate where water enters a pond, to highlight a scene or to provide a focus. If a natural cascade is not available, an artificial waterfall is created by directing water over a cliff formed by planting rocks on a vertical face cut from a hill. The top is often obscured by vegetation to create the illusion of indeterminate height.

There are several varieties of waterfalls. In some, water drops directly from a cliff whereas in others it descends in stages over river rocks. The early gardening manual *Sakuteiki* lists nine types of waterfalls, a classification system that provided the basis for the following categories still in use today: "right and left-falling" (divided into two cascades), "side-falling" (falling on one side only), "front-falling," "folding-falling" (falling in a series of falls), "stepped-falling," "wide-falling" (wide in proportion to its height), "heaven-falling" (falling from a great height), "thread-falling" (falling in thin lines), and "linen-falling" (falling in thin sheets).

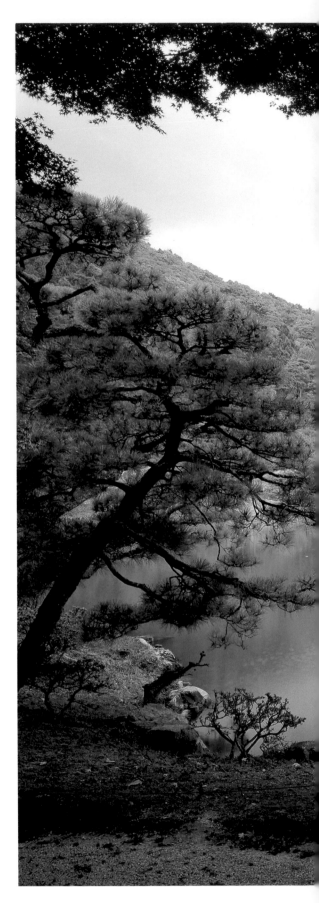

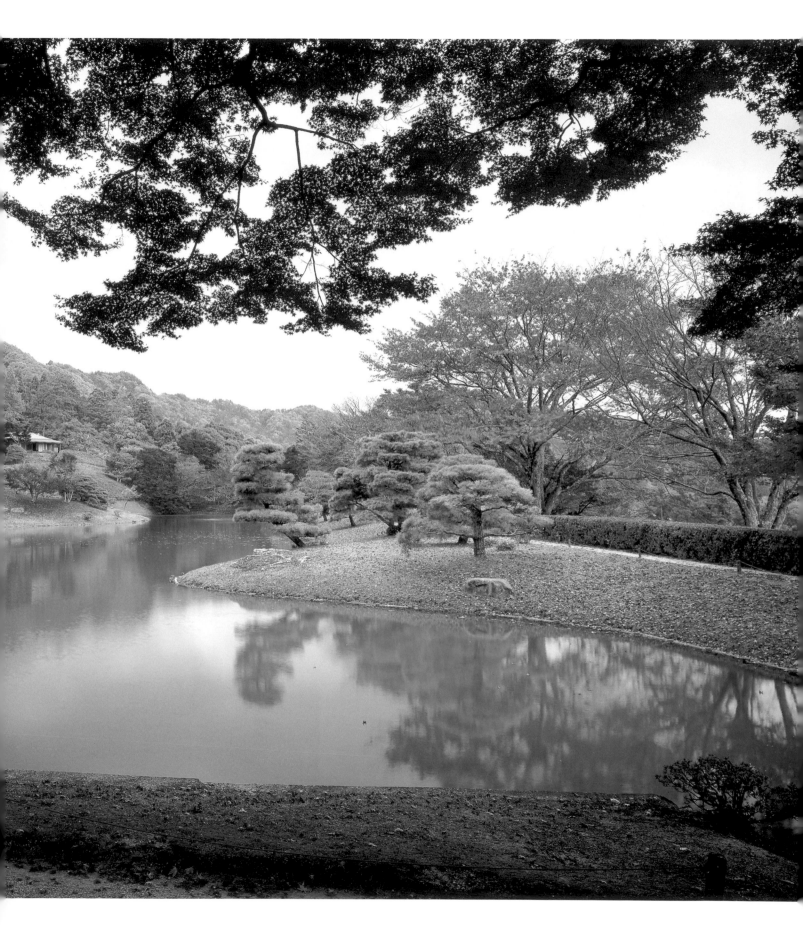

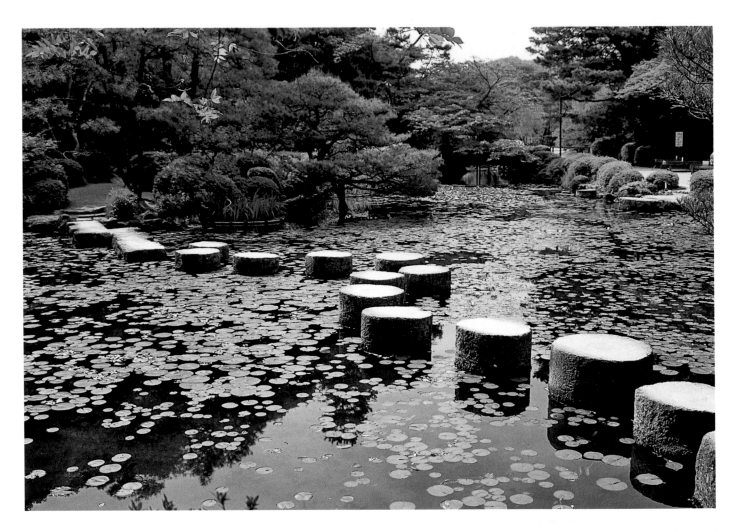

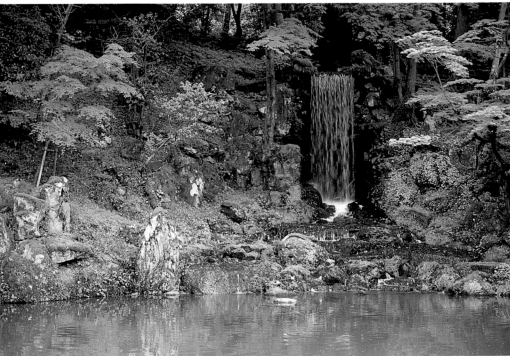

Above: Garyūkyō stepping stones in the Dragon Pond at Heian Shrine, salvaged from the supporting pillars of the Sanjō and Gojō bridges in Kyoto (page 79). The interconnected ponds in the garden are graced by lavish plantings of flowers, trees and water plants.

Right: The 7 meter (23 feet) high Midoritaki waterfall on the north edge of Hisago Pond at Kenrokuen (pages 148–53) was created in 1774 by the eleventh Maeda lord Harunaka, who held a large tea party to mark the completion of the waterfall. By this time, rock formations associated with waterfalls seem to have lost the religious symbolism they had in earlier gardens, such as Tenryūji.

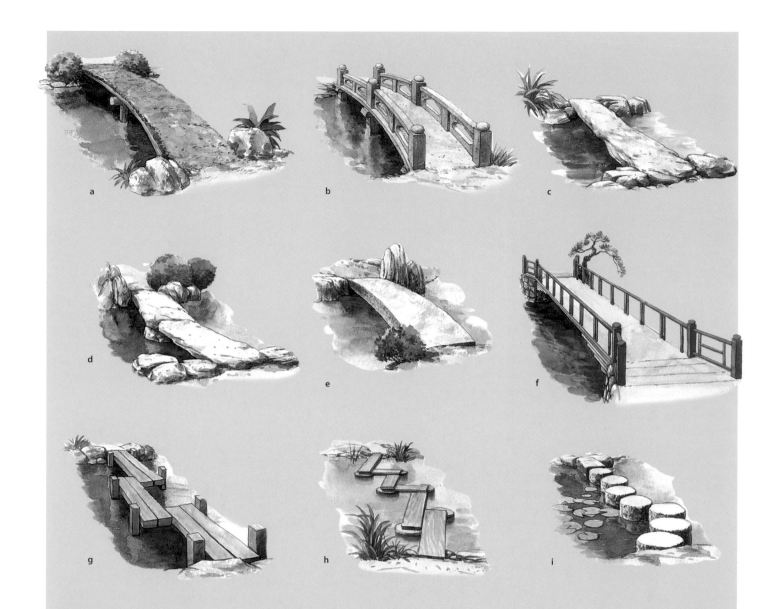

Bridges

Like walls and fences, bridges are almost endless in their variety of shapes, materials and means of construction. The main variables for common types of bridges are as follows:

Shape: arched (*soribashi*) or flat (*hirabashi*)

Alignment: straight, staggered or zigzag

Materials: stones or logs covered with organic materials such as bark and sod

Construction: suspended with a center support, suspended with no center support, wood or stone slabs resting on multiple supports, or stepping stones planted directly in the pond or stream bed

Character: refined or rustic

Arched bridges (*soribashi*) can be either painted red or left unpainted. When a log bridge is covered with cedar bark and dirt, upon which moss or grass is encouraged to grow, it is referred to as a *dobashi*. Stone bridges (*ishibashi*) employ either natural or cut rocks and are generally used to cross streams running into ponds. Covered bridges with benches, seldom seen in gardens today, are called *rōkyō* or *kurehashi*. Rustic slab or stepping stone bridges are suitable for Tea and Sukiya style gardens, whereas ornate wooden or cut stone bridges help create a more formal atmosphere.

a rustic arched bridge made of logs covered with mud and grass

b refined arched bridge made of cut stone

c flat single-slab stone bridge with no center support

d flat two-slab stone bridge with center support

e arched single-slab stone bridge with no center support

f flat wooden bracket bridge

g flat wooden bridge with staggered planks supported on pillars sunk in the stream or pond bed

h flat wooden bridge with a zigzag pattern

i stepping stones sunk directly in the stream or pond bed

Decorative Elements

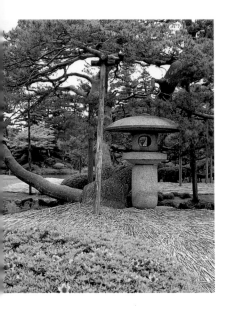

A pruned pine tree provides a backdrop for a large stone lantern at Kenrokuen Garden in Kanazawa City (pages 148–53). Poles support the branches of old trees to protect them from heavy winter snows. Straw is used to protect new vegetation, particularly in colder areas of the country.

In contrast to structural elements such as stones, trees and ponds, decorative elements or artifacts add a human touch to a natural scene. Some also have practical uses. For example, lanterns light the pathways in gardens and water basins are used for purification prior to a tea ceremony. Artifacts such as Buddhist statues and miniature pagodas normally have sacred connotations, but in a garden context they are used purely for decoration.

Lanterns

It is said that Sen-no-Rikyū, the great Momoyama Period tea master, became intrigued by the hanging bronze Buddhist votive lamps in a cemetery on the outskirts of Kyoto and decided to use lanterns to provide illumination for evening tea ceremonies. Though the early garden lanterns were bronze, eventually stone and wood came into use. Lanterns were placed by the gate; along paths, ponds or streams; near a bridge or water basin; by a waiting arbor; or next to the entrance of the teahouse. It was not considered tasteful, however, to use lanterns in all of these locations. As in most things connected with the tea ceremony, understatement was the key. Other design principles include planting a tree beside a lantern so that one branch hangs over the top or front. Also, stone lanterns often are included in a rock composition in which the lantern is flanked by two or three stones of lesser height.

Two basic types of stone lantern are those made of natural stones that are reworked just enough so that they can be stacked, with a lamp housing in the middle, and those made of cut stone such as granite. The former are used when a rustic touch is desired, as in a tea *roji*, whereas the latter are suitable for more conventional gardens. A more

elaborate classification system divides stone lanterns into four types: pedestal lanterns in which the shaft rests on a base (*tachigata*); buried lanterns in which the shaft is sunk into the ground and thus does not require a base (*ikekomigata*); snow scene lanterns that have legs instead of a shaft as well as a large, relatively flat roof to catch and hold snow (*yukimigata*), and small "set" lanterns that are used where space is limited or where their function is to provide illumination without attracting attention (*okigata*).

Within each type, there is a great deal of variation since designers have always had considerable leeway in selecting and combining potential design elements. Some designs are named after a Buddhist temple or shrine where the design originated, whereas others are named after tea masters who created them for their own gardens. Over time, new designs have been invented, some of which are unique and found only in a single garden.

Pagodas

Evolved from the Indian stupa, pagodas commemorate the death of the historical Buddha, Shakamuni. When constructed on the grounds of Buddhist temples, they generally are large wooden buildings with an uneven number of floors. Garden pagodas, however, are smaller stone structures that have a purely decorative function. They are often placed along streams and ponds so their images can be reflected in the water, or erected on artificial hills to provide a focal point.

Statues

Like votive lamps and pagodas, Buddhist statues normally have religious functions and meanings. Used in a secular garden, such statues may be the

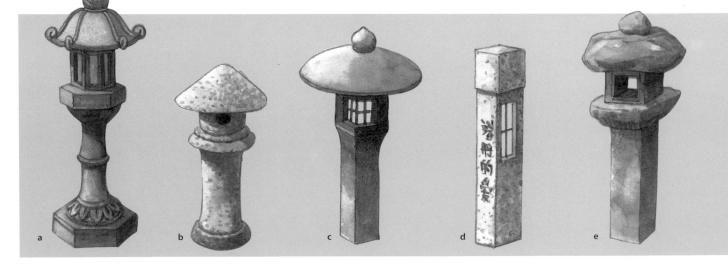

a b c d e

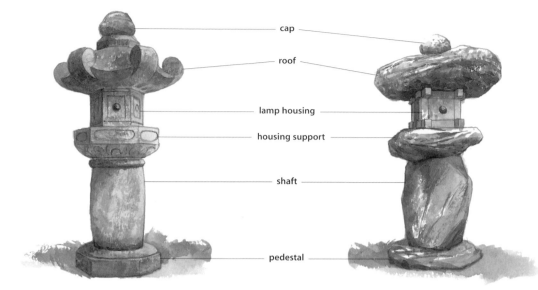

cap

roof

lamp housing

housing support

shaft

pedestal

Contrast between a cut stone lantern and one that, except for the housing, is made of natural rocks. The housing, in which a candle or an oil lamp traditionally was placed, is usually made of stone. In this natural stone lantern at Sanzenin Temple, however, the housing is made of wood.

object of a certain amount of reverence, but their function is basically decorative. While statues in the gardens of Buddhist temples are often made of bronze, stone statues tend to predominate in secular gardens.

Water Basins

Water pitchers originally used by tea guests to purify their hands prior to a tea ceremony developed into water basins (*tsukubai*). They are usually made of stone but can be of other materials such as bronze. Water is introduced to the basin through a bamboo pipe (*kakei*). Though most commonly found in tea gardens, water basins are also used in other types of gardens where they provide a subtle visual touch by reflecting the sky or nearby vegetation. The main difference between the basins found in tea gardens and those in other gardens

is that the former are placed close to the ground (*tsukubai* means "crouching basin") on a partially buried stone rather than on a pedestal.

Shishi Odoshi

A *shishi odoshi* consists of a length of bamboo centered over a pivot, with the closed end of the bamboo resting on a stone and the other (open) end tipped up. A pipe feeds water into the open end until the bamboo is heavy enough to drop, releasing its contents onto a graveled patch of ground, basin or stream. The bamboo then returns to its original position, hitting the stone with a "thunk." The movement and sound of this device, usually called a "deer scare," originally were used by farmers to frighten away deer and wild boar. The *shishi odoshi* emphasizes the importance of appealing to all five senses when designing a garden.

Below: A few examples of the many types of stone lanterns:

a *nigatsudō* style pedestal type
b planet style pedestal type (rustic)
c planet style buried shaft type
d mile post style buried shaft type
e *oribe* style buried shaft type (rustic)
f three-legged style snow scene type
g four-legged style snow scene type
h–j three styles of small "set" type

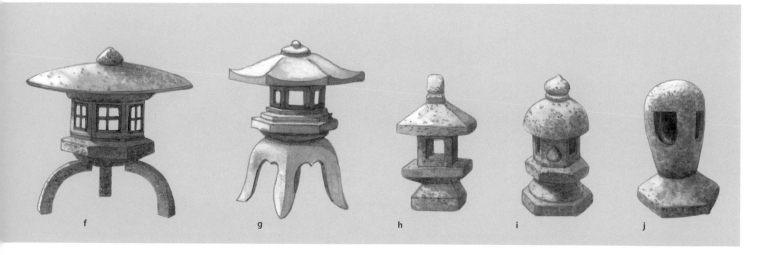

f g h i j

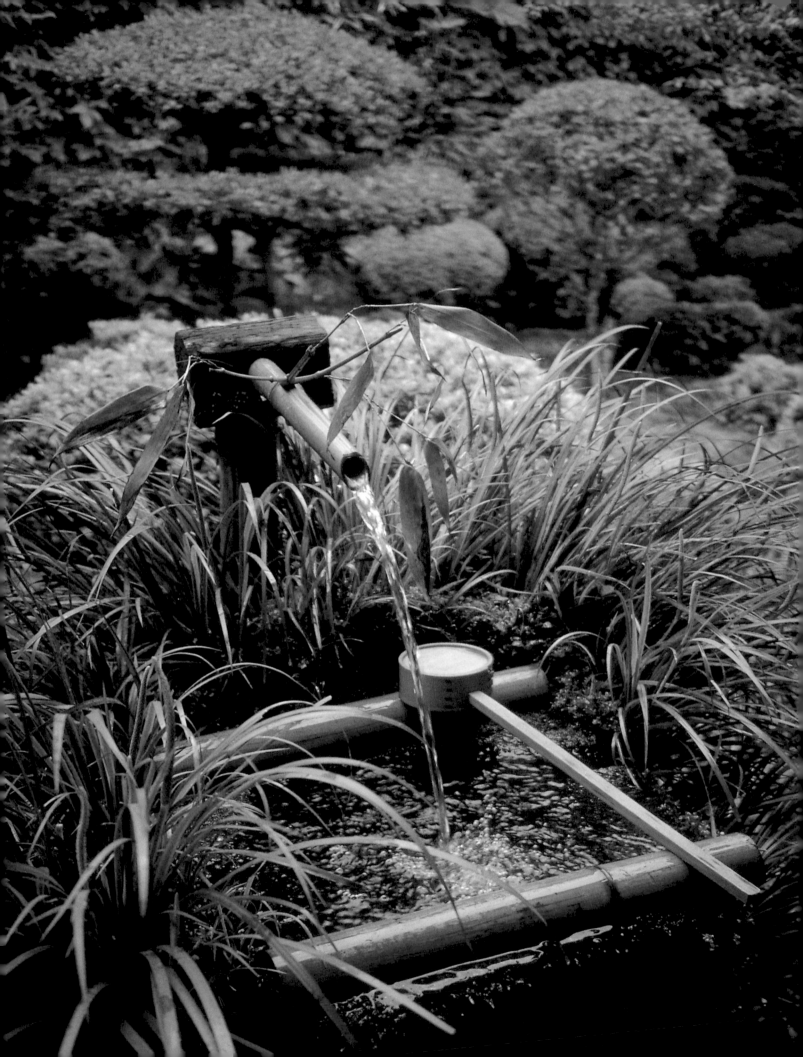

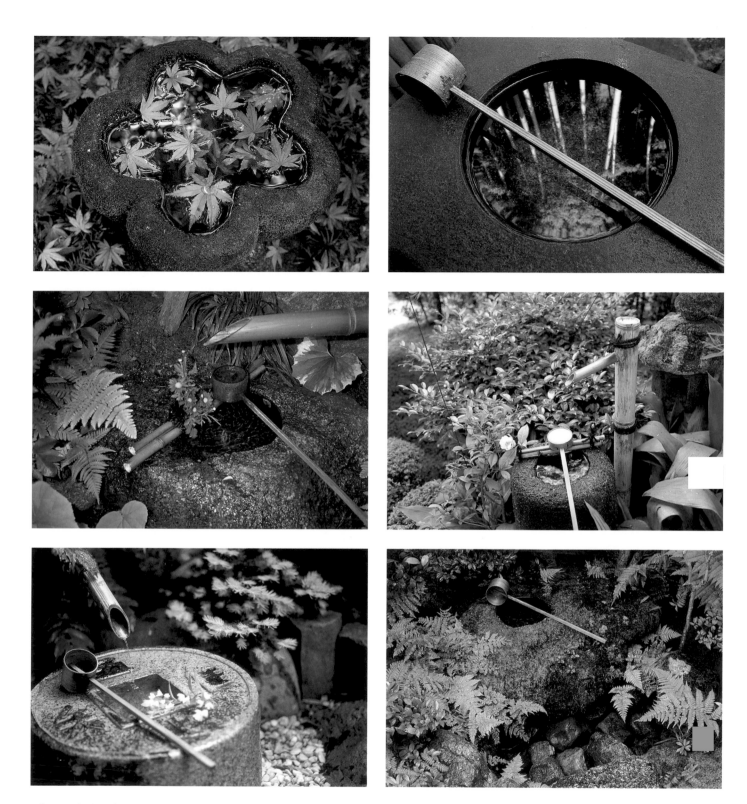

Left: Water basin with a ladle resting on bamboo supports.

Above from top: Decorative water basin with an unusual shape.

Tea garden water basin set close to the ground.

Millstone transformed into a water basin.

Above from top: Bamboo reflected in a cut stone water basin.

Natural stone water basin fed by a bamboo pipe.

Stone water basin surrounded by multi-level greenery.

Islands, Hills and Pavilions

Opposite: South Pond, Kikugetsutei teahouse and Engetsukyō Bridge viewed from the top of Hiraihō Hill at Ritsurin Kōen, Takamatsu City (pages 142–7).

Below: A miniature Mount Fuji dominates the artificial hills in Suizenji Jōjuen in Kumamoto City (pages 138–41).

Bottom: Flatland garden at Ishiyamadera Temple. The small pond is surrounded by a marshy area that hosts water-loving flowers such as irises.

When we think of Japanese gardens, images of mountains and flowing rivers come to mind. Japanese gardens, however, also contain more passive and quiet elements. For example, islands and gently sloping hills provide contrast and balance, just as *yin* complements *yang*. A variety of structures, such as pavilions and teahouses, have their own role to play in terms of providing places to rest, to enjoy refreshments and to view the surroundings.

Islands

There is an elaborate classification system for islands based upon shape or special features, such as "mountain isles," "forest isles," "bare-beach

isles," and "cloud-shaped isles." In addition to helping create different kinds of landscapes, islands can have more specialized functions such as preventing the pond from being seen as a whole—an example of the "hide-and-reveal" technique discussed elsewhere in the book.

Islands often have symbolic meanings and sacred functions. For example, islands are used to represent the mountainous "isles of bliss" where the immortals live (*hōrai* islands associated with Taoism, or the crane and turtle islands so ubiquitous in stroll gardens), the sea-enclosed mountain at the center of the universe (Mount Sumeru, or Shumisen, in Sanskrit and Buddhist thought), or Nakajima ("island in the middle") representing the Western Paradise of Pure Land Buddhism. Since these sacred islands were located in a pond representing the sea, they normally were not connected to land by a bridge but had to be reached by boat.

In contrast to ponds representing sacred isles in the sea, ponds can also represent lakes used for recreational purposes, as in the Shinden style gardens of aristocrats in the Nara and Heian periods. Such ponds usually have two or more islands connected to each other and to the rest of the garden by bridges.

Islands vary considerably in size, depending upon their role in the overall composition, as well as the size of the pond. Some islands are large enough to contain a hill (see below) and to be planted with trees, whereas other islands may consist of only one or two rocks.

Hills and Flatlands

Japanese gardens are most famous for their depiction of rugged mountain scenery, complete with rocky streams and dramatic waterfalls. Sometimes, however, a more gentle landscape is achieved through the use of flowing hills interspersed with lowlands. Hills can be covered with grass or planted with pine trees. They are frequently constructed on islands to provide a contrast to the flatness of the surrounding pond or to block a view of part of the pond. Hills also offer elevated spots for viewing the rest of the garden or as a location for a pavilion. A particularly interesting device, sometimes used in *karesansui* gardens, is to use trimmed bushes to create abstract shapes suggestive of hills.

Flatlands include plains, fields or marshes where the beauty of grasses and water plants is emphasized. The use of flatlands is particularly prominent in large stroll gardens such as Shūgakuin Detached Palace near Kyoto.

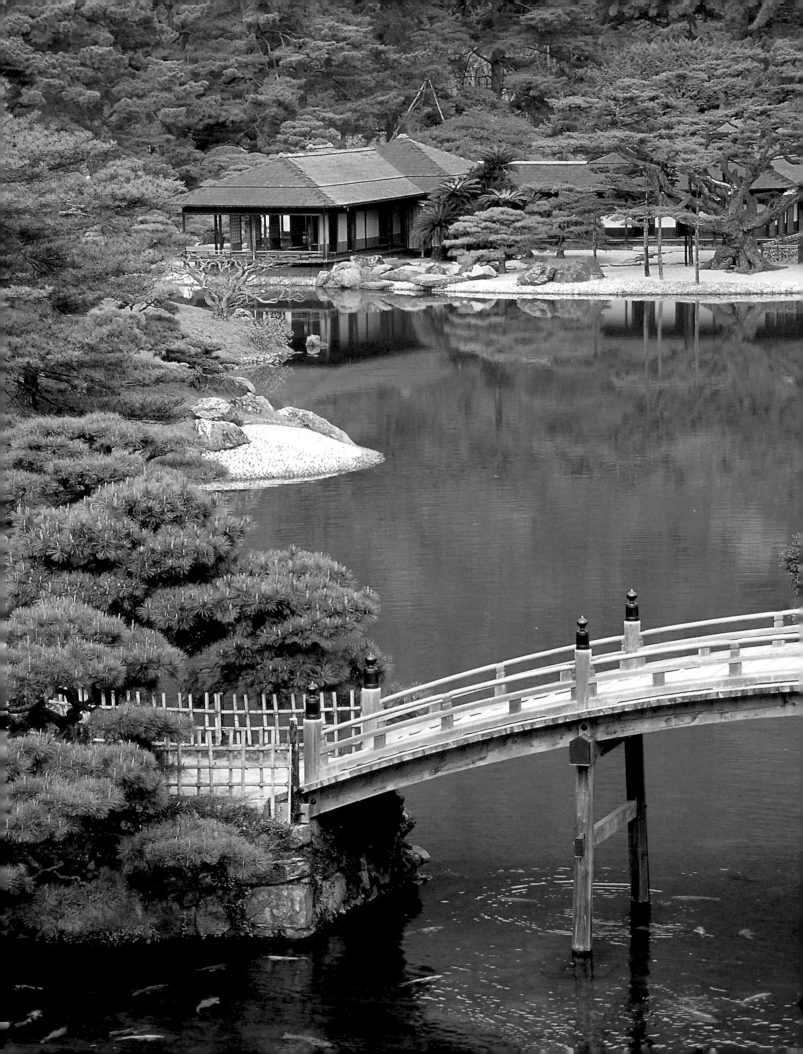

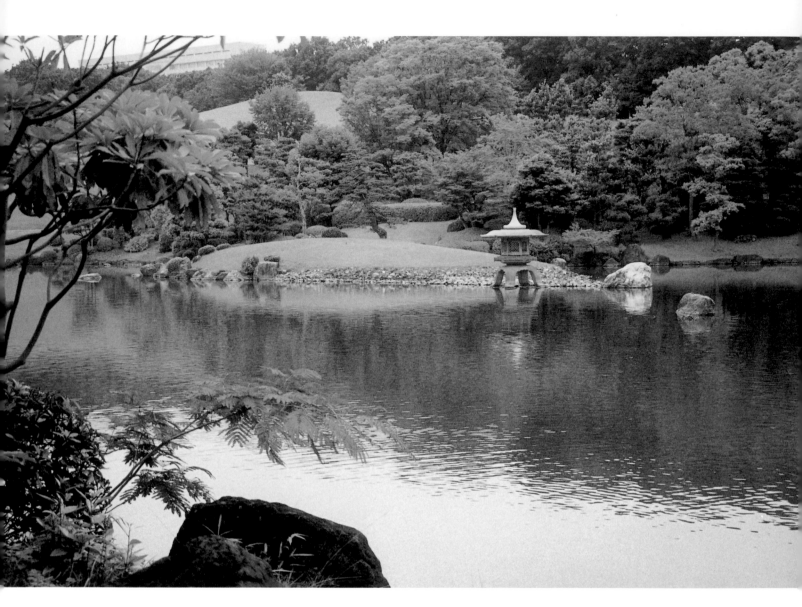

Pond with an island at Expo Park in Osaka. The artificial hill in the background complements the slope and grassy surface of the island.

Pavilions and Other Structures

Garden structures include pavilions, teahouses, privies and small ornamental features, such as water wheels. Pavilions are most commonly found in tea *roji* and large stroll gardens. In tea *roji*, they are used as places to sit while waiting for the tea master to summon guests to the tea ceremony. In stroll gardens, they are used as resting places. The latter type of pavilion usually has a good view of the surrounding scenery.

Teahouses and associated privies also are most commonly located in tea *roji* and large stroll gardens. Their function is the same in either location. Teahouses, which can be small and austere or large and comfortable, are the site of formal tea ceremonies. Associated privies were, at one time, used by guests, but are, today, purely ornamental.

Ornamental features such as water wheels, wisteria arbors and wells are found in various types of gardens, where their basic function is to add interest by providing a contrast with the more natural surroundings. The layering of various elements also lends depth to a garden.

Framing Devices

When a garden is adjacent to a main building, verandas and views of the garden from the inside should be considered as well. Verandas are transitional devices between a building and the garden that make the movement of eye and body from indoors to outdoors less abrupt. In contemplation gardens, a veranda is a place to sit and view the garden. It completes the frame provided by walls on the other three sides of the garden. Windows and openings created by sliding doors are frequently used as framing devices through which a garden can be viewed from the inside. The shape of the frame can be used to complement the outdoor scene and amplify the feeling that one is viewing a work of art.

Pavilions

Pavilions are structures where one can rest, view the moon or wait for a tea ceremony to begin. Located on hills, islands or on the edges of a pond, they can range from the simplest of shapes, such as an "umbrella roof" on a pole, to elaborate edifices with raised floors and *tatami* mats.

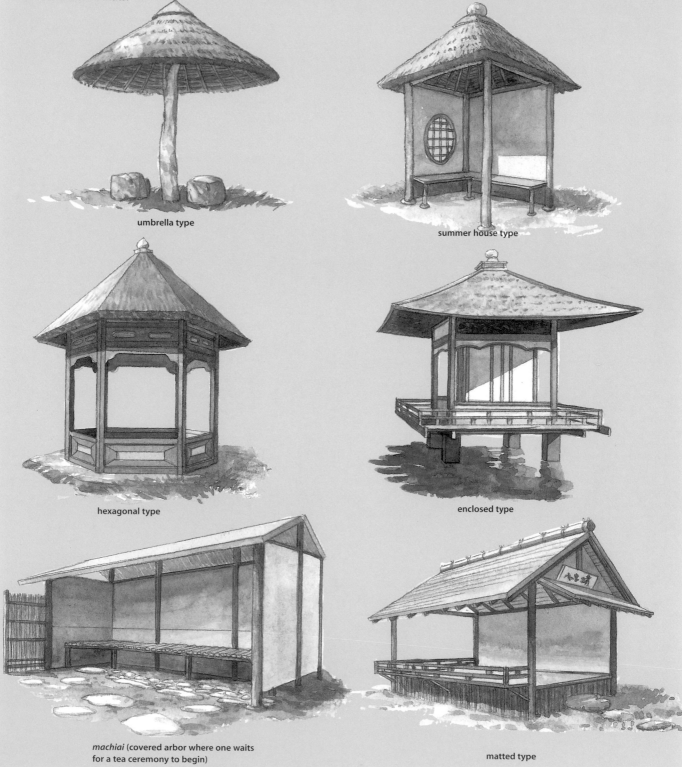

umbrella type

summer house type

hexagonal type

enclosed type

machiai (covered arbor where one waits for a tea ceremony to begin)

matted type

Flora and Fauna

Above: A vertical triangle composed of various kinds of vegetation, with a pine tree at the apex, from the 1735 edition of the gardening manual *Tsukiyama Teizōden* (Building Mountains and Making Gardens).

Opposite above: Trees, clipped shrubs and groomed lawns provide interesting contrasts in both form and color at the Adachi Museum Garden in Shimane Prefecture (pages 165–7).

Opposite below: Of the many types of bamboo that grow in Japan, some are not suitable as they become too large. The three species shown here are favored because of their relatively small size and attractive stem colors. From left to right:

Phyllostachys aurea Golden Bamboo (*Hoteichiku*)

Phyllostachys bambusoides "Castillon" Variegated Running Bamboo (*Kinmeichiku*)

Phyllostachys nigra Black Bamboo (*Kurochiku*)

The first gardens in Japan were graveled plots symbolizing sacred space. In the Heian Period, new traditions from China introduced gardens in which ponds and stone compositions provided the basic structure. Trees, bushes and flowers were also introduced but because plants, compared to rocks, are impermanent, they were regarded as decorative elements. In later periods, trees and shrubs came to be regarded as structural elements, as they are today.

Types of Vegetation

Between the Heian and Edo periods, various practices were adopted regarding plant usage. For example, in "wet" landscape gardens, trees and grasses were employed to create shorelines, rolling hills and meadows, whereas in "dry" landscape gardens, vegetation was kept to a minimum so as not to dwarf the mountains and streams represented by rocks and gravel. The most popular plants have always been those indigenous to the area.

Of the many plants available for use, trees are the most important. A tree usually provides the focal point of a composition, with other plants used as accents. Four types of trees are employed in Japanese gardens: broad leaf evergreens, deciduous trees, needle leaf trees and bamboo. Most common broad leaf evergreens include camellia, azalea, Japanese fatsia (*yatsude*), pasania and oak. Deciduous trees include plum, cherry, maple, willow, gingko and zelkova. Commonly used needle leaf trees include pine, Japanese cypress (*hinoki*), Japanese cedar or cryptomeria (*sugi*) and fir. Around fifteen species of bamboo, including bamboo grass, are found in Japan. Pines are particularly important because they are relatively easy to train into interesting shapes. Bamboo is used with caution as it spreads quickly and can rapidly take over a garden.

Like rocks, trees are usually arranged in triangular or pyramidal compositions to create an asymmetrical balance of forces. Different species are normally planted together to provide contrast in form and color. For example, a twisted pine goes well with a weeping willow. Care is taken to plant trees in areas similar to where they would grow in nature. Thus, trees that normally grow on mountain slopes are not planted in flatlands.

Clipped shrubs became common in Momoyama Period *karesansui* gardens, particularly in conjunction with gravel. Shrubs such as junipers and azaleas are usually trimmed into rounded shapes and are sometimes grouped in clusters to suggest hills. More infrequently they are used to create geometric shapes or artifacts such as boats. Unless this is

done with great skill, the result can look artificial. Trees and shrubs are often planted near, or overhanging, stone objects such as lanterns, wells and basins. This provides an interesting contrast and helps blend human artifacts into the scenery.

Moss is particularly suited to Japan's humid temperate climate. Over a hundred varieties of moss can be found in Saihōji (Kyoto's Moss Temple) alone. The use of grass to create lawns began in the early Edo Period and was reinforced in the Meiji Period after the invasion of Western culture. Flowers are generally found in flatland gardens, especially along streams or ponds.

Uses of Vegetation

Trees and shrubs contribute to the basic compositional structure of a garden, but like other plants, they have a variety of uses. For example, trees and shrubs provide shade, disrupt long-range views, screen undesirable elements outside the garden, frame "borrowed scenery" and provide borders to areas selected for emphasis. Vegetation is also used to provide a transition between different scenes in a stroll garden, thereby unifying the composition. Non-flowering trees and shrubs can provide a relatively homogeneous backdrop for compositions such as rock arrangements. Of particular interest is the use of vegetation to aid in the creation of perspective. For example, a feeling of distance can be achieved by placing plants with bright colors or large leaves in the foreground and dark-colored plants with small leaves in the background. Vertical distance can be manipulated in the same manner. For example, a hill can be made to appear higher by planting large trees at the base and smaller trees at the top.

Symbolism and Color

Some species of plants have specific meanings. For example, the lotus, most commonly found in Paradise gardens, though rooted in the mud, grows to the surface of a pond to produce a beautiful flower, giving rise to the hope that humans can rise above the impurities of life to attain enlightenment. This is one of the reasons that Buddha is often depicted as sitting on a lotus blossom.

To take another example, pines are a symbol of endurance. Their shape and color, however, can also be important. A twisted pine suggests a windswept coast whereas a stunted pine connotes a high alpine plateau. Regardless of its shape, the evergreen foliage of a pine tree provides a touch of life to a garden even in the cold winter months and thereby connotes the ability to withstand difficult external conditions.

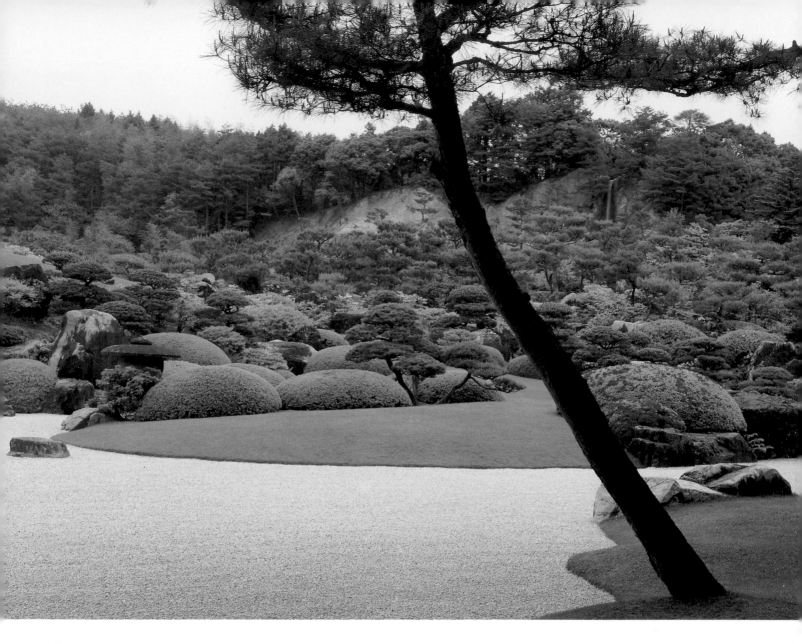

Fauna

Fauna are an important and often overlooked part of Japanese gardens. Fish eat algae and other vegetation that otherwise can take over a pond. *Koi*, a type of carp, is the most common fish in Japanese gardens. *Koi*, which add a decorative touch with their flashes of gold and orange, must be provided with places to hide from predatory birds and animals. Other residents of garden ponds include turtles and water snakes, as well as a variety of insects and amphibians such as frogs and salamanders. Although not as decorative as *koi*, they all play a role in helping maintain the balance of a pond. Ponds and the surrounding vegetation also play host to waterfowl and other birds that provide a touch of spontaneity in gardens that in many ways are tightly managed. Finally, some parks and gardens are home to special residents such as the hoofed creatures that entertain visitors by bowing for food in Nara's famous Deer Park.

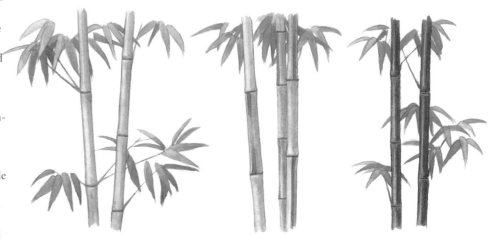

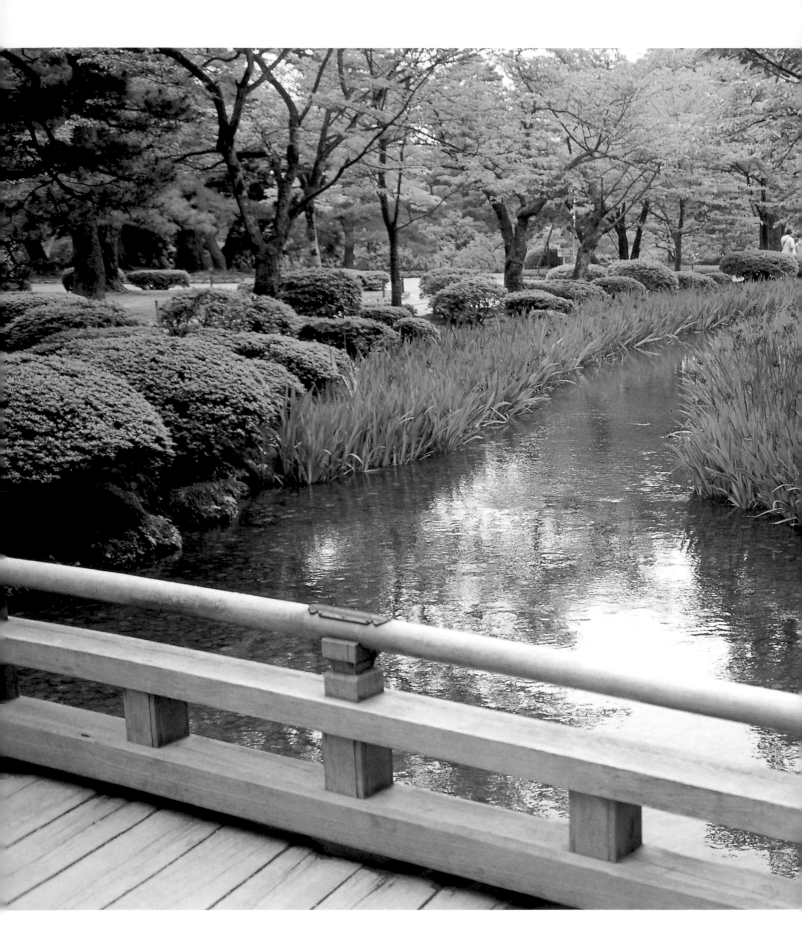

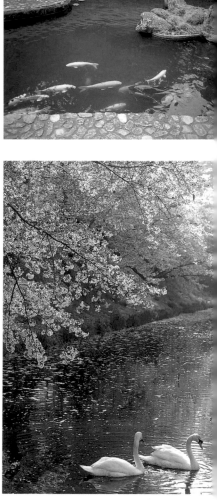

Left: Kenrokuen in Kanazawa City (pages 148–53) has a variety of trees and flowers. It is particularly famous for its cherry trees in the spring, irises and azaleas in the summer, and brilliantly colored leaves in the fall.

Top: *Koi* help maintain the balance of a pond, in addition to adding a touch of color.

Above: Swans amid cherry blossoms at Hirosaki Castle Park in Aomori Prefecture, famous for its blossoms.

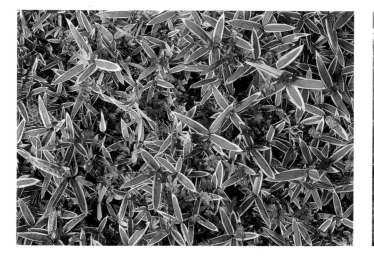

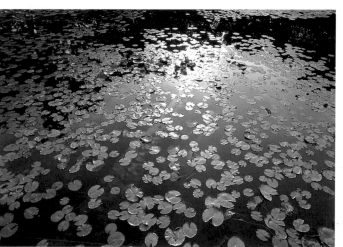

Left: Japanese maples in autumn at Tōfukuji Temple, Kyoto.

Above from top: Kumazasa, a variety of dwarf bamboo (Sasa grass), often used in gardens.

Ostrich ferns grown in flatland where there is shade and moisture.

Dense grove of bamboo at Jizōin Temple, Kyoto.

Above from top: One of the more than a hundred varieties of moss found at Saihoji, Kyoto's Moss Temple.

Water lilies in a pond at Heian Shrine.

September lilies along the Yatsuhashi Bridge in Koishikawa Kōrakuen Garden, Tokyo.

The Changing Seasons

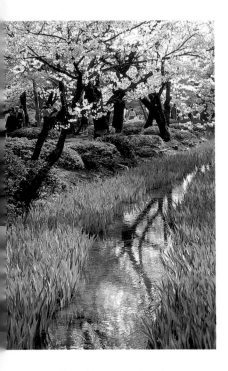

Cherry blossoms at Kenrokuen, Kanazawa (pages 148–53).

The main island of Japan (Honshu) has a temperate climate with four distinct seasons that long have been a major inspiration for the Japanese. The four seasons are expressed in picture scrolls and flower arrangements that are displayed in the recessed alcove (*tokonoma*) of a traditional room, as well as in short poems (*haiku*). A particularly eloquent expression of the changing seasons is the annual cycle of a Japanese garden.

Featuring the Seasons

All gardens are planned in such a way that they will be beautiful throughout the year. This requires great attention to factors such as the succession of plants in bloom and the inclusion of different types of lanterns: some that mark the path in summer, and others that hold the snow in winter. Despite the general goal of changing with and reflecting all four seasons, most gardens are at their best during one or two seasons of the year, and a few are famous for a single event, such as the blooming of irises in the summer or the turning of maple leaves in the autumn.

An ancient method of featuring all four seasons in a single garden is described in *The Tale of Genji*, the world's first full-length novel, written in the Heian Period. According to *The Tale of Genji*, the garden at the Rokujō Palace in the capital was divided into four quarters, one for each season, following Chinese principles of geomancy. Thus, a cool natural spring, appreciated most on a hot summer day, was included in the summer quarter located to the south. Thickly planted pines, beautiful after newly fallen snow, were planted in the winter quarter located to the north. The spring quarter was in the east and the autumn quarter was located in the west.

Garden Sightseeing

Seasonal changes in Japan are major events, heralded by television announcements concerning the first appearance of a particular species of flower in the spring or the peak weekend for viewing cherry blossoms at specific locations around the country. Every spring, companies in the Kansai area send a young employee to Osaka Castle Park to camp out for a couple of days in order to reserve a place under the budding cherry trees. When the blossoms open, an excited call to the company brings the other employees flocking for a party under the cherry trees. Since the blossoms do not last long, timing is everything. The same is true in the fall. At the peak of the season for viewing maple leaves, millions jump in cars, buses and trains in an attempt to reach a favorite viewing spot, often a garden belonging to a temple, shrine or villa. Some temples depend upon the hundreds of thousands of dollars in admission fees that can be received on a single weekend to keep the buildings and grounds in repair.

Seasonal Variation in Gardens

Each of the four seasons described below is accompanied by a *haiku*, a brief 17-syllable "tone poem" that attempts to capture the beauty of a fleeting moment. Most *haiku* are dedicated to one of the four seasons. The translations are by R. N. Blythe.

Spring by Yaha

After the garden
Had been swept clean,
Some camellia flowers fell down

The reawakening of the Japanese garden in spring is heralded by flowering trees. The first trees to flower in the spring are plums, soon followed by cherry, peach and pear. Azaleas also make their appearance in late spring. Hirosaki Castle Park in Aomori Prefecture is most famous for its cherry blossoms, which are at their best in late April. Visitors come from all over the world to view the masses of blossoms that overhang the picturesque bridge and to participate in *saké* (rice wine) parties. Other famous spring gardens are Maruyama Park in Kyoto, well known for its weeping cherry trees, and Heian Shrine in Kyoto, also famous for its cherry blossoms.

Summer by Kirei

A single fire-fly coming
The garden
Is so dewy!

Summer in Japan is hot and humid. It is the best season for viewing a variety of flowering plants. Irises and wisteria arrive in late spring to early summer. Other summer flowers are the blue bell-flower, gardenia and lotus. Gardens that are particularly pleasing in summer are those with ponds, such as Kyoto's Ginkakuji and Kinkakuji temples, where the silver and golden pavilions are reflected in the water, or the lotus garden at Meiji Shrine in Tokyo. Other famous summer gardens are Koishikawa Kōrakuen Garden in Tokyo, where one can follow an elevated boardwalk through masses of irises, and Sentō Gosho in Kyoto with its trellises of hanging wisteria. Summer is also the best time to view the delicate raked gravel patterns of *karesansui* gardens such as those at Ryōanji and Daisenin temples, both in Kyoto.

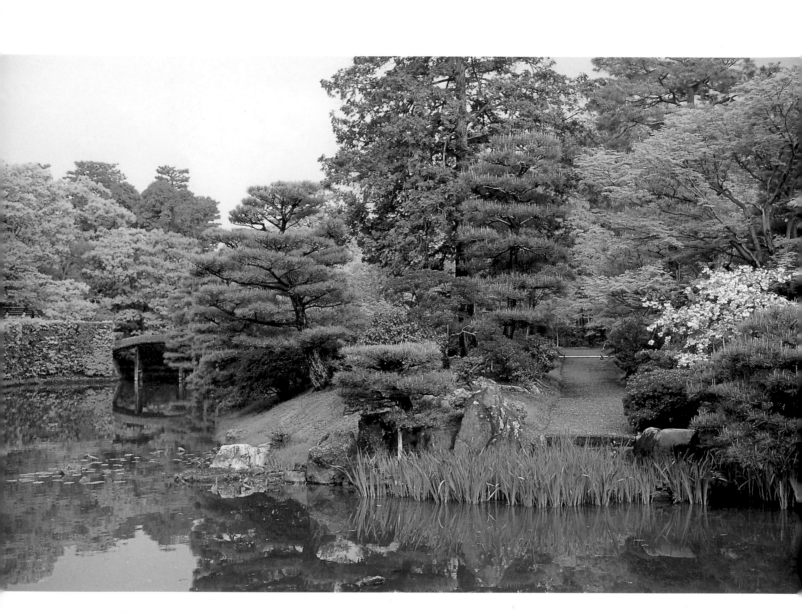

Autumn by Basho

A hundred years old it looks
This temple garden
With its fallen leaves

In autumn the heat and humidity of summer grad-
ually dissipate, to be replaced by shorter, dryer days
and cooler nights. In autumn, color is supplied
by the foliage of trees such as maples and gingko,
the former red and the latter yellow. Other favorite
plants are bush clover, osmanthus and grasses that
turn a variety of hues. Autumn is also famous for
chrysanthemums. Though usually not planted in
Japanese gardens, a variety of potted chrysanthe-
mums are on display in the fall at temples, shrines
and other public places. Favorite gardens for view-
ing colored leaves are those of Tōfukuji Temple
in Kyoto and Jōruriji Temple near Nara.

Winter by Shado

In the newly made garden,
The stones have settled down in harmony;
The first winter shower

Winter is marked by the disappearance of brighter
colors from the Japanese garden. Evergreens, par-
ticularly the various species of pines, play an im-
portant role by providing contrast, not only to the
gray color of rocks and stone lanterns, but to snow
and the stems, trunks and branches of other trees
and shrubs that have lost their leaves. Two gardens
that are much visited in winter because of the
large amounts of snow they receive are Kenrokuen
Park in Kanazawa and the garden of Sanzenin
Temple in the mountain village of Ōhara, near
Kyoto. Another favorite winter garden is that
of Shūgakuin Detached Palace near Kyoto.

Above: Katsura Rikyū in spring is
ablaze with azalea and cherry blos-
soms (pages 130–1). Irises, along the
water's edge, will follow.

Pages 50–1: Autumn is a good time
to see brightly colored leaves in the
large stroll garden of Naritasan Park,
Shinshōji Temple, near Tokyo.

Pages 52–3: Snow scene at the South
Pond of Sentō Gosho, adjacent to the
Imperial Palace in Kyoto (page 132).
It is said that the 11,000 flat oval
stones comprising the south shoreline
of South Pond were presented to the
emperor by peasants from the realm
of Lord Ōkubo, *daimyō* of Odawara.
Ōkubo paid one *shō* (about 0.5 US
gallons) of rice for each rock.

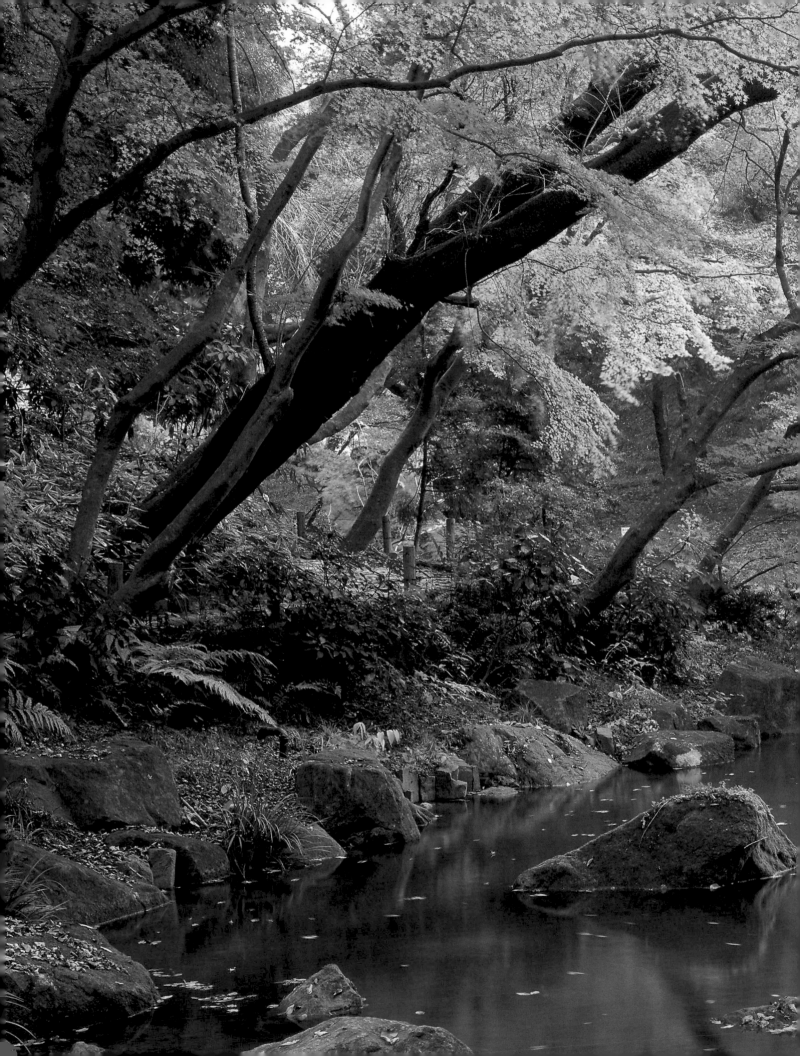

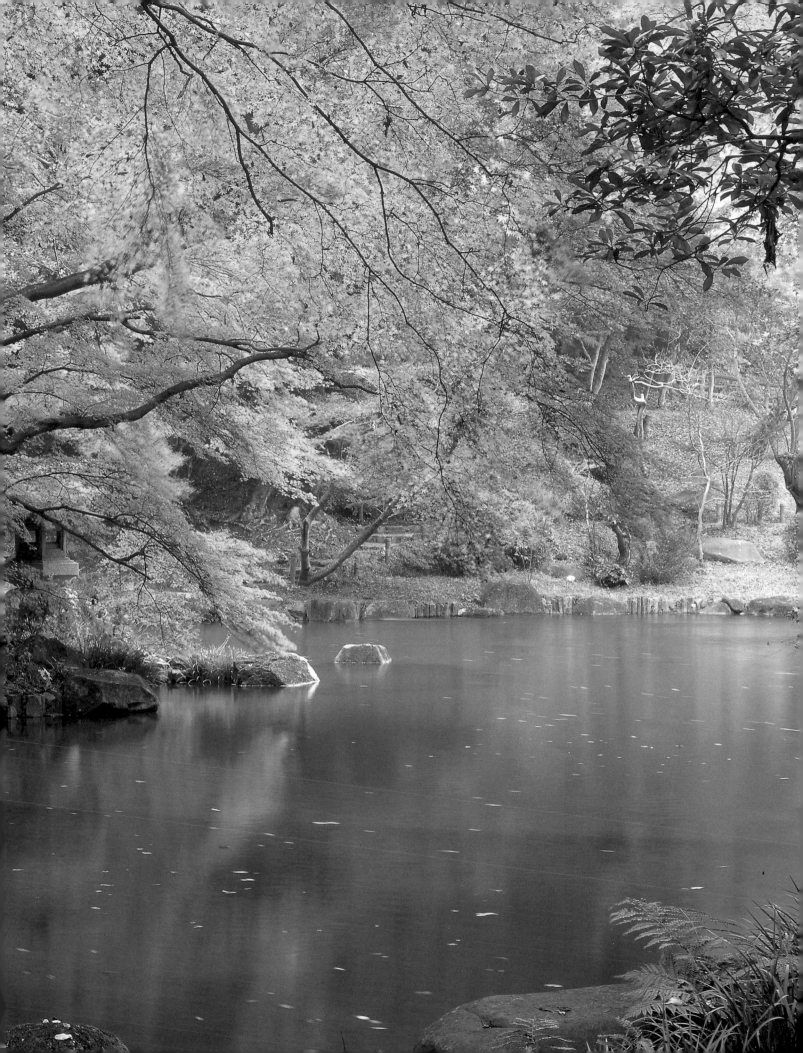

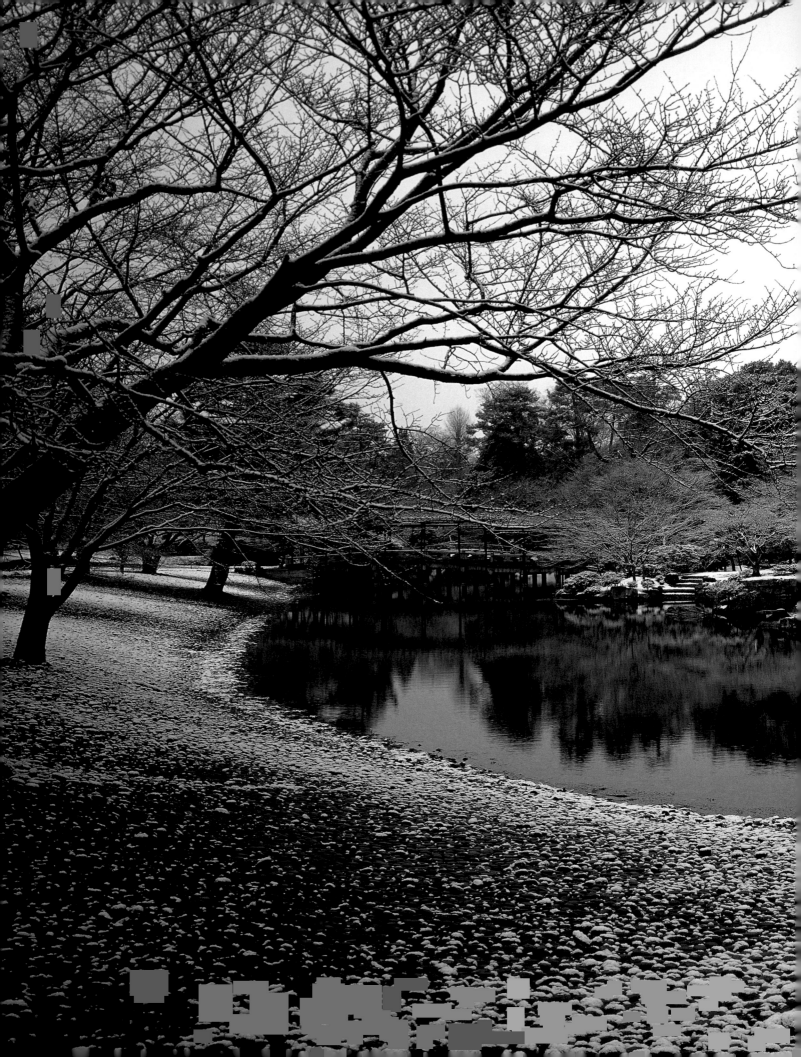

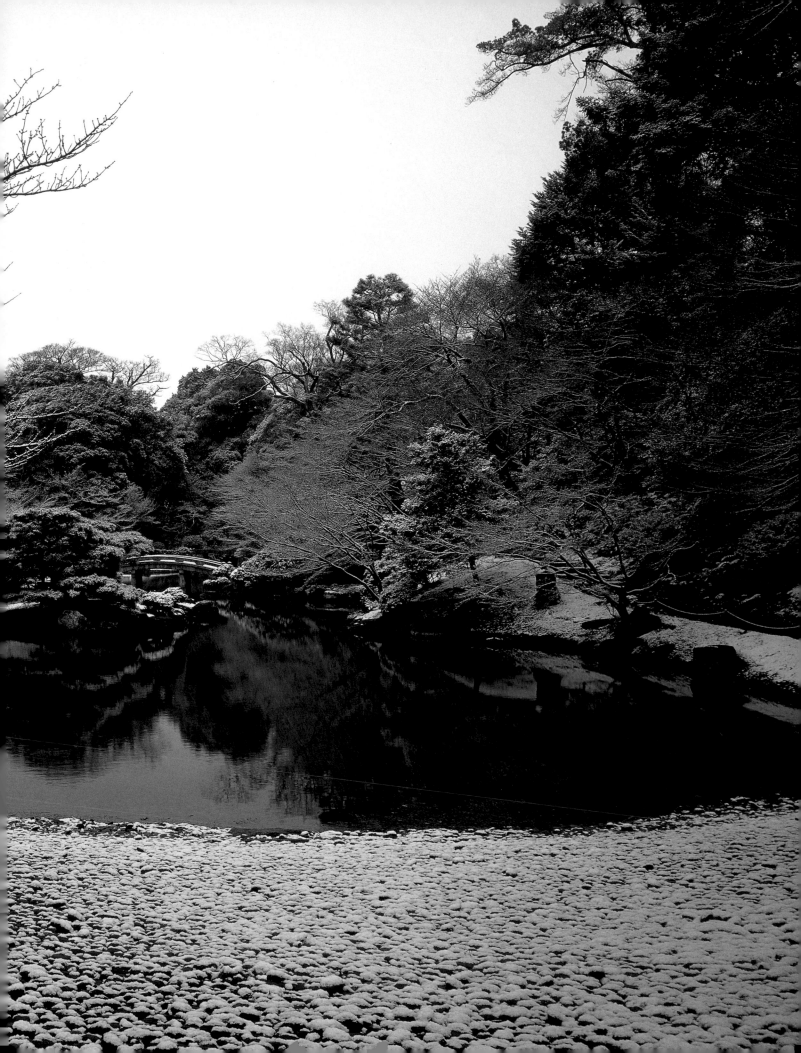

Behind the Scenes

Designers, as well as those who translate designs into reality, are required to create a garden. One "behind the scenes" issue concerns the social standing of Japanese garden artists and their changing role in garden design and construction through the centuries. A related issue is how gardens are maintained in such a way that the original design is not lost over time.

Gardeners

In the Nara and early Heian periods, gardens were designed primarily by aristocrats who relied upon gardening texts such as *Sakuteiki*, advisors from the priestly class, and the physical labor of serfs. In the late Heian and Kamakura periods, gardens were constructed mainly by itinerant priests, known as *ishi-date-sō* (stone-setting priests), who offered their services to wealthy patrons. In the Muromachi Period, stone-setting priests were replaced by semi-professional gardeners from the "unclean" or outcast classes, known as *kawara-mono* (people who live by the river). The suffix "-ami" was attached to their names to indicate their low birth. These "-ami" gardeners were enlisted by Zen temples to work with priests in the creation of gardens. One of the first outcasts to become a respected gardener was Zen'ami (1386–1482).

Zen priests did not consider it demeaning to work alongside outcast gardeners since Zen emphasized equality, and in contrast to the general disdain for physical labor on the part of the upper classes, Zen taught that there is no distinction between the sacred and the secular. Any task, no matter how humble, can become a spiritual discipline as long as one maintains an attitude of "mindfulness" in whatever one is doing. Although the heavy work of creating a garden was generally left to professional gardeners such as Zen'ami, Zen priests involved themselves in the daily care and maintenance of temple gardens. The same was true of tea masters, who were expected to take a personal hand in preparing the tea *roji* in advance of a tea ceremony. The most famous garden designer of his time was Musō Soseki, a Zen priest of high rank, who designed several important gardens, including Tenryūji and Saihōji, to be discussed in some detail later in the book.

The Edo Period saw the development of a class of gardeners known as *ueki-ya* (those who plant trees). This new breed of gardeners was composed of professionals who eventually divided into specialties such as those who collected wild plants, those who grew plants from seeds, and those who constructed gardens. The most famous garden

Above: Pine trees can be shaped into a variety of forms. The trunk of the tree above takes three major turns. The branches have been trained to correspond to these turns, resulting in distinct and parallel layers. The tree below has a more informal shape that suggests a windswept shore or mountain slope.

Right: At Kenrokuen in Kanazawa City, the branches of old trees are given the support of wooden crutches.

Opposite: Tidying plants at the Iris Garden at Meiji Shrine, Tokyo.

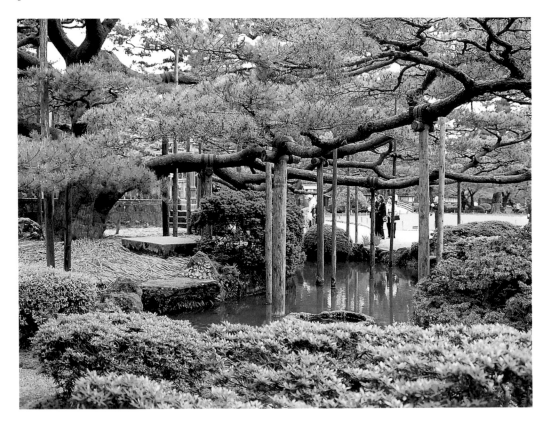

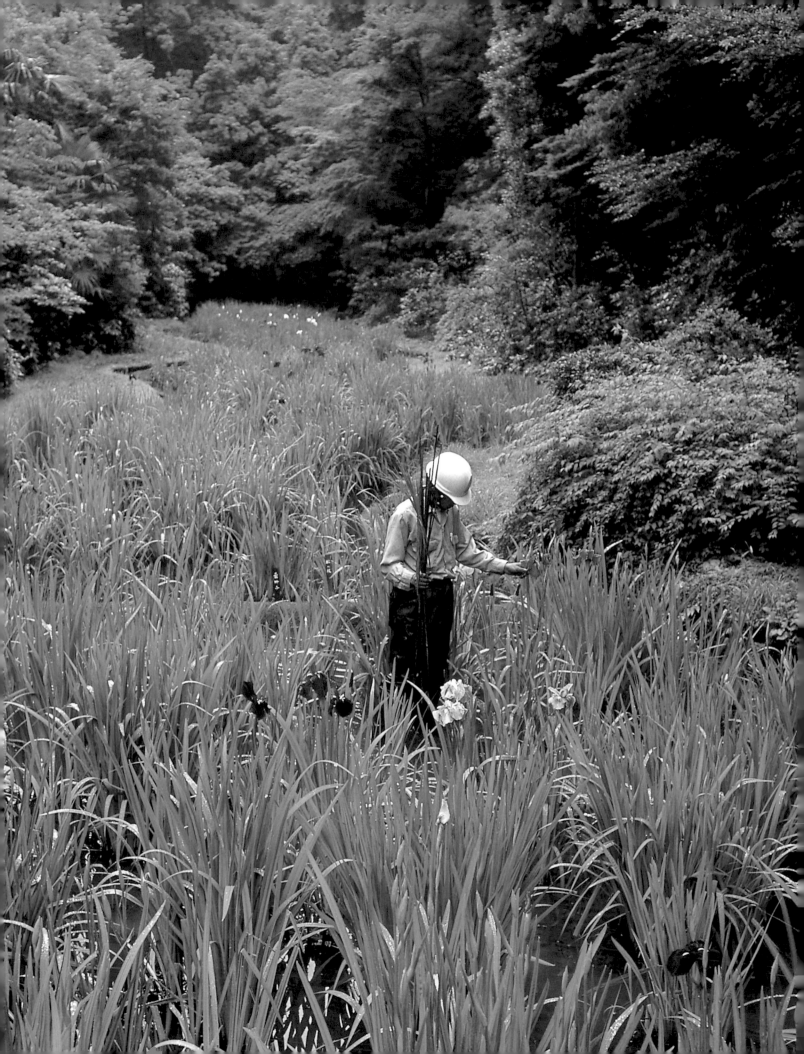

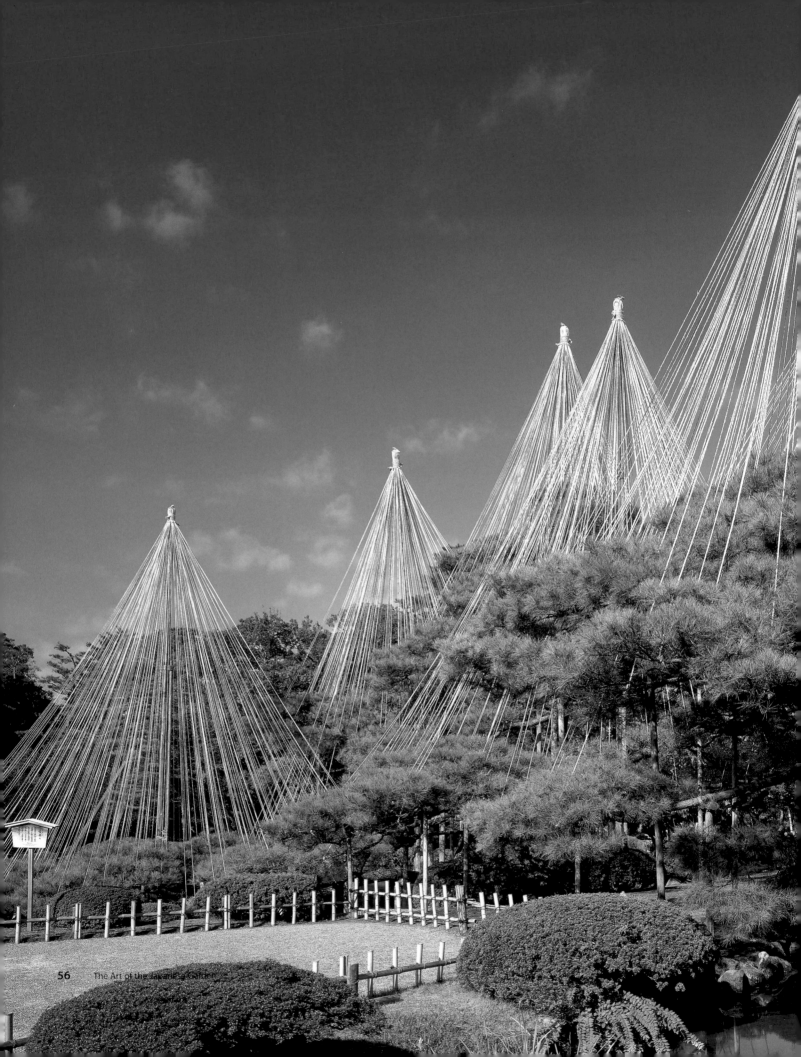

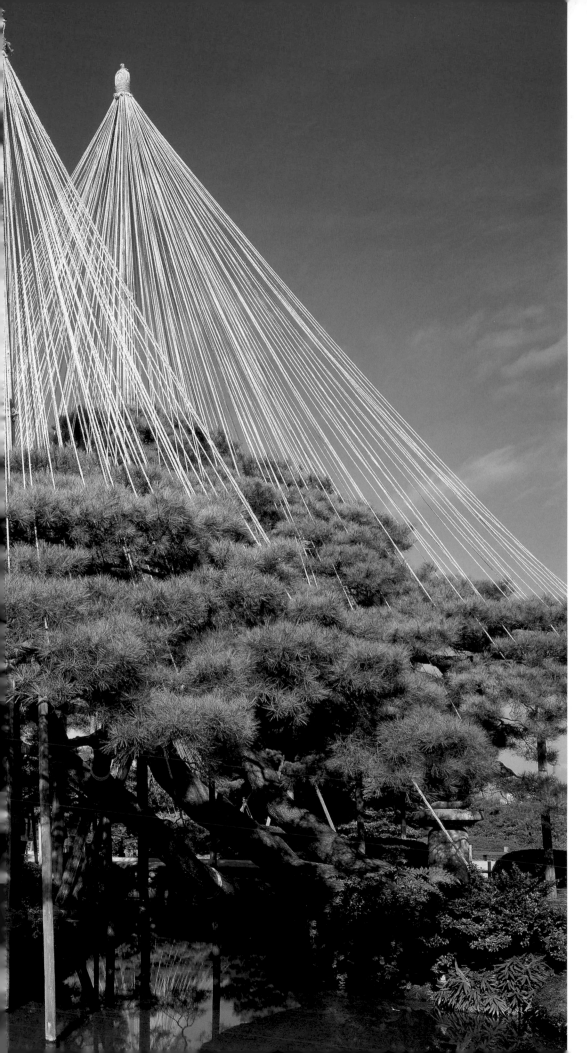

Rope "umbrellas" at Kanazawa's Kenrokuen. Pine tree branches are tied to the ropes to prevent them from breaking under the heavy weight of winter snow.

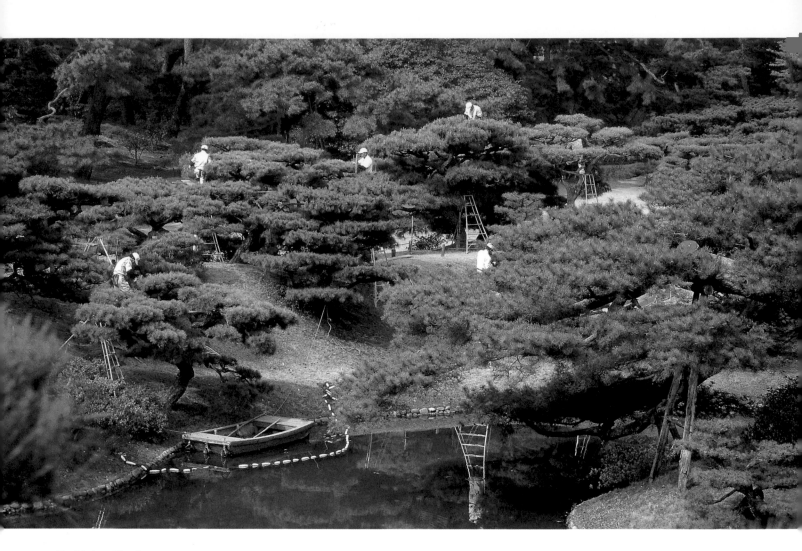

North Lake at Ritsurin Kōen in Takamatsu City, on the island of Shikoku, is famous for the beautifully trained black and red pine trees that line its shores (pages 142–7). Here, workers trim the branches.

designer from this period was Kobori Enshū (1579–1647), an aristocrat and high-ranking bureaucrat in the central government. As a commissioner of public works, Enshū was responsible for designing palace gardens and overseeing the construction of castles.

Maintenance

All gardens change over time but usually change is so slow that many Japanese gardens appear to have a timeless quality. It is not easy to maintain a garden design over time. For example, wind and rain destroy the intricate patterns in the gravel of a dry landscape garden, thereby making it necessary for the gravel to be raked on a regular basis. Bamboo spreads rapidly and trees and shrubs grow in size. This requires constant digging, replanting, grooming and pruning—often at great expense.

In some cases, nature has been allowed to take its course, either by design or by necessity, with the result that a garden changes significantly over time. For example, in contrast to the meticulously controlled gardens in the Kyoto area, some gardens in eastern Japan, including the Tokyo area, allowed

trees to grow naturally without pruning or trimming. Another source of change is remodeling gardens to bring them into line with current cannons of taste.

One of the most important maintenance activities is pruning and providing support. Elaborate pruning techniques are used to train trees into a variety of shapes, often based upon famous trees found in a natural setting. This involves cutting alternating branches and training the remaining branches by tying them to poles. Branches that are trained to extend laterally over ponds sometimes need the support of wooden crutches. Support is also provided for old trees whose trunks or branches have been partly destroyed by rot and insects. Needles are hand-picked from pine branches to produce an austere look, as well as to open up the view beyond the tree.

Another important maintenance activity in cold or snowy areas is preparing shrubs and trees for winter. Shrubs and small trees are often wrapped in straw matting to protect them from the cold. Even full-grown trees may be wrapped for the winter if they recently have been moved. A critical task

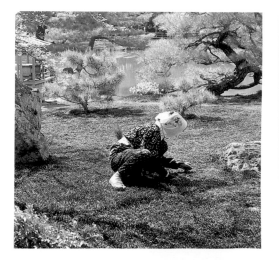

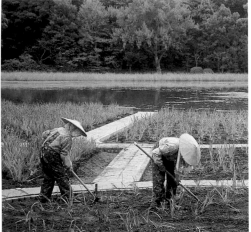

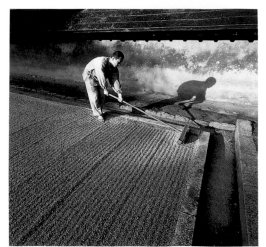

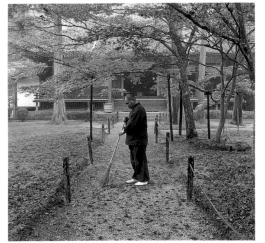

Clockwise from top left: A worker picking pine needles and weeds by hand at Kinkakuji Temple garden.

Planting irises bordering a pond at Ise Jingū requires intensive labor and considerable expense.

Raking leaves off the path is part of the daily duties of a monk.

Leaves must be raked regularly from stream beds.

Dead and crowded pine needles must be laboriously removed by hand.

Raking sand patterns without stepping on one's work requires practice.

is to deflect snow from evergreen trees, particularly pine species, whose branches can extend a fair distance from the trunk. One way to do this is to attach numerous rice fiber ropes to the top of a pole that extends beyond the top of the tree and fasten the ropes to the ground around the circumference of the tree to form an umbrella. Each pine bough is tied to one of these ropes so it will not break under the weight of wet snow.

Maintenance also includes hand weeding mossy plots, cleaning ponds and replacing water plants. If the garden is small, these can be handled by a single individual, often a temple priest. If the garden is large, a small army of people may be required.

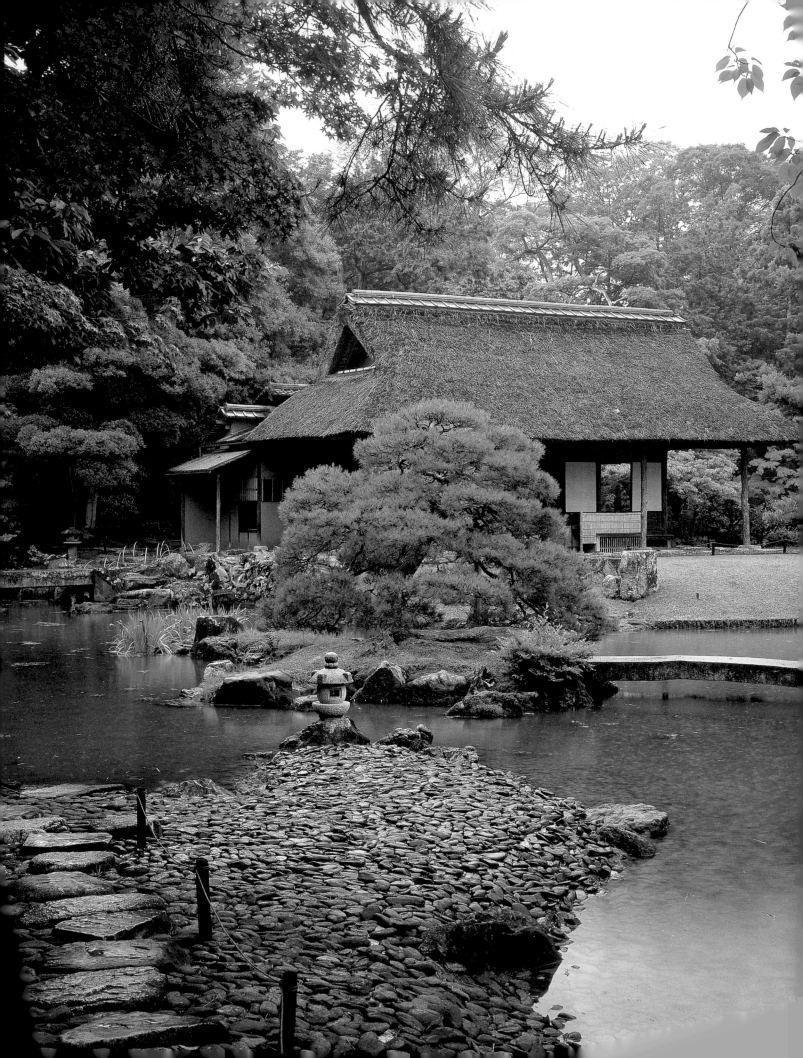

Japan's Traditional Gardens

The gardens in the following section of the book were selected on the basis of four criteria: they are well-known and frequently visited because of their outstanding quality; they are good illustrations of basic garden types (such as a "dry landscape garden" or "stroll garden"); they are historically important; and they are open to visitors, though in some cases special permission is required to visit them.

The gardens are organized by types within a historical chronology (see Contents, page 5 and Chronology, page 13) in which earlier types of gardens (such as Early Graveled Courtyards) are followed by later types (such as Zen Temple Gardens). Two or more gardens have been selected to illustrate each type.

The dominant characteristic of the traditional Japanese gardens selected for discussion is that they were constructed in pre-modern times by Japan's élite, including nobility, aristocrats, warriors, clergy and wealthy businessmen, many of whom enlisted the aid of some of Japan's greatest garden designers. Consequently, these gardens frequently required the expenditure of considerable amounts of money, labor, and time.

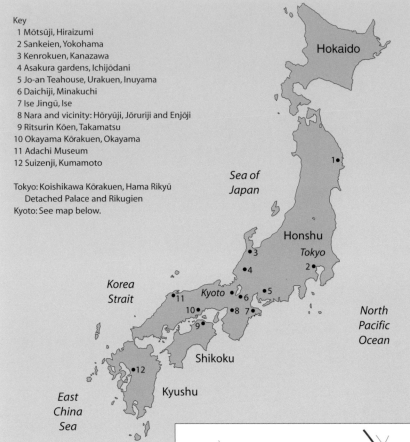

Key
 1 Mōtsūji, Hiraizumi
 2 Sankeien, Yokohama
 3 Kenrokuen, Kanazawa
 4 Asakura gardens, Ichijōdani
 5 Jo-an Teahouse, Urakuen, Inuyama
 6 Daichiji, Minakuchi
 7 Ise Jingū, Ise
 8 Nara and vicinity: Hōryūji, Jōruriji and Enjōji
 9 Ritsurin Kōen, Takamatsu
10 Okayama Kōrakuen, Okayama
11 Adachi Museum
12 Suizenji, Kumamoto

Tokyo: Koishikawa Kōrakuen, Hama Rikyū
 Detached Palace and Rikugien
Kyoto: See map below.

The gardens described in the following pages are found on three of Japan's main islands: Honshu, Shikoku and Kyushu. The fourth main island, Hokkaido, was too remote, until recently, to come under the influence of Japan's élite. The main center of power in Japan from the sixth through nineteenth centuries was in the area of present-day Nara, Kyoto and Osaka.

Most of Japan's important gardens are located in Kyoto. Since Kyoto was the capital for over a thousand years, there were numerous emperors, shoguns and high-ranking aristocrats to provide the initial capital and ongoing patronage for the construction of villas, temples and gardens. In comparison, cities such as Tokyo are relatively new. Moreover, Tokyo was almost completely destroyed during World War II.

Because of the great number of traditional gardens in Japan, especially in Kyoto, many of the finest examples could not be included here. The gardens that have been selected, however, illustrate the variety and richness that have characterized garden art in Japan for many centuries. Most are open daily to the public.

Above: Location of the gardens described in the book.

Right: Location of Kyoto's gardens.

Pages 60–1: Shōkintei Teahouse at a scenic spot in the garden at Katsura Rikyū, the earliest known stroll garden in Japan (pages 130–1). The garden is organized around an irregular-shaped pond. Many flat stones are packed onto the *suhama* (shoreline), which juts out into the pond. The stone lantern at the tip represents a lighthouse on a cape.

Opposite: A visitor contemplating the cherry blossoms at Shinjuku Gyoen Park, Tokyo.

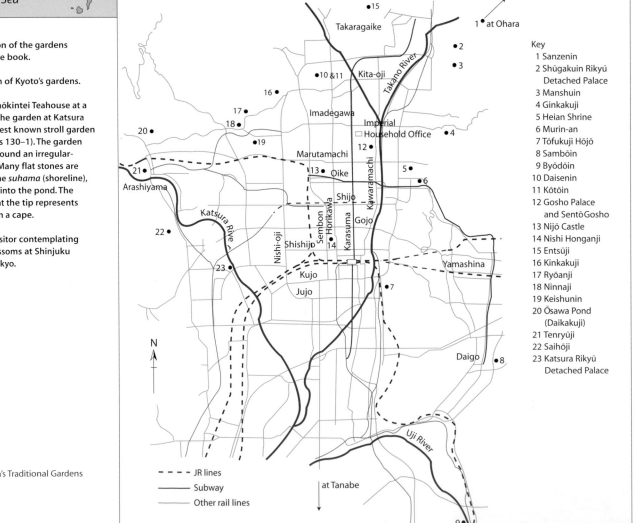

Key
 1 Sanzenin
 2 Shūgakuin Rikyū
 Detached Palace
 3 Manshuin
 4 Ginkakuji
 5 Heian Shrine
 6 Murin-an
 7 Tōfukuji Hōjō
 8 Sambōin
 9 Byōdōin
10 Daisenin
11 Kōtōin
12 Gosho Palace
 and SentōGosho
13 Nijō Castle
14 Nishi Honganji
15 Entsūji
16 Kinkakuji
17 Ryōanji
18 Ninnaji
19 Keishunin
20 Ōsawa Pond
 (Daikakuji)
21 Tenryūji
22 Saihōji
23 Katsura Rikyū
 Detached Palace

- - - JR lines
——— Subway
——— Other rail lines

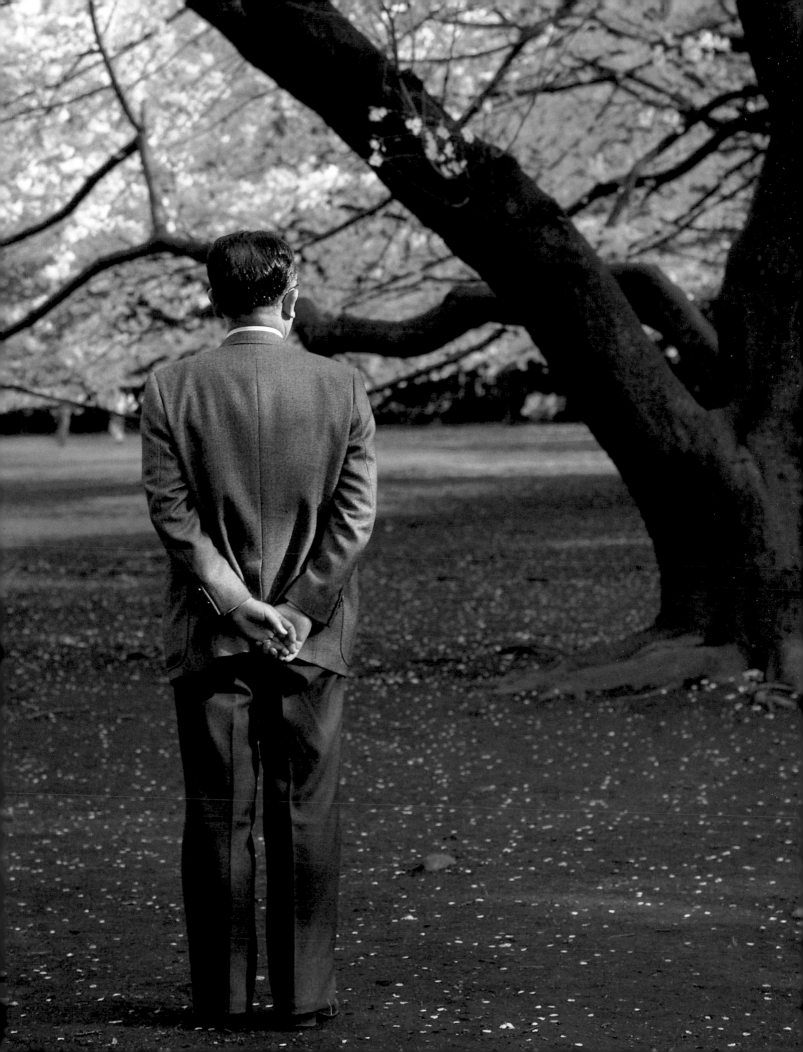

Early Graveled Courtyards

Japanese gardens have their beginnings in pebbled beaches or areas in the forest (*shiki-no-himorogi*), marked off from the surrounding trees only with a rice-fiber rope and covered with pebbles. These graveled areas, designed for ceremonial activities associated with *kami*, were later used to indicate sacred space associated with Shinto shrines and Buddhist temples, as well as ceremonial areas in front of chiefs' houses, aristocratic mansions and imperial palaces.

Divine Power

The early "gardens" of prehistoric times were designed to attract *kami*, spiritual entities that exist primarily in nature. At a more abstract level, the term *kami* refers to a divine power that exists in everything but is more highly concentrated in certain things than others. This indigenous concept was compatible with Buddhism, introduced from the continent in the sixth century CE. The cosmic Buddha is not a transcendent Creator who exists outside of nature but an imminent force that continually manifests itself in natural processes. At a popular level, both Shinto and Buddhism are populated with deities, but at a more sophisticated level, divine power is abstract and all-encompassing. In both Shinto and Buddhism, simple graveled courtyards serve to express such abstract concepts.

Miya

The word *miya* can mean either a palace or a shrine. In ancient times, the head of the clan was also the chief priest of the religion. Thus the word *miya* appears to have referred to a building that was both the residence of the ruler and the abode of the *kami* with which the clan was associated.

The area in front of the *miya* probably was spread with white gravel. In addition to symbolizing sacred ground (*yuniwa*), this empty space would have provided room for dignitaries to assemble for religious and political ceremonies.

As time passed, political and religious functions were divided, leading to separate buildings for shrines and palaces. Nevertheless, both Shinto shrines and imperial palaces retained the graveled courtyard, often set apart from the mundane world by walls—a feature introduced from China and Korea in the sixth century with the coming of Buddhism. Continental Buddhist temples, based upon Chinese palace architecture styles, generally had large graveled courtyards, within which temple buildings were arranged symmetrically. After the coming of Buddhism to Japan, indigenous and continental traditions of using graveled areas to indicate sacred ceremonial space influenced each other, and were integrated in various ways, to exert a profound influence upon subsequent architecture and gardens.

Meaningful Space

The concept of *yuniwa*, described earlier, refers to sacred space that has been set aside and purified for the use of *kami*. Since *kami* utilize such spaces intermittently, the idea of a time interval was added to the idea of a space interval to create a rich concept implying a connection between time and space, in the sense of an interval that is beyond time and space. These indigenous ideas were later enriched by Buddhist and Taoist concepts from the continent.

One of the most important of these mature ideas is the concept of *ma*, which means something like an interval in time or space that is pregnant with meaning. In architecture, *ma* refers to the empty space covered by *tatami* mats between pillars or sliding doors. In a sense, *ma* is space waiting for an event to happen. In music, *ma* refers to the meaningful space between notes, and in drama, it refers to a dramatic pause in the action or spoken lines. In painting, *ma* is used to describe the empty spaces characteristic of black ink painting. A related concept is the idea of *mu* in Zen Buddhism. *Mu* is sometimes translated as "the void." This is misleading. *Mu* refers to the realm

Garden at Tōkaian, a sub-temple of Myōshinji Zen Monastery in Kyoto. Representing *mu*, the formless potentiality at the heart of reality (sometimes referred to as the "void"), the garden consists entirely of raked sand, framed by a wall. Though not directly in the ancient graveled courtyard tradition discussed earlier, *karesansui* gardens nevertheless draw on many of the same cultural concepts.

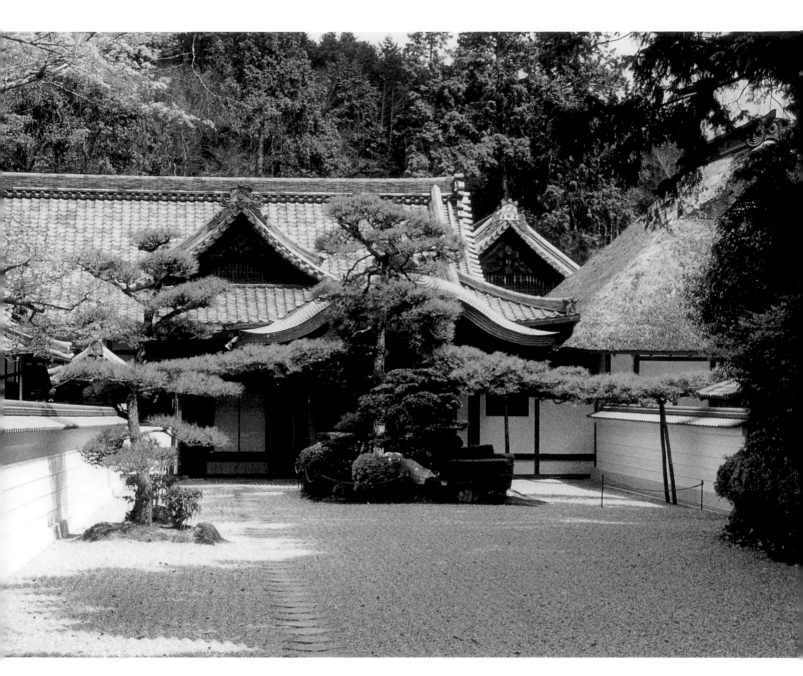

of pure potentiality beyond space and time from which the phenomenal world of the senses is constantly being born.

Such ideas are important for understanding the graveled courtyards of Shinto shrines and Buddhist temples. Such courtyards are not just empty spaces but sacred areas that link worshippers with that which lies beyond time and space. The best examples of the early graveled courtyard tradition in Shinto and Buddhism are Ise Jingū and Hōryūji Temple, described in this section.

Above: Graveled courtyard at Enshōji Temple near Nara, a favorite haunt of the famous writer Mishima Yukio. The stepping stones indicate that the courtyard is to be treated as a garden and that the gravel is not to be walked upon.

Left: A rice-fiber rope demarcates a pebbled area at the Kamigamo Shrine in Kyoto.

Ise Jingū

Above: Wooden lantern on the grounds of Ise Jingū.

Below: The main compound of the Naikū at Ise Jingū, viewed from the southeast. The compound consists of a sanctuary and two treasure houses, enclosed by fences and gates, set in a courtyard graveled with pebbles. To the west is an adjacent graveled lot where the compound will be reconstructed at the end of the current twenty-year cycle.

The best example of the graveled courtyard tradition in early Shinto is provided by Ise Jingū, the traditional shrine of the imperial family that has been rebuilt every twenty years, with few exceptions, since the late seventh century. Ise Jingū includes two compounds, the inner or Naikū dedicated to the sun goddess, and the outer or Gekū dedicated to the goddess of food.

History

Sometime in the latter part of the third century CE (Yayoi Period), the Yamato clan was in the process of establishing its authority over the other clans. Emperor Suinin built a permanent shrine for a sacred mirror that symbolized the sun goddess, Amaterasu-Ōmikami, progenitor of the Japanese people and ancestor of the imperial line. The inner and outer shrines, collectively known as Ise Jingū, are set in an ancient cryptomeria forest in Mie Prefecture, south of Nagoya.

The shrines, with a few exceptions, have been rebuilt every twenty years, a policy instituted by the Emperor Temmu in 685. Rebuilding is extremely expensive since it involves replacing 65 structures and approximately 16,000 artifacts. Minor modifications have been made over the years. Nevertheless, Ise Jingū provides a unique insight into early Shinto shrines, the prehistoric raised rice storehouses from which they evolved, and the graveled courtyards that surrounded them.

Shrine Compound

The main compounds of both the inner and outer shrines consist of a sanctuary and two treasure houses situated in a graveled courtyard. Though the compounds are enclosed by a series of fences and cannot be entered by anyone except the emperor, his entourage and shrine priests, the style can be seen at subsidiary shrines throughout the vast grounds. Like the main shrines, subsidiary buildings also are surrounded by coarse white gravel or pebbles. Every twenty years, each major building is reproduced on an adjoining graveled lot, after which the original building is torn down. This method ensures a more or less faithful transmission of the original style.

The architectural significance of the shrines is that they demonstrate that many of the basic principles of Japanese aesthetic taste existed in prehistoric times. Some of these principles are the use of natural materials such as thatch and unpainted wood, raising structures on wooden posts, adapting buildings to the natural environment, and a preference for simplicity and uncluttered space. Though these principles have often been broken, particularly by ostentatious feudal military rulers, Ise Jingū continues to symbolize the preference for understatement that characterizes much of Japanese art, including its gardens.

Ise Courtyards

The courtyards of the shrines at Ise Jingū are covered with relatively large white pebbles, reminiscent of the ancient plots (*shiki-no-himorogi*) that in prehistoric times were constructed on beaches or in forested areas. The rectangular pebbled courtyards in which the main shrines are located are surrounded with fences, and the pebbled plots of subsidiary shrines are delineated by rock borders. Though the pebbles must be regularly cleaned of dead leaves, they are too large to be raked into patterns, as in later Zen temples where graveled areas are used for aesthetic purposes. The function of the pebbles at Ise is to demarcate sacred space.

Following the introduction of Buddhism in the sixth century, many Shinto shrines were strongly influenced by Buddhist temple architecture and introduced design elements such as curved roofs and vermilion colored wood. Ise Jingū is one of the few shrines to keep its original prehistoric character more or less intact. To this day, however, most Shinto shrines, whether indigenous or continental in style, have retained the ancient tradition of the graveled courtyard.

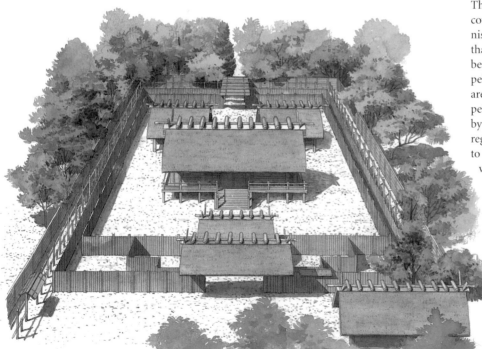

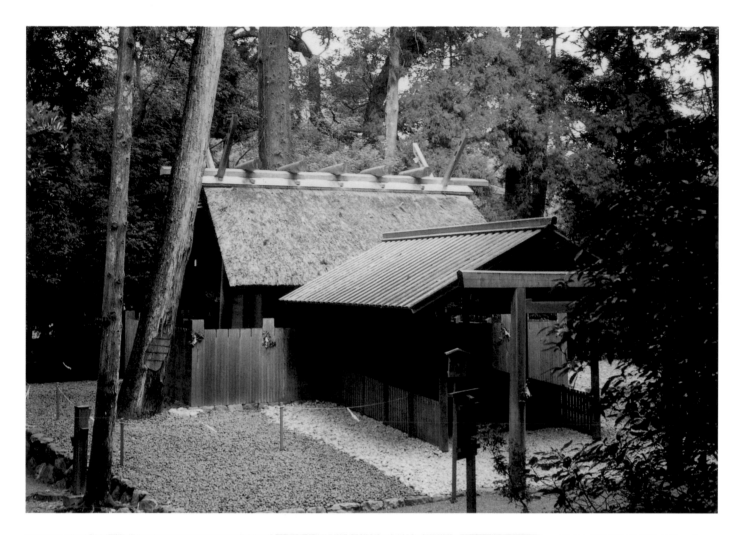

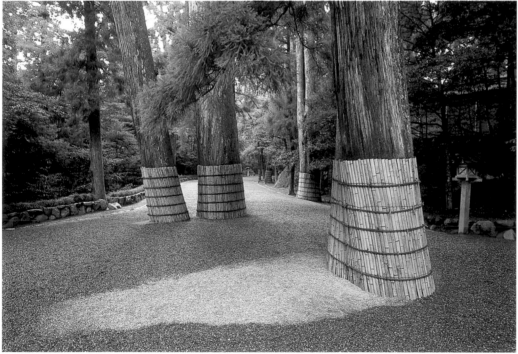

Above: Pebbled courtyard of a subsidiary shrine on the grounds of Ise Jingū in Mie Prefecture. The pebbled courtyard is an ancient indigenous tradition, dating back to prehistoric times. The importance of graveled areas can be seen in the fact that they were retained in later developments, such as in the space between a Shinden style mansion and the pond, in Zen *karesansui* (dry landscape) gardens, and in front of the residences of high-ranking warriors. Graveled areas are sometimes used even today in the gardens of private residences and public institutions.

Left: Some of the bases of the ancient cryptomeria trees scattered along the graveled paths at Ise Jingū are wrapped with split bamboo screens to prevent damage from pedestrians.

Hōryūji Temple

The most outstanding example of an early Buddhist temple is Hōryūji near Nara, dating from the Asuka Period. Hōryūji is the oldest extant temple in Japan and, in fact, has the oldest wooden buildings in the world. The most important area of the extensive grounds is the Western Precinct, consisting of a graveled and walled courtyard containing the main hall, pagoda and lecture hall.

History

Hōryūji was founded by Prince Shōtoku, devout Buddhist, regent and the most eminent statesman of his time. Under the guidance of Shōtoku, Buddhism was declared the official religion of Japan, replacing Shinto as the state religion. This was part of an attempt to break the power of the other clans by creating a nation state modeled after the advanced civilization of China. Hōryūji was constructed in the village of Ikaruga, near the present-day city of Nara, under the tutelage of Korean carpenters and craftsmen. Fulfilling a vow made to his ill father, the emperor, Shōtoku dedicated the temple to Yakushi, the Buddha of Healing.

The original layout was symmetrical, with the main gate, pagoda, Buddha hall and lecture hall in a straight line running from south to north. Though there is some uncertainty about the details, Hōryūji was built in 607 and burned in 670. When it was rebuilt a few years later, the pagoda was placed to the left of the main hall, breaking the symmetry of the original layout. Near the Western Precinct is an Eastern Precinct containing the Yume-dono (Hall of Dreams), built in 739 for the repose of Prince Shōtoku's soul. The temple's treasure house contains priceless relics from the Asuka and Nara periods, such as the Kudara Kannon, a tall slender statue in the Korean style. Due to its great age, as well as its historical and architectural significance, Hōryūji is Japan's most significant temple. In 1993, it was designated a UNESCO World Cultural Heritage site—the first in Japan.

Temple Layout

Chinese Buddhist architecture was based upon cosmological principles that dictated how life and human behavior should be organized. A temple compound, like the Chinese palace from which it was derived, was rectangular, surrounded by a roofed wall, and entered through a massive gate on the south side. The land upon which the temple was constructed was flattened, cleared of all vegetation, and graveled to create an elegant and stark setting, suitable to the dignity required for a place

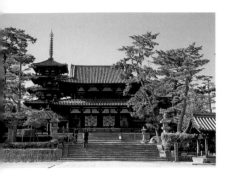

Above: The entrance to the walled compound of the Western Precinct of Hōryūji Temple is a two-story gate (Chūmon). The most important buildings in the compound are the Kondō (Main Hall) and the five-story pagoda.

Below: Western Precinct of Hōryūji Temple near Nara, the oldest wooden buildings in the world. As in other temples of that period, the buildings are situated in a graveled compound surrounded by a wall.

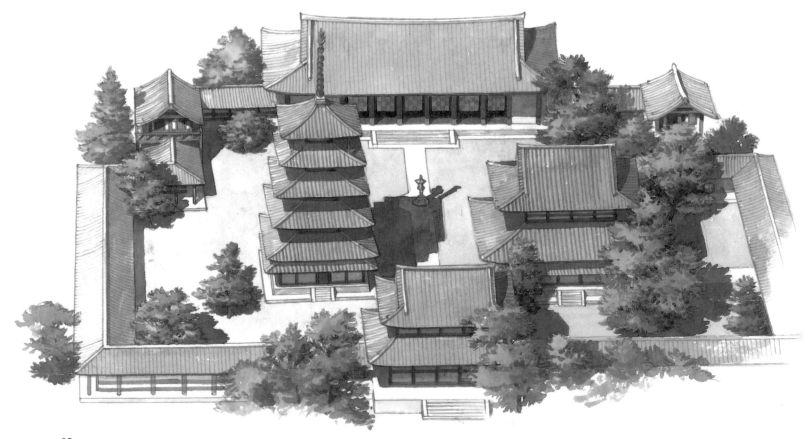

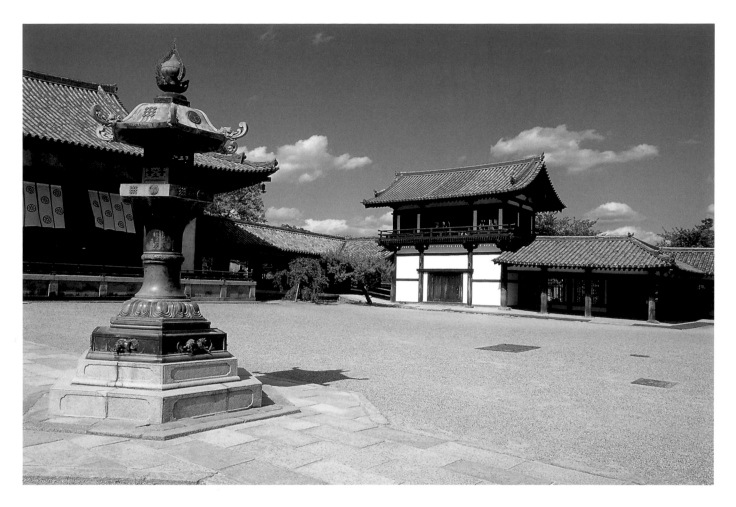

where heaven meets earth. The compound as a whole was oriented in a north–south direction. The mathematical precision involved in the construction of a Buddhist temple demonstrated the necessity of exerting control over unruly natural forces. The dimensions of all of the structures in the compound were determined by the diameter of the pole, measured at its base, used in the construction of the pagoda, and buildings were arranged symmetrically. Wood portions of buildings were painted a bright vermilion to form a dramatic contrast with the white plastered areas between the posts, and the massive roofs were capped with sturdy ceramic tiles.

The Hōryūji compound is based upon this continental prototype, though the symmetry of the building arrangement was altered after the fire, as mentioned above, and the vermilion colored paint has been allowed to weather away. Though a few trees have been allowed to grow, the spacious courtyard is still covered with white gravel, leaving a good deal of empty space for worshippers, processions and religious ceremonies that frequently are conducted outside.

The rigid sense of order exhibited in Chinese style compounds was not entirely compatible with indigenous Japanese standards of aesthetic taste, which leaned towards a preference for asymmetry and fitting into the natural environment. Over time, many Japanese temples assumed a more flexible compound format, adopted the use of natural materials such as bark roofs, and incorporated a variety of different kinds of gardens to provide a more relaxed and natural setting.

Formal graveled courtyards did not die out, however, with the introduction of more indigenous forms of Buddhist architecture. Graveled courtyards continued to be used in later periods to provide a sense of grandeur at the headquarters of the Pure Land denominations, such as Nishi and Higashi Honganji temples in Kyoto. Though not constructed until the Momoyama and Edo periods, these large compounds with their monumental buildings preserve something of the feeling found at Hōryūji and other continental style temples of the Asuka and Nara periods.

Graveled courtyards also continued to be used to create a sense of authority and dignity by imperial palaces, as well as the major shrines associated with state Shinto in the Meiji Period. Thus, the graveled courtyard tradition has a venerable history, stretching from prehistoric to modern times.

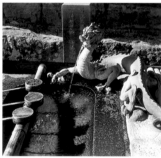

Top: The large graveled courtyard is almost entirely bare of trees. On the left is the Daikōdō (Great Lecture Hall) at the rear of the compound.

Above: Bronze dragon fountain outside the entrance to the Eastern Precinct where visitors rinse their hands and mouths before entering.

Shinden Style Complexes

Chinese culture had a pervasive influence on the gardens of the nobility in the Nara (710–94) and Heian (794–1185) periods. Between 630 and 838, Japanese envoys made numerous trips to the Tang Dynasty capital of Chang'an, bringing back a number of books, building plans, paintings and other documents that provided the basis for the construction of Chinese style mansions and gardens in Japan.

Idealized Shinden style mansion and garden in the Chinese symmetrical style.

a *shinden*, the main building
b covered corridors
c flanking side halls
d fishing pavilion
e spring pavilion
f gates
g stream and pond

Shinden Style Mansions

Chinese mansion prototypes called for a plan in which the main building (*shinden*) was flanked on either side by halls and other symmetrically arranged subsidiary buildings (*tainoya*), all of which were connected by corridors. To the south of the main building was a white graveled area, reminiscent of the sacred spaces associated with religious edifices and imperial palaces in the Japanese tradition, where ceremonies and entertainments were held. Beyond this graveled area was a pond, containing one or more islands, which were reached by a bridge. The space around the pond was planted with trees, shrubs and flowers, and the area beyond the pond was contoured into artificial hills planted with trees.

From both ends of the *shinden* complex, long covered corridors extended to the pond. At the end of one corridor was a "fishing pavilion" and at the end of the other was a "spring pavilion." These two open pavilions, built on stilts over the pond, were areas where guests could enjoy the scenery depicting miniature landscapes based upon famous places in China and Japan, watch dragonboat races, drink *saké* and exchange poems. The entire complex was surrounded by a wall and oriented due north, in accordance with Chinese cosmological principles.

In addition to the large garden to the south of the *shinden*, there were small courtyard gardens located between the buildings. These small, intimate *tsuboniwa*, designed to be viewed from inside, were the forerunners of the Edo Tsubo gardens discussed later.

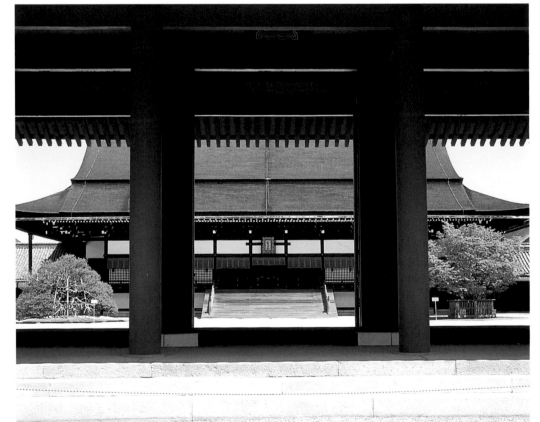

Right: Looking through a gate and across the graveled courtyard to the Shishinden (Ceremonial Hall) of the Kyoto Imperial Palace (Gosho).

Opposite below: Painting on an exterior wooden sliding door of Kyoto Gosho depicting a Heian Period poetry party in one of the palace gardens.

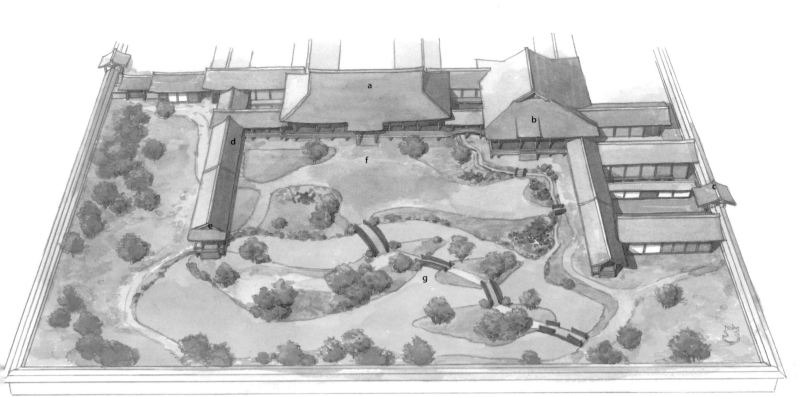

Imperial Palaces

Modeled after the Chinese Tang capital of Chang'-an, the capital of Heijōkyō (present-day Nara) occupied an area 5.9 kilometers (3.6 miles) from east to west and 4.8 kilometers (3 miles) from north to south, with 1.2 square kilometers (0.7 square miles) allotted to the palace. The main palace buildings were the Daigokuden (Hall of State), where important events took place, and the Chōdōin, where government offices were located. The Daigokuden was situated at one end of a large walled compound covered with white gravel. When the capital was moved to Heiankyō (present-day Kyoto) in 794, it was laid out in a style similar to that of its predecessor, with the palace grounds at one end of the city. The original palace was destroyed by fire in 876. Repeatedly burnt and reconstructed, the Daigokuden was not rebuilt after a disastrous 1177 fire. Its general appearance, however, can be seen at Heian Shrine in Kyoto. Constructed in 1895 to commemorate the 1100th anniversary of the city, Heian Shrine is a two-thirds reproduction of the third Daigokuden, reconstructed in 1072. Like its predecessors, the main buildings are located at one end of a large walled courtyard covered with white gravel.

After repeated conflagrations, the present imperial palace compound in Kyoto (the Gosho) was reconstructed in 1855, based on designs from the Heian Period. Inside the large walled compound are eighteen buildings joined by covered corridors that create small courtyards, as well as gardens with vegetation, bridges and streams. The main structure is the Shishinden, a Shinden style mansion with a magnificent roof covered with cypress bark. In front of the building is a large open courtyard covered with white gravel, where outdoor ceremonies and court dances are performed.

Today, the Kyoto palace, which is used only for the coronation of new emperors, is a living reminder of the ancient tradition of graveled courtyards—a status it shares with Ise Jingū, Hōryūji Temple and many other compounds constructed in the traditional style.

Reconstructions

There are no extant Shinden mansions or palaces from the Heian Period. There are, however, various reconstructions that provide an idea of what Shinden style mansions and gardens were like. A large-scale reconstruction project was recently begun in Nara City that over a number of years will bring back to life palaces and mansions of the Heijōkyō capital in the Nara Period. Though the mature Shinden style had not yet been developed at that time, the basics of the style were already in place. The buildings at the imperial palace in Kyoto (Gosho), discussed above, are in the mature Shinden style. Reconstructed Shinden style buildings and gardens can also be found at Daikakuji Temple, Ninnaji Temple, Heian Jingū and a few other places in Japan.

Tōsanjōden, residence of the powerful Fujiwara family. Constructed in Heiankyō, the mansion abandons the symmetry of the idealized Chinese prototype of a Shinden style mansion in favor of an asymmetrical "geese-in-flight" design in which the west annex is excluded. The garden remains at the front of the complex.

a Shinden (main building)
b east annex (*tainoya*)
c east gate
d west covered corridor
e "fishing" pavilion
f graveled area in front of *shinden*
g pond with three islands, fed by a stream that runs between the *shinden* and the east *tainoya*

Daikakuji Temple

Pages 74–5: View of the northwestern part of Ōsawa Pond. The building on the left is the Gomadō (Holy Fire Hall) where cedar sticks are burnt on the altar, and the vermilion colored pagoda rising above the trees on the right is the Shingyō Hōtō in which copies of the Heart Sutra (Hannya Shingyō or Prajnaparamita sutra) are kept.

Below: Small island and rock islets at the northern end of Ōsawa Pond. The Hondō (Main Hall) of Daikakuji Temple is situated across the lake.

Daikakuji Temple in Kyoto was originally a detached palace constructed around 834 (Heian Period) for the retirement of Emperor Saga. A large Shinden style garden featuring a 2.4 hectare (6 acre) artificial lake, modeled after Lake Tungting in China, was created to the southeast of the palace so that the moon could be viewed rising over the water. Though the original palace is gone, Ōsawa Pond is the most complete pond to survive from the Heian Period.

History

About 1200 years ago, in the Heian Period, Japan experienced a disastrous epidemic. Kōbō Daishi, founder of the Shingon sect of esoteric Buddhism, suggested that the Emperor Saga copy the Hannya Shingyō (Heart Sutra) as a form of prayer. It is said that when this was done, the country quickly recovered. In 876, the Emperor converted the palace to a Shingon temple. The sutra copied by the Emperor is still extant and is displayed for the

public once every sixty years, the next exhibition being in 2018. Many people still come to Daikakuji Temple every day to copy the Heart Sutra. To date, around seven million copies have been completed and are kept in the Shingyō Hōtō pagoda.

In subsequent periods, other emperors retired at Daikakuji. The original palace was destroyed, but in the early Edo Period, Emperor Gomizuno-o donated a Momoyama Period building located on the grounds of the Kyoto Imperial Palace. The thatched Shinden style building was moved to the grounds of Daikakuji as a replacement for the original palace. In the ancient tradition associated with major shrines and palaces, the building is situated in a graveled courtyard adjacent to the pond. Sliding doors in the Shinden are decorated with paintings by Momoyama Period artists of the Kanō School. Also facing the graveled courtyard are the Founder's Hall (moved from the Kyoto Gosho in the early twentieth century) and the Hondō (Main Hall) which overlooks Ōsawa Pond.

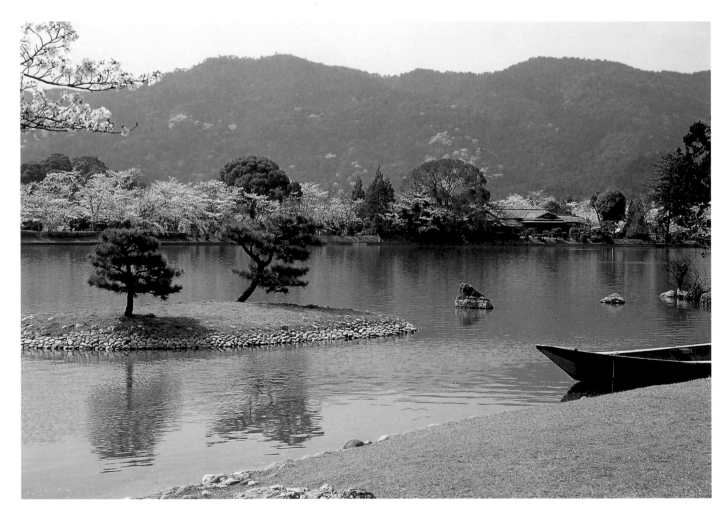

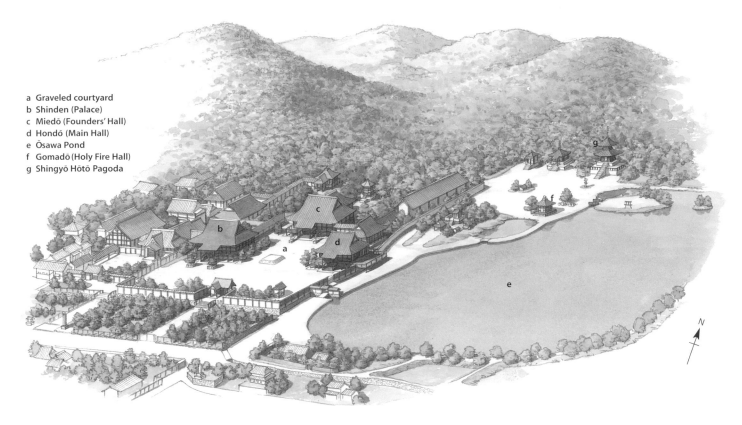

a Graveled courtyard
b Shinden (Palace)
c Miedō (Founders' Hall)
d Hondō (Main Hall)
e Ōsawa Pond
f Gomadō (Holy Fire Hall)
g Shingyō Hōtō Pagoda

The Pond Garden

The garden at Daikakuji consists of Ōsawa Pond and the landscaped area with its leisurely walking trails around the pond. The garden was built in the *chisen shūyū* style—a garden to be enjoyed from a boat. Viewing the garden from water level in a boat creates the illusion that the garden is much larger than is actually the case.

Ōsawa Pond was created by damming a stream issuing from Nakoso Waterfall to the north of the property. On the northern portion of the pond are two islands, one large and one small, the smaller one known as Chrysanthemum Island. Between them are several stone islets arranged in a straight line to resemble junks anchored in a harbor, a configuration that came to be known as *yodomari-ishi* (night-mooring stones).

A scattering of rocks on the hillside north of the pond is thought to have been a "dry waterfall" (*karedaki*), perhaps the oldest one thus far discovered in Japan. As in the case of later "dry landscape" (*karesansui*) gardens associated with Zen temples, flowing water was suggested by a skillful arrangement of stones that make up the waterfall.

The collection of thatched and tiled buildings in Daikakuji Temple today does not re-create the original palace and garden of the Heian Period. Nevertheless, the temple retains many of the features of a Shinden style complex, with buildings connected by covered corridors, a graveled courtyard in which the main buildings are located, and small courtyard gardens (*tsuboniwa*) located between the buildings.

Of particular interest is Ōsawa Pond which, in addition to being one of the few surviving garden lakes from the Heian Period, is noted for the numerous cherry trees that blossom along its shore in the spring. A special moon-viewing party, around the time of the harvest moon, is held every autumn for three days. Colorful boats adorned with dragons and carrying gorgeously robed dancers and musicians drift around the lake, evoking the image of aristocrats enjoying boat rides in the Heian Period. Daikakuji pond garden is one of the favorite strolling spots for people living in Kyoto.

Above: Daikakuji temple is a large complex, reminiscent of the Shinden style popular in the Heian Period. The complex is adjacent to Ōsawa Pond, one of the few remaining garden lakes from the Heian Period. The most important buildings are situated in a graveled courtyard.

Below: This relatively large courtyard garden between the buildings at Daikakuji Temple features a small pond, trimmed bushes and several rock arrangements.

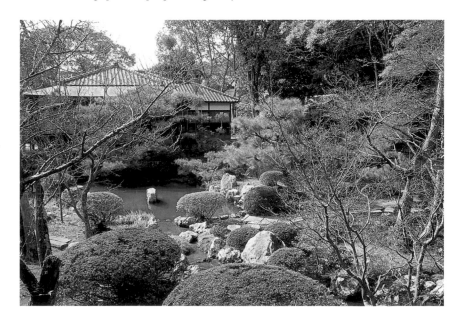

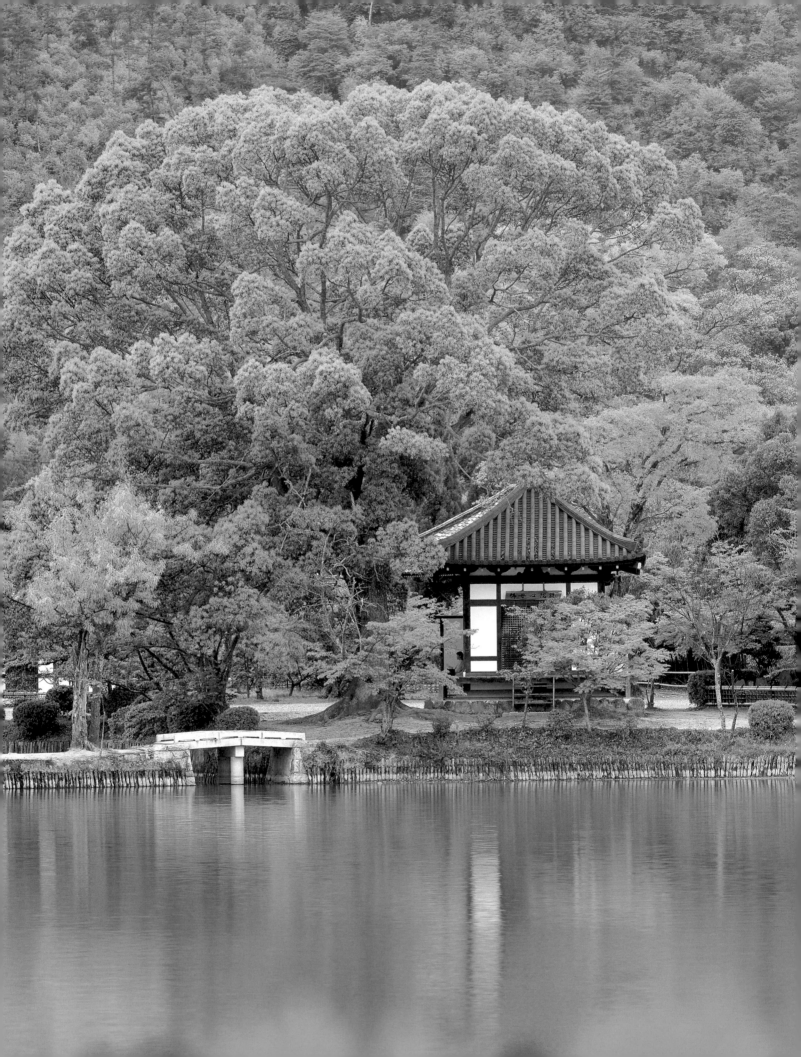

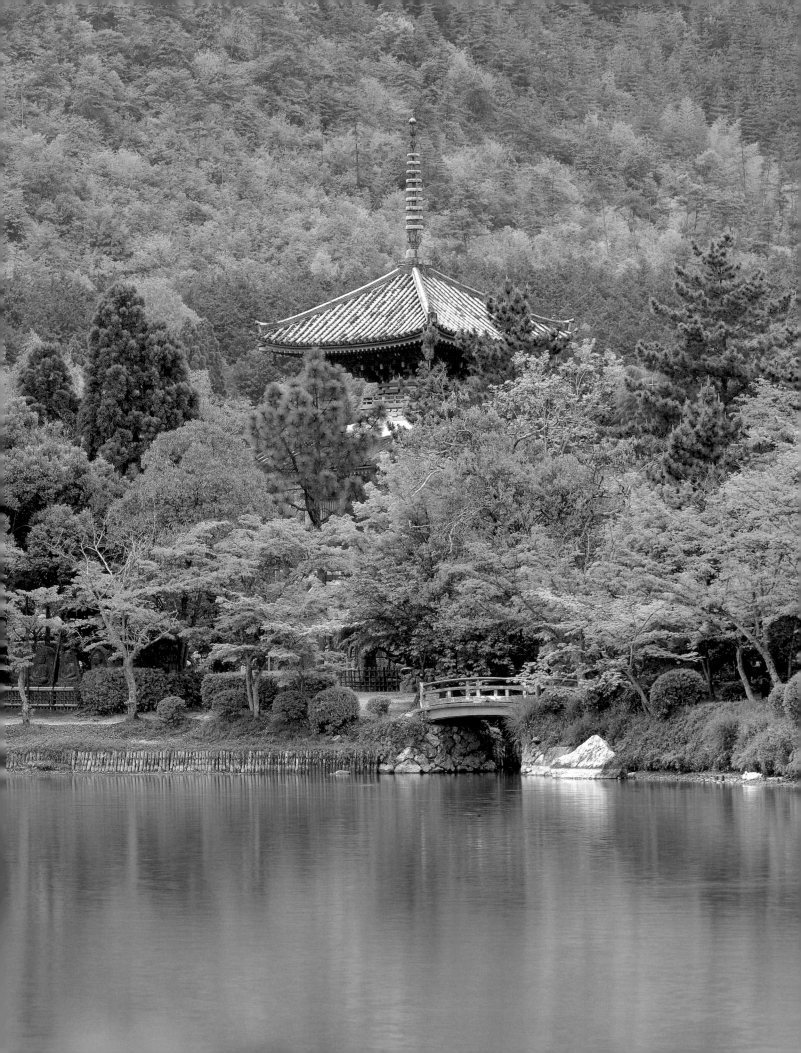

Ninnaji Temple

Below: Ninnaji's North Garden viewed from the deck of the Shinden (main building). Two teahouses are shown on the hillside behind the garden.

Opposite above: The North Garden was planned on two levels, with a flat field of sand and water that contrasts with a hill covered with bushes and trees. Behind the pond can be seen the roof of the Hitōtei Teahouse.

Opposite below: In contrast to the North Garden, the South Garden is simple, with white sand and a famous spreading pine tree. The five white lines on the wall surrounding the compound indicate the temple's former imperial status.

Ninnaji Temple was completed in 888 for the retirement of Emperor Uda, who served as the temple's first abbot. Though the temple burned in the fifteenth century, the Edo Period reconstruction retained many of the original features of a Shinden style complex, including buildings organized around a graveled area, and a large pond garden used by aristocrats for boating and for viewing the moon.

History

Ninnaji was the first of Kyoto's *monzeki*—temple villas whose heads were provided by the imperial line or the families of high-ranking nobles. *Monzeki* were discontinued in the Meiji Period, but their imperial status is still evidenced by the five white bands on their walls. Ninnaji burned in the Ōnin War (1467–77) but was reconstructed in the Edo Period as part of a massive rebuilding of Kyoto undertaken jointly by Emperor Gomizuno-o and the Tokugawa shogunate. Originally a large complex with more than sixty sub-temples, Ninnaji was rebuilt on a modest scale.

Today, Ninnaji is the headquarters of the Omuro branch of Shingon Buddhism, as well as the Omuro school of flower arranging. In 1994, Ninnaji was designated a World Cultural Heritage Site.

Three Compounds

Ninnaji is divided into three main areas: the eastern, southwestern and southeastern compounds. The most important buildings surviving from the Edo Period reconstruction are the Niō Gate,

the main entrance to the complex as a whole, and three structures located in the eastern compound: a five-storied pagoda, the Kondō (Main Hall), and the Miedō (Founder's Hall). The latter two buildings were moved to Ninnaji from the Kyoto Imperial Palace (Gosho), which was being reconstructed at the time. Before being moved, the Kondō and Miedō were the Shishinden and Seiryōden, the two most important structures at the palace.

The most important building in the southeastern compound is the Shinden (Main Building), originally the Tsune Goten, a bark-covered building on the grounds of the Gosho (imperial palace). The Tsune Goten was moved from the imperial palace in 1630 (at the same time the Kondō and Miedō were moved to the eastern compound) and situated on the site of Emperor Uda's original villa. The Tsune Goten burned in 1887 and was reconstructed soon thereafter.

The Southeastern Compound

Of the three compounds at Ninnaji, the southeastern compound is the most important for purposes of this discussion. The compound is a walled Shinden style complex where the Tsune Goten is located. To the southeast of the Tsune Goten is a graveled entrance courtyard, famous for a pine tree whose lower limbs have been trained to spread out horizontally. To the northeast of the Shinden is a pond garden originally designed in the fourteenth century when the imperial court was divided into rival northern and southern dynasties. The garden is believed to have undergone extensive renovation in 1690 by stone-setting priests. Ninnaji was the headquarters of one of the two most famous stone-setting schools of gardening, the other being the Saga School headed by the influential Zen priest, Musō Soseki. The inspiration for the renovation appears to have been provided by Paradise gardens of the Heian Period and Zen gardens of the Muromachi and Momoyama periods. The complex as a whole, however, is in the Shinden style, with buildings connected by covered corridors, small courtyard gardens and an area of white sand between the main building and the pond.

Features of the Garden

The pond is fed by a waterfall and divided into two parts by a stone slab bridge. The white sand between the Shinden and the pond is raked into a pattern of parallel strips, reminiscent of Zen style *karesansui* gardens. Separating the sand from the pond is a border of grass. On the other side of the pond, a grass border is punctuated by trimmed

N

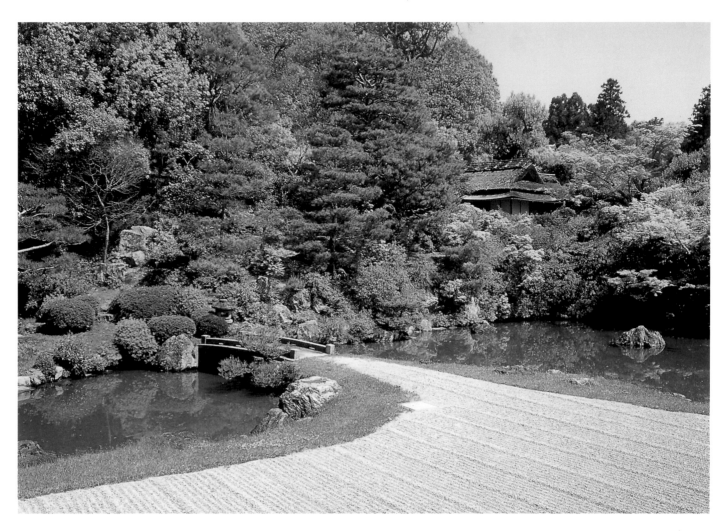

bushes. Rocks are placed intermittently around the edge of the pond, with an occasional rock in the pond itself. Behind the pond is a densely planted hillside with two teahouses, Hitōtei and Ryōkakutei. Perspective is exaggerated by narrowing the path that leads to the bridge and by controlling the height of middle-range trees on the hill. The tip of the pagoda in the eastern compound can be seen peaking above the hill—an example of *shakkei* (borrowed scenery) that adds to the spatial depth of the garden.

The garden is a good example of using foreground (raked sand), middle ground (pond) and background (planted hillside and pagoda) to create a balanced composition that appears to be larger than it actually is. The original garden was used for strolling. The remodeled garden, however, was designed to be viewed from the veranda of the Shinden or from other buildings and corridors that connect to the Shinden and partly circle the pond.

Heian Shrine

Above: The extensive forecourt in front of the Daigokuden (Hall of State) is covered with white gravel. On the left is Byakkorō (White Tiger Tower).

Below: Layout of Heian Jingū. Behind the Daigokuden is the Hondō commemorating the emperors Kammu and Kōmei. In front of the Daigokuden are two graveled courtyards, the forecourt and outer court. The walled complex is surrounded by four interconnected gardens.

a Heian Garden (South Garden)
b West Garden
c Honden (Main Hall)
d Hall of State
e Middle Garden
f Shōbikan Guest House
g East Garden
h Taiheikaku Bridge
i New Area
j Ōtenmon Gate

Heian Jingū was built in 1895 to commemorate the 1100th anniversary of moving the capital to Heiankyō (present-day Kyoto). The large compound consists of an approximately two-thirds scale reproduction of the third great Hall of State (Daigokuden), constructed in 1072 on the original palace grounds. The impressive structures, surrounded on three sides by connected gardens, provide a glimpse of some of the characteristics of a Heian Period Shinden style complex.

The Buildings

The Hall of State is connected to the White Tiger and Dragon towers, as well as to two other buildings, by covered corridors that create a large walled compound, entered through a two-story gate (Ōtenmon) on the south. Behind the Hall of State is the Honden (main shrine), dedicated to the emperors Kammu and Kōmei, the first and last emperors to rule in Kyoto. The buildings are in the Chinese style with green tiled roofs, vermilion colored wood and white plastered walls. The courtyard of the main complex is covered with gravel, as would have been the case in the original Heian Period palace. Various renovations were undertaken in 1940 and were completed in 1979. Millions of people visit this colorful and impressive shrine each year.

Surroundings

Three of the four connected gardens (the West, Middle and East gardens) were designed by the well-known Meiji Period landscape architect Ogawa Jihei, selected because of the excellence of his work in designing Murin-an Garden, to be described later in the book. The purpose of the garden was not to create a Heian Period Paradise garden but to provide a large area where visitors could stroll after worshipping at the shrine. Construction of the gardens designed by Ogawa was begun in 1894 and completed in 1913, the second year of the Showa Period.

The fourth garden, south of the West Garden, is the Heian Garden (or South Garden). Completed in 1968, it features plants mentioned in Heian Period literature, such as *The Tale of Genji*, as well as a famous weeping cherry tree. None of the four gardens are authentic Heian Period reproductions since they were influenced by Edo Period stroll gardens, Meiji Period aesthetic tastes (that combined indigenous and Western influences), and more recent trends. Nevertheless, the gardens are beautifully laid out, and the East Garden, in particular, provides some indication of the nature of a Shinden style garden. Together, the four gardens, renowned for their seasonal displays, cover an area of about 3.3 hectares (8 acres).

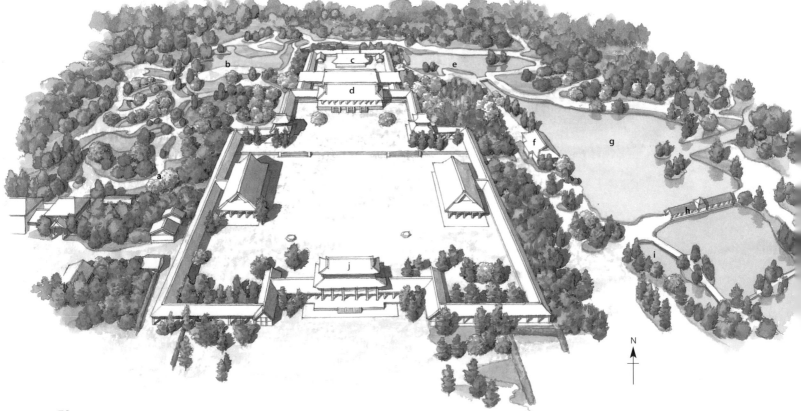

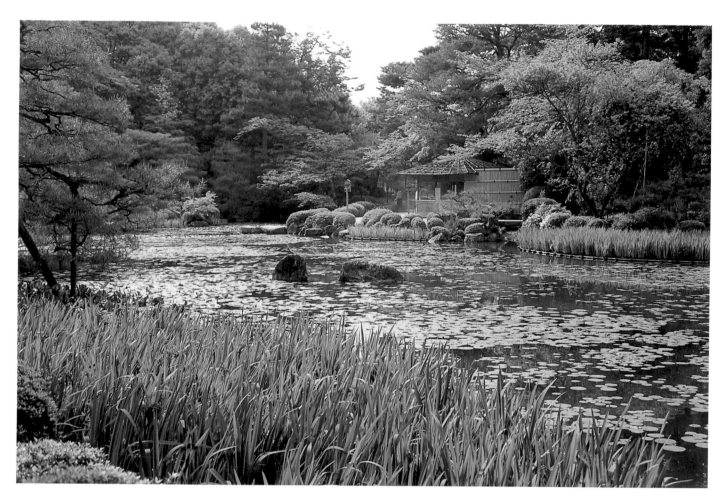

The West and Middle Gardens

The West Garden features White Tiger Pond. Lined with weeping cherry and willow trees, the pond is planted with 2000 irises that bloom in June. The northern end of the pond features a waterfall and small peninsula. In the southwestern part of the garden is an artificial mound, on top of which is Chōshintei Teahouse, where tea ceremonies are conducted once a month.

From the West Garden, visitors follow a path bordered by trees along a stream that leads to Dragon Pond in the Middle Garden. Dragon Pond, which contains a number of rock islands, features a different species of iris (rabbit-ear iris) than that found in White Tiger Pond. Dragon Pond is also the site of a famous stepping stone bridge (Crouching Dragon Bridge) salvaged from the supporting pillars of the Sanjō and Gojō bridges in Kyoto (page 32), built by Toyotomi Hideyoshi in the sixteenth century, and eventually destroyed by an earthquake. The stepping stones of Crouching Dragon Bridge represent the spine of a dragon. It is said that looking at the clouds reflected in the pond while standing on the bridge provides the sensation of riding a dragon through the heavens.

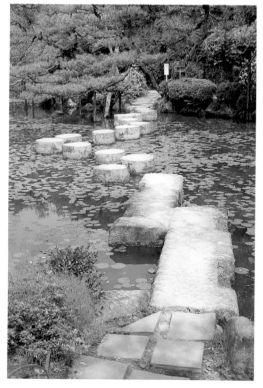

Above: Around 1000 rabbit-ear irises are planted on the shores of Dragon Pond and are in full bloom in mid-May.

Left: The famous stepping stone bridge in Dragon Pond, which represents the spine of a dragon.

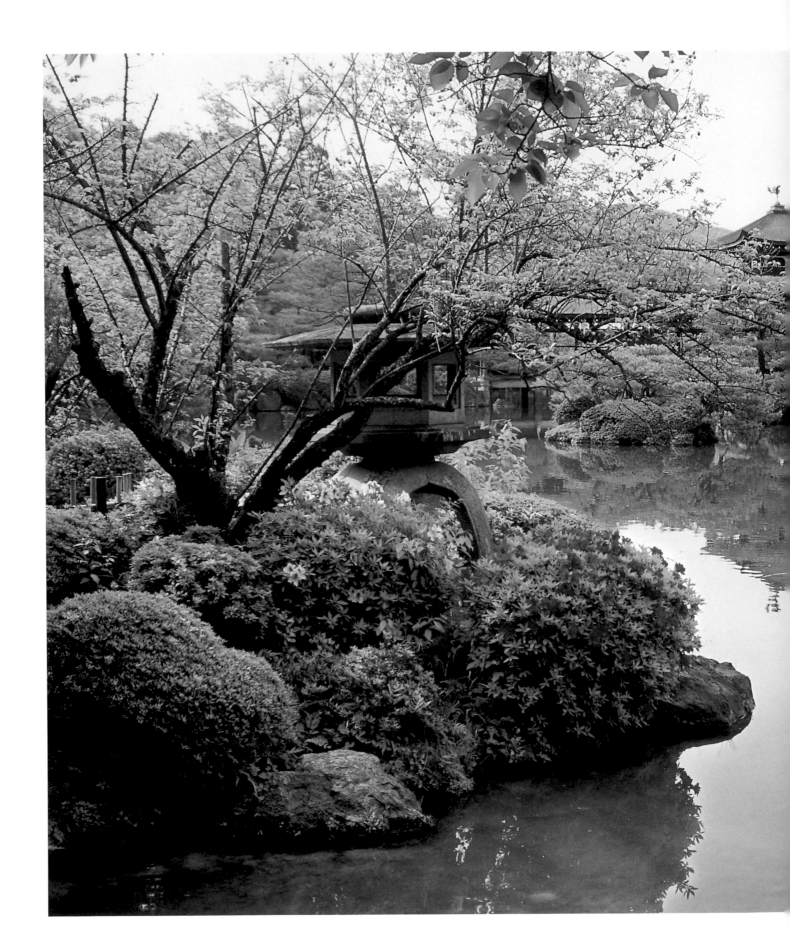

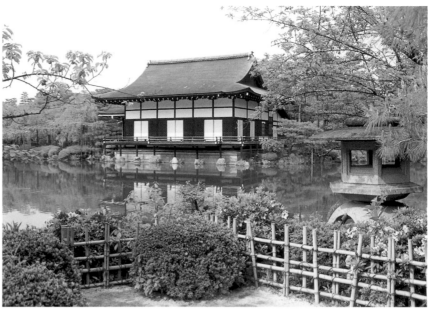

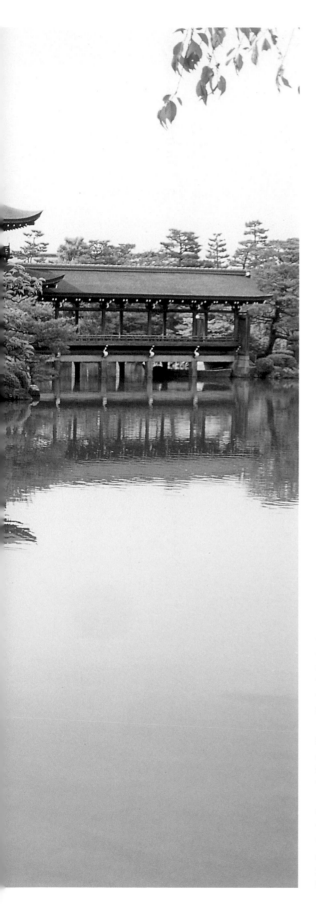

The East Garden

The East Garden is organized around Seihōike Pond. Spanning the pond is a Chinese style covered bridge (Taiheikaku), the middle portion of which is a pavilion moved from the Kyoto Gosho in 1912. The bridge, which resembles the fishing pavilion that extended over the pond in early Shinden style complexes, is capped with a phoenix.

A guest house, Shōbikan, located on the west shore of the pond, was also moved from Kyoto Gosho for the use of high-ranking guests. Viewed from across the pond, the guest house and bridge re-create some of the atmosphere of a traditional Shinden style mansion and garden. The area around the pond is lavishly planted with maple trees and bush clover.

The East Garden employs borrowed scenery, featuring the Higashiyama Mountains that loom up behind the Taiheikaku Bridge, to provide a sense of depth. Also featured in the East Garden are a large stone lantern, a waterfall and crane and turtle islands. Thus, though modern in origin, the East Garden uses traditional techniques and themes to help link Heian Shrine with the past it commemorates.

To the south of the East Garden is a recent addition by Nakane Kinsaku, who designed the Adachi Museum Garden (pages 165–7). The main attraction of this garden is a small pond lined with interesting rock compositions.

The Heian Shrine Garden is an eclectic endeavor that is difficult to classify. What helps unify this ambitious project is the waterway that runs throughout the garden and is always in sight as one strolls along the shaded paths. Because of its numerous species of flowers, bushes and trees, the garden is attractive in any season of the year.

Above: Shōbikan, a Shinden style building with a *hinoki* bark roof, was brought from Kyoto Gosho in 1913.

Opposite: The focal point of the East Garden is a covered bridge, Taiheikaku, which resembles a Shinden style fishing pavilion from the Heian Period.

Esoteric and Paradise Gardens

Opposite: Sanzenin, a Tendai temple in the village of Ōhara near Kyoto, has preserved much of its natural forest setting, while adding a small pond, shrubs, flowers and mosses.

Below: Looking across the pond to the gate of Enjōji Temple in Nara, which has one of the few surviving Paradise lotus ponds in Japan.

Two of the most important developments in the Heian Period were the introduction of esoteric Buddhism in the early part of the period and Pure Land Buddhism in the latter part. Esoteric temples were often constructed in mountainous areas in which the surrounding forest provided a "natural" garden setting. In contrast, early Pure Land temples featured formal Paradise gardens organized around a sacred lotus pond.

Esoteric Buddhism

One of the most influential developments in the early part of the Heian Period was the introduction of esoteric Buddhism from China, which provided a powerful stimulus to the arts of the period, particularly architecture, sculpture and painting. The esoteric denominations, Tendai and Shingon, which emphasized the secret transmission of

Buddhist teachings, built many of their temples in the mountains to provide a quiet place for study and meditation. Unlike the great Buddhist temples of Nara, such as Tōdaiji and Hōryūji, which were constructed in large graveled compounds surrounded by walls, esoteric temples often were not enclosed. Buildings were constructed wherever a flat spot could be found, leading to an arrangement that lacked the symmetry of urban temples.

Two of the most important esoteric temples are Enryakuji on Mount Hiei, the headquarters of Tendai Buddhism, and Kongōbuji on Mount Kōya, one of the headquarters of Shingon Buddhism. Some esoteric temples extend up the sides of mountains. Buildings are constructed on terraces that are surrounded by trees and connected by long flights of steps. Their "gardens" are not planted or contoured spaces, but the surrounding forest in which they are situated. Other esoteric temples have maintained the natural forest cover but have added small ponds, shrubbery and artifacts such as lanterns and statues. A good example of such a modified natural environment can be found at Sanzenin in the mountain town of Ōhara, near Kyoto. The lush green surroundings are strikingly different from those of the cleared courtyards of Nara Period temples.

Pure Land Buddhism

The latter part of the Heian Period, known as the Fujiwara Epoch, was a time when Japan severed many of its ties with the continent and developed its own cultural identity. Members of the imperial court were cut off from the larger society and spent their time in the pursuit of pleasure and the arts. While this stimulated the development of indigenous literature, painting and architecture, it also produced what many viewed as a moral degeneracy that alarmed priests such as Kūya, who traveled about Japan preaching the glories of heaven and the dangers of hell. Another priest, Genshin, expounded upon the worship of Amida Buddha who would ensure the rebirth in Jōdo, the Pure Land (or Western Paradise), of anyone who called upon the name of Amida in an act of sincere faith. These teachings had great appeal, first among the aristocracy, and later among the common people.

Mōtsūji Temple in northeastern Japan was founded in the ninth century by the priest Ennin in memory of the warriors who had died subduing the aboriginal inhabitants of the area. Using Byōdōin in Kyoto as an example, the complex originally had forty buildings organized around a Jōdo style Paradise garden. The Main Hall, of which only the foundations remain, was situated to the north of the lotus pond. A large gate (Nandaimon) was constructed to the south. The pond is the best preserved example of a Heian Period garden.

a Foundation for the Main Hall (Kondō)
b Foundation for the Sutra Hall (Kyōzō)
c Foundation for the Bell Tower (Dōrō)
d Nakajima Island
e Daisenchi Pond
f Foundation for the Gate (Nandaimon)

Paradise Gardens

Partly in response to the teaching of priests such as Kūya and Genshin, members of the nobility began building Pure Land temples in and around the capital of Heiankyō. The Pure Land was depicted in the Taima Mandala as a place with a lotus pond and platform on which sits Amida Nyorai who saves all people. The nobility tried to re-create this scene on their own estates by constructing Buddha halls in front of lotus ponds. These creations often were referred to as Paradise gardens.

The Shinden style mansions and pond gardens of the early Heian Period provided designers with additional models. The marriage of Shinden style pleasure ponds and religiously inspired lotus ponds produced some of Japan's most interesting gardens, most of which no longer exist. The most distinctive feature of a Paradise garden was a large island (Nakajima) situated in the lotus pond. In some cases, a stage was constructed on the island for conducting religious ceremonies. In other cases, Nakajima housed the Buddha hall itself.

The most famous Buddha hall associated with a Paradise garden still in existence is the Phoenix Hall of Byōdōin Temple, which was built in 1053 in the town of Uji near Kyoto. Housing a large

statue of Amida Buddha, the hall is situated on an island in the western part of the pond. The hall faces east across the main part of the pond. Originally, worshippers occupied a platform in the pond, east of the main island, and faced west towards the Phoenix Hall.

Other good examples of early Paradise gardens are Enjōji Temple in Nara, Hōkongōin in Kyoto, Mōtsūji Temple in Hiraizumi (northeastern Japan), and Shiramizu Amidadō Garden in Iwaki City. Later periods saw the construction of different types of Jōdo gardens.

Sakuteiki: A Treatise on Gardens

Continental culture had a great impact upon Japan, including its gardens. The first great wave of influence in the Asuka and Hakuhō periods brought Buddhist temples with their graveled courtyards. This served to reinforce the indigenous Japanese use of gravel to signify sacred places. The second great wave of continental influence, beginning in the Nara Period and culminating in the early Heian Period, introduced landscape gardens with ponds, artificial hills, vegetation and rocks. Many of these basic concepts and practices from China and Korea, which were so influential upon Shinden and Paradise gardens, as described above, were summarized in the earliest gardening book in the world, *Sakuteiki*, written towards the end of the eleventh century by Tachibana-no-Toshitsuna (1028–94), a member of the important Fujiwara family that supplied regents for the emperor.

The *Sakuteiki* begins with a treatise on general principles of garden design, followed by a discussion of a number of specific topics. One of the general principles propounded in the *Sakuteiki* is the emphasis upon view-obscuring techniques that make a garden that is restricted in size look larger and more interesting. An example of a view-obscuring technique is to offset objects such as buildings, paths and bridges so they are not in a straight line. Thus, a zigzag path is superior to a straight walkway because it provides only partial views of objects and conceals the depth of the site. Examples of other general principles expounded by the *Sakuteiki* are the necessity of using nature as the prime model for a garden, the obligation to make good use of features (such as rocks) already existing on the site, and the importance of balancing the symmetry of the rectangular wall by placing rocks, islands and ponds in an asymmetrical arrangement. The creative application of such techniques assisted Japan in the process of adapting continental designs to its own conditions and in establishing its own gardening identity.

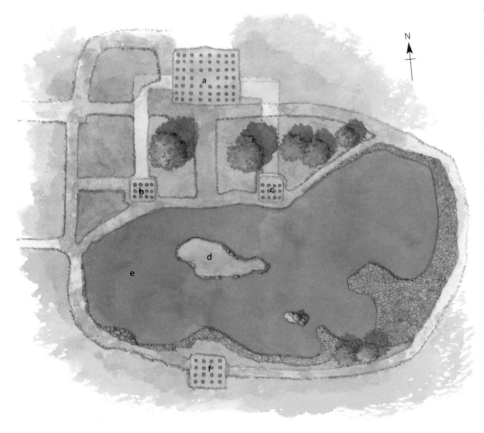

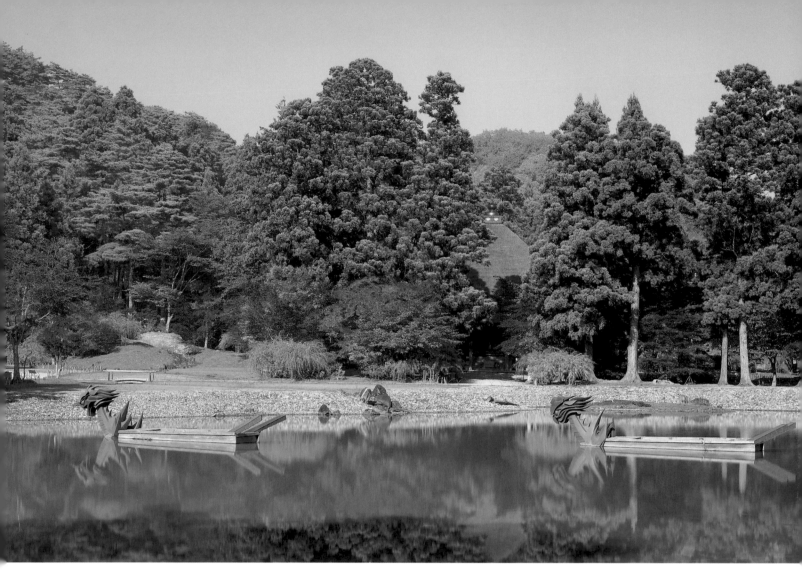

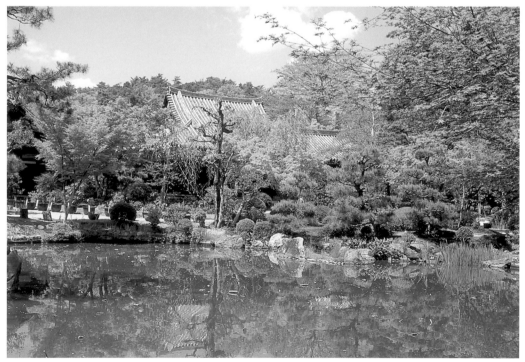

Above: View across the pond of the Paradise garden at Mōtsūji Temple in northeastern Japan. Near the shore are dragon boats used for ceremonies commemorating ancient rites, in which musicians in boats performed for worshippers.

Left: Hōkongōin in Kyoto is a Paradise garden constructed on the grounds of an earlier monastery in 1129 by Taikenmonin, consort of the retired Emperor Toba. The garden features a large lotus pond, on the west side of which was an Amida Hall with a statue of Amida Nyorai. Though the original Amida Hall is gone, the statue survived and is housed in the Main Hall (shown here), dating to 1615. On the south side of the pond was a hall housing nine Amida Buddhas, no longer extant. North of the pond is a waterfall which was excavated in 1970.

Sanzenin Temple

Sanzenin is a small Tendai temple located in the mountain village of Ōhara, north of Kyoto. Unlike many esoteric mountain temples, Sanzenin is surrounded by a wall and has a formal garden, as well as an informal pond garden. Sanzenin is best known, however, for the way its modest, unpainted buildings blend into a natural setting of mature trees and luxuriant moss.

History

Sanzenin originally was located on Mount Hiei, northeast of Kyoto. Mount Hiei is home to Enryakuji Monastery, headquarters of the Tendai denomination founded by the famous priest Saichō (767–822), posthumously known as Dengyō Daishi. Saichō studied in China, at the request of the emperor, before establishing Enryakuji in 806. Women could not enter the grounds of Enryakuji, but they were permitted to visit nearby Sanzenin, a *monzeki* temple whose abbot was appointed from the ranks of the imperial family or related royalty. In 1156, Sanzenin was relocated to Ōhara where it was joined with an existing temple, Ōjō Gokurakuin, founded in 985 by Priest Genshin, a retired vice-abbot of Enryakuji who preached that ordinary people could be saved by calling upon the name of Amida Buddha. This doctrine was further developed in later years by the Pure Land denominations.

Sanzenin consists of three principal buildings. The Kyakuden (Reception Hall for the Abbot)

serves as the entry point for visitors. Attached to the Kyakuden by corridors is the Shinden (Imperial Hall), a 1926 reconstruction of the sixteenth century original, and to the south of the Shinden is the Hondō, or Main Hall, Ōjō Gokurakuin, rebuilt in 1143. The Main Hall houses a statue of Amida Buddha thought to have been carved by Genshin himself.

Sanzenin is the headquarters of Tendai *shōmyō*, Buddhist hymnal chanting. Priests have been coming to Sanzenin to practice this specialized music since the ninth century. On May 30, Osenbōkō, the most important *shōmyō* event of the year, can be observed from the Yūseien Garden.

Yūseien Garden

The main garden at Sanzenin is the Yūseien Garden (Garden of Pure Presence), located between the Kyakuden and the Amida Hall. At the end of the Heian Period, the garden existing at that time was remodeled into a *chisen-kaiyū-shiki teien* (a stroll style garden around a pond) and further expanded in the Edo Period. The pond, fed by a stream that flows from a hill to the east, is long and narrow with turtle and crane islands, edged with clipped bushes. Though it was probably designed to be the central feature of the garden, the pond is eclipsed by the beautiful cryptomeria (Japanese cedar) and maple trees that surround the pond and the Amida Hall. Luxuriant green moss covering the forest floor is accented by a roughly hewn stone lantern. The natural feeling of the Yūseien Garden is carried up the slope to the east of the main complex, where visitors can follow paths that wind among mature trees, flowers and mountain grasses, or that follow the stream that feeds the pond. Sanzenin is most popular in the fall when the maples turn to brilliant reds and oranges, as well as in the winter when the grounds are covered by a deep mantle of snow.

Shūhekien Garden

In the late sixteenth century, lumber left over from rebuilding the Shishinden at the Kyoto Imperial Palace was used to construct the Kyakuden. Attached to the Kyakuden is the formal Shūhekien Garden that bends around the south and east sides of the building. Fed by water that comes from a river to the north of the grounds, the garden is designed to be viewed from the inside, through the sliding doors of the Kyakuden. The garden consists of clipped hedges and bushes (*karikomi*), rocks, moss and a stone pagoda. In the early Edo Period, the garden was remodeled by the tea master Kanamori Sōwa.

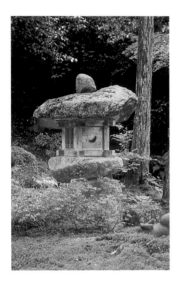

Above: A special feature of the Yūseien Garden is a lantern constructed of natural rocks and a wooden lamp housing. The lantern illustrates the *wabi-sabi* character of artifacts that fit into their surroundings without attracting too much attention.

Below: The slope to the east of the main complex has been left in a semi-natural state with mature cryptomeria (Japanese cedar) and maple trees interspersed with flowering bushes and rocks.

Opposite: In contrast to the more natural feeling of the Yūseien Garden, the Shūhekien Garden features abundant clipped bushes and is bordered by a hedge.

Pages 88–9: Japanese cedar and maple trees surround the Main Hall in the Yūseien Garden.

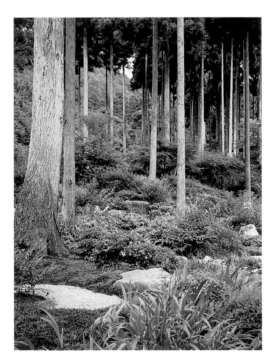

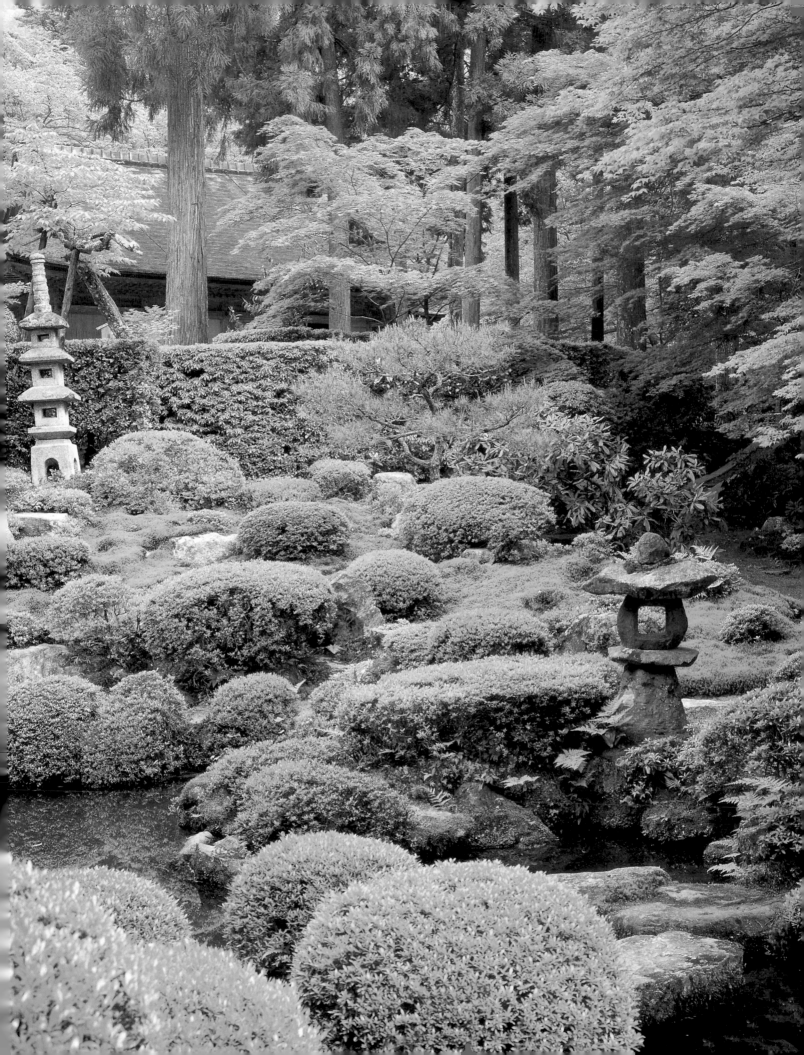

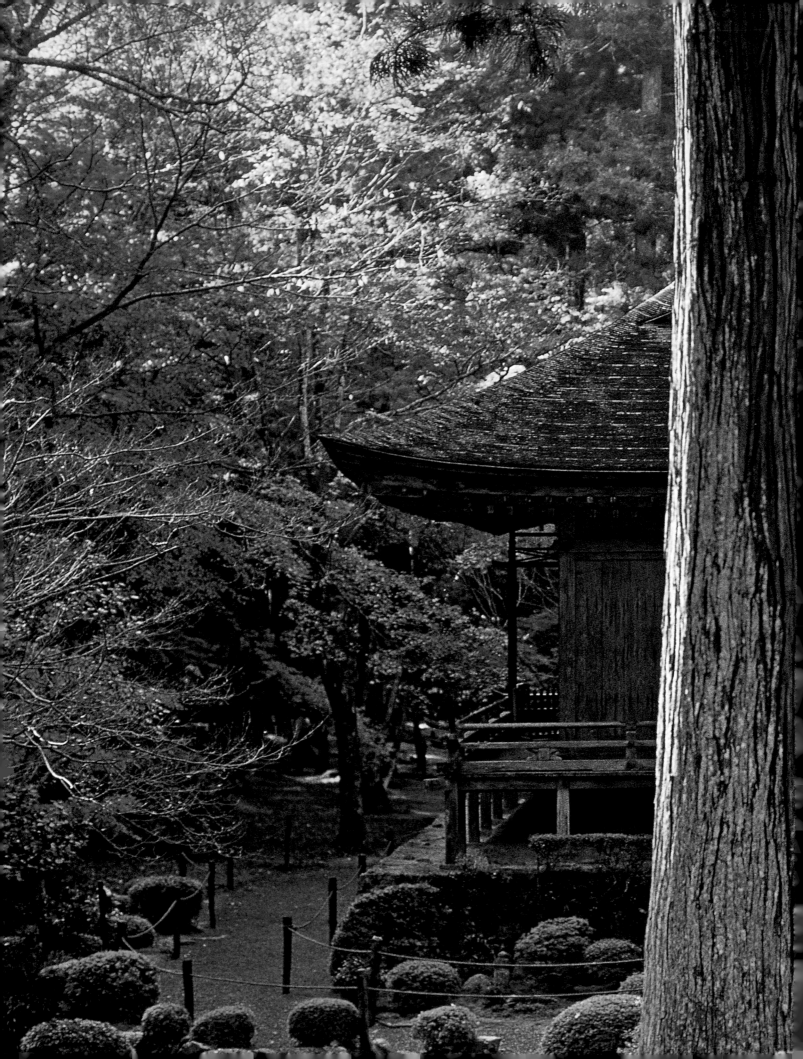

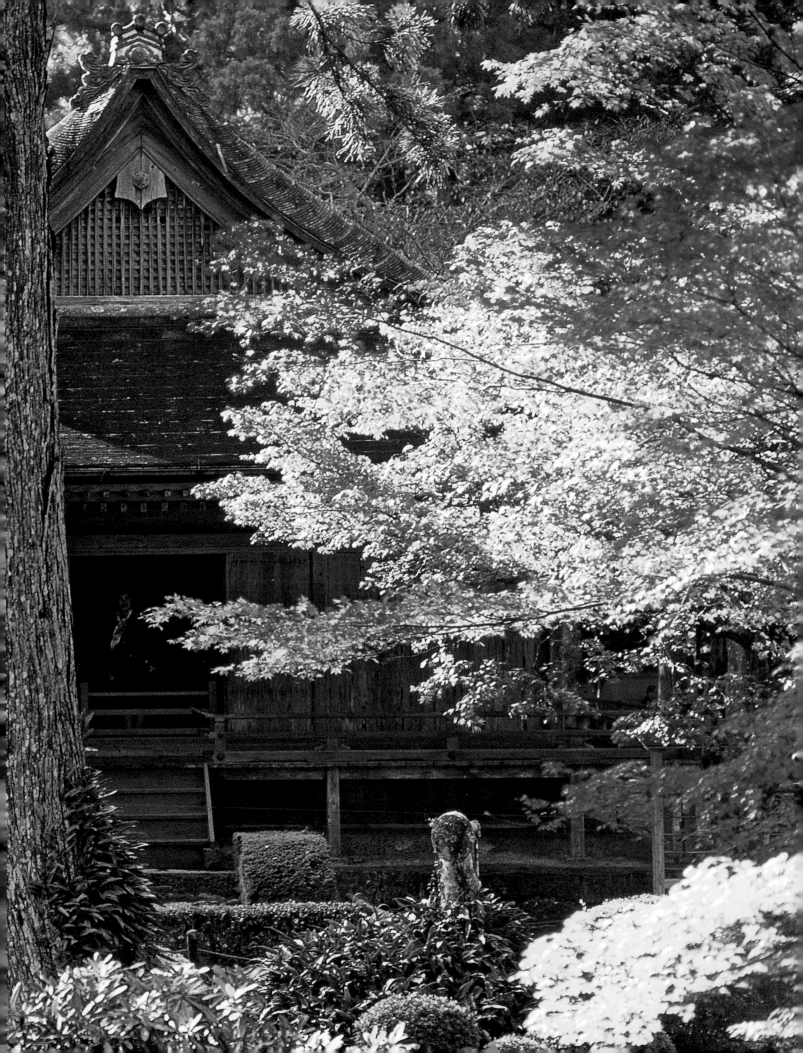

Byōdōin Temple

Byōdōin is a Pure Land temple in the town of Uji, near Kyoto. Constructed in the Heian Period to re-create the Western Paradise of Amida Buddha, the temple is famous for its Phoenix Hall, situated on an island in a pond. The garden at Byōdōin features a landscaped area and walking paths that afford visitors a variety of views of the Phoenix Hall and its reflections in the pond.

History

In 1052, Fujiwara-no-Yorimichi (regent to the emperor) turned a villa near Kyoto, constructed by his father, into a temple called Byōdōin. The following year, he built the Hōōdō (Phoenix Hall) on an island in a pond to house a statue of Amida Buddha. Over the next two decades, additional buildings were added in an attempt to re-create Amida's Western Paradise. Today, only the Phoenix Hall and its beautiful pond garden remain.

At the time of Yorimichi's death, Byōdōin encompassed thirty-three buildings, including seven pagodas. Fortunately, the most important building, the Phoenix Hall, has survived the

ravages of time to provide a glimpse into Pure Land architectural and garden styles of the Heian Period. The focus of the garden is Ajiike Pond, constructed from an inlet of the nearby Uji River. Originally much larger, the garden was considered the ideal prototype for Pure Land gardens and was copied at places as far away as Hiraizumi in the Tohoku area north of present-day Tokyo.

The Amida Hall was renamed the Hōōdō (Phoenix Hall) in the Edo Period because of its resemblance to a bird with outstretched wings, represented by ornamental structures reminiscent of the fishing pavilions of Heian Period Shinden style mansions. The central structure, crested by a pair of metal phoenixes, is located on Nakajima Island in the pond. It houses a 10-foot-high statue of Amida Buddha sitting on a lotus pedestal under an elaborate canopy once inlaid with mother-of-pearl. Flanking the Buddha are fifty-two small statues of bodhisattvas floating on clouds, many of them playing musical instruments. According to ancient records and drawings, every inch of the walls, ceiling and pillars was decorated with rich

The Phoenix Hall is situated on an island in an irregularly shaped pond. Between the Phoenix Hall and the Kannon Hall, rebuilt in the Kamakura Period, is a wisteria arbor.

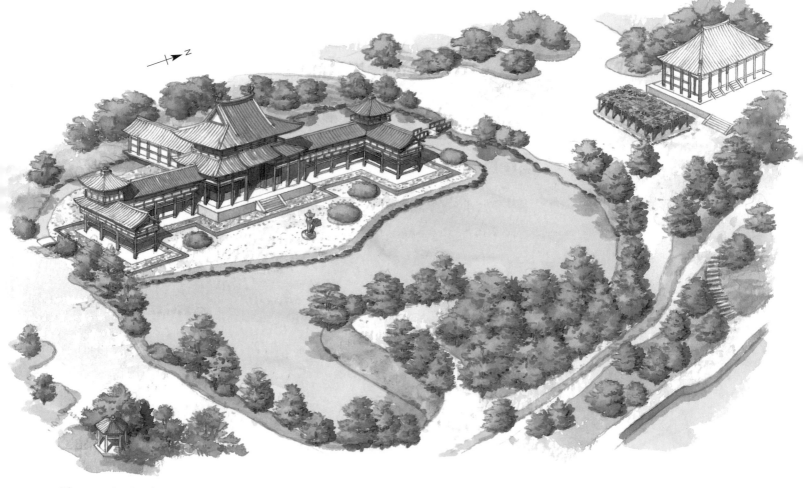

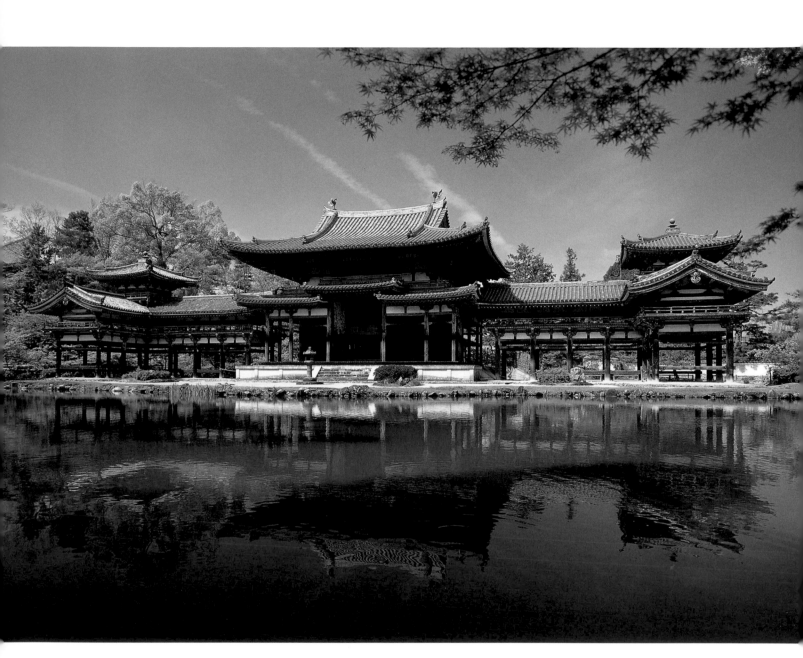

colors and gold leaves, in an attempt to portray the Western Paradise. The main statue and all except one of the bodhisattvas are national treasures and widely regarded as the high point of Buddhist art of the period.

When the massive doors to the central structure are opened, the meditating Amida Buddha can be seen from across the pond. On the days of the spring and autumnal equinox, the sun comes up directly to the east of the Phoenix Hall, and the face of Amida Buddha is illuminated by the reflection of the sun on the pond. In the evening of those days, the sun sets directly behind the hall, projecting the building's silhouette on the pond. The Phoenix Hall is best viewed in the early morning when the pond is smooth and the compound is not yet crowded with people.

The Garden

Excavation and historical research initiated in 1990 discovered that originally there was a small pebble covered islet (Kojima) between Nakajima Island, on which the Phoenix Hall is located, and the northern shore. This islet was connected to Nakajima and the shore by two vermilion colored wooden bridges. On the basis of this evidence, the islet and bridges have been reconstructed. Today, a flat *hirabashi* bridge (see page 33) spans the water from the islet to the mainland and an arched *soribashi* bridge extends from the islet to the Phoenix Hall. Another bridge constructed of a stone slab spans the water between Nakajima Island and the shore to the south of the Phoenix Hall.

The space in front of the Phoenix Hall is divided into areas of white sand and rounded river

The Phoenix Hall is reflected in Ajiike Pond on a still spring morning.

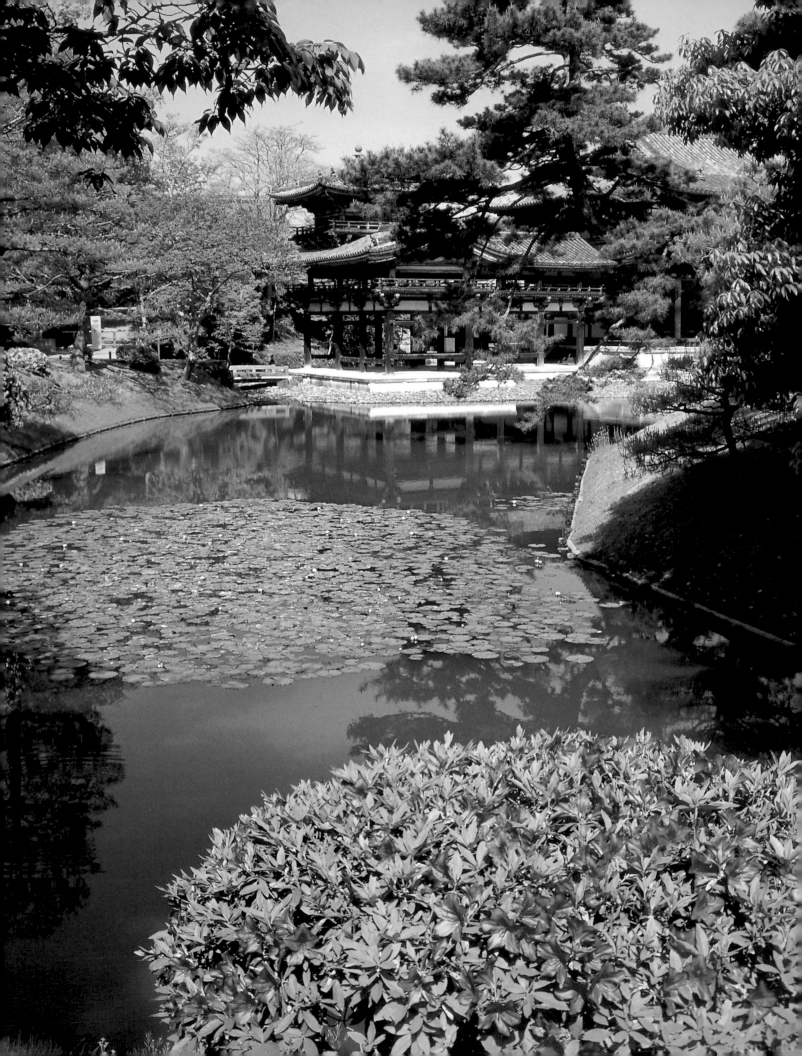

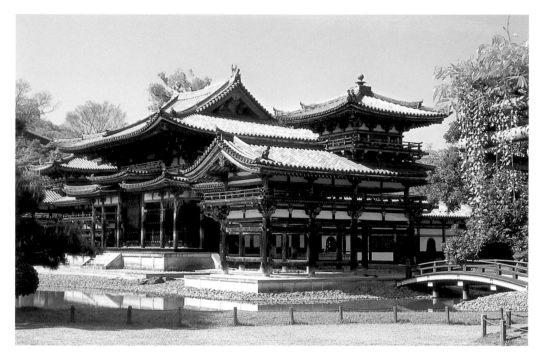

pebbles, accented by a stone lantern and several rocks. The banks of the irregularly shaped pond are planted with grass and pine trees. The south part of the pond extends towards the Uji River to create a somewhat separate area that hosts numerous water lilies. The pond is surrounded by a sandy beach-like area that allows visitors to walk entirely around the pond for a view of the Phoenix Hall, beautifully reflected in the calm waters, from all angles. Looking east from the pond, the visitor is afforded a view of the mountains in the distance, an example of borrowed scenery.

In addition to the pond and Phoenix Hall, the garden includes a Kannon Temple to the north. Adjacent to the temple is a fan lawn (Ōgi-no-Shiba) where a well-known warrior, Minamoto Yorimasa, committed suicide in 1180 after losing a battle at Uji to the leader of the opposing Taira clan. Between the Kannon Temple and pond is a wisteria arbor that blooms profusely in the spring.

Recent Additions

In 2001, the garden was refurbished to more closely resemble the Heian Period original, and a new fireproof museum was constructed to house the impressive collection of Byōdōin treasures. Adjacent to the museum is a rectangular garden designed by Miyagi Shun. The abstract simplicity of the moss covered garden blends well with the modern architecture of the museum. This new complex is discretely situated so that it does not detract from the Phoenix Hall and its pond garden.

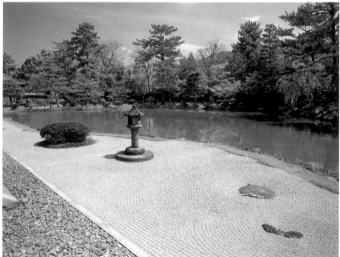

Jōruriji Temple

Jōruriji is a Pure Land temple located northeast of Nara City. The garden is organized around a large pond, in the middle of which is an island symbolizing earth. The Amida Hall on the west side of the pond represents the Western Paradise of Amida Nyorai and the three-story pagoda on its east side represents the Eastern Paradise of Yakushi Nyorai, the Buddha of Healing.

History

Founded in 1047 (Nara Period) by the priest Eshin, Jōruriji is the only remaining example of Paradise halls, once numerous, containing nine statues of Amida Buddha, each representing one of the nine stages of Nirvana. The present hall, originally constructed elsewhere in 1107, was dismantled and moved to its current location, on the west side of the pond, in 1157 to replace an earlier structure. The pagoda was moved from a temple in Kyoto in 1178 and situated on the other side of the pond. The complex as a whole symbolizes the cosmos, with earth situated between the Western and Eastern paradises. The pond represents the ocean that separates birth and death. Yakushi Nyorai, housed in the pagoda, is responsible for looking after those in search of the Western Paradise. He is known as the Buddha of Healing because he holds a medicine jar in his left hand. The two buildings and nine statues of Amida Buddha are National Treasures. Two stone lanterns made in 1366, one on each side of the pond, are Important Cultural Properties.

The Garden

The pond was dug in 1150 by a priest from Nara's Kōfukuji Temple. Water for the pond is supplied by two streams issuing from a mountain to the south. The garden contains two notable rock arrangements: one off the northern end of the island and the other in the vicinity of the pagoda. On the southern end of the island is a stone slab bridge that connects the island to the mainland. The pond has relatively steep banks with a variety of plants. Mature trees surround the pond, except for the area immediately in front of the Amida Hall.

The pond was excavated and the garden restored to its original twelfth-century formation in 1976 under the direction of well-known landscape garden designer Mori Osamu. Restoration involved considerable research concerning the original size and shape of the pond, as well as the kinds of plants that would have been used in the Heian Period. Jōruriji is one of the finest examples of the few surviving Paradise gardens in Japan.

A Related Garden

Another Paradise garden currently being reconstructed is that of Ganjōji Temple in Iwaki City—the Shiramizu Amidadō Garden. The Amida Hall at Ganjōji is an original Heian Period structure built in 1160. Its paradise pond has been under reconstruction since 1966 when it was declared a National Historical Site. When completed, Ganjōji will rival Byōdōin and Jōruriji in terms of historical importance and aesthetic merit.

Layout of Jōruriji with earth, represented by Nakajima Island, situated between the Western Paradise, represented by the Amida Hall, and the Eastern Paradise, represented by the pagoda. The pond represents the ocean that separates birth and death. Nakajima Island houses a small shrine dedicated to Benzaiten, the Indian goddess of good fortune.

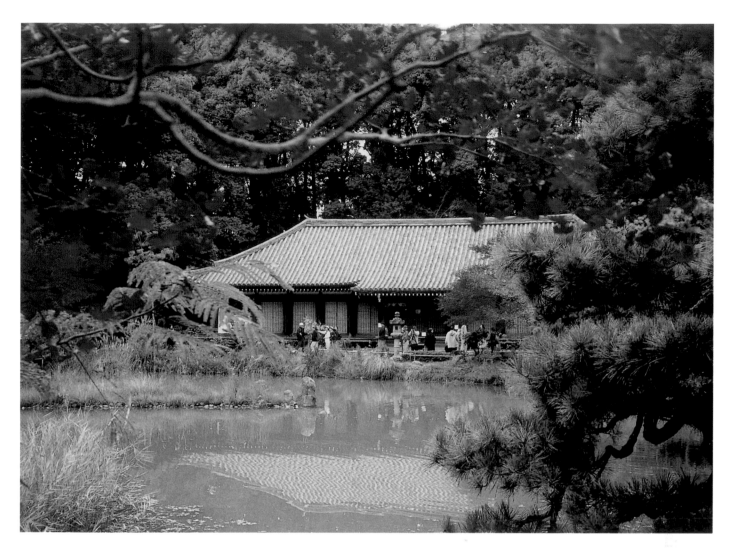

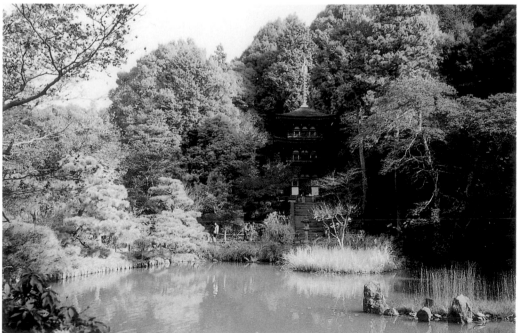

Above: Jōruriji's Amida Hall is situated so that worshippers standing on the east bank of the pond can face west towards the nine statues of Amida Buddha housed in the hall.

Left: The three-story pagoda, restored in the Kamakura Period, viewed from the west side of the pond in autumn, when the foliage is at its best.

Zen Temple Gardens

Zen brought with it many aspects of the culture of the Southern Song Dynasty (1127–1279) in China. This new form of Buddhism was one of many factors that influenced the evolution of pond gardens used for boating in the Heian Period into early stroll gardens and eventually into contemplation gardens to be viewed from the main building of a Zen temple.

Influence of Zen

Meditation was an important aspect of earlier forms of Buddhism in Japan, but in the twelfth and thirteenth centuries (late Kamakura and early Muromachi periods), Zen Buddhism as a separate sect was introduced from China, where it was known as Chan. In contrast to the doctrinal complexity and esoteric rituals emphasized by earlier denominations, Zen emphasized the importance of being keenly aware of everything that one does in the course of a day. This includes meditation (*zazen*), but it also includes practical activities such as walking, bathing and chopping wood.

Zen was eagerly adopted by the samurai class because of the importance it attached to self-discipline, simplicity and austerity. Zen also had a major impact upon Japanese aesthetics, including intellectual and artistic pursuits. Zen priests incorporated calligraphy, black ink painting and gardening into their daily practice since such activities were regarded as an aid to meditation and to developing an intuitive insight into the nature of reality. Zen was also influential in the development of aesthetic concepts such as *sabi* (the patina that comes with age) and *wabi* (naturalness, simplicity and imperfection), as well as art forms such as the tea ceremony and Noh drama, both characterized by understatement and subtlety. Zen was equally influential in the development of new, austere gardening styles.

Above: An early print from *Tsukiyama Teizōden* (Building Mountains and Making Gardens) of Saihōji Temple depicting a rock formation in the upper left and a building on the edge of a pond in the lower right.

Right and opposite: Saihōji Temple in Kyoto (popularly known as the Moss Temple because of the many varieties of moss growing on the grounds) is transitional between the pond gardens of the Heian Period and the Zen gardens of the Muromachi Period. The lower half is a pond garden with several islands, whereas the upper half contains several rock compositions that provide the earliest extant examples of Zen *karesansui* techniques.

a Main Hall
b Central Island
c Golden Pond

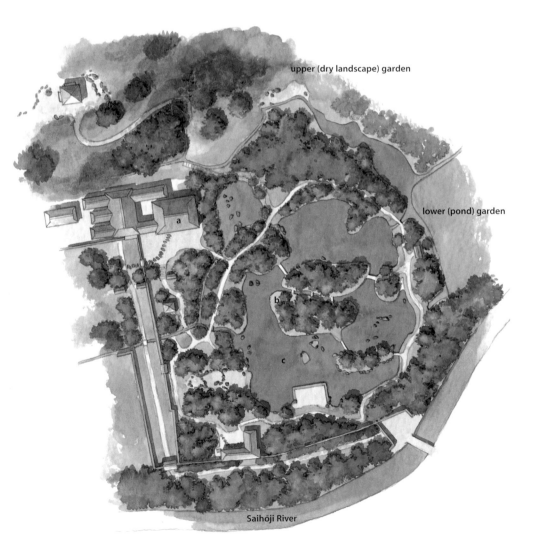

upper (dry landscape) garden

lower (pond) garden

Saihōji River

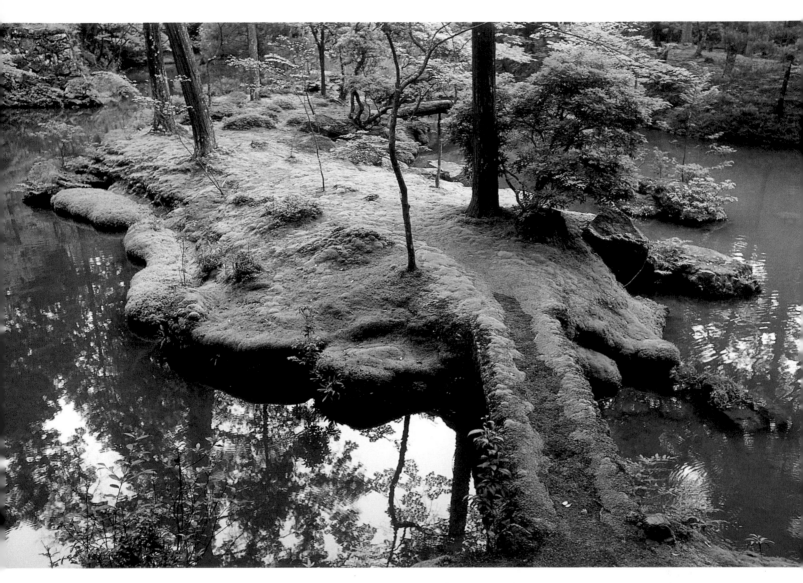

Evolution of Zen Gardens

Initially, the gardens of the late Kamakura and early Muromachi periods began as outgrowths of the large pond gardens of the Heian Period associated with Shinden mansions and Pure Land temples. Early gardens at Zen temples such as Tenryūji and Saihōji in Kyoto basically were converted Paradise gardens. Two additional Zen temples that incorporated the principles of earlier Shinden and Paradise gardens, featuring a pond, are the famous Temple of the Golden Pavilion (Kinkakuji) and Temple of the Silver Pavilion (Ginkakuji) in Kyoto. Both were originally designed as shogunal villas and later converted to Zen temples. Whereas in the Heian Period large ponds were used for pleasure boating (*funa asobi*), the emphasis in the Muromachi Period had shifted to "pond-spring-strolling gardens" (*chisen-kaiyū-shiki teien*)— pond gardens designed to be enjoyed on foot. As a result, ponds tended to decrease in size.

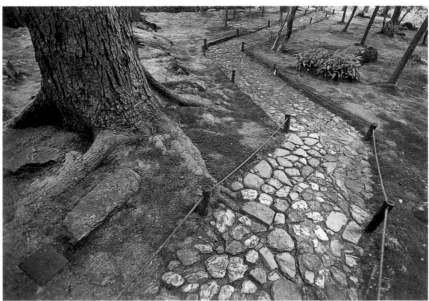

Right: The austere simplicity of this *karesansui* masterpiece at Ryōanji Temple in Kyoto is considered by many to be the prime example of the mature Zen garden.

Below: A woman stops to admire a sand cone in this small *karesansui* garden in the Daitokuji complex.

Opposite above: *Karesansui* South Garden in front of the Hōjō of Tōfukuji Zen Temple in Kyoto. The garden was designed in 1939 by Shigemori Mirei, a well-known garden designer who received his inspiration from the gardens of the Kamakura and Muromachi periods.

Opposite below: Whirlpool pattern (page 25) often found in *karesansui* gardens.

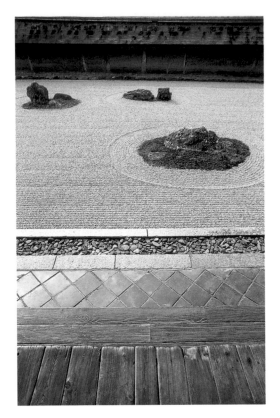

This trend was accompanied by an evolution of architecture from the Shinden to the Shoin style, partly due to the influence of Zen and esoteric temples. Originally, the *shoin* was a small study in the residence (*hōjō*) of the abbot that looked out upon a garden. The main feature of a *shoin* study was an alcove in an outer wall containing a desk, above which were papered windows that provided light for reading and writing. Gradually, the *shoin* evolved into an audience chamber for important guests and the *hōjō* garden developed into a place to be contemplated (*kanshō*) from the inside rather than an area for strolling. Like the large south gardens of earlier Shinden style mansions, the *hōjō* garden contained a sanded courtyard next to the main hall, though it had lost its function as a ceremonial space by this time. If there was enough space, the *hōjō* garden might include a pond as well as a *karesansui* (dry landscape) arrangement. By the early Edo Period, *hōjō* gardens were almost exclusively of the *karesansui* type.

Saihōji Temple Garden

Saihōji, popularly known as Kokedera or Moss Temple, is a particularly interesting Zen garden. Founded in the eighth century, Saihōji was remodeled as a Pure Land Paradise garden in the twelfth

century and remodeled again in 1339 to give it a Zen flavor. The latter transformation was accomplished by Musō Soseki, a well-known Zen priest and avid gardener, who believed that a properly designed garden was a suitable place for gaining enlightenment. The lower part of the garden is organized around a pond in the Pure Land style, whereas the upper part represents an early form of dry landscape gardening.

Saihōji was repeatedly destroyed and reconstructed. Eventual neglect allowed the growth of large trees that provided shade and retained the moisture necessary for the growth of the many species of moss that cover the grounds today. Ironically, though the Moss Temple garden probably bears little resemblance to Musō's original design, it has come to be considered an eloquent example of many of the values associated with Zen aesthetics, such as a feeling of tranquility and closeness to nature. Its space and spontaneity provide an interesting contrast to the tightly controlled *karesansui* gardens most typical of later developments in Zen landscape gardening.

Dry Landscape Gardens

In *karesansui* gardens, rocks and gravel, sometimes supplemented with moss and other forms of vegetation, are used to suggest water and mountains. The first contemplation garden in the *karesansui* style was constructed at Ryōanji Temple in Kyoto (pages 108–9). Other famous dry landscape gardens are the Daisenin garden at Daitokuji Temple in Kyoto (pages 110–11), Konchiin garden at Nanzenji Temple in Kyoto, and the garden of Zuizenji Temple in Kamakura.

Fundamentally, *karesansui* gardens were designed to translate Southern Song and Yuan black ink landscape paintings into three-dimensional forms on a microcosmic scale. Black ink paintings featured large empty or misty spaces that were represented in gardens as expanses of white sand. The powerful and sometimes jagged mountains in Song paintings, created by strong calligraphic strokes using a Chinese "fountain-brush," were represented in gardens by stones. Ranging in color from dark to light, stones were layered to create a sense of spatial and tonal depth.

A typical Zen idea is that the universe can be found in a grain of sand. Accordingly, *karesansui* gardens strove to convey the deeper meaning of life by reducing materials used to stones, gravel and, occasionally, pruned shrubs such as tea and azalea. The stones stand for the eternal framework of the universe, and the gravel symbolizes the transience of the phenomenal world.

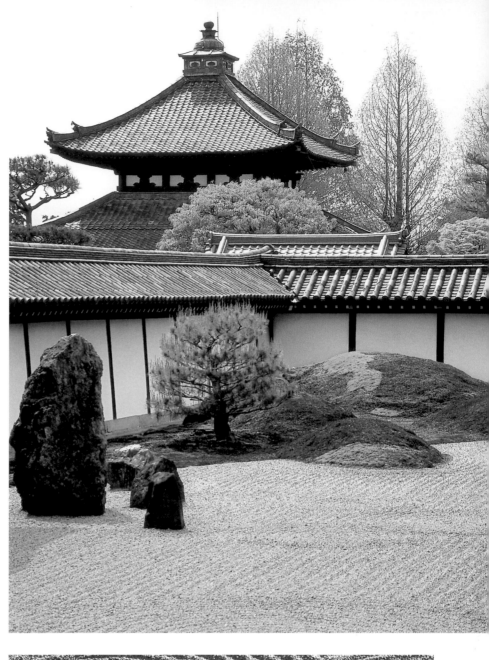

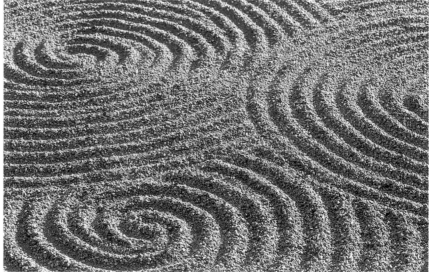

Tenryūji Temple

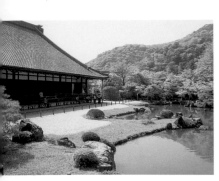

Above: Pond garden in front of the Main Building (Hōjō), with the borrowed scenery of Mount Arashi in the background.

Below and opposite: Unlike gardens in earlier times, where the main feature was an island in the middle of a pond, rock arrangements provide the focus of the Tenryūji Garden. The most important rock arrangements are on the shore opposite the Hōjō. In the foreground is a stone bridge. The large standing rock behind the stone bridge is the base of the Dragon Gate Waterfall (dry arrangement). Above and slightly to the left of the base rock is the famous "carp" rock. Further up is a rock with a round top representing a seated Kannon (Goddess of Mercy). To the right of the bridge is the Mount Hōrai composition. The inset shown here is represented in greater detail in the drawing opposite.

Tenryūji, "Temple of the Heavenly Dragon," was originally a villa belonging to a Heian Period noble family, and later served as the residence of retired Emperor Gosaga (1242–46). In 1399, the shogun Ashikaga Takauji built a Zen temple on the grounds and appointed Musō Soseki, a well-known Zen priest and advisor to Takauji, as abbot. Musō oversaw the reconstruction of the original villa garden, giving it more of a Zen flavor.

History

With the assistance of the Ashikaga family, Emperor Godaigo (1288–1339) successfully rebelled against the Kamakura shogunate in an attempt to restore imperial power. His reign was short-lived, however, as he was betrayed by Ashikaga Takauji, his general, who banished the emperor to Mount Yoshino and established a new military shogunate in Kyoto. Soon after the death of Godaigo at Mount Yoshino in 1339, Musō Soseki dreamed that he saw the emperor, who had turned into a golden dragon, rising out of the river in the Arashiyama area of western Kyoto. Musō convinced the shogun to appease the spirit of Godaigo by converting the Arashiyama villa where Godaigo had lived as a child into a temple. The villa, which dated back to the Heian Period, had been constructed in the Shinden style and probably had a pond garden, though the details of the original garden are not known. Musō was charged with reconstructing the garden.

Partly for the purpose of funding reconstruction of the garden, Musō Soseki persuaded Takauji to resume trade with China, which had slowed to a trickle following the attempted Mongolian invasions in the latter part of the Kamakura Period. Priests such as Musō, who were familiar with the language and customs of China, became increasingly influential as a result of this resumed trade, and their temples became the headquarters for a revival of Chinese art and culture. Inspired by the black ink paintings of the Song Dynasty, the style favored in Zen, Musō was one of the first to advocate the idea that gardens could be used as an aid to meditation. Though he probably was not directly involved in their design, Musō oversaw the construction of several gardens, including that of the famous "Moss Garden" at Saihōji Temple in Kyoto.

Tenryūji, which at its height had 150 subtemples, was one of the Five Great Temples of Kyoto (Kyoto Gozan). In 1864, it was burned for the last time in a battle between the Chōshū and Satsuma clans. Most of the buildings were rebuilt in the Meiji Period.

The Garden

The reconstructed garden at Tenryūji, in the western part of Kyoto, represents a transition between earlier pond gardens and the *karesansui* (dry landscape) gardens that later became popular in Zen temples. The focus of the garden is a pond that lies at the base of hills rising to Mount Arashi, which is incorporated into the design of the garden in the earliest known example of borrowed scenery (*shakkei*). At the far end of the pond are two rock groups that reflect Musō's interest in the use of Chinese Song Dynasty gardening techniques to translate two-dimensional painting themes into three-dimensional forms.

One group consists of a number of rocks arranged into a dry landscape waterfall (*karedaki*) known as Ryūmon-baku (Dragon Gate Waterfall), situated on the bank of the pond. The composition, with a stone carp halfway up the falls, depicts the Yellow River Gorge at Lung Men (Dragon Gate) where, according to legend, a carp swam up the falls and was transformed into a dragon—a metaphor for students who successfully pass the qualifying examinations for government service. In Zen, the carp attempting to climb the falls stands for the severity of training required by a monk. If he succeeds, he achieves enlightenment, represented by the dragon. The waterfall was designed to be viewed from the abbot's quarters

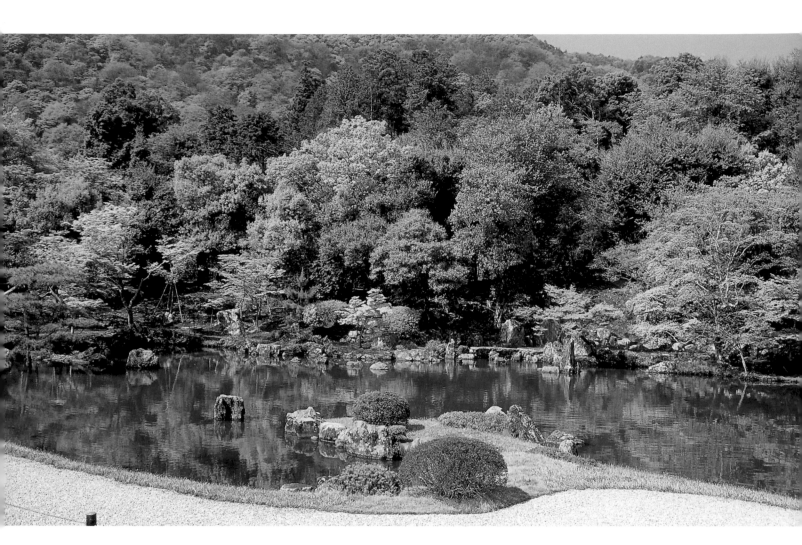

(Hōjō) situated on the pond. A stone bridge made of three natural stones, said to be the oldest in Japan, is situated in front of the waterfall.

The other rock group consists of seven vertical stones that represent Mount Hōrai (in Taoist thought, a sacred realm where the immortals live), rising from the pond near the waterfall. Both stone groupings have a more natural appearance than similar rock arrangements in China in their use of fewer stones and a marked preference for simpler shapes.

In accordance with basic principles of Song landscape painting, spatial depth is achieved in the garden at Tenryūji Temple by the use of three successive planes representing foreground, middle ground and background. In the foreground is a strip of white sand between the deck of the Hōjō and the pond. The pond and rock compositions make up the middle ground. In the background is the borrowed scenery provided by Mount Arashi. Tenryūji's pond garden, with its intricate layout and symbolism, is an eloquent example of early Zen garden architecture and is one of Kyoto's most important gardens.

Below: Detail of the rock arrangement in the photograph above.

Kannon rock

carp rock

base of waterfall

bridge

Mount Hōrai grouping

Kinkakuji Temple

Kinkakuji Temple (Temple of the Golden Pavilion) in Kyoto was constructed by the third Ashikaga shogun for use as a private residence. It was later converted to a Zen temple. The elegant three-storied structure is situated in a stroll garden organized around a pond containing ten islands. Other features of the garden include an earlier pond, a Dragon Gate waterfall and a teahouse.

History
In 1397 (Muromachi Period), the third Ashikaga shogun, Yoshimitsu, began construction of a villa on the grounds of an old mansion belonging to the Saionji court family in the northern part of Kyoto City. The villa, Kitayamaden, was constructed as a retreat where the former shogun, who had abdicated in favor of his son, could concentrate on religion and the arts. In addition to the Golden Pavilion, the villa included two Shinden style palaces, one used as a private residence and the other used for entertaining guests. In 1407, thirteen new buildings were constructed in preparation for a visit the following year by reigning Emperor Gokomatsu. It was very unusual for an emperor to visit a shogun, so Yoshimitsu went to great lengths to entertain his royal guest, organizing elaborate parties lasting for twenty-one days.

The Golden Pavilion combines Chinese Song architectural influences and indigenous forms. The resulting edifice, while eclectic, is well integrated and graceful. It was positioned to afford a good view of the pond as well as the mountains to the west and north of Kyoto, an example of employing borrowed scenery to improve and extend the view. The first floor, constructed of unpainted wood and white plaster, was used for receiving guests and for embarking on rides in ornate Chinese style boats, reminiscent of Heian Period boating parties. The second and third floors are covered with gold leaf, from whence the popular name, Golden Pavilion, is derived. The pavilion was used for religious purposes as well as for discussions and tea drinking with close friends and political advisers.

After Yoshimitsu's death, the villa was turned into a Zen temple known as Rokuonji. Over the years, most of the buildings were lost to war and decay until today only the Golden Pavilion and the pond garden remain from early days. Partial restoration was carried out in the Edo Period, and again in the Meiji Period. The Golden Pavilion was

Layout of the Kinkakuji grounds. Anmintaku Pond can be seen in the upper left. Sekkatei Teahouse is on top of the hill to its right.

a Ryūmon (Dragon Gate) Waterfall
b Kinkaku Pavilion
c Departing Turtle
d Arriving Turtle
e Crane and Turtle Island pair
f Ashiharajima
g Hōjō (Abbot's Quarters)
h Kyōkochi

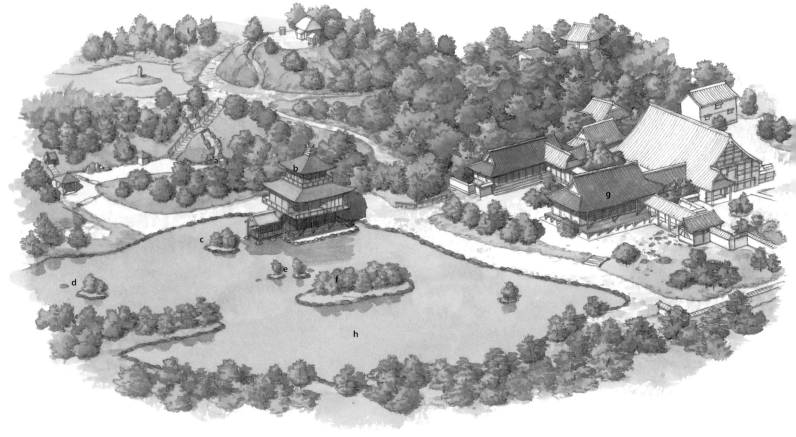

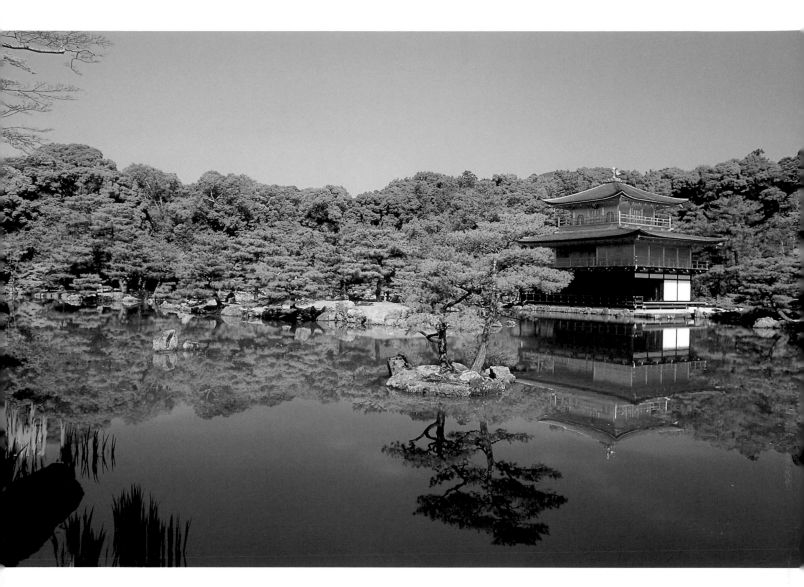

burned by a crazed priest in 1950 and reconstruct-ed in 1955. In 1987, a layer of gold leaf, five times the original thickness, was applied to the second and third floors. Kinkakuji was designated a UNESCO World Cultural Heritage Site in 1994.

The Garden

Yoshimitsu designed the garden on the basis of Paradise garden prototypes, which were organized around a pond. The layout of the garden and its rock arrangements also were influenced by the earlier Zen pond gardens at Tenryūji and Saihōji, both designed under the direction of the famous priest, Musō Soseki.

Though there is a path around the pond, the garden was designed to be seen from a boat or from the Golden Pavilion. The pond is divided into two zones. The inner zone, in front of the Golden Pavilion, features two turtle islands: an "arriving" turtle whose rock head faces the pavil-ion, and a "departing" turtle that faces the other

direction. The outer zone, created by a peninsula and a large island, Ashiharajima, contains several rock islets. Between Ashiharajima (symbolizing Japan) and the pavilion are two small islands, one a crane and the other a turtle island. Altogether, Kyōkochi (Mirror Pond) contains ten islands, including three crane and five turtle islands.

The banks of the pond are planted with bushes and pruned trees, whose size in the foreground, near the pavilion, is small. Taller trees and bushes on the further bank lie in front of even larger trees to create a middle and background. This creates the illusion of considerable space, augment-ed by the borrowed mountain scenery in the dis-tance. One of the mountains in the background is Mount Kinugasa (Cloth Hat). The name is said to be derived from an incident involving a certain emperor who came to visit this area of the capital in summer. Because the emperor wished to see a snow scene, he had his retainers drape white silk on the top of the mountain.

Kinkaku (Golden Pavilion) is situated on the northeastern edge of Kyōkochi Pond. Tsurushima (Crane Island) can be seen in the foreground. Obscured by Tsurushima is a small turtle island. The larger island behind and to the left of Tsurushima is Irikamejima (Arriving Turtle Island). The pond is surrounded by pruned trees.

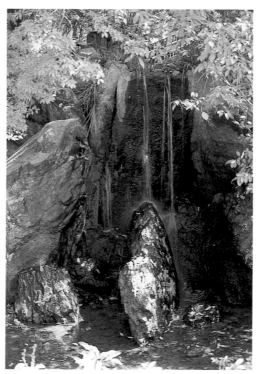

Opposite: Tsurushima (Crane Island), shown here, and nearby Kameshima (Turtle Island) make a pair, said to be the oldest extant example of this frequently used combination.

Left: Ryūmon-baku (Dragon Gate Waterfall), representing a moment when a carp jumps up the waterfall. Like the waterfall at Tenryūji Temple, after which this waterfall is modeled, a large rock has been placed to the left of the carp rock. The main difference is that the Kinkakuji waterfall is "wet" whereas that of its predecessor is "dry."

Below: Ashihara Island in the center of the pond contains this *sanzon-seki* (triad rock formation), modeled after a similar triad at Saihōji Temple. As is often the case in such triads, a smaller fourth rock has been added at the base, perhaps for balance.

From Kyōkochi, a path winds through the remainder of the well-treed 1.82 hectare (4.5 acre) property, passing an older pond (Anmintaku) that served as the focal point of the original Kamakura Period Saionji Villa garden. An island in the pond contains a small stone pagoda dedicated to a white snake that guarded the Saionji family villa.

A special feature of the garden is a Dragon Gate waterfall, modeled after the dry waterfall at Tenryūji Temple. In contrast to its predecessor, the waterfall at Kinkakuji is wet. A large rock at the base represents a carp trying to climb the falls. According to ancient Chinese legend, a carp which manages to struggle to the top of a waterfall becomes a dragon, the symbol of enlightenment in Zen Buddhism. Other attractions include a Sōan style teahouse (Sekkatei), a Fudōdō shrine near the exit and an old pine tree in front of the Hōjō (abbot's quarters) shaped like a boat. It is said that the tree originally was a bonsai tree belonging to Yoshimitsu.

Ginkakuji Temple

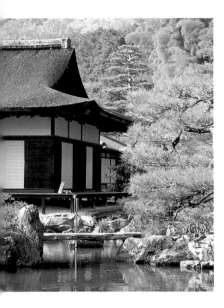

In 1482 the eighth Ashikaga shogun, Yoshimasa, an asthete and patron of the arts, began construction of a villa in the foothills of Mount Tsukimachi in eastern Kyoto. The villa consisted of a large garden with twelve buildings, of which only the Kannon Hall (Silver Pavilion) and the Tōgudō hall have survived. The garden is divided into two areas: a lower section organized around a pond area facing the Tōgudō and an upper section that occupies a rock and tree-covered steep slope.

History

To build his villa, Yoshimasa confiscated property belonging to a temple affiliated with Enryakuji Monastery on Mount Hiei. Because times were hard and he had little success in collecting taxes to finance the project, he forced aristocratic families to provide labor and construction materials.

In addition to the surviving Kannon Hall (Silver Pavilion) and the Tōgudō (built to house a statue of the Buddha), the original buildings included living quarters (*tsunegosho*), a meditation room named Saishian at the upper end of the garden, an arbor called Chōzentei for enjoying the view, a gathering room (*kaisho*) for socializing with friends, a water pavilion on the bank of the pond (*izumidono*), a bridge arbor, a pond arbor and a bamboo arbor. Today, the Tōgudō stands where the water pavilion was originally located.

Inspiration for the Silver Pavilion was provided by Saihōji Temple, as well as the Golden Pavilion constructed by Yoshimasa's grandfather. Though the Silver Pavilion resembles the Golden Pavilion, it has only two stories. A statue of Kannon, Goddess of Mercy, is housed on the second floor. The ground floor, which looks out upon the garden, was used for meditation.

After the death of Yoshimasa, the villa was turned into a Zen temple known as Jishōji, which came to be known in the Edo Period as Ginkakuji, Temple of the Silver Pavilion. Over time, most of the original buildings were lost. The two surviving structures, the Silver Pavilion and the Tōgudō, have been designated as National Treasures. The Silver Pavilion was never covered with silver as originally may have been intended. Though much less striking than its golden cousin, the modest but graceful structure blends unobtrusively into the beautiful garden in which it is situated.

The Garden

Leading from the main gate of the temple compound to the middle gate, from which one enters the garden, is a long pathway lined with a bamboo fence and tall trimmed hedges that provide a transition from the outside world to the secluded area within. Like the Saihōji Temple garden, designed by Musō Soseki, the Ginkakuji garden is divided

Above: Stone bridge over a pond in front of the Tōgudō, the oldest extant Shoin style building in Japan. The large rock on the left (part of White Crane Island) represents the head of a crane (see drawing opposite).

Below: Layout of Ginkakuji, showing the lower level of the garden with its elaborate pond system and raked gravel. The Silver Pavilion is on the left and the Tōgudō on the right.

a Ginkaku (Silver Pavilion)
b Kōgetsudai Cone
c Ginsadan (Sea of Silver Sand)
d Hakkakutō (White Crane Island)
e Tōgudō

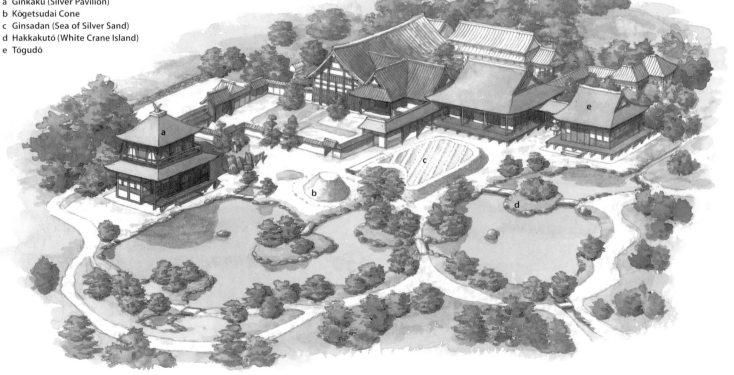

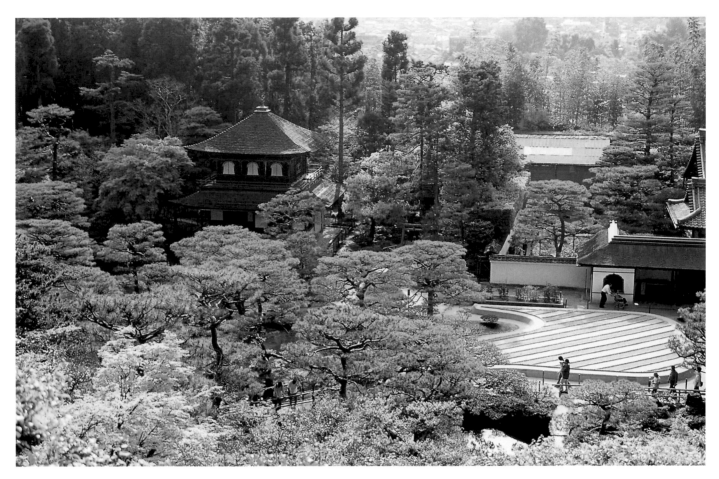

into two parts. The lower part, consisting of an early Zen style stroll garden organized around a pond (*chisen-kaiyū-shiki teien*), features rock compositions, bridges and plants arranged into scenes inspired by famous places described in classical Japanese and Chinese literature. Kinkyōchi Pond (Brocade Mirror Pond) features seven stone bridges. Mount Tsukimachi (Mountain Awaiting the Moon) provides a backdrop for the garden, and is a good example of borrowed scenery.

Adjacent to the planted pond area is a *karesansui* zone, added in the Edo Period. The long furrows of raked sand resemble waves in the moonlight—giving rise to its name, Sea of Silver Sand. The *karesansui* portion of the garden is dominated by a perfectly shaped sand cone, known as Kōgetsudai (Moon-viewing Dais), that resembles Mount Fuji. While some scholars consider the pond and sand areas incongruous, others believe that the strong contrast provides much of the garden's aesthetic power.

Upper Garden

The upper part of the garden is organized around a path that winds along a steep slope featuring a dry rock arrangement, as well as a variety of trees, shrubs and flowering plants confiscated

by Yoshimasa from other temples and villas, as he was prone to do. Dry rock and planted areas are well integrated to produce a dynamic and balanced whole. In back of the garden on the upper slope is a bamboo fence that separates the formal part of the garden from a dense grove of Japanese cedars. The upper slope provides a good view of the pond, raked sand and buildings below.

Top: Ginkaku is surrounded by vegetation and a white raked sand area. The flat sand mound is called Ginsadan (Sea of Silver Sand).

Above: White Crane Island viewed from the Tōgudō. The three larger rocks in the foreground provide a good example of a typical rock triad.

Ryōanji Temple

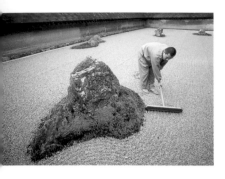

Above: Raking the patterns back into gravel is a relatively simple process, yet it requires attention to detail and composure to do correctly. Maintenance is part of the daily ritual of the monks.

Below: Unlike pond gardens in earlier periods, the famous rock garden at Ryōanji does not include any trees, but is designed to be contemplated from the deck of the Hōjō (Main Building). The fifteen rocks in the garden are arranged into five groupings, with the two at the left forming one composition and the three at the right forming another. The rectangular garden is framed by a low earthen wall capped with a bark roof, known for its subtle but beautiful colors.

Ryōanji, a Zen temple in the northwestern part of Kyoto City, encompasses several sub-temples and an extensive pond garden. The abbot's quarters (Hōjō) of the temple proper has a large room that opens onto a walled *karesansui* garden to the south—probably the most famous garden in Japan. Ryōanji also has Shoin style rooms that face a smaller garden to the north.

History

Ryōanji, "Temple of the Peaceful Dragon," originally was the estate of a member of the powerful Fujiwara family that provided regents for the government in the Heian Period. The estate eventually passed into the hands of the Hosokawa family. In accordance with the wishes of Hosokawa Katsumoto, a famous general, the estate was converted into a Zen temple under the patronage of nearby Myōshinji, a Rinzai Zen monastery.

There is considerable debate concerning the origins and evolution of Ryōanji's famous rock garden. Ryōanji was burned during the Ōnin War (1467–77) and rebuilt near the end of the fifteenth century. It is most likely that the walled rock garden was created between 1619 and 1680. The original rock garden apparently had a covered corridor running through it in a north–south direction, with a view of the garden on both left and right, and a gate at the south end. The temple was again destroyed by fire in 1797, after which the garden was filled in with debris and a new rock garden constructed on top—thereby accounting for the

fact that although the wall is normal height on the outside, it appears to be unusually low from the inside. A 1799 woodblock print shows the garden largely as it is today, without the corridor.

The garden is said to have been designed by Sōami, a painter and gardener, who died in 1525, but this is not in accord with the history described above. Two signatures carved on the back of one of the stones in the garden suggest that the garden may have been created by semi-professional gardeners from the "unclean" or outcast classes—the "-ami" gardeners described earlier in the book.

The garden remained relatively unknown until the twentieth century when it was praised by foreigners, including Queen Elizabeth II of Great Britain who visited the garden in 1975. Today, Ryōanji's rock garden is recognized by both Japanese and Western experts as one of Japan's greatest garden masterpieces.

The Rock Garden

The rectangular rock garden is small—only 25 meters (83 feet) from east to west and 10 meters (33 feet) from south to north. Fifteen rocks (only nine in the original version) are arranged in five groupings, surrounded by carefully raked white sand. The garden was designed in such a way that, regardless of vantage point, one of the fifteen rocks is hidden. The arrangement is an example of a *karesansui* garden in its purest form, without water or plants, except for the moss at the base of each of the rock groupings.

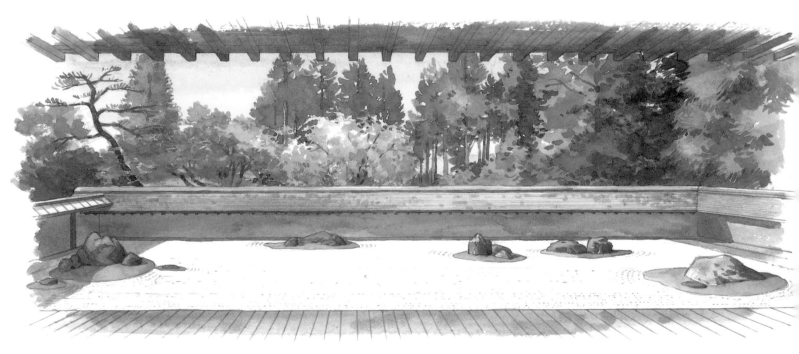

The garden is surrounded on three sides by walls and on the remaining side by the deck of the Hōjō (Main Building) where visitors can sit and contemplate the elegant simplicity of the rock arrangements. Most of the wall on the east side consists of an entrance gate. The walls on the south and west sides were constructed of clay boiled in oil. Over time, oil seeped out to create the subdued colors and designs that exemplify the qualities associated with aesthetic concepts such as *wabi-sabi* and *shibui*—both of which refer to the unassuming but sophisticated beauty associated with artifacts that are natural in appearance and improve with time. In 1977, the tile on the roof over the wall was restored to its original bark. Like the garden as a whole, the wall is a National Treasure.

There are various interpretations of the symbolic significance of the garden. The rock groupings surrounded by white sand have been described as representing islands in the sea, mountains rising above the clouds, or a mother tiger and cubs crossing a river. Regardless of what the creators originally might have had in mind, the garden, like a Zen black ink painting, is a meditative device that encourages those sitting on the deck to participate in the creative act and provide their own interpretations. Some Zen priests contend that by intense meditation one may be transported into the garden, which, despite its small size, represents infinity—a place beyond time and space where it is possible to experience the pure potentiality that is the source of all existence.

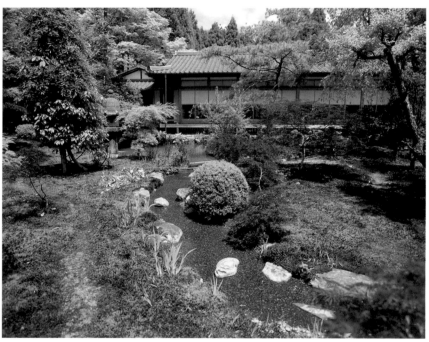

Other Attractions

Though the rock garden is the most important feature of Ryōanji Temple, there are other attractions. Until recent years, Ryōanji was commonly known as Oshidoridera, Temple of Mandarin Ducks, because of the many ducks that made their home on Kyōyōchi Pond, situated on the approach to the main temple complex. The pond, a remnant of the original Fujiwara estate, was constructed in the twelfth century and thus predates Ryōanji's famous rock garden by around five centuries.

To the northwest of the pond is a newly planted area with numerous cherry trees. The grounds also contain several Heian Period imperial tombs and an early seventeenth-century teahouse, near which is a famous stone water basin (*tsukubai*) with four characters meaning "I learn only to be content"—a Zen saying which implies that the secret of happiness rests in learning to be content with one's circumstances, no matter how poor they may be in a material sense.

Top: Close-up of the multi-hued earthen wall surrounding the rock garden.

Above: The historic teahouse near Ryōanji's main temple building.

Left: This ingenious stone wash basin (*tsukubai*) outside the teahouse at Ryōanji has four characters around a central character (*guchi*) that serves as the container for the water. The central character is combined with the other four characters to create four phrases that mean "I learn only to be content."

Daitokuji Temple

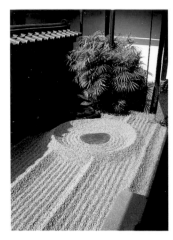

Above: Ryōgenin, a sub-temple of Daitokuji, is famous for its five gardens. The "A-Un" garden shown here is south of a *shoin* study attached to the Main Hall. It features two foundation stones from Hideyoshi's Jurakudai Castle, dismantled around 1615.

Below: The garden in the northeast corner of Daisenin is the most important aesthetically and historically. It is considered one of the great masterpieces of Zen style miniature landscapes. The other gardens, constructed later, enrich the symbolic meaning of the layout as a whole.

a dry waterfall
b stone bridge
c *shoin*
d sand cones

Daitokuji is one of the largest monasteries in Kyoto. Located in the northern part of the city, the walled Rinzai Zen compound includes the buildings of the temple proper, twenty-three sub-temples, and some of Kyoto's finest gardens, only four of which are normally open to the public. The two described here are *karesansui* gardens. A third, belonging to Kōtōin Temple, is included in the section on tea *roji* (pages 120–1).

Daisenin

Daisenin, meaning "Great Hermit Temple," was founded in the early sixteenth century. Its principal garden occupies an L-shaped area on the northeast corner and east side of an enclosed compound facing a *shoin* study in the Main Hall (Hōjō). Other areas were added later to completely surround the temple. Occupying a narrow strip 3.7 meters (12 feet) wide, the northeast garden portrays an idealized landscape of the type depicted in Chinese Song black ink paintings. The garden is composed entirely of rocks, gravel, trees and clipped shrubs that suggest mountains, a waterfall and a river that flows under bridges and around islands. Despite its small size, the garden creates a scene of considerable majesty and dynamism with a minimum of materials. It is a superb example of the type of understatement preferred in Zen gardens.

A gravel river that issues from a waterfall in the northeast garden splits into two branches. One branch runs westward along the north side of the compound and empties into a nearly empty graveled area known as the "middle sea." The other branch runs southward along the east side of the compound and empties into a larger graveled area to the south of the Main Building representing an ocean. Featured in the "ocean" area are two sand cones, whose origins are unclear. They may symbolize the sacred mountains traditionally associated with Buddhism or they may have been derived from similar sand compositions (originally sand piles intended for future use) found in the graveled courtyards of Shinto shrines. The "sea" and "ocean," both later additions, are joined by a graveled area on the west side of the Main Hall.

Like other *karesansui* gardens, the Daisenin garden is amenable to various symbolic interpretations. For example, the transition from waterfall to river can be interpreted as moving from the exuberance of youth to the maturity of adulthood. The depiction of water flowing over and around a variety of differently shaped rocks can be seen as a representation of the difficulties that must be solved as one travels through life. The "sea/ocean" perhaps suggests the return to the Eternal at the end of life's voyage.

Ryōgenin

Ryōgenin, also in Daitokuji Monastery, was constructed in the Muromachi Period. The meditation hall in the Main Hall is the oldest in Japan. Ryōgenin includes five gardens, one of which (Tōtekiko) claims to be the smallest rock garden in Japan. The *hōjō* garden (Isshidan) to the north of the Main Hall is a *karesansui* composition reconstructed in 1980 with three rock groupings: Mount Hōrai, Crane Island and Turtle Island. The composition as a whole, with its relatively large rocks and raked gravel, is quite powerful.

The most important garden at Ryōgenin is the rock and moss composition known as Ryūgintei (Dragon Singing Garden) to the north of the Hōjō. The garden, the oldest in Daitokuji, is attributed to the famous designer Sōami. It represents the universe, consisting of mountains arising from the sea. The main stone grouping, close to the wall in back, features a tall rock tilted to the east. It is generally thought to depict sacred Mount Shumisen, the center of the universe in Hindu and Buddhist thought. The white stripe on the side of the rock can be viewed as a waterfall. An alternative interpretation is that the grouping as a whole represents a dragon, the tilted stone serving as its head. In Zen, a dragon is the symbol of the Buddha nature or enlightenment. Originally, the area covered with moss consisted of raked gravel.

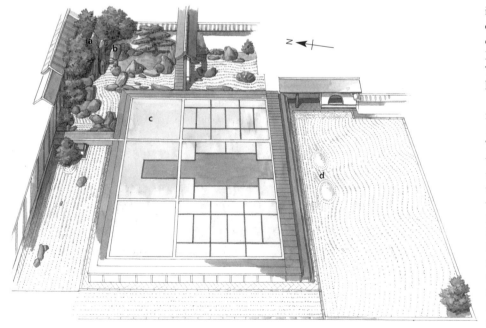

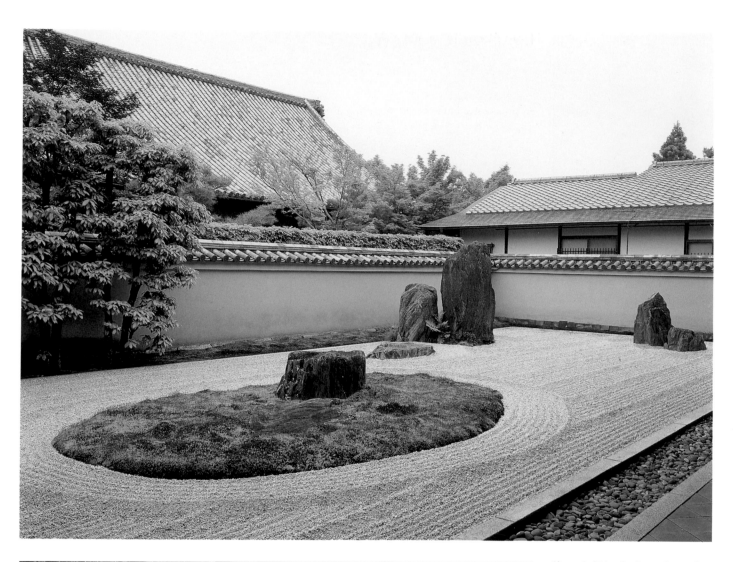

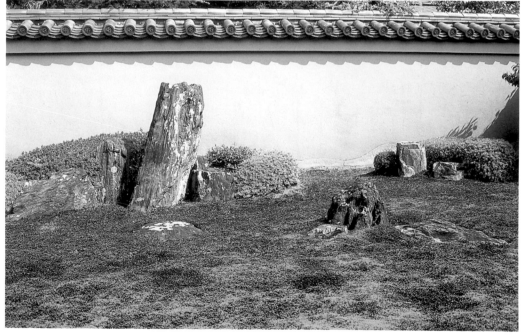

Above: Isshidan Garden to the south of Ryōgenin's Main Hall was remodeled in 1980. The large rock formation in the corner represents Mount Hōrai. To the right is Crane Island and in the middle is Turtle Island. The raked sand represents the sea. Like Ryūgintei (below), Isshidan is a miniature symbolic depiction of the universe. The contrast between the large rocks, the green moss and the white sand is quite powerful.

Left: Ryūgintei, the oldest garden at Daitokuji, lies to the north of Ryōgen-in's Main Hall. Constructed entirely of rocks and moss, it is said to represent mountains rising from the sea. Some people believe that the tilted rock represents Mount Shumisen, the center of the universe.

Warrior Gardens

In the Muromachi (1333–1573) and Momoyama (1573–1600) periods, high-ranking warriors used two types of buildings: castles and mansions. Warriors preferred to stay in the more luxurious quarters provided by Shoin style mansions, unless under attack. Guests seated in a formal reception room had a good view of a pond garden, generally characterized by overall complexity of design and large, powerful rock compositions.

Mature Shoin Style

Originally small but tasteful studies for the abbots of temples, Shoin style rooms were adopted for informal residential purposes in Shinden style mansions. By the end of the Muromachi Period, the *shoin* had undergone a curious metamorphosis, evolving into a luxurious audience chamber for important guests on the south side of a great temple or warrior mansion.

The four basic features of the Shoin style were *tokonoma* (recessed alcoves where decorative objects are displayed), *chigaidana* (alcoves with staggered shelves, usually next to the *tokonoma*), *tsukeshoin* (built-in desks), and *chōdaigamae* (decorative doors). In addition, the mature Shoin style was characterized by many of the features associated with contemporary Japanese residential architecture, such as *tatami* mats, *fusuma* (interior sliding doors), *shōji* (wood-latticed exterior sliding doors covered with rice paper), and *amado* (exterior wooden outer shutters to cover and protect the *fusuma* in inclement weather).

Whereas Heian Period Shinden style mansions had several side entrances and early Buddhist temples had one main entrance on the south, the entry to a warrior mansion was shifted to the east. After entering the gate in the east wall, guests crossed a graveled courtyard to the main entry of the mansion, often located in a subsidiary building. This arrangement was called *kuruma-yose* or carriage approach. Eventually, the entry to the mansion was covered for the convenience of guests. This covered area was the predecessor of the *genkan* in contemporary Japanese houses.

Warrior Gardens

When space was limited, designers of warrior gardens eliminated some features of earlier Shinden style gardens, such as artificial hills and the white sand area between the main building and the pond. The pond itself was reduced in size, sunk below ground level and moved closer to the main building so it could easily be viewed by guests seated within. Though smaller, the pond was more complex in terms of shape, with a shoreline that accommodated a variety of inlets and peninsulas.

Whether creating gardens for castles or Shoin style mansions, high-ranking warriors eager to display their wealth and power collected large stones, often confiscated from other gardens, which were used to create bold rock compositions. Many of these stones have since been returned to their original owners. Large stones also were used for constructing bridges and waterfalls. Soldiers did much of the construction work during interludes between wars, using skills acquired in building castle foundations, walls and gates.

Innovations

Some of the larger Momoyama Period gardens experimented with combining "wet" and "dry" elements by including a pond as well as *karesansui* graveled areas. Another innovation in the Momoyama Period was the use of evergreen shrubs that were clipped into abstract shapes that suggested, rather than represented, features such as hills. At

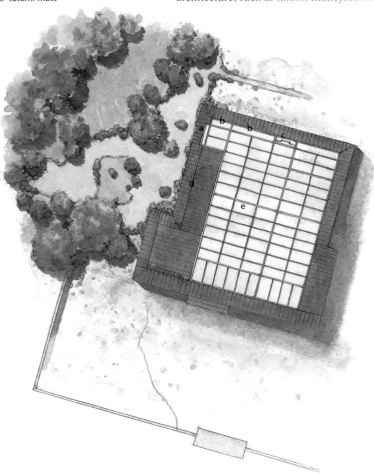

Shoin style room comprising the guest hall of Kōjōin, a sub-temple of Onjōji Tendai Monastery in Ōtsu. Although the guest hall is located in a temple, the layout is more in line with that of a warrior mansion in that the Shoin style room, instead of facing a small garden to the north (the more common arrangement in Muromachi Period temples), looks out onto a formal pond garden to the south.

a built-in desk with window
b *tokonoma*
c staggered shelves
d wooden veranda
e *tatami* mats

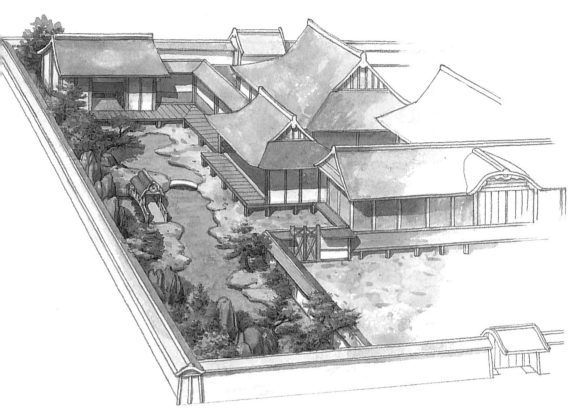

Left: Layout of a Shoin style warrior mansion with a carriage approach, based on a drawing of the Hosokawa residence in Kyoto. Owing to limitations of space, the south garden is small and the main entry has been shifted to the east.

Below: A unique glimpse of a warrior garden is provided by the Ichijōdani Historic Site in Fukui Prefecture. The site consists of the remains of a castle town that was burned in 1573 after the local Asakura clan lost a battle against Oda Nobunaga, who was attempting to unify the country. Shown here is the partially excavated site of the Asakura mansion, with the entrance gate in the distance. Part of a rock garden can be seen at the bottom.

times, the combination of rocks, gravel, clipped shrubs and trees created a powerful effect. Frequently, however, the emphasis upon complexity of design produced gardens that lack the tastefulness and contemplative atmosphere of their Muromachi predecessors.

By the latter part of the Momoyama Period, warrior gardens had become somewhat more subdued, and some designers introduced paths so that gardens could be explored on foot rather than simply being viewed from the inside. Although the idea of walking in a garden was not new, it was Momoyama innovations that gave rise to the stroll gardens of the succeeding Edo Period.

Extant Examples

Prime examples of warrior gardens are Sambōin, a sub-temple of Daigoji Temple in Kyoto, which was refurbished by Toyotomi Hideyoshi in 1598 and contains more than 800 rocks (in contrast to the fifteen at Ryōanji); the Ninomaru Palace at Nijō Castle in Kyoto, designed by the famous garden architect Kobori Enshū; and the Kokei-no-niwa Garden at Nishi Honganji Temple in Kyoto. There are a few other garden sites from the Momoyama Period, such as those associated with the ruins of the Asakura Mansion in Ichijōdani.

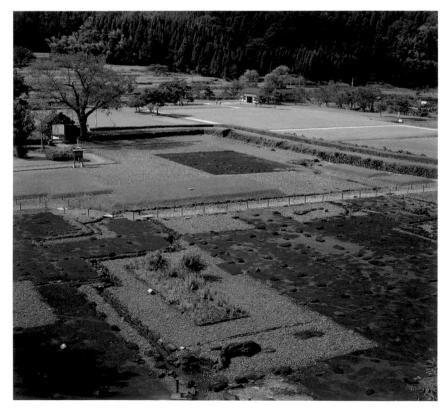

Nishi Honganji Temple

Kokei-no-niwa Garden is in a courtyard surrounded by historically important buildings. The building with the bark roof to the left (south) of the garden is Tora-no-ma, a reception hall. To the west (top) is the tiled Daishoin Hall, a Shoin style building consisting of the Taimenjo audience hall where Hideyoshi originally received important visitors, and the Shiro Shoin, a classic Shoin style study. To the north of the garden is the Kuro Shoin, a subtly decorated study used by the abbot. To the east of the garden is the temple office, with the enormous Founder's Hall to its right. The temple complex as a whole is much larger than the area shown here.

Nishi Honganji in central Kyoto is the headquarters of Jōdo-Shinshū, a Pure Land denomination started by Shinran Shōnin (1173–1262). Constructed in its present location in 1591, the temple contains outstanding examples of Momoyama Period buildings, some of which were moved from Hideyoshi's Fushimi Momoyama Castle. Connected to the lavish Daishoin Hall is the Kokei-no-niwa (Tiger Glen Garden), one of the best examples of a warrior style garden.

History

Nishi Honganji was originally built in 1272 as a memorial chapel to Shinran. After the original temple was burned by Tendai monks from Enryakuji Monastery on Mount Hiei, the burgeoning organization moved to the Kanazawa area and eventually to Osaka, where it constructed an immense fortress on the spot now occupied by Osaka Castle. The temple defied attempts to conquer it by foes as notable as Oda Nobunaga, the first of the three great generals who unified Japan in the Momoyama Period. Eventually, a truce was arranged and the temple was burned. Oda Nobunaga's successor, Toyotomi Hideyoshi, granted Nishi Honganji the land in Kyoto where the present structure, near the Japan Railways Kyoto station, is located. After Hideyoshi was succeeded

by the Tokugawa family, Tokugawa Ieyasu, the first Tokugawa shogun, ordered the dissolution of Hideyoshi's palace-castle at Fushimi near Kyoto. Some of its buildings and garden materials were relocated to Nishi Honganji.

The Setting

The main buildings at Nishi Honganji are the Amida Hall and Founders Hall, situated in a large graveled courtyard entered by an immense gate. The large compound contains a variety of other historic buildings, including two Noh stages and the famous Hiunkaku (Flying Cloud) Pavilion, considered, together with the Gold and Silver pavilions, to be one of the three most beautiful pavilions in Japan.

To the southwest of the Founder's Hall is a complex of buildings surrounding the Kokei-no-niwa Garden. To the south of the garden is Tora-no-ma, a reception hall, and to the west is the Daishoin Hall, moved to Nishi Honganji in 1632 after the destruction of Hideyoshi's Fushimi-Momoyama Castle. One of the best examples of Momoyama Period architecture still in existence, this enormous Shoin style building is divided into two sections: the large Taimenjo audience hall where Hideyoshi originally received important visitors, and the Shiro Shoin, a classic example of a Shoin style study. Both the Taimenjo and Shiro Shoin are profusely decorated with gorgeous screen paintings by several of the most famous artists of the day. To the north of the garden is the Kuro Shoin, a smaller, subtly decorated study used by the abbot. To the east of the garden is the temple office.

The Garden

The Kokei-no-niwa is a *karesansui* garden designed to be seen from the veranda of the Daishoin or interiors of the Taimenjo and Shiro Shoin. The garden is composed of different kinds of cycads (a tropical gymnosperm resembling a palm), large rocks from Hideyoshi's castle and a stone slab that bridges a gravel river to link Crane and Turtle islands. The river flows from a dry waterfall in the distance, behind which looms the Founder's Hall, whose steep roof is incorporated into the garden as a symbolic representation of Mount Lu in China. The garden is unusual in that there is an absence of pine trees, so ubiquitous in most Japanese gardens. Though constructed in the early Edo Period from the remains of Hideyoshi's castle garden, the Kokei-no-niwa is a good example of Momoyama warrior taste with its abundance of large rocks and complex composition.

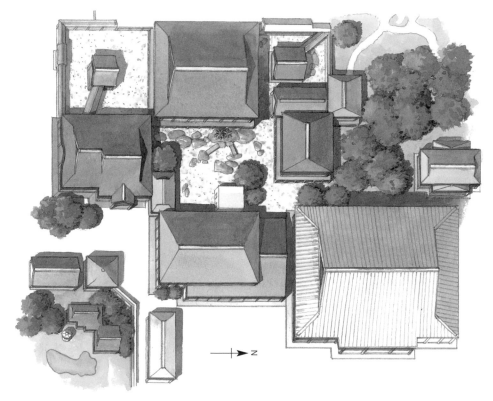

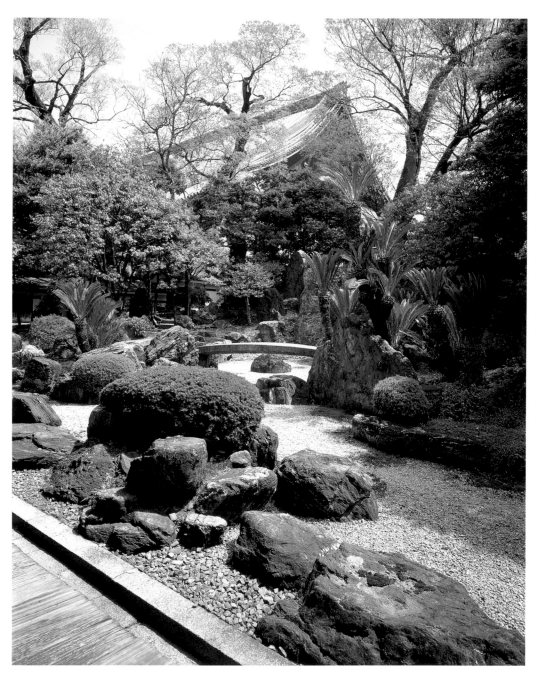

Left: Kokei-no-niwa or Tiger Glen Garden, east of the Daishoin at Nishi Honganji, was designed in the seventeenth century in a typical Momoyama style, with a dry garden that features stone bridges spanning the shore and Crane and Turtle islands. The garden features a representation of Mount Hōrai and a dry waterfall. Included in the vegetation are tropical gymnosperms, which are rare in Japan.

Below: Main rock composition of the Kokei-no-niwa Garden. In the left foreground is Turtle Island. The head juts out to the right and the tail is represented by the smaller rock at the other end. Turtle Island is joined to Crane Island at the right. In the background, the rocks on the right represent a cluster of Hōrai mountains, while the rocks on the left depict a dry waterfall. The various components are connected by cut slab bridges, under which flow white sand "water."

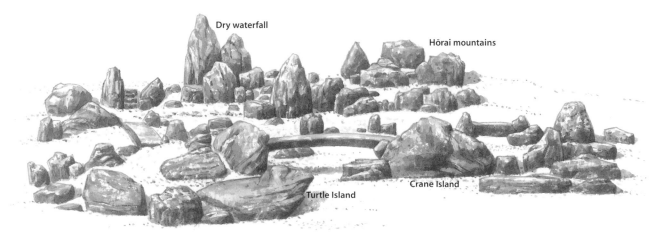

Dry waterfall

Hōrai mountains

Turtle Island

Crane Island

Nijō Castle

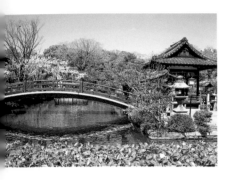

Nijō Castle was built in 1603 by Tokugawa Ieyasu as his Kyoto headquarters. The main structure, Ninomaru Palace, was remodeled for a 1626 meeting between Ieyasu's grandson Iemitsu and Emperor Gomizuno-o, at which time an elaborate garden was built. Both the palace and the garden, constructed to demonstrate the power and wealth of the Tokugawa shogunate, provide good insight into extravagant warrior taste.

History

Relations between shoguns and emperors were complex. In feudal times, the emperor had higher status but the shogun held the real power. To demonstrate this power, Tokugawa Ieyasu, whose home castle was in Edo, constructed his Kyoto castle on the site originally occupied by the Dairi, the emperor's living quarters in the original imperial palace in Heiankyō (present-day Kyoto). The castle grounds are surrounded by a moat and stone wall and are entered through a massive stone and plaster gate (Higashi Ōtemon). Inside are two walled compounds, the Honmaru and Ninomaru.

The Ninomaru compound contains a palace constructed by Tokugawa Ieyasu in 1603 for his personal use when visiting Kyoto. The palace was remodeled by the third Tokugawa shogun, Iemitsu, between 1624 and 1626 in preparation for a meeting between the shogun and the emperor. The palace, a National Treasure, consists of five buildings with thirty-three rooms lavishly decorated with paintings by members of the Kanō School.

The Honmaru, surrounded by its own moat, housed a palace and five-story donjon, built for the personal use of the shogun. It was constructed in 1626 when Iemitsu remodeled the Ninomaru Palace. Iemitsu transferred Momoyama Period structures from Hideyoshi's Fushimi Castle to the grounds, but the entire complex burned in 1750 when it was struck by lightning. In 1893, the former residence of Prince Katsura was transferred to the Honmaru compound from the Kyoto Imperial Palace to replace the burned palace.

Sovereignty was restored to the imperial line in a ceremony conducted in 1867 at Nijō Castle, just prior to the Meiji Restoration of 1868. The castle was given to the imperial family in 1884 and then donated to Kyoto City in 1939. Nijō Castle was registered as a UNESCO World Cultural Heritage Site in 1994.

The Garden

The garden attached to Ninomaru Palace is attributed to Kobori Enshū, the primary landscape architect and tea master for the Tokugawa government. To create Ninomaru Garden, Enshū used a portion of an older garden, Shinsenen, created in the Heian Period. In the Heian Period, Shinsenen was adjacent to the original imperial palace (Gosho). Covering a very large area, the garden was used for important court ceremonies. The present Imperial Palace lies several blocks to the

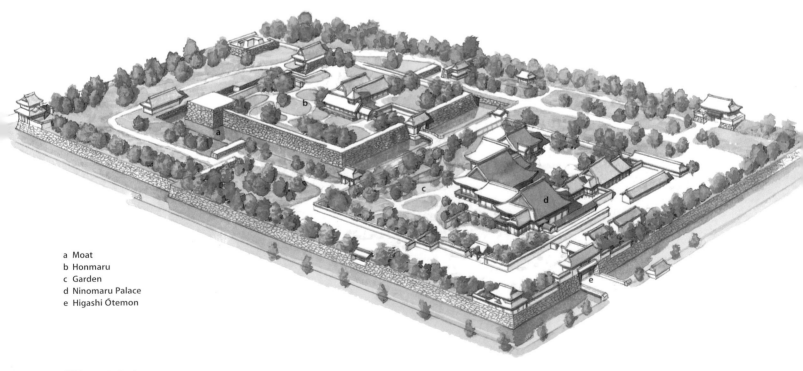

a Moat
b Honmaru
c Garden
d Ninomaru Palace
e Higashi Ōtemon

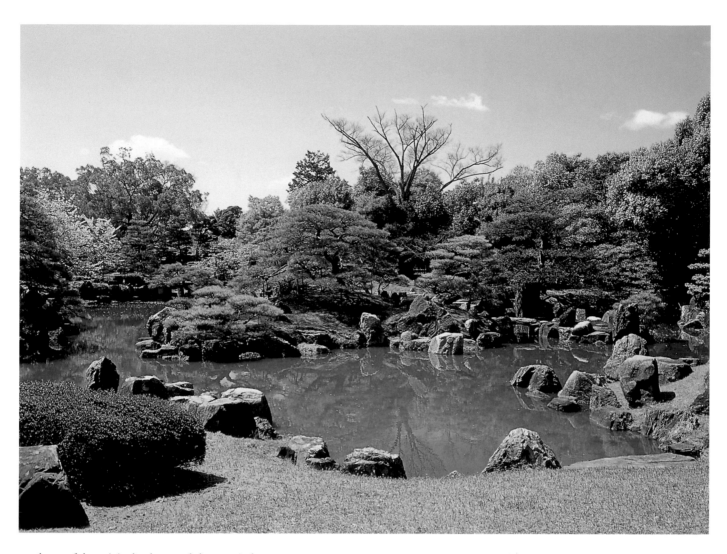

northeast of the original palace, and the remainder of the original Shinsenen Garden (the part not used by Enshū) lies outside the walls of Nijō Castle in a small walled compound of its own. Enshū designed the Ninomaru Palace Garden to express the power of the Tokugawa shogunate. The garden, which lies to the southwest of the palace, features a pond with three islands: Hōraijima (Island of the Immortals), Tsurushima (Crane Island) and Kameshima (Turtle Island). Like the garden at Nishi Honganji, there are rare plants, including cycads, and several rock arrangements whose very large stones, brought at great cost, create a picture of considerable complexity. The contrast with the austere simplicity of a rock garden such as that at Ryōanji could hardly be greater.

The garden was designed to be viewed from the Ōhiroma (Audience Hall) of Ninomaru Palace located on the west shore of the pond, as well as from another smaller palace constructed to the south of the pond for the private use of the emperor during his 1626 meeting with Iemitsu. The smaller palace was dismantled after the meeting.

Above: The Ninomaru Palace garden as seen from the Ōhiroma (Audience Hall). In the center of the pond is a large *hōrai* island connected to a turtle (*kame*) island by a bridge.

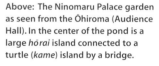

Layout of Ninomaru Palace Garden.

a Ōhiroma (Audience Hall)
b Hōraijima (Hōrai Island)
c Kameshima (Turtle Island)
d Tsurushima (Crane Island)

Tea Roji

During the Muromachi (1333–1573) and Momoyama (1573–1600) periods, the tea ceremony (*chanoyu*) led to the development of teahouses and tearooms, approached by a *roji* ("dewy path"). Through the use of carefully placed stepping stones, basins, lanterns and plants, the guest is presented witha series of constantly changing "small views" which encourage one to enter a state of meditation that will carry over into the ceremony itself.

Above: Path to a teahouse at Zuihō-in Temple in Kyoto.

Below: Basic layout of a tea *roji*, based on a woodblock print in the 1828 edition of *Tsukiyama Teizōden*.

Outer *roji*
a outer gate
b toilet
c waiting pavilion
d middle gate

Inner *roji*
e dust pit
f well
g water basin
h teahouse

Outer and Inner Roji

The *roji* is divided into two parts: the outer and inner *roji*. The outer *roji* consists of the outer gate, a covered arbor (*machiai*) where guests wait to be invited to the teahouse, and a privy (*setchin*). When the invitation comes, guests move slowly one by one along a path leading to the middle gate (*chūmon*) that marks the division between the outer and inner *roji* and symbolizes the fact that one should be entering a state of meditation. Having passed the middle gate, the guest finds a water basin (*tsukubai*) where hands and mouth are purified, as when entering a Shinto shrine. There is also a well (*ido*) and a small dust pit (*chiri-ana*) where originally gardeners left debris until it could be disposed of. Today, the pit symbolizes a place where one leaves the dust of the mind. Finally, the visitor comes to a small crawl-through entry to the teahouse.

Vegetation

Originally, the word *roji* meant alleyway or path, but was assigned new characters by tea masters that mean "dewy ground." The term describes the practice of sprinkling the path with water before the arrival of the guests so that the walkways and greenery along the path are moist and fresh. The plants, rocks and other materials used along a *roji* should look as natural as possible as the goal is to create the atmosphere of a path deep in the mountains. This is achieved by using a mixture of moss, evergreen trees and shrubs, and perhaps a few bamboo. Flowers, as well as anything else that is too beautiful, are avoided so as not to disrupt the feeling of austere simplicity. As one progresses along the path, one attempts to enter more deeply into a state of mind that will be fully receptive to the subtle feelings aroused by the tea ceremony and its surroundings.

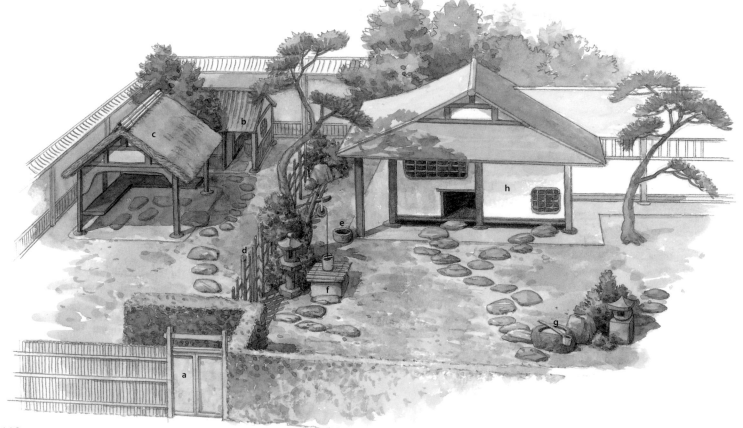

Stepping Stones

The most important parts of a *roji* are the stepping stones, which should never take one in a straight line. They should be flat enough to be easily walked upon, but varied enough in shape to be interesting. They should not be valuable stones of the kind sought after by wealthy warriors for their gardens, as this would distract from the simplicity and austerity of the *roji*. At the same time, however, they should not be ugly. This illustrates a basic principle in all aspects of tea aesthetics: it is important to walk the fine line between art and nature. It is easy to fall off this line and lean too far towards artificial beauty in one direction, or towards artificial rusticity in the other.

Stepping stones are utilitarian in that they guide the visitor through the garden and keep his or her feet out of the mud. But they serve another function as well. Because they are no larger than necessary, they force one to practice "mindfulness" in the sense of watching where one is going.

Occasionally, there is a large, flat stone that invites guests to stop, look up and enjoy the garden. Thus, stepping stones are an important guide to entering an appropriate state of mind.

Basic Principles

The tea garden was, in part, inspired by the contemplation gardens of Zen temples. The primary difference is that the tea garden is a place where one walks, which is why tea gardens often are called tea *roji*, in reference to their most important feature—the path. The tea *roji* was, in fact, the first type of Japanese garden to take walking explicitly into consideration in its composition. It was thus, along with the walk-in type Warrior garden of the late Momoyama Period, the forerunner of Edo Period stroll gardens, as well as modern domestic gardens.

Another basic principle in designing a tea *roji* is that it is considered beneficial to use materials originally intended for other purposes, particularly things such as rocks that have been discarded, overlooked or excavated from the site of a previous building. A good example is the use of old millstones as stepping stones. It is obvious that a millstone in the path is a discarded artifact, but it is also sufficiently irregular in shape to blend with the other stepping stones.

Using discarded materials forces one to look at things in a new way and creates the kind of beauty associated with tea ceremony aesthetic terms such as *wabi* (austere, ordinary and natural) and *sabi* (the patina that comes with age). Examples of items other than stepping stones adapted by the

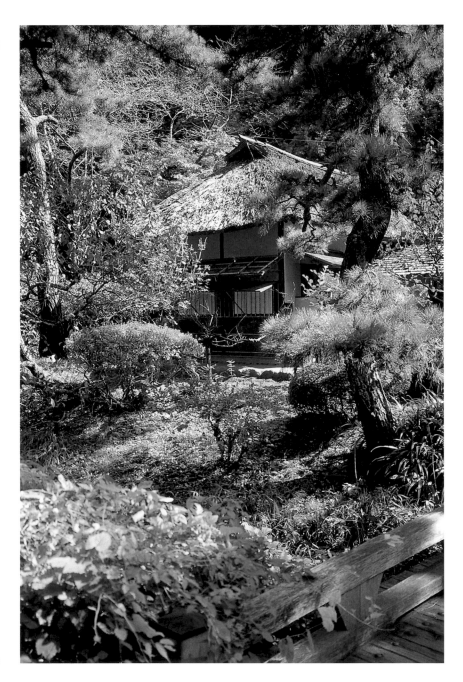

Grass hut (Sōan) style teahouse and garden at Sankeien Garden in Yokohama. The "dewy path" is partly visible behind the vegetation.

early tea masters specifically for *roji* gardens are stone lanterns and ritual water basins.

A third basic principle is the use of *miegakure* (hide-and-reveal) techniques to present the guest with a series of sequential scenes as one walks along the path. These techniques, which had their beginnings in Shinden style gardens, involve interrupting the line of sight and obscuring the overall view. This helps create a sense of size and distance in a relatively small space.

Kōtōin Temple

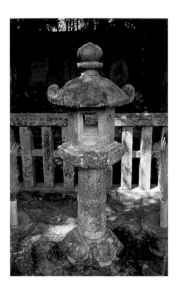

Kōtōin is a quiet sub-temple in the great Zen monastic complex of Daitokuji. Somewhat off the route of the many tourists who visit Daitokuji to see the famous garden at Daisenin, another of Daitokuji's sub-temples, Kōtōin is one of the few places in Kyoto where it is possible to sit on the deck and contemplate the peaceful gardens.

History

Kōtōin was established by Hosokawa Tadaoki (1563–1645), a famous Momoyama Period *daimyō* and military leader who served under Oda Nobunaga. In a strange twist of fate, Oda Nobunaga was assassinated by the father of Tadaoki's wife Gratia in a failed rebellion. To make matters worse, Gratia was a member of the outlawed Catholic faith. There are various stories about Gratia's premature death. One version is that Tadaoki ordered her killed in battle when it appeared that she was about to be captured by his enemies. Despite the religion of his wife and the notorious reputation of his father-in-law, Tadaoki's military skills were so highly valued that he was asked to assist Oda Nobunaga's successor, Toyotomi Hideyoshi, in his campaign to conquer Korea. Tadaoki later was a leading figure in the wars that led to the unification of Japan under Tokugawa Ieyasu.

As a young man, Tadaoki studied the tea ceremony with the famous tea master Sen-no-Rikyū, and came to be considered one of the master's "seven great disciples." Because of his close association with Rikyū, who was ordered to commit *seppuku* by Hideyoshi in 1591, Tadaoki inherited some of the tea master's most treasured artifacts. Tadaoki, who had an intense interest in Zen, established Kōtōin Temple in 1601. One of the buildings of Sen-no-Rikyū's personal residence was moved to Kōtōin, along with some of the artifacts Tadaoki had inherited from the tea master.

As a result of his interest in tea, Tadaoki built Shōkōken Tearoom at Kōtōin in 1628. Shōkōken is a small two-mat tearoom of the type most favored by Rikyū. Next to Shōkōken (meaning Pine Facing Eaves) is Hōrai, a larger Shoin style tearoom.

The Gardens

One enters the temple grounds by a long stone-paved walkway shaded by maples and bordered by green moss. The austere moss-covered garden to the south of the main building is accented by

Above: The Kamakura Period stone lantern favored by Sen-no-Rikyū. The defaced stone lantern was bequeathed to Tadaoki when Rikyū was ordered to commit suicide by Hideyoshi. It is used as a gravestone for Tadaoki and his wife. From the front, it appears to be a complete lantern, but from the back the effects of being intentionally defaced are obvious.

Right: The south garden next to the Main Building (Kyakuden) was created in the early Edo Period. Composed mainly of maple trees and moss, it reflects the changing seasons.

Opposite above: The long natural stone pathway leading from the entrance to the temple prepares one to leave the world outside and enter a serene setting.

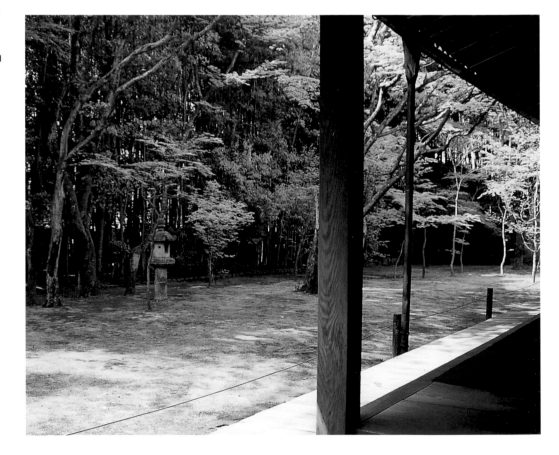

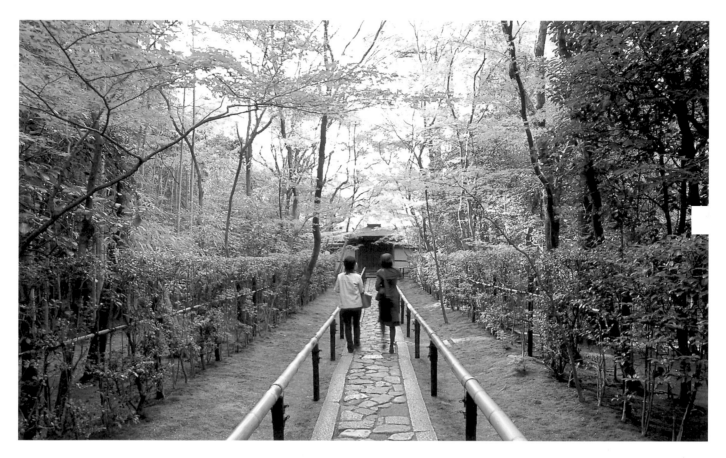

a single stone lantern. It is famous for the maple trees that provide a colorful backdrop for the garden in the autumn.

On the west side of the main building is a tea garden whose stepping stone path (*roji*) connects the two adjacent tearooms with a small area enclosed by a stone fence housing the graves of Tadaoki and his wife Gratia. The marker for the grave is Sen-no-Rikyū's favorite stone lantern. When Hideyoshi learned that this beautiful lantern was in Rikyū's possession, he demanded it for himself. To prevent the lantern from being taken, Rikyū broke off one of its lips so it would lack the perfection favored by Hideyoshi. After Rikyū's death, the lantern was given to Tadaoki. The general, who hated perfection because of his training in the tea aesthetic of *wabi*, broke off another piece.

A famous water basin in the tea garden is made from the foundation stone of the imperial palace in Korea. Tadaoki loved the stone lantern and water basin so much that he took them to Edo, the military capital, every time he had to visit the shogun. This was no mean feat, given the weight of the two objects and the time required to reach the capital in those days.

Kōtōin and its modest tea *roji* receive relatively little attention from the general public, but its great historical significance and peaceful grounds make it a place of considerable significance.

Above: A wash basin hollowed from a stone brought to Japan from the imperial palace in Korea. It is said that Sansai loved this basin and the stone lantern so much that he took them with him whenever he traveled to and from Edo.

Left: The tea *roji* at Kōtōin Temple is made of stepping stones formed of natural rock, and is lined with kuma-zasa (bamboo grass) on both sides.

Urakuen

Oda Uraku, brother of Oda Nobunaga and noted tea master, retired late in life to Kenninji Temple in Kyoto where he built a teahouse and study in the sub-temple of Shōdenin. The teahouse, named Jo-an, passed through many hands until it was moved in 1971 to Urakuen Park on the grounds of Hotel Inuyama in Inuyama City. The teahouse is considered to be the best example of its kind.

The Setting

Jo-an Teahouse is located in back of the Shōdenin, Uraku's Shoin style study that was moved to Inuyama at the same time the teahouse was relocated. Both buildings are situated in a tea garden, together with another teahouse, the Gen-an. The Jo-an Teahouse, a National Treasure, is a good example of the Sōan "grass hut" style. Though very small, Uraku's genius as a designer can be seen in details such as the lower portion of a wall covered with old calendars and an interior arched doorway. Some of the windows are crisscrossed with vines, an invention of Uraku's known as the Uraku-mado (Uraku window).

The Shōdenin is a much larger building where

Uraku lived and occasionally entertained guests at larger tea ceremonies than could be handled in the Jo-an. The interior is decorated with black ink landscape paintings by Kanō Sansetsu and Hasegawa Tōhaku, two of the most important painters of the Momoyama Period.

Urakuen Garden

When Jo-an Teahouse and the other buildings were moved to Inuyama, Horiguchi Sutemi, who was in charge of the project, designed a tea garden set within a larger park named after Oda Uraku. The tea garden is entered through the Kayamon Gate, constructed of poles covered with a grass roof. From the gate, a stone walkway takes visitors to a large flat stone, from which the path breaks into several *roji* ("dewy paths") that lead to a stone water basin, the Shōdenin and the Jo-an Teahouse. Back of Jo-an is a *machiai* where guests wait to be summoned to ceremonies in the Gen-an. The covered waiting bench is connected to the Gen-an by its own tea *roji*. The tea garden is separated from the rest of Urakuen Park by fences and vegetation that provide a sense of seclusion.

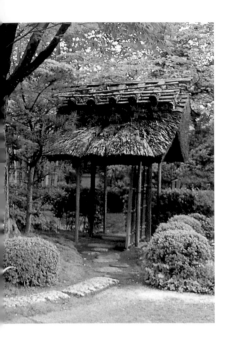

Above: Kayamon (Thatched-roof Gate) marks one of the entrances to the Shōdenin Shoin and Jo-an Teahouse.

Below: Layout of the garden area surrounding Jo-an, Shōdenin and Gen-an buildings in Urakuen Garden.

a entrance
b water basin
c stone walkway
d Shōdenin Shoin
e Jo-an Teahouse
f Gen-an Teahouse
g entrance area to Gen-an
h rock basin
i waiting place (*machiai*)
j well curb

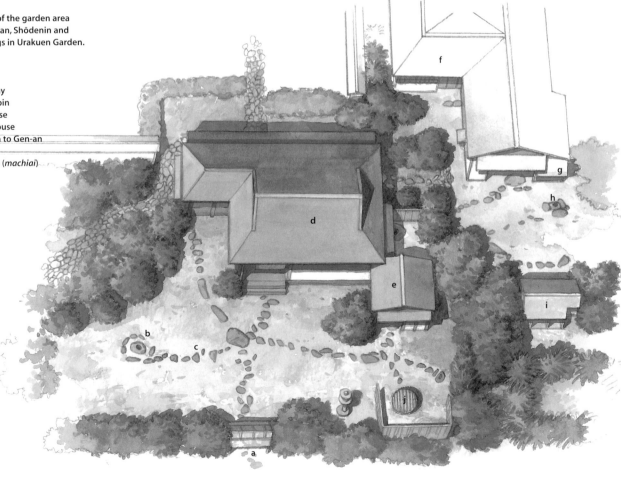

Above: Stepping stones leading to the Jo-an Teahouse.

Left: Uraku's favorite well curb.

Below: Round water basin in front of the Shōdenin. The low height of the water basin is intentional, to help induce humility among those attending a tea ceremony by requiring them to stoop while washing.

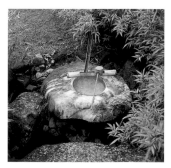

Edo Period Gardens

The Edo period is best known for large stroll gardens associated with the villas belonging to aristocratic families and warlords. There were other important developments, however, including hermitage gardens constructed by former warriors who wished to lead lives of seclusion, courtyard gardens (*tsuboniwa*) associated with the townhouses of the urban merchant class, and clipped hedge gardens (*karikomi*) that provided a transition to the Modern Period.

Stroll Gardens

In the Edo Period, formal Shoin style architecture developed into Sukiya style villas for the imperial family, aristocrats, military warlords (*daimyō*) who were required to maintain residences in the capital, and other élite. Sukiya architecture combined a taste for luxury with more informal features, such as leaving the bark on posts used in constructing the recessed alcove (*tokonoma*). The goal of stroll gardens, developed to complement Sukiya style villas, was to demonstrate the power and wealth of their owners and to entertain important guests by providing a constantly changing landscape composed of water, bridges, lanterns, shrubbery, rocks and flowers.

Kobori Enshū (1579–1647), a high-ranking official in the Tokugawa government, is credited with creating the Edo style stroll garden. Edo stroll gardens were not always large to begin with. Sometimes, they started as small tea *roji*, to which additional teahouses were added over time, until there was a collection of teahouses in a large park-like setting. As they expanded, stroll gardens sometimes incorporated religious sites, in which case local people were occasionally granted permission to enter the garden to make offerings and prayers. Edo Period stroll gardens were, however, entirely secular. Religious edifices, when included, served a purely decorative function.

Techniques for Providing Interest

Stroll gardens were not new. Although most gardens from earlier periods were designed to be seen from a fixed point of view, such as the interior of a Shinden or Shoin style building, some earlier gardens provided paths so visitors could move around. Momoyama tea gardens also required using a "dewy path" to walk from the entrance to the teahouse. The primary difference between Edo stroll gardens and earlier "entry" gardens is that Edo gardens tended to be much larger. Because castle towns such as Edo were relatively undeveloped in the Edo Period, *daimyō* were given estates that were much larger than those provided to the élite of the old capitals of Heijōkyō (Nara) and Heiankyō (Kyoto).

With a large space at their disposal, garden designers combined traditional techniques in original and creative ways to provide interest. One technique (*shin-gyō-sō*) involves moving from a formal entrance through semiformal features to an informal interior. A second technique, *miegakure* (hide-and-reveal), uses hedges, structures and other objects to block long-range views and provide an ever-changing vista as one turns a corner or crosses a bridge. A third technique, *shakkei* (borrowed scenery), involves incorporating a distant hill, mountain or pagoda into the garden view, a principle that had been used as early as the Kamakura Period by Tenryūji Temple. The designer hides unwanted elements between the garden and the distant object, thereby bringing the foreground and distant object closer together. In addition to improving the composition, this technique creates the illusion that the garden is larger than it really is.

Incorporating Famous Scenes

Another characteristic of Edo stroll gardens was the incorporation of famous natural places of scenic beauty in Japan and China or scenes described in Heian Period literature. The Japanese

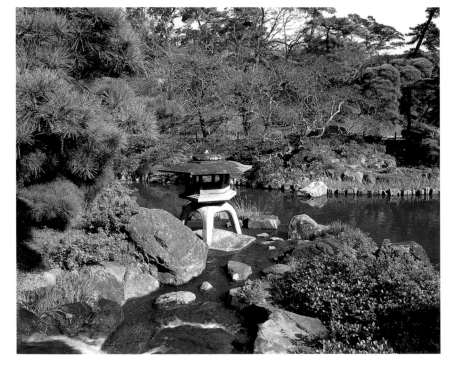

Naritasan Shinshōji garden in Chiba Prefecture is frequently visited by travelers using the nearby airport that services the Tokyo area. The park, connected with a Buddhist temple in the town of Narita, features a large stroll garden organized around a pond.

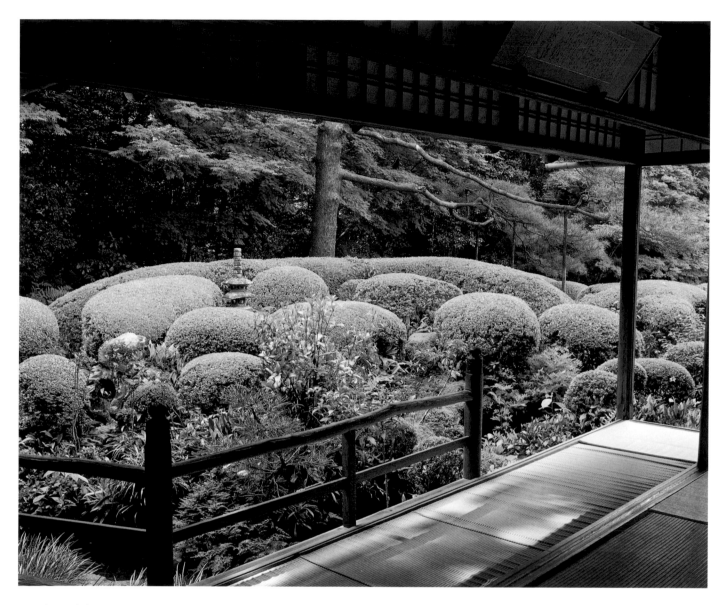

term *kaiyūshiki teien*, meaning "excursion garden," captures the flavor of providing a place where one can take an excursion and see many different kinds of places as one walks in a clockwise direction around the central pond. The basic metaphor for the Edo Period stroll garden was not a Song style landscape painting (the inspiration for many Zen gardens) but a musical composition in which one encounters a sequence of scenes as one follows the path around the pond.

Examples of the incorporation of famous natural places of scenic beauty are the use of an artificial hill shaped like Mount Fuji in Suizenji Garden in Kumamoto and the re-creation of Ama-no-hashidate in the Katsura Detached Palace garden in Kyoto. An example of a literature-inspired garden is Rikugien Garden in Tokyo, which re-creates eighty-eight scenes taken from famous Japanese poems.

Hermitage Gardens

Hermitages were constructed by former warriors who wished to become literati, priests, artists or tea masters. A hermitage consisted of a modest dwelling with a garden that combined traditional elements from *karesansui* gardens, tea *roji* and stroll gardens. The most notable feature of the hermitage is an irregular entry route that uses a variety of techniques to create the illusion that one is traversing a long path through the forest. At the end of the journey is a quiet place for meditation and study.

One of the best examples of a hermitage is Shisendō in Kyoto. Shisendō was constructed by Ishikawa Jōzan who was exiled by Tokugawa Ieyasu for opposing some of the shogun's policies. Ishikawa lived in Shisendō, where he studied tea, the arts, philosophy and garden design until his death in 1672. After passing through an unimposing

The Shisendō garden in Kyoto viewed from the veranda of the hermitage. The surrounding trees give the garden a feeling of intimacy, privacy and tranquility.

Opposite above: A *tsubo* garden at the Edo Period Nomura residence in Kanazawa.

Opposite below: A small *tsubo* garden in Tokyo changes in appearance with the seasons.

entrance from a street in the northeastern part of Kyoto, the visitor climbs a flight of stone steps to a small courtyard from which one enters the hermitage, a rustic thatched and tiled building that is now a Sōtō Zen temple. The veranda of the hermitage overlooks a secluded garden composed of white raked sand and clipped azalea bushes, complemented by scenery "borrowed" from an adjacent hillside. A path leads from the upper area to a lower garden organized around a small pond. Because of its seclusion and tranquility, it is not unusual to find people quietly sitting or reading in the hermitage. Beautiful in any season of the year, Shisendō is considered to be one of the finer small gardens of Kyoto.

Tsubo Gardens

Tsubo gardens date back to the Heian Period when small courtyard gardens were constructed between the various wings of a Shinden style mansion. The word *tsubo*, the standard measurement for houses or property, refers to an area of about 3.3 square meters—the size of two *tatami* mats. Sometimes as small as one *tsubo* in area, these gardens were often named after a featured plant. The basic function of *tsubo* gardens attached to a Shinden style mansion was to provide a touch of nature, as well as a sense of privacy, for small rooms at the rear, in contrast to the large pond garden to the south of the main building used for entertaining guests.

Tsubo gardens were also constructed for temples and warrior mansions in the Muromachi and Momoyama periods. As in the case of Shinden style mansions, *tsubo* gardens filled the small spaces between buildings or provided a pleasant view for Shoin style rooms used as studies or private living quarters by monks and warriors.

The Edo Period saw the rise of an urban class (*chōnin*), composed largely of merchants and artisans. Because taxes were levied on the basis of street frontage, the *chōnin* built long, narrow residences called *machiya* around a one-*chō* city block, with a communal area in the middle. Shops were located at the front of the *machiya*,

Layout of an Edo Period *machiya* that incorporates several small *tsubo* gardens.

a shop adjacent to the street
b *tsubo* garden that can be viewed from the shop and one of the sitting rooms
c passageway between the street and kitchen
d larger courtyard garden, adjacent to the toilets and bath, that can be viewed from the guest room
e storehouse (*kura*)

facing the street, with private rooms in the back. Small spaces left between *machiya* to provide light and fresh air eventually developed into *tsubo* gardens. Large *machiya* sometimes included small courtyard gardens within the building itself. Modeled after tea *roji*, these gardens included a stone lantern, water basin, stepping stones and a statue or other decorative elements. They also incorporated a few plants. Because of their small size, *tsubo* gardens usually were designed to be looked at rather than entered. In this way, they differed from their tea *roji* prototypes.

In modern times, this long tradition of small *tsuboniwa* has provided the primary inspiration for residential gardens, as well as gardens connected to restaurants, inns, hotels and public buildings.

Clipped Hedge Gardens

Clipped shrubs (*karikomi*) were used as early as the Muromachi Period to complement the raked sand patterns of dry landscape Zen gardens. In the Momoyama and Edo periods, shrubs were trained to form hedges that were clipped into flowing forms that became the central focus of the garden. Although Zen gardens had an abstract feeling that appeals to the modern taste, *karikomi* gardens of the Edo Period carried abstraction much further. The reliance upon nature that characterizes traditional gardens was replaced by a type of formalism found in many gardens in the West. It has been speculated that Western influence may, in fact, have been introduced to Japanese garden design by Christian missionaries. *Karikomi* gardens of the Edo Period provide a fitting transition to the gardens of the modern period discussed in the final part of this book.

One of the best examples of an Edo *karikomi* garden is the Hōrai Garden at Daichiji Temple in Shiga Prefecture, where azalea hedges have been clipped into cubes and serpentine forms that writhe and twist in a dynamic but controlled display of energy. Some have suggested that the garden is like a coiled dragon. It is said, however, that the original intent was to depict a treasure ship sailing around a sacred island. Sheared bush cubes in the center of the hedge coil represent the treasure. The garden was constructed at the beginning of the seventeenth century after the Tokugawa government had restored peace and order. Though it has been claimed that the garden was designed by the famous gardener Kobori Enshū (1579–1647), it was more likely created by his grandson.

A similar garden from this period is at Raikyūji Temple in the town of Bitchū-Takahashi, Okayama Prefecture. Purported to have been designed by

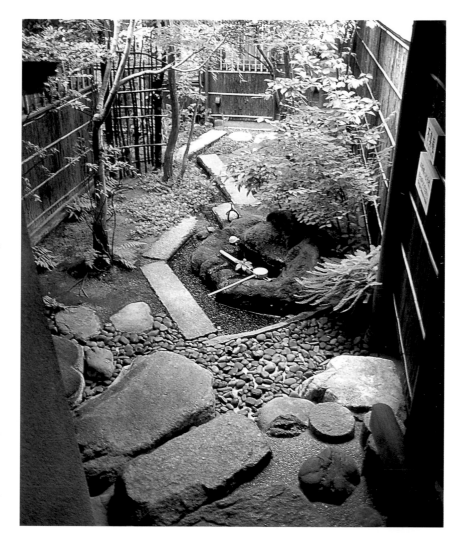

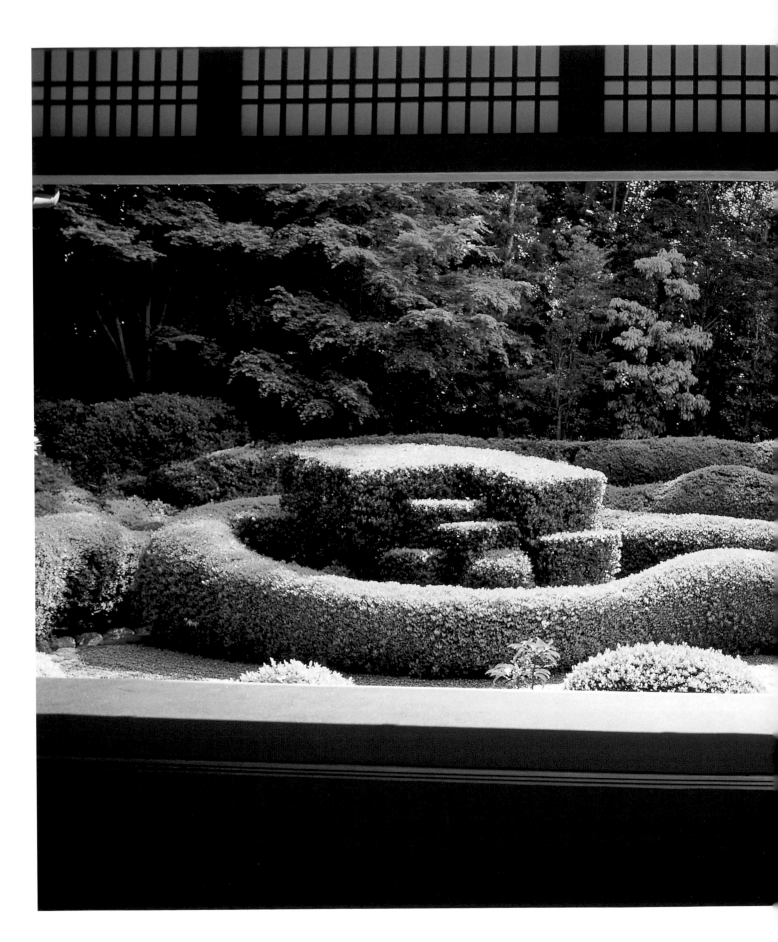

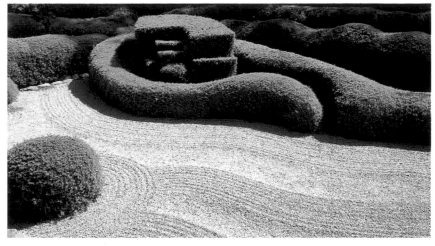

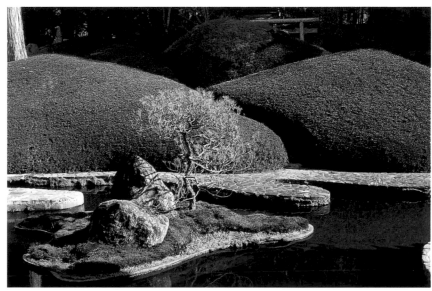

Kobori Enshū in the early seventeenth century, the garden features an island composed of rocks and trimmed hedges in a sea of raked white sand. Along one side of the garden are azalea hedges shaped to suggest giant waves. On the other side of the garden, hedges have been trimmed to frame a view of Mount Atago in the distance—a good example of *shakkei* (borrowed scenery).

A smaller but beautiful example of clipping hedges into abstract shapes is provided by the garden of Fukuchi-in, a sub-temple of the great Shingon monastic complex on sacred Mount Kōya in Wakayama Prefecture. Guests who stay overnight at this *shukubō* (temple lodging) have the privilege of watching the clipped azalea hedges, suggestive of grassy slopes, change in appearance through the day as the sun moves across the sky. The appearance of the garden also varies with the season. In spring, the hedges are covered with flowers; in summer, they are a verdant green, and in winter, they turn a golden orange.

Opposite: *Karikomi* garden of Daichiji Temple in Shiga Prefecture viewed from inside the temple.

Top: Detail of the *karikomi* garden of Daichiji Temple featuring raked gravel in front of the serpentine trimmed hedge.

Above: *Karikomi* garden of Fukuchi-in on Mount Kōya featuring an island in a pond, raked gravel and trimmed azalea hedges.

Katsura Rikyū

Above: A pruned pine tree and high hedges are used to block a long-range view of the garden. This technique is part of the "hide-and-reveal" strategy employed so successfully at Katsura Rikyū.

Below: Layout of Katsura Rikyū with its "geese-in-flight" pattern villa situated on an elaborate strolling pond featuring miniature landscapes and tasteful teahouses.

In the early Edo Period, the second Tokugawa shogun, Hidetada, gave Hachijō-no-miya Toshihito, an imperial prince, a property in western Kyoto where a detached palace known as Katsura Rikyū and a pond for boating were soon constructed. Between 1641 and 1662, Prince Toshihito's eldest son, Toshitada, expanded the palace and erected additional structures in a beautiful garden setting considered by many to be Japan's finest.

The Detached Palace

Prince Toshihito received the Katsura estate in return for his services as a liaison between the imperial family and the Tokugawa shogunate. Originally, the property was the site of a Heian Period mansion that may have provided the setting for some of the episodes in Lady Murasaki Shikibu's famous novel, *Genji Monogatari* (The Tale of Genji).

The Sukiya style villa consists of four staggered structures—the Old Shoin, Middle Shoin, Music Room and New Palace—all connected to create a single building that is well integrated into the extensive 6.9 hectare (17 acre) garden. This staggered arrangement, with the floors and eaves of each building on slightly different levels, is known as the "geese-in-flight" formation developed in the Heian Period for Shinden style mansions. It maximizes fresh air and good views of the garden. The floors are covered with *tatami* mats and interior space is divided by decorated sliding doors that can be opened or closed to change the size of the rooms. Exterior sliding doors can be opened or removed to provide more intimate contact with the beautiful surroundings.

Attached to the main room of the Old Shoin is a platform facing the pond where moon-viewing parties were held. The New Palace (Shingoten), a Shoin style room with one of Japan's three most famous sets of staggered shelves, is believed to have been built for a visit by retired Emperor Gomizuno-o.

The Garden

Entry gardens were developed earlier but Katsura Rikyū is the earliest known full-scale stroll garden. It became the model for landscape gardens in the Edo Period. The garden is organized around a large pond that frequently twists and bends back upon itself to create a complex arrangement of peninsulas, bays and islands. This ensures a constantly changing view, enhanced by "hide-and-reveal"

a Detached Palace
b Gepparō Teahouse
c Waiting Pavilion
d Shōkintei Teahouse
e Shirakawabashi Bridge
f Shōkatei Teahouse
g Onrindō Memorial Pavilion
h Shōiken Teahouse

techniques that block one from seeing too much of the garden at one time. The garden has three kinds of stepping stones—formal (*shin*), semiformal (*gyō*) and informal (*sō*)—which lead over bridges and past stone lanterns and rock arrangements as one moves deeper into the garden. Situated at especially scenic spots along the path are four teahouses that are so well integrated into their surroundings that they are considered part of the scenery. Like the villa, the teahouses are in the Sukiya style with unpainted wood, simple straight lines and roofs covered with thatch or bark. Despite the large size of the garden, it has the intimate feel of a tea *roji* because of the great attention to detail and the rustic but tasteful atmosphere.

Katsura Rikyū was introduced to the West by the influential German architect Bruno Taut, who declared Katsura Rikyū and Ise Jingū to be the high points of Japanese aesthetic taste. Though other gardens have challenged the supremacy of Katsura Rikyū, none have exerted such a powerful influence upon subsequent gardens, not only in Japan but in other parts of the world. Permission to visit Katsura Rikyū must be obtained in advance from the Imperial Household Agency located next to the Imperial Palace in Kyoto.

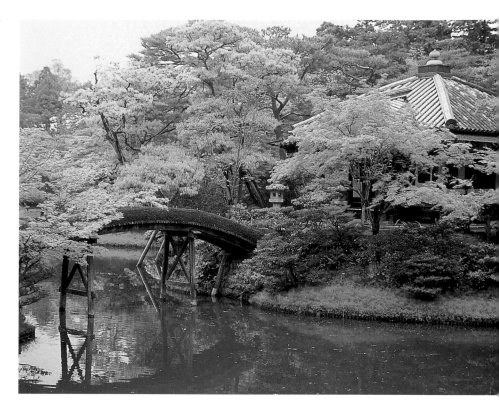

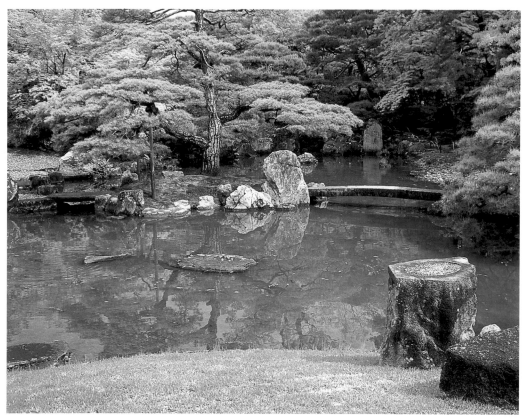

Above: Abundant use of various trees, bushes and flowers, as well as bridges and pavilions, provides interest to the ever-changing scenery as one strolls through the garden. Shown here is the Onrindō Memorial Pavilion, dedicated to the memory of the Katsura family.

Left: Stone and wooden bridges connect various areas of the garden. On the east side of the Shōkintei is a 6 meter (20 feet) long cut stone bridge known as Shirakawabashi. According to Buddhist teaching, to reach the Pure Land one has to cross a long, narrow bridge with various dangers, such as fires and devils, on both sides. Shirakawabashi probably symbolizes this teaching.

Sentō Gosho and Shūgakuin

Below: Looking at the Yūshintei Teahouse, across the North Pond at Sentō Gosho. Yūshintei was brought from the house of the Konoe family in 1884 to replace the original pavilion, which was lost to fire.

Opposite above: Wisteria in bloom on Yatsuhashi Bridge (zigzag bridge) at Sentō Gosho. The bridge connects the west shore of South Pond to an islet in the pond.

Opposite below: Earth-paved *dobashi* bridge at Sentō Gosho Imperial Palace in Kyoto connects an island in the pond with the shore of the mainland.

Pages 134–5: Autumn at North Pond, Sentō Gosho.

Sentō Imperial Palace (Sentō Gosho) and Shūgakuin Imperial Villa (Shūgakuin Rikyū) were constructed for retired Emperor Gomizuno-o. Sentō Gosho, adjacent to the palace of the reigning emperor in Kyoto (Kyoto Gosho), was completed in 1630 as a retirement residence for abdicated emperors, and Shūgakuin, in the foothills northeast of the city, was completed in 1659 as a vacation retreat. The magnificent surroundings of both the palace and the villa reflect Gomizuno-o's preference for gardens that appear to be natural rather than contrived.

Emperor Gomizuno-o

The Emperor Gomizuno-o ascended the throne when he was fifteen years old. At the age of twenty-four, he married a daughter, Kazuko, of the second Tokugawa shogun, Hidetada. Kazuko later was elevated to empress, an honorary title indicating her position as imperial consort. When the couple had a son, the Tokugawa government hired Kobori Enshū, the most eminent garden architect of his day, to build Sentō Gosho as a palace for retired emperors in order to encourage Gomizuno-o to abdicate early in favor of his son. The son died, to be followed by another son, who also died. Finally, a daughter was appointed reigning empress (in contrast to the honorary position held by her mother), and Gomizuno-o retired at the age of thirty-three under pressure from the shogun. This was the first time since the early part of the Nara Period that Japan had been ruled by an empress.

Though offended by the political meddling of the Tokugawa family, Gomizuno-o and his consort eventually made peace with the shogun in return

for a generous stipend. Together, Gomizuno-o and the Tokugawa family worked to restore the capital, which had been destroyed by inter-clan warfare in the previous two centuries. Gomizuno-o attended the funerals of the first four Tokugawa shoguns, including Hidetada, who had forced him from power, and Hidetada's son and grandson. One of the most interesting emperors in Japanese history, Gomizuno-o died at the age of eighty-five after fathering thirty-two children and making an indelible contribution to Japanese garden art.

Sentō Gosho

In addition to the new palace for the retired emperor, Sentō Gosho, a separate palace, Ōmiya Gosho, was constructed for his consort, renamed Tōfukumonin after her elevation to the position of honorary empress. Both palaces were completed in 1630, after which Kobori Enshū spent several years constructing a large *chisen-kaiyū-shiki* (stroll around the pond) garden on the palace compound. A man of impeccable taste, and an adept in Zen Buddhism, flower arranging and the tea ceremony, Gomizuno-o was directly involved in designing the garden.

Both palaces burned several times and were repeatedly reconstructed by the Tokugawa government. Sentō Gosho continued to serve as the official residence for retired emperors until both palaces were destroyed by fire in 1854, for the sixth time, together with the adjacent palace (Kyoto Gosho) of the reigning emperor. Ōmiya Palace was reconstructed on the Sentō Gosho grounds in 1867 for the Empress Dowager, consort of Emperor Kōmei. The main building of the Ōmiya Palace remains today, and is still used by the emperor whenever he visits Kyoto. Sentō Gosho was not reconstructed as there has never been another abdicated emperor. Today, the oldest two structures on the palace grounds are the Seikatei and Yūshintei teahouses.

The large 8.9 hectare (22 acre) garden, which employs hide-and-seek techniques, is organized around two ponds. A path leads from the south garden of the Ōmiya Palace past the Yūshintei Teahouse and around the North Pond, crossing a canal connecting the North and South ponds by an earthen bridge. From the west shore, there is a good view of a waterfall and rock formation on the far side. The path then crosses the South Pond via a zigzag bridge covered by a wisteria arbor and rounds the south shore, known for its pebbled beach created from stones nearly identical in size and shape (pages 52–3). The Seikatei Teahouse is located on the south shore.

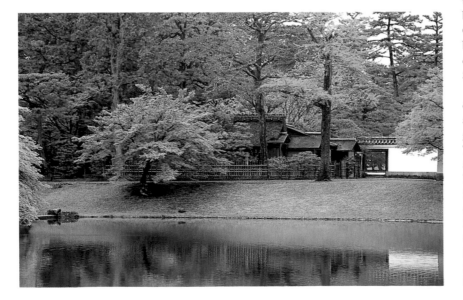

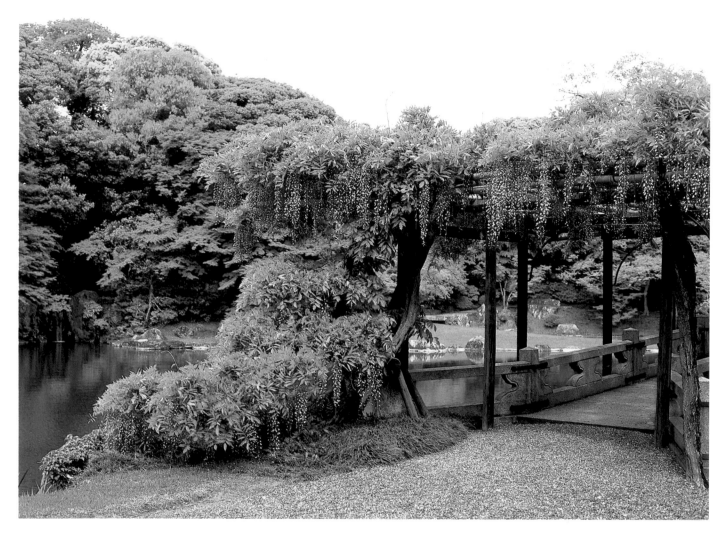

Shūgakuin

After retiring, Emperor Gomizuno-o spent many years searching for a suitable place for constructing a mountain villa (detached palace) to be used for recreational and aesthetic pursuits. He finally settled on a site in the foothills of Mount Hiei in northeast Kyoto. Funded with resources provided by the Tokugawa government, the new villa, Shūgakuin, was built on the site of a former temple after which the villa was named. It is said that Gomizuno-o was so keen on the new villa that he had earthen models made for each stepping stone and plant before the actual items were selected and set in place.

The large estate of 53.8 hectares (133 acres) incorporates three different plateaus, each with its own buildings, as well as 7.7 hectares (19 acres) of paddy fields, purchased in 1964 by the Imperial Household Agency to preserve the rural scenery

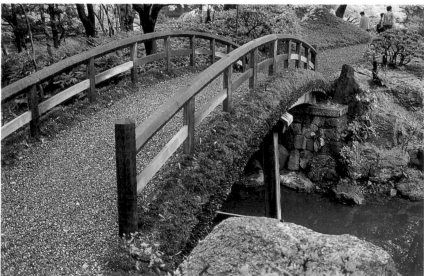

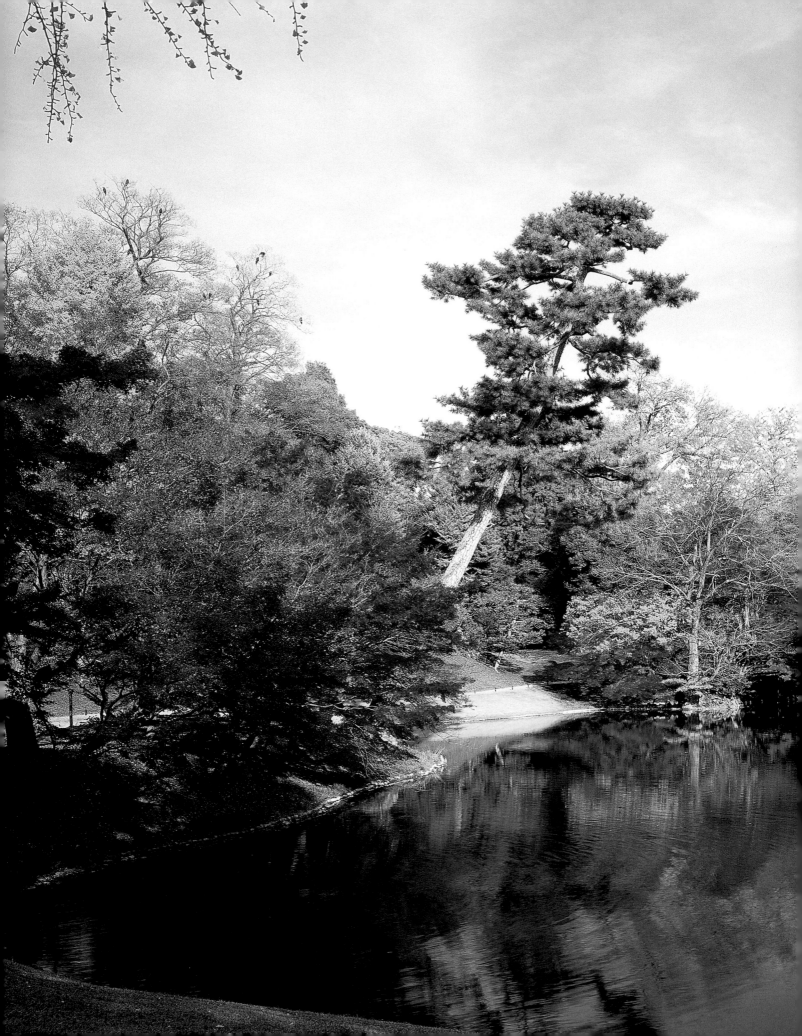

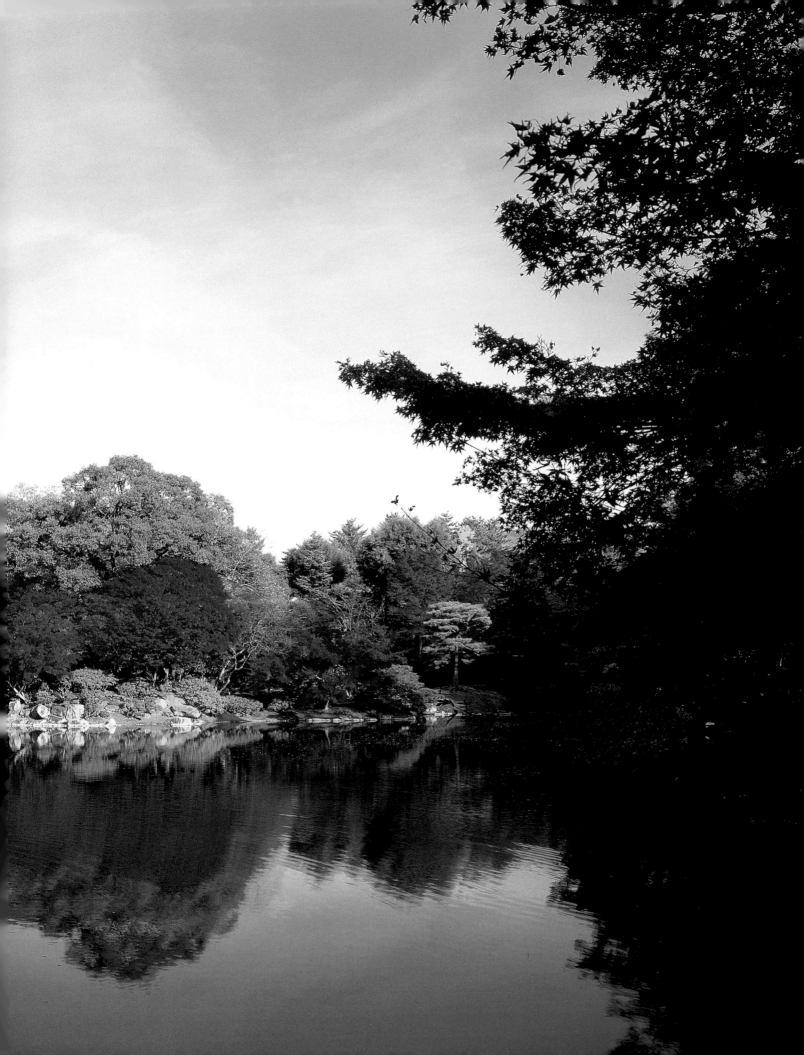

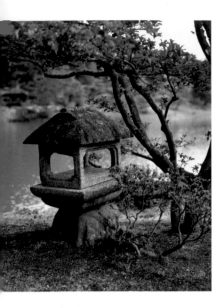

Above: Stone lantern at Shūgakuin in the shape of a thatched house.

Below: Layout of Shūgakuin Imperial Villa with its three different levels, connected by pine-bordered paths.

a Jugetsukan
b Rakushiken
c Kyakuden
d Yokuryūchi Pond
e Kyūsuitei
f Rinuntei

of the original layout. The three plateaus are connected by a graveled path lined with pine trees. A mountain range featuring sacred Mount Hiei provides a backdrop that vastly extends the view in what has been called the most dramatic use of *shakkei* (borrowed scenery) in the history of Japanese gardening.

The Lower Villa, the Jugetsukan, is a tea style pavilion where the Emperor rested before climbing to the upper levels. The front garden contains a stream that originates on Mount Hiei and empties into a pond below the villa. Along the garden path are lanterns named for their shapes. The veranda of the villa provides a view of the adjacent rice fields, flanked by a two-tiered clipped hedge (Ōkarikomi), 200 meters in length. The hedge hides an embankment that dams water for the pond of the upper garden; it also provides a skillful transition from the terraced rice fields below to the mountain slopes above.

The Middle Villa, built as a residence for Gomizuno-o's eighth daughter, Princess Ake, consists of two adjacent buildings, the Rakushiken and the Kyakuden. The latter contains one of Japan's three most treasured Shoin style staggered shelves. From the Middle Villa, the path climbs up a steep flight of stairs to emerge on a

high plateau with a dramatic view of Kyoto, the surrounding mountains and a pond (Yokuryūchi), said to resemble a swimming dragon. Two islands in the pond are connected by bridges to each other and to the mainland. One island contains a tea pavilion (Kyūsuitei). Situated on the south bank of the pond is the Rinuntei (Pavilion of Near-Cloud), an austere tea style villa. Because Rinuntei was built so that visitors could enjoy the panorama below, there are no unnecessary decorations inside that might detract from the view. Behind the building, trees stretch into the foothills and mountains beyond to provide a sense that the garden has no boundaries.

Upper Villa

Lower Villa

Middle Villa

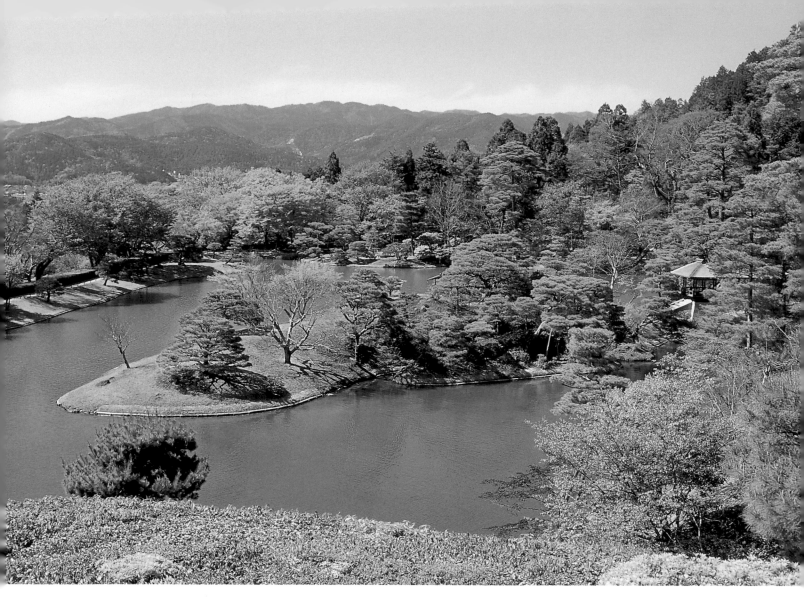

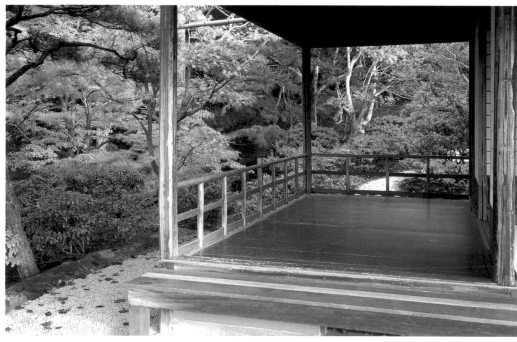

Above: Panoramic view of "borrowed scenery" beyond Yokuryūchi Pond at Shūgakuin Imperial Villa. To the right can be seen part of a covered bridge, Chitosebashi.

Left: Rinuntei (Pavilion of Near-Cloud), located on the upper level at Shūgakuin, is an austere tea style villa on the south bank of Yokuryūchi Pond. It was kept simple so as not to detract from the panoramic view below.

Suizenji Jōjuen

Construction of Suizenji Jōjuen in Kumamoto City, Kyushu, was begun in 1636 by Hosokawa Tadatoshi, *daimyō* of Higo Province, and completed about eighty years later. It was converted into a public park in 1879. With a central spring-fed lake, it is a classic stroll garden featuring artificial hills dominated by a miniature Mount Fuji and a 400-year-old Shoin style teahouse moved from Katsura Rikyū in Kyoto.

History

In 1632, Hosokawa Tadatoshi founded a temple named Suizenji on the site of the present garden. The temple was later replaced by a teahouse and the garden was renamed Jōjuen. In 1878, Izumi Shinto Shrine was built on the north end of the pond as a memorial to the Hosokawa rulers. The same year, a Noh theater was constructed on the south end of the garden. Noh plays are still conducted in spring, summer and fall.

Other structures on the grounds include a fox shrine, a theater for performing sacred shrine dances, a memorial to the Emperor Meiji and a teahouse, Kokin Denju no Ma, which was moved in 1912 from Katsura Rikyū in Kyoto in memory of the first Hosokawa *daimyō*, Hosokawa Fujitaka. Fujitaka had initiated Toshihito, the imperial prince responsible for constructing Katsura Detached Palace, into the secret teachings of *waka* (classic short poems). In 1964, the Kumamoto prefectural government designated the teahouse an Important Cultural Asset.

Kumamoto City also is known for its reconstructed castle, originally built in 1607 by Katō Kiyomasa, Japan's greatest castle architect. The original was destroyed in 1877.

Overview of Suizenji Jōjuen Garden in Kumamoto, Kyushu. The famous cone representing Mount Fuji is to the right of the pond. The thatched Kokin Denju no Ma teahouse, originally located at Kyoto's Katsura Rikyū, is on the left.

a Kokin Denju no Ma
b Meiji Emperor Memorial
c Kagura theater
d Izumi Shinto Shrine
e Cone representing Mount Fuji
f Noh theater

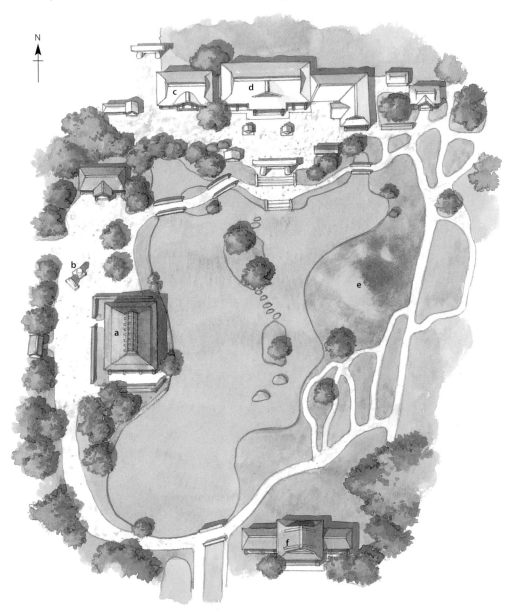

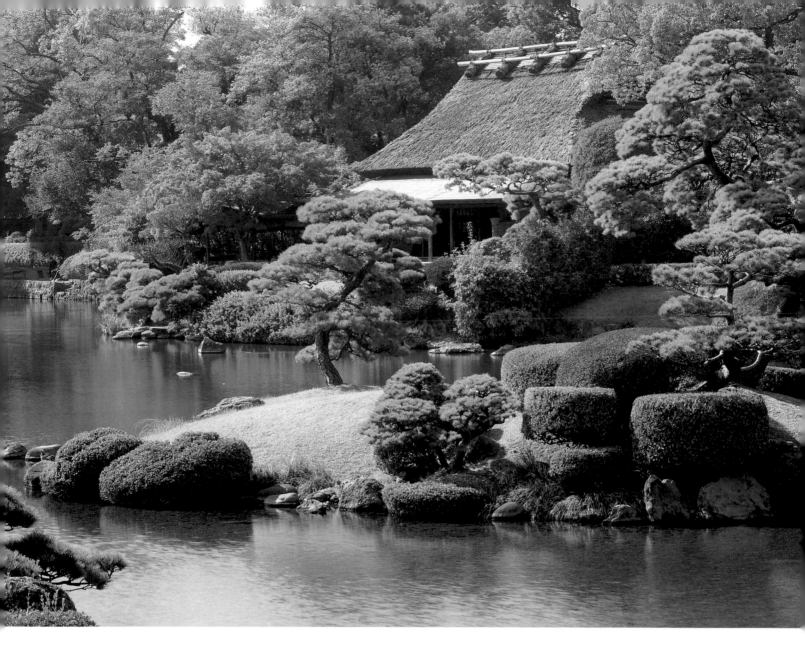

The Garden

Suizenji Jōjuen is a 6 hectare (15 acre) stroll garden that reproduces in miniature the fifty-three post stations of the Tokaidō, a Tokugawa Period road that connected the imperial capital, Kyoto, and the military capital, Edo. These post stations (overnight stopping places for travelers) were immortalized by the woodblock prints of the famous artist Hiroshige. The most prominent feature of the garden is a gently sloping, grass-covered cone, suggesting the shape of Mount Fuji. Mount Fuji does not stand alone but is tied into an undulating line of artificial hills, dotted with trained pine trees. The size of the hills is exaggerated by controlling the growth of trees on the slopes so that they decrease in height as they ascend towards the summit.

This panoramic line of hills stretches along the east shore of a large pond modeled after Lake Biwa, Japan's largest lake. The pond is fed by clear spring water from Mount Aso, a nearby active volcano. It was, in fact, the presence of this spring that led Hosokawa Tadatoshi to select this site. Wishing to develop a tea retreat, the *daimyō* believed the water was suitable for making a superior beverage. The lake contains three islands, two of which are connected to each other and the mainland by a line of flat rocks that stretches across the pond from north to south. The stones are known as *sawatobi-ishi* (stepping stones across a marsh).

Though Suizenji Jōjuen was designed as a stroll garden, the area to the east of the hills lining the pond has limited aesthetic appeal. The garden is best seen from a vantage point near the entrance, looking east across the pond towards Mount Fuji. When the sun is about to set, the pond and hills are beautifully illuminated to create one of the most idyllic garden views in Japan. In this sense, Suizenji Jōjuen is more in the tradition of a Shinden or Shoin style garden, designed to be

On the west side of the pond is a 400-year-old teahouse (originally located at Katsura Rikyū) housing the Kokin Denju Room in which the first Hosokawa lord, Hosokawa Fujitaka, initiated the imperial prince Hachijō-no-miya Toshihito into the secret teachings of the tenth-century Kokinshū anthology of poetry. In front of the teahouse is a line of stepping stones that connect two of the three islands in the pond.

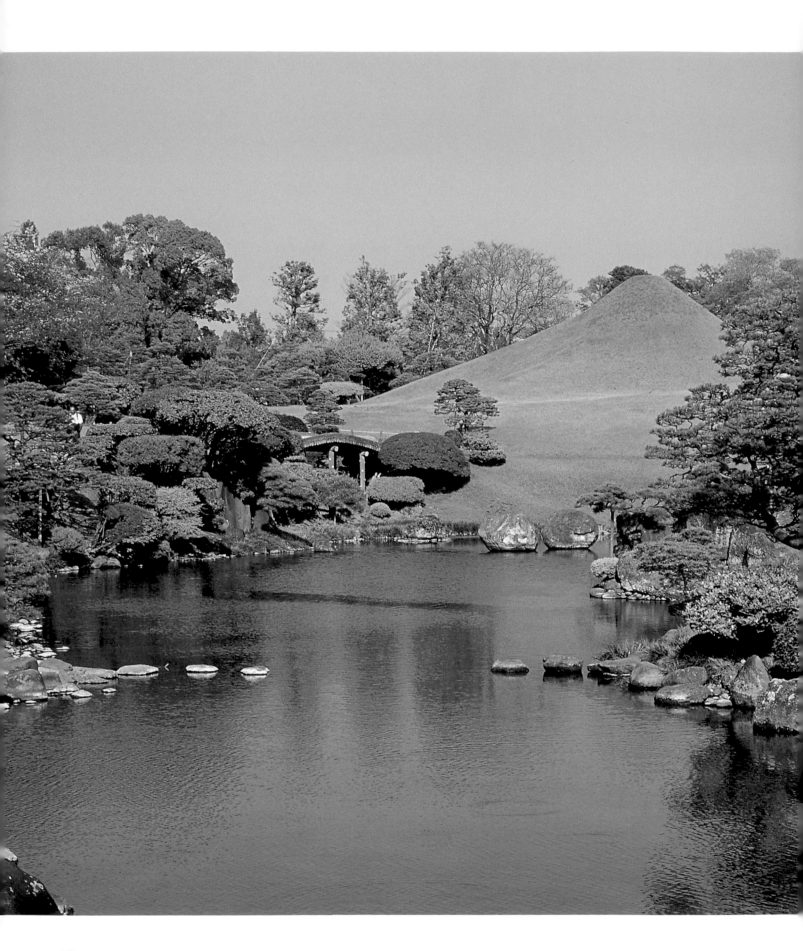

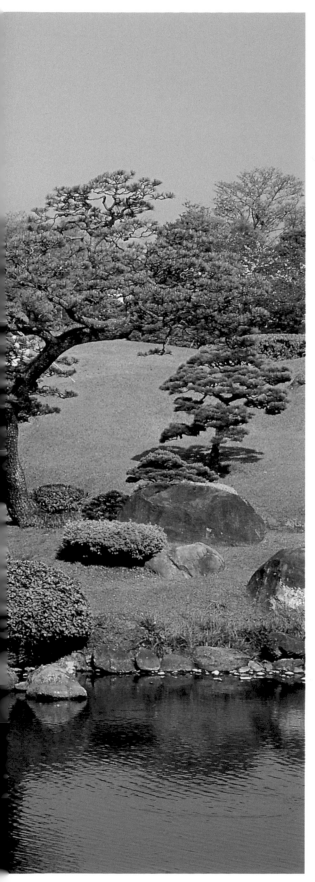

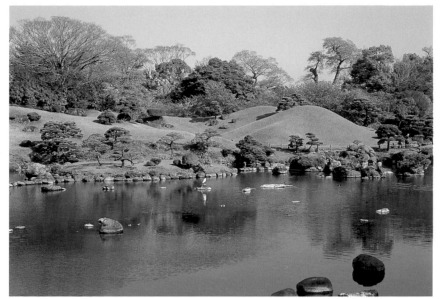

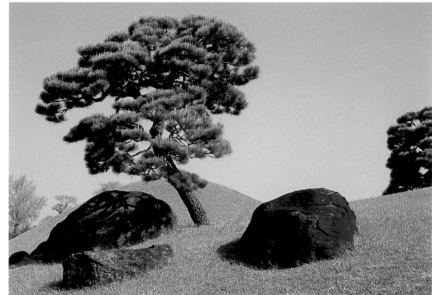

taken in at a glance, than in the tradition of a garden such as Katsura Rikyū, where great pains are taken to prevent the visitor from seeing too much at once. To use another comparison, Suizenji Jōjuen reminds one of the beautiful gardens viewed through windows at the Adachi Museum, described in the next section. In both cases, one is presented with painterly compositions so perfect that moving a single item could be disastrous.

Unfortunately, the west side of the pond is dominated by food and souvenir shops, and in the winter, when the large trees that provide a backdrop to the garden have lost their leaves, tall buildings of the surrounding city are much in evidence. Despite these commercial and urban distractions, Suizenji Jōjuen is one of Japan's great garden masterpieces.

Opposite: The pond is fed by subterranean water originating on nearby Mount Aso. A miniature Mount Fuji can be seen across the reflecting waters of the pond.

Top: The long gentle slope in the photograph on the left is continued in the line of hills shown here. The unbroken panoramic view that unfolds as one passes through the entrance gate is quite startling.

Above: A lone pine has been pruned to pick up the slope of the hill behind. These curves are further reinforced by the shape of the rocks.

Ritsurin Kōen

Ritsurin Kōen in Takamatsu City on the island of Shikoku is one of the best examples of a large *daimyō* stroll garden. Consisting of six ponds and thirteen artificial hills, Ritsurin Kōen, completed in 1745, was under construction for nearly a hundred years. Nestled at the foot of Mount Shiun, the garden is famous for its sculpted black pines, rock arrangements and hilltop views of waterways, bridges and a villa.

History

The origins of Ritsurin Kōen have been obscured by time. The oldest rock arrangement in the garden, Shōfuda, has been excavated and appears to have been constructed in the early Muromachi Period. The identity of the designer and the circumstances surrounding its creation are unknown. The Ikoma family lived on the grounds in the subsequent Momoyama Period. Eventually, the property fell into the hands of Matsudaira Yorishige, who was appointed *daimyō* of the area in 1642 by the Tokugawa shogunate. When the Matsudaira family began developing the property, they initiated flood control measures that included changing the course of the nearby Katōgawa River. The old riverbed provided an ideal location for expanding the existing garden to the north. Yorishige built a retirement villa in the garden for himself and his daughter.

During the rule of the second Matsudaira *daimyō*, Yoritsune, the area was in dire shape because of a drought. To help alleviate the situation, Yoritsune hired local people to continue developing the garden. They were paid with money or rice for their labor and for bringing interesting rocks or rare wood. The South Garden was completed during the rule of the third *daimyō*, who lived in the garden villa rather than the nearby castle.

The 54 hectare (134 acre) garden was used as a villa for eleven successive Matsudaira family lords, ending with the Meiji Restoration of 1868 when the feudal system of government was replaced by a Western style democracy. In 1872, the garden was transferred to Takamatsu Prefecture, now called Kagawa Prefecture, and the name changed in 1876 from Ritsurinsō to Ritsurin Kōen, when it was opened to the public. In 1953, the garden was designated as a Special Place of Scenic Beauty.

Above: Stone water basin at Kikugetsutei.

Below: Layout of Ritsurin Kōen.

a Fuyōhō Hill
b North Lake
c Hiraihō Hill
d Engetsukyō Bridge
e South Lake
f Kikugetsutei (Moon-scooping Pavilion)
g Shōfuda rock formation
h Kansui Pond
i Higurashitei Teahouse
j Bairinkyō Bridge
k West Lake
l Fuyo Pond
m Gunōchi Pond

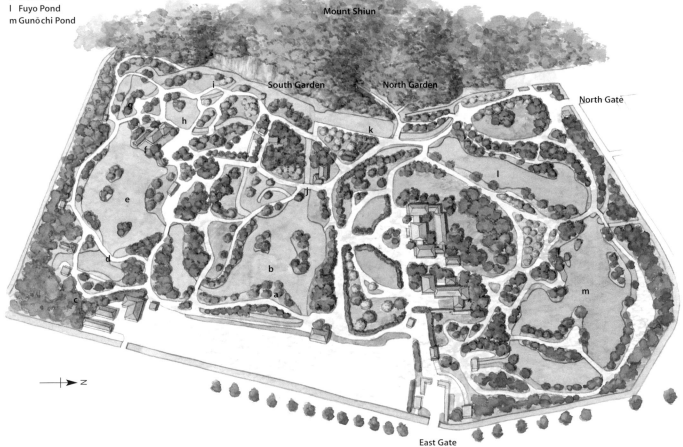

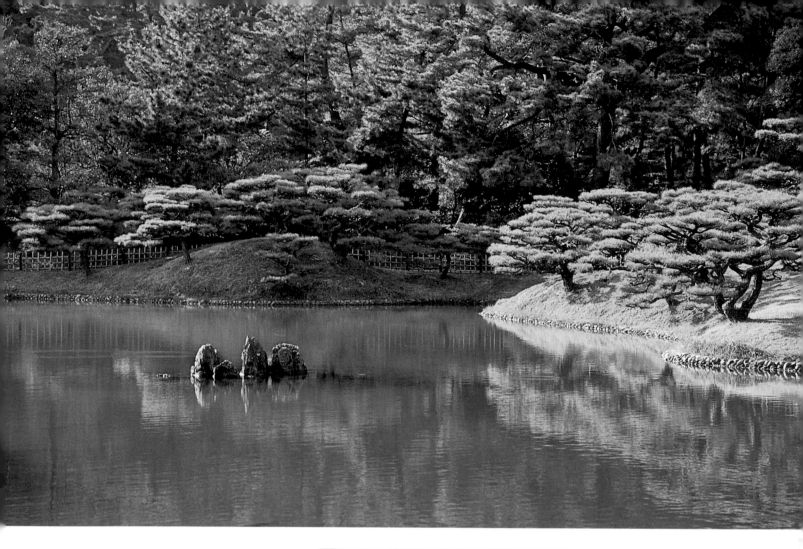

The Garden

Ritsurin Kōen is divided into South and North gardens. North Garden originally was used for duck hunting. Today, it is a botanical garden that grows replacement plants for the South Garden. Separating North and South gardens is a long row of *kuromatsu* (black pine), referred to as box pines because the closely planted trees are trimmed into a tall square hedge. Only South Garden will be discussed here.

There are numerous paths in South Garden that meander around hills and ponds connected by streams. The three largest ponds are North Lake, South Lake and West Lake. Mount Shiun, immediately to the west, forms a dramatic backdrop that seems to be part of the garden, thereby enhancing its size and grandeur. The Kikugetsutei (Moon-scooping Pavilion), a teahouse originally constructed as part of a villa for the Matsudaira clan, is located on the shore of South Lake. The South Garden is a typical Hōrai style garden with islands and rocks representing the abode of the immortals. An outstanding example of Sukiya style architecture, Kikugetsutei commands a good view of the lake with its colorful arched bridge and artificial hill beyond. The name of the teahouse villa was inspired by a line in a famous

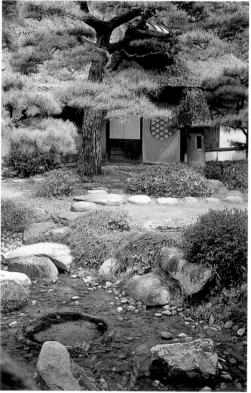

Above: The focal point of South Pond is a group of five rocks representing *hōrai* islands, where the immortals live.

Left: The old Higurashitei Teahouse was moved to different locations three times before coming to rest in its present spot on the bank of the garden's West Lake.

Pages 144–5: South Pond viewed from the top of Hiraihō Hill. Man-made elements (Kikugetsutei and the arched Engetsukyō Bridge) are placed so that the "borrowed scenery" of Mount Shiun does not overpower the garden.

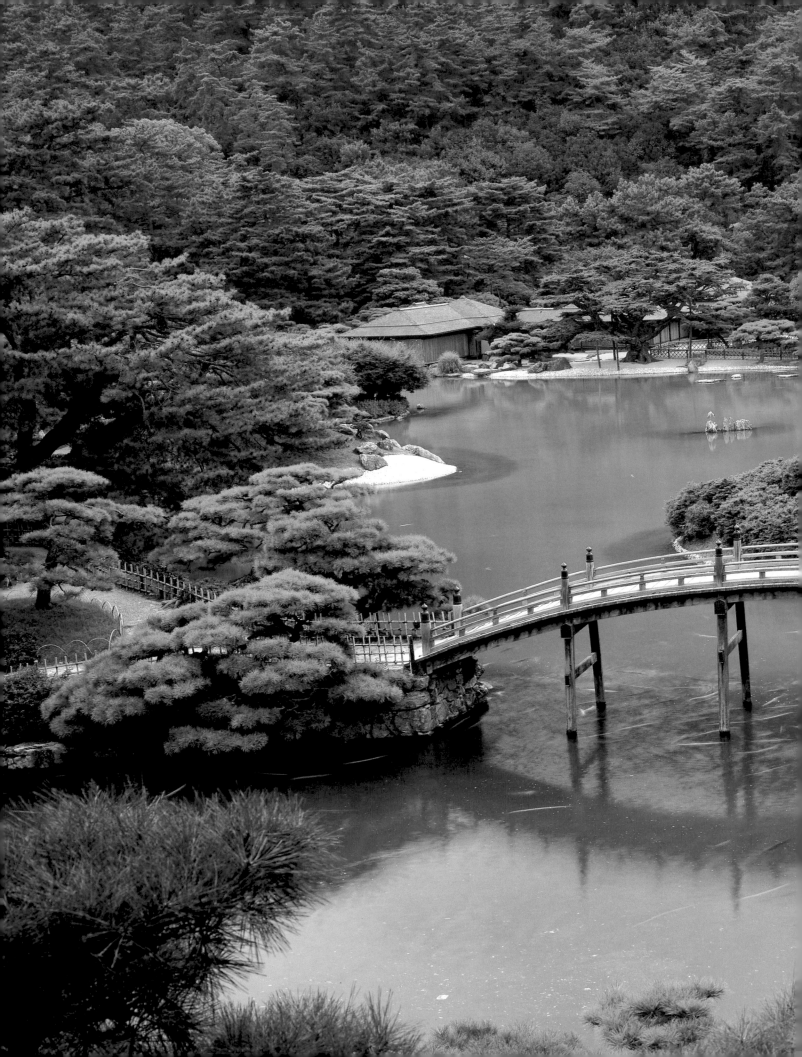

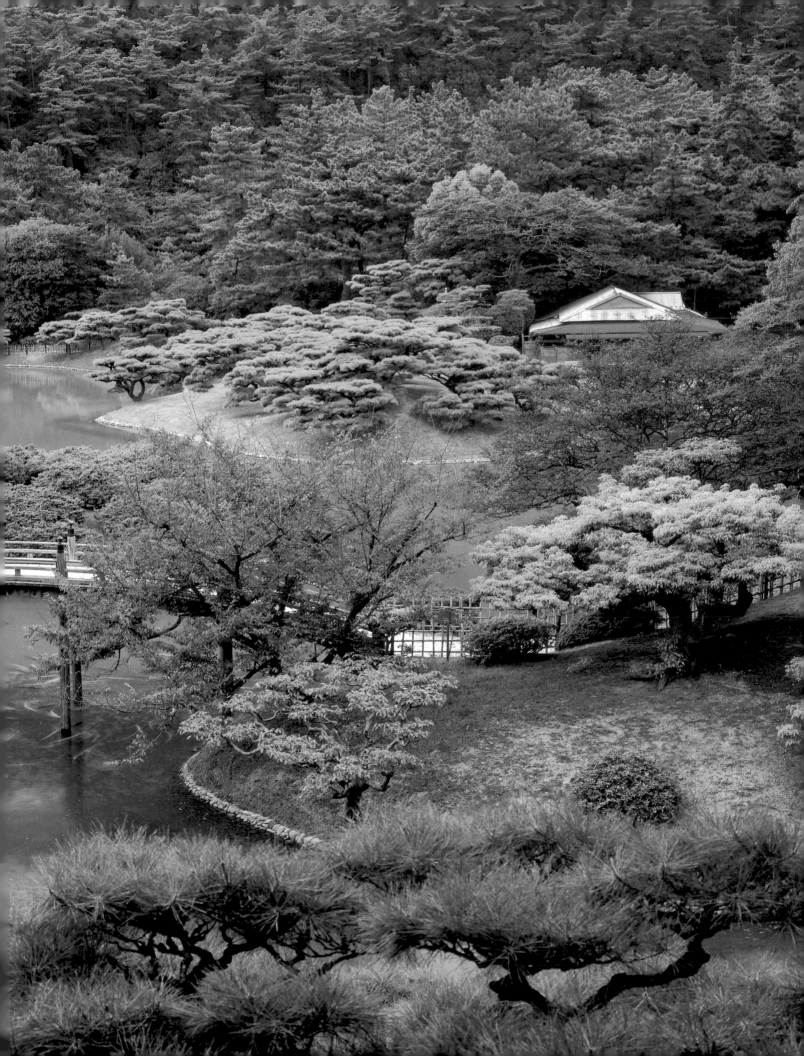

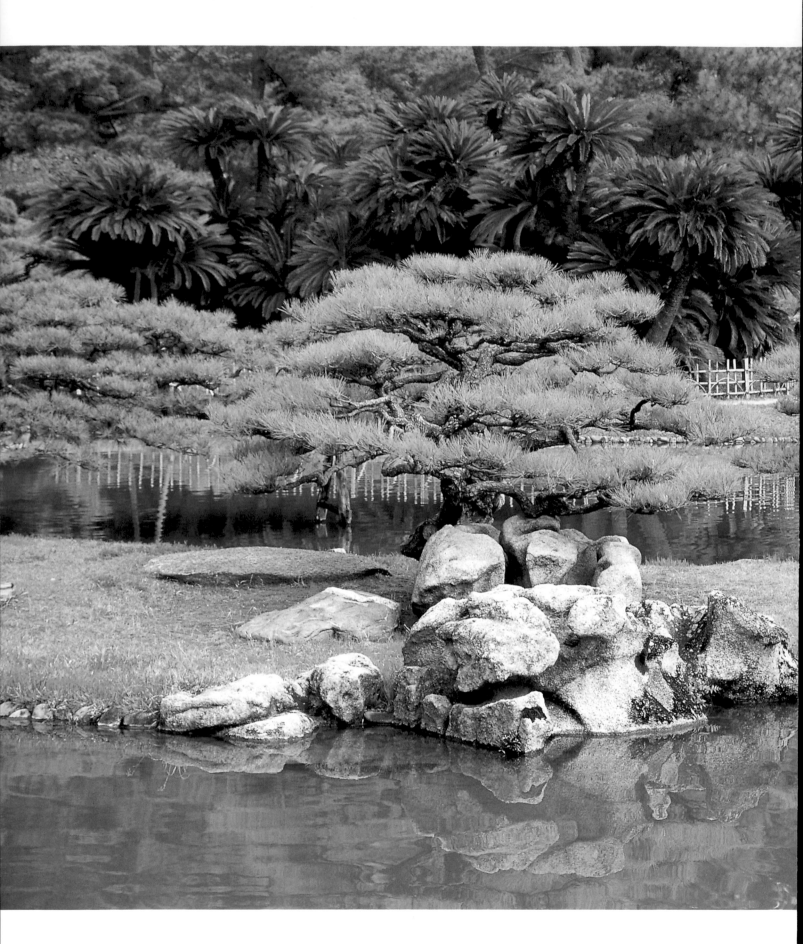

Chinese poem: "Scooping the water, the reflection of the moon is in my hands."

North Lake, built in the days of the second *daimyō*, is bordered on the east by an artificial hill, Fuyōhō, which provides a view of two islands in the lake, as well as a red bridge that spans a stream connecting North Lake and West Lake. North Lake is especially famous for the beautifully trained black and red pine trees that line its shores. Along the path from North Lake to South Lake are several renowned rock formations, including Mikaeri-shishi (lion looking back) and Botan-ishi (peony rock). The stones for these formations were probably brought from islands in the Inland Sea.

The far shore of West Lake rises steeply into the foothills of Mount Shiun. Cascading down the slope is an artificial waterfall. In feudal times, barrels of water were carried up the slope and hidden in the trees, and whenever the lord walked by, the barrels were emptied to create the falls. Located on the east shore of West Lake is a grass-hut style teahouse, constructed by the second Matsudaira *daimyō*. Moved off the grounds to another estate, the teahouse was returned in 1945. A larger Shoin style teahouse, constructed in 1898, is located nearby. In some portions of the park, shrubs are trimmed into cubic shapes to provide both a transition and a contrast between highly manicured and more natural areas.

Above: Shōfuda rock formation, named after sacred Mount Fuda in China, is believed to have been made in the early Muromachi Period (around 1400).

Opposite: Yōtō Island on Kansui Pond, west of Kikugetsutei, incorporates the most interesting rock formations in the garden.

Kenrokuen

Opposite: There are eighteen lanterns of various shapes and sizes in Kenrokuen. The most famous is the Kotoji stone lantern, so-called because its shape resembles the bridge that supports the strings of a *koto*, a classical musical instrument.

Pages 150–1: In addition to pines, Kenrokuen has a variety of other trees and flowers. Loveliest of these are the cherry trees, irises and azaleas that bloom along the winding streams.

Below: Layout of Kenrokuen Garden.

a Hisago Pond
b Kasumi-ga-Ike (Misty Pond)
c Kotoji stone lantern
d Karasaki Pine
e Seisonkaku Villa

Kenrokuen in Kanazawa City is a large stroll garden established in 1676 by Maeda Tsunanori, the fifth *daimyō* of Kaga, and completed in 1837 by Maeda Nariyasu, the thirteenth *daimyō*. The name Kenrokuen (Garden of Six Qualities) is said to be derived from the Song Chinese classic *Rakuyō Meienki*, which considered it desirable for a garden to have six characteristics: spaciousness, seclusion, air of antiquity, ingenuity, flowing water and scenic views.

History

In 1583, Maeda Toshiie took control of the Kaga area in the name of Toyotomi Hideyoshi who was in the process of trying to unify the country. The Maeda castle was built on a hill between two rivers, and the town of Kanazawa developed around it. Serving as an administrative center for the feudal government, Kanazawa was Japan's fourth largest city in the Edo Period. The Maeda family was classified as *tozama daimyō* (outside *daimyō*), members of lineages founded by Oda Nobunaga or Toyotomi Hideyoshi, rather than the first Tokugawa shogun, Ieyasu. During the Edo Period, *tozama daimyō* were under the close scrutiny of the shogun. To avoid suspicion, they spent their money on magnificent gardens as well as the arts and crafts, rather than upon impressive castles. For this reason, the castle was never strongly fortified. When it was destroyed by fire in 1881, it was not rebuilt. Kenrokuen Garden, one of the three most famous gardens in Japan, was once the outer garden for the castle. As in the case of Okayama Kōrakuen, the walled garden provided additional protection for the castle, as well as a private strolling area for the Maeda family. Samurai and commoners were unable to enter without permission of the lord. The large two-storied gate with sentry rooms on both sides (Renchimon) was removed when Kenrokuen was opened to the public in 1874. The garden is now separated by a road from the castle remains, also open to the public.

Kanazawa Castle Park

Kenrokuen Garden

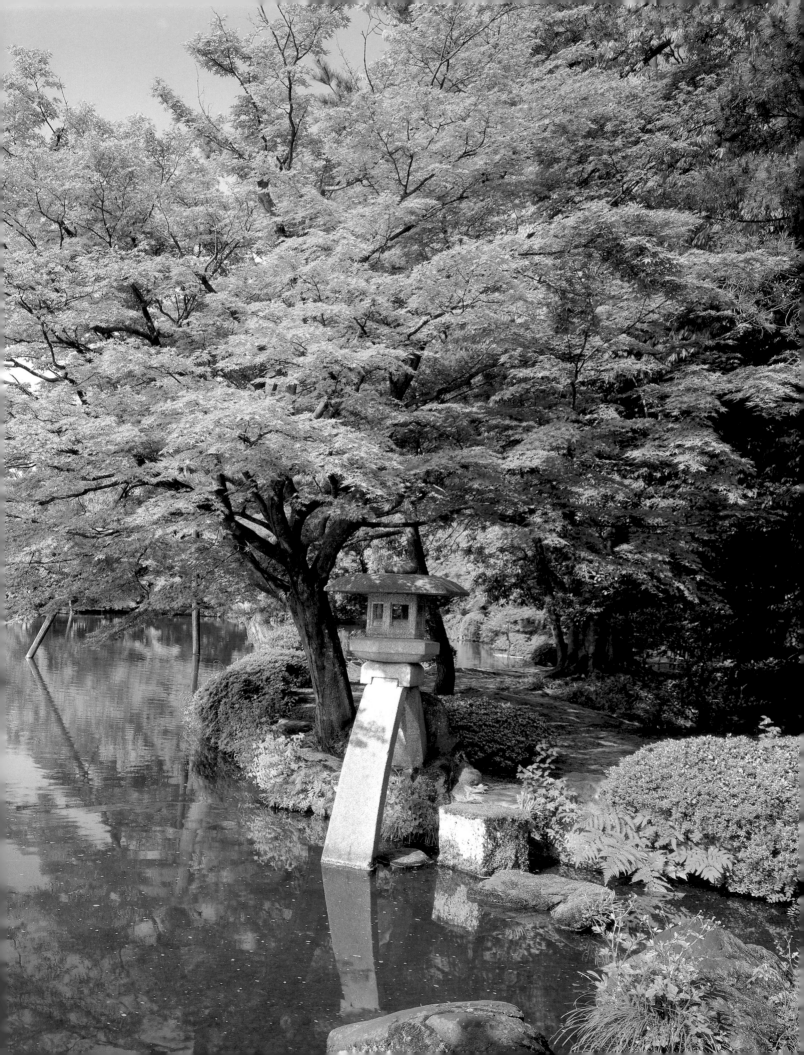

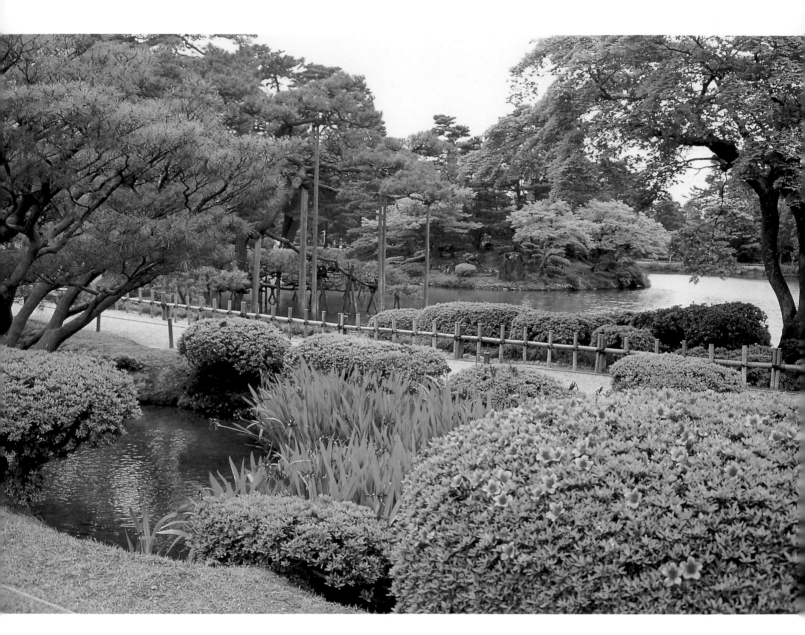

Above: Blessed with a natural source of abundant water, Kenrokuen is most famous for its ponds connected by waterways lined with irises and luxurious vegetation.

Opposite above: A stone walk leads to Funa-no-ochin, a resting place resembling a covered boat.

Opposite below: Gankōbashi (Flying Wild Geese Bridge) consists of eleven tortoiseshell-shaped stones.

The Garden

The 11.3 hectare (28 acre) stroll style garden is constructed on two levels. The upper plateau contains a pond known as Kasumiga-Ike (Misty Pond), with its famous two-legged stone lantern shaped like the bridge of a *koto* (traditional musical instrument). One leg rests on land while the other stands in the water. From the northeast shore of Misty Pond, the largest of the four ponds in the garden, it is possible to see the Japan Sea and Noto Peninsula to the north and Mount Yamazaki to the east. To the west of Kasumiga-Ike is a small pond featuring a fountain said to be the oldest in Japan. The 3.5 meter fountain, fed by

Kasumi-ga-Ike, operates by natural water pressure and thus serves as a handy indicator of water pressure in the garden.

The lower plateau, nearest the castle, is where construction of the garden began approximately 320 years ago. This area contains gourd-shaped Hisago Pond with a *hōrai* island in the middle. The island is unique in that the rock formation surrounding Mount Hōrai is a *tsuru-kame* combination. The same rock looks like a crane when viewed from one direction and a tortoise when viewed from another. Cascading into the pond is a 7-meter waterfall, Midoritaki (Emerald Waterfall). The artificial waterfall, unusual because of

its considerable height, is less stylized than those of many early gardens, and its rocks lack the symbolic significance of compositions in temple gardens such as Tenryūji, discussed earlier.

The ponds, as well as the many iris-planted streams that wind throughout the garden, are fed by water brought by underground tunnels and canals from Saigawa River, several kilometers away. Because the river is 100 meters above sea level and considerably higher than the garden, the water reaches Kenrokuen without the aid of mechanical devices. The water system, which was constructed by the third Maeda lord, Toshitsune, after a disastrous fire in 1631, also served as a back-up system for the castle in event of attack.

Kenrokuen is known for its 400 cherry trees in the spring, irises and azaleas in the summer and brilliantly colored leaves in the fall. It is particularly beautiful in the winter when the pine trees are tied up with *yuki-turi*, maypole-like poles and rope supports that protect them from the heavy wet snow received in the area (pages 56–7). This procedure, which begins on November 1st of each year, was at one time common in the area but now survives only at Kenrokuen. The most famous tree in the garden is Karasaki Pine, a black pine planted by the thirteenth Maeda lord.

Other features of Kenrokuen include Yūgaotei, a grass hut style teahouse, a hill with an umbrella-shaped pavilion on top, a sacred well named Kanazawa, from which the name of the city is derived, numerous lanterns, beautifully crafted bridges and a pond and plum grove recently developed on land used for riding horses during the latter years of the Edo Period. Two historic buildings used by the Maeda family for social gatherings also have been recently reconstructed.

Kenrokuen is a classic stroll garden in which the visitor can spend hours traversing the many paths. With every turn, one is presented with a visual feast, both colorful and varied in composition. Kenrokuen, like Katsura Rikyū in Kyoto and Ritsurin Kōen in Takamatsu, is one of the few stroll gardens in Japan that include all of the attributes an ideal garden should have—thus its name, Garden of Six Qualities. Kenrokuen was designated a Special Place of Scenic Beauty in 1922.

At the east end of the garden is Seisonkaku, a villa constructed in 1863 by the thirteenth Maeda *daimyō* for his mother. Having survived the fire that destroyed the castle in 1881, the villa serves as a museum today. The power of the Maeda family is reflected in its lacquered beams and walls covered with gold leaf. When visiting Kenrokuen, it is worth one's while to see this historic mansion.

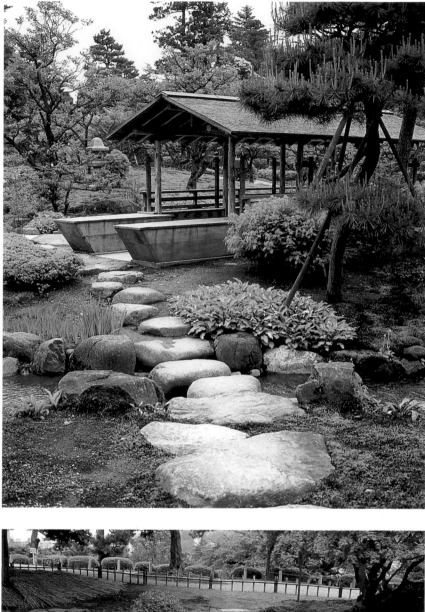

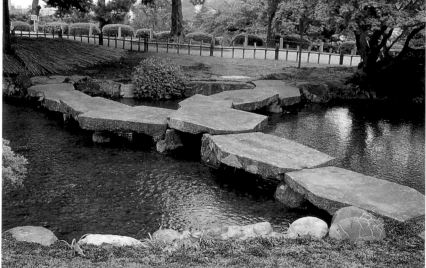

Okayama Kōrakuen

Opposite above: Okayama Castle is incorporated into the scenery (*shakkei*) of Kōrakuen. Since its moats were not sufficiently wide to prevent rifle attacks, the Ikeda family built the garden surrounded by walls to provide an outer defense zone.

Opposite below: Jarijima Island in Sawa-no-ike Pond, constructed of white gravel and two pruned black pines, resembles an island floating in an ocean.

Below: Layout of Okayama Kōrakuen.

a Ryūten Pavilion
b Yuishinzan Hill
c Okayama Castle
d Kayō-no-ike Pond
e Enyōtei House
f Sawa-no-ike Pond

Kōrakuen Garden in Okayama City is a large stroll garden commissioned by Lord Ikeda Tsunamasa, *daimyō* of the Bizen region, in 1687, and completed in 1700. The Ikeda family retained possession until 1884, when it became a public park. Since 1871 the garden has been called Kōrakuen (Garden for Taking Pleasure Later), referring to a Chinese saying that "the lord must grieve earlier but enjoy later than his subjects."

History

Kōrakuen was used by the Ikeda clan for relaxing, entertaining important guests and training vassals in the literary and military arts, such as archery and horsemanship. Each succeeding generation of clan leaders constructed a new edifice on the grounds, such as a teahouse or Noh stage. The garden was transferred to Okayama Prefecture in 1884. It was severely damaged by floods in 1934 and again by bombing in 1945, but the grounds have been restored to their original condition on the basis of paintings and diagrams owned by the Ikeda family. In 1952, the garden was designated as a Special Place of Scenic Beauty. It has been customary since the Edo Period to regard Kōrakuen as one of Japan's three most beautiful gardens.

The Garden

Kōrakuen occupies a 13.3 hectare (33 acre) site on the north bank of the Asahi River in Okayama City. Across the river is Okayama Castle, which is incorporated into the garden as borrowed scenery (*shakkei*). The garden is designed in the *rinsen kaiyū* (scenic promenade) style, with a network of paths that crisscross the grounds in all directions. It is not unusual to walk several kilometers while exploring these paths.

The garden is somewhat unusual in that it provides broad vistas of grassy lawns, ponds, hills and trees. Enyōtei House is a traditional thatched villa in the southwest area of the grounds where the clan chief stayed when visiting. The villa offers a good view of Sawa-no-ike Pond in the center of the garden. With its three islands, Sawa-no-ike is said to represent the scenery of Lake Biwa, the largest lake in Japan. Behind the pond is Yuishinzan, an artificial hill covered with trimmed azalea bushes, which provides a panoramic view of the entire garden, as well as Mount Misao in the distance. A small pavilion on top of Yuishinzan Hill has long been a favorite spot for moon viewing.

Yuishinzan (Sole Heart Mountain) serves to divide the grounds into two main areas—an area

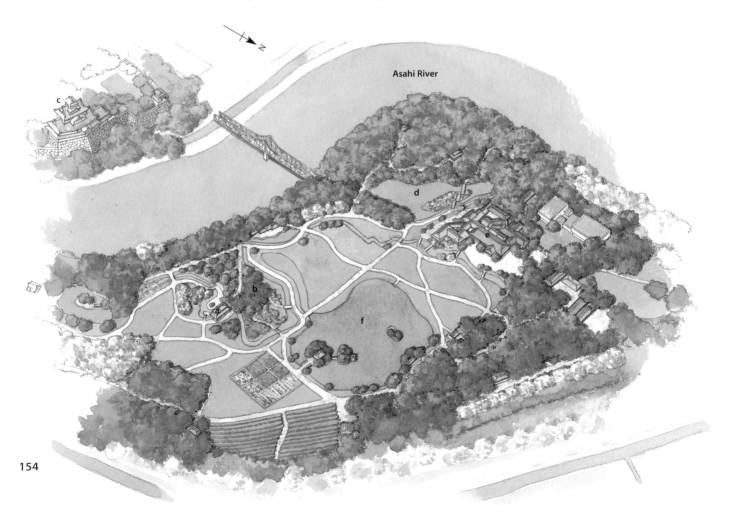

Asahi River

stretching southwest towards the villa and an area to the east of the pond originally reserved for rice paddies arranged in squares, a tea plantation and orchards of flowering fruit trees. Though these features still remain, the open areas between the fields and orchards have been occupied since the Meiji Period by the same kind of lawn cover featured in the rest of the garden. The widespread use of spacious lawns may have been influenced by gardening ideas from the West.

There is also a third area in the south part of the garden with a thick grove of cypress trees and a small hill. To the east of the grove is Kayō-no-ike Pond, featuring a large rock 7.5 meters (25 feet) high on its bank that was cut into ninety-six pieces in the Edo Period and moved from its original location in the Inland Sea. The villa is situated near the bank of Kayō-no-ike Pond.

Streams wind between the ponds, one flowing through the center of an open structure where the lord rested when walking in the garden and where poetry contests were held. Nearby, a zigzag bridge crosses an iris bed in the stream. Throughout the garden are rock compositions symbolizing the male and female principles associated with the Chinese concepts of *yin* and *yang*.

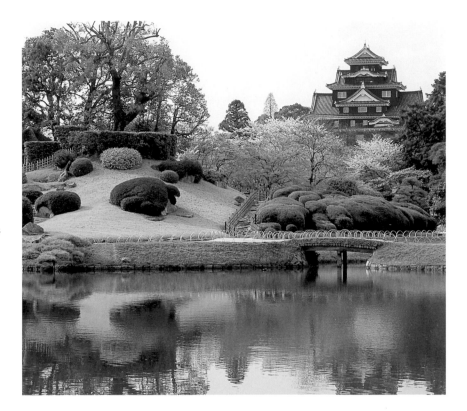

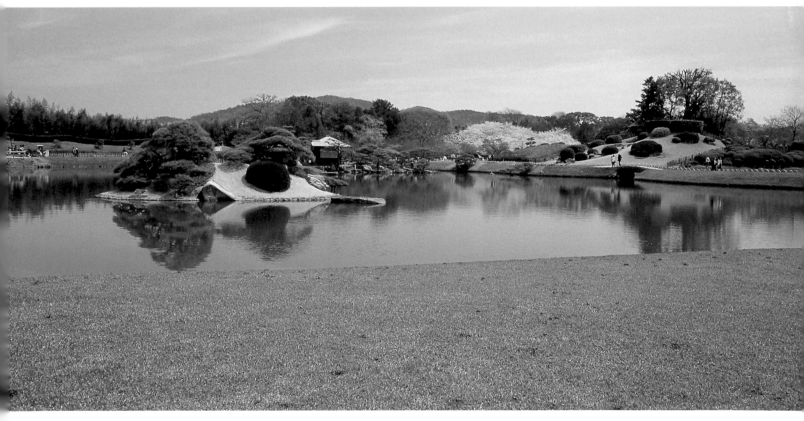

Tokyo Stroll Gardens

Above: A large flat rock representing a turtle's head on an island in the pond of Koishikawa Kōrakuen.

Below: Mount Lu in Jiangxi Province, China, is represented by a mound at Koishikawa Kōrakuen covered with bamboo grass, clipped to resemble two peaks.

Edo achieved prominence after it became the military capital of Japan in the early seventeenth century. Though it could not compete culturally with the old imperial capital of Kyoto, Edo quickly developed into a metropolis with large mansions and gardens belonging to *daimyō* families. Most of these estates were destroyed in World War II, but three that remain—Koishikawa Kōrakuen, Rikugien and Hama Rikyū—provide some idea of the grandeur of Tokyo's traditional gardens.

Koishikawa Kōrakuen

In 1629, Tokugawa Yorifusa, the first head of the Mito branch of the Tokugawa family, was given a piece of property in Edo (Tokyo) by the third Tokugawa shogun, Iemitsu. Yorifusa ordered the immediate construction of a residence and a garden on this site, but he died soon after, leaving completion of the project to his son Mitsukuni. Mitsukuni completed the garden with the assistance of Zhu Shunshui, a refugee Chinese scholar who is thought to have suggested the garden's name, which, like the name of Okayama Kōrakuen, refers to an old Chinese saying "the lord must grieve earlier but enjoy later than his subjects".

The garden is organized around a pond. Visitors walking around the pond encounter various scenes designed to imitate famous and scenic sites both in China and Japan, such as the causeway on China's West Lake and Togetsu Bridge in the Arishiyama area of Kyoto. In the pond is a wooded *hōrai* island, at the edge of which is a large flat rock, Tokudaijiseki, that represents a turtle's head. Steeply arched Engetsukyō Bridge (meaning Round Moon), designed by Zhu Shunshui, is famous for its reflection in the water, resembling

a full moon. The garden incorporates a rice field constructed by Mitsukuni to instruct his daughter-in-law concerning the hardship of farmers. The garden is particularly noted for the flowering plants and trees that mirror the changing seasons, starting with plum blossoms in early February, followed by cherry, wisteria, azaleas, irises, water lilies and lotuses in summer, and colorful leaves in autumn.

Although Kōrakuen was the most famous and best preserved garden in Tokyo at the end of the nineteenth century, now only a quarter of the original 25.5 hectares (63 acres) remains, squeezed between the Tokyo dome and office towers. The oldest *daimyō* garden in Tokyo, Kōrakuen has been designated a Special Historical Site/Special Place of Scenic Beauty by the national government.

Rikugien

Yanagisawa Yoshiyasu, the son of a government official who rose to the status of *daimyō*-confidante to the fifth Tokugawa shogun, Tsunayoshi, constructed Rikugien between 1695 and 1702. After Yanagisawa's death in 1714, the garden deteriorated until 1877 when it was purchased by Iwasaki Yatarō, founder of Mitsubishi Corporation, who made extensive renovations. The garden was donated to the city of Tokyo in 1938.

The garden's name refers to the six principles of *waka* (classical short poems) identified in an ancient Chinese anthology, *The Book of Songs*. The six Chinese characters were read as "Mukusano-sono" in Japanese—the original name of the garden, later changed to Rikugien, essentially meaning the same thing. The garden is organized around a large pond with a treed island and a striking rock composition that represents a *hōrai* island where the immortals live. As one strolls around the pond, one encounters eighty-eight miniature landscape scenes described in classical Chinese and Japanese literature. There are also teahouses, resting pavilions and an artificial hill, Fujishirotōge, whose summit provides a good view of the pond, an earth-covered bridge, azalea bushes, manicured lawns and trees. Rikugien, with its tasteful composition and ever-changing views, is considered by some to be the finest garden in the city.

Hama Rikyū

Hama Rikyū Garden, famous for its double-blossomed trees in spring, lies on reclaimed marshland where the Sumida River empties into Tokyo Bay. Its seawater tidal pond was once a wildfowl hunting preserve presented by the fourth Tokugawa shogun, Ietsuna, to his younger brother,

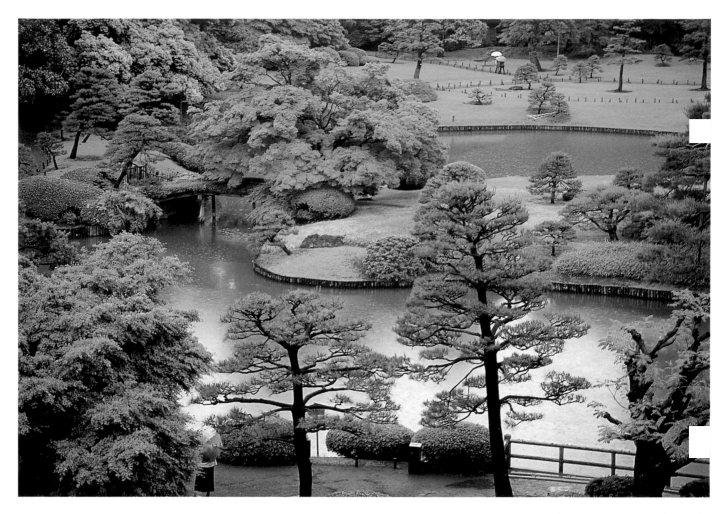

Tsuna-shige, for a residential estate. The 25 hectare (62 acre) garden was constructed in 1654. Tsuna-shige's son Ienobu, appointed shogun in 1709, made numerous improvements and named the estate Hama Goten (Palace on the Coast). The garden was used as a summer resort by imperial and shogunal élite until the villa was destroyed by fire in 1725. Shogun Ienari remodeled the garden at the end of the eighteenth century.

The estate was transferred to the Ministry of Foreign Affairs after the Meiji Restoration in 1868 and used to entertain foreign visitors of distinction. Eventually, the property passed into the hands of the Imperial Household Agency, which renamed the garden Hama Rikyū (Hama Detached Palace). Japan's first Western style stone building was constructed on the site and used to entertain American President Ulysses S. Grant during an 1879 visit. Turned over to the city of Tokyo in 1945, Hama Rikyū was opened to the public in 1946.

The present garden features a pleasant walk around the old seawater tidal pond, artificial hills and a flower garden. A tea pavilion, Ochaya, situated on an island in the tidal pond, provides a good view of the pond and its surroundings.

Above: A vantage point at the top of an artificial mound, Fujishirotōge, at Rikugien provides a panoramic view of the pond with a large island, Naka-noshima, in the middle.

Below: Rikugien's *hōrai* island is represented by a rock arrangement that looks like a sea-eroded island with a cave. The cave, where the immortals live, is the entrance to Mount Hōrai.

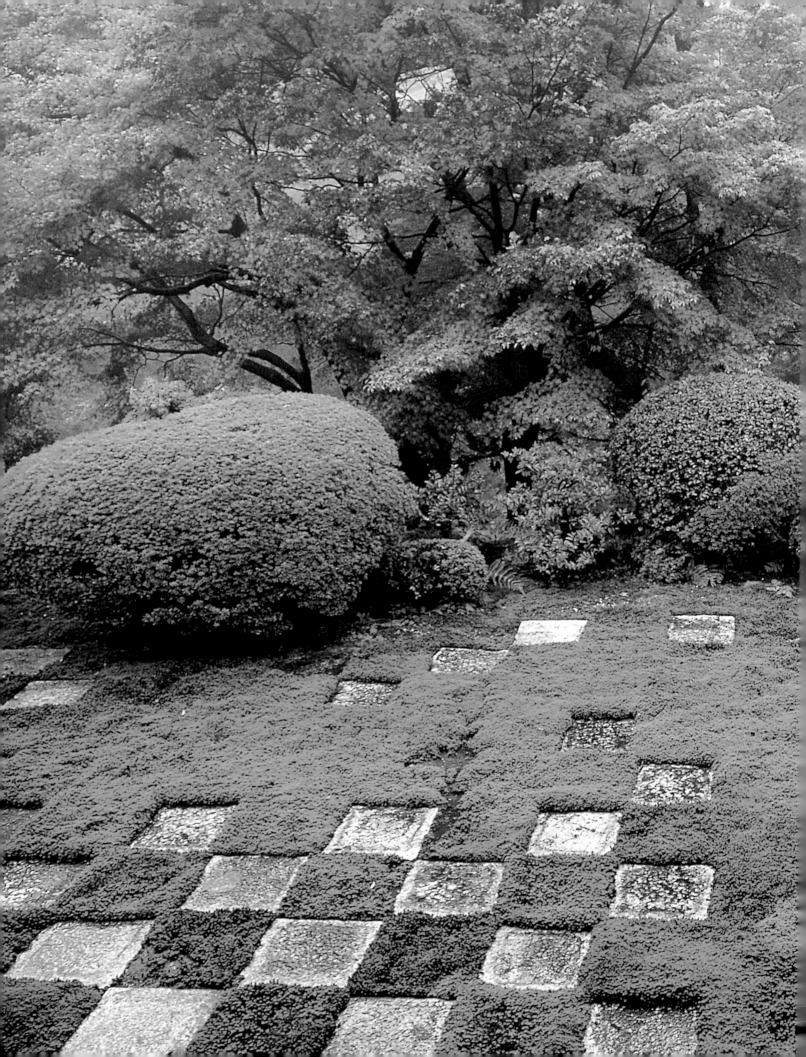

More Recent Gardens

During the Early Modern era, Japan was heavily influenced by Western culture. For a time in the Meiji Period, Western ways of doing things threatened to overwhelm traditional values and practices. Though the changes were most keenly felt in the area of economic development, the traditional arts, including gardening, were affected as well. Gradually, however, Japan was able to reassert its identity and begin to integrate indigenous and foreign elements—often giving rise to new and interesting artistic forms. For example, some gardens incorporated the use of large grassy areas into their designs, giving them a park-like feeling. Since then, the Japanese have continued to experiment with new garden forms, including the adaptation of traditional techniques and materials to restaurants, hotels, public buildings and private residences. As might be expected, the challenge has been to adapt to the needs of modern society without losing the essence of traditional gardens. This challenge is even more keenly felt by those who construct Japanese gardens in other countries where the historical and cultural context is different.

Above: Inspired by the West, expansive lawns became more common in the Meiji Period.

Pages 158–9: A checkerboard of moss and stone slabs bordered by clipped hedges in the North Garden of the abbot's quarters at Tōfukuji Temple, Kyoto.

History

The Meiji Restoration, which ushered in the Meiji Period (1868–1912), abolished the shogunate and samurai class and restored the emperor to power, at least in theory. Japan became a constitutional monarchy and embarked upon the road to rapid modernization, industrialization and urbanization. Young people were sent to Europe and the United States to study modern institutions such as banking, railroads and factories. They also studied the arts, including Western style gardens. Foreign advisors were brought to Japan and many aspects of Western culture became the vogue. The modernization program was so successful that within a few years Japan had built an overseas empire and become a world power. In the following Taisho Period (1912–26), Japan's fledgling democracy gradually gave way to the rising power of the military. During the Showa Period (1926–89), the military took control and led the country into World War II, eventual defeat and occupation by a foreign power for the first time in its history. The death in 1989 of the Showa Emperor Hirohito, the longest-lived emperor in Japanese history, ushered in the present Heisei Period under Emperor Akihito and his consort Michiko.

Post-Edo Trends

In the Meiji Period, a law required the transformation of many larger gardens, such as Edo stroll gardens, into public parks. A few retained their distinctly Japanese character, whereas others, remodeled by designers who had studied in Europe, showed the influence of the West. In some cases, Japanese and Western elements coexisted in different areas of the park without intermingling. In other cases, the two cultural influences were blended. Occasionally, a garden or park was purely Western in inspiration.

The dominant influence from the West was a fascination with naturalism. The traditional emphasis upon the garden as a work of art in which elements such as rocks and trees are shaped and arranged into stylized forms according to widely shared canons of taste and rules was replaced by a much freer creation of natural scenery. Two characteristic features of Western style gardens in the Meiji Period were large grassy areas resembling Western style lawns and the use of a greater variety of vegetation than in the past, with the possible exception of the Heian Period, when many new plant species were introduced from the continent or domesticated from the wild. The former feature

made gardens more "user friendly" and less labor intensive in terms of maintenance. The latter feature made it easier to maintain an attractive appearance throughout the year with a constant succession of flowering plants, shrubs and trees.

In the Showa Period (1926–89), there was a revival of interest in more symbolic and abstract forms, such as those found in traditional *karesansui* (dry landscape) gardens. Even here, however, there was greater freedom in the interpretation of traditional elements and principles. For example, there was more use of dressed stone, such as split granite, rather than natural rocks; new patterns were invented for raked gravel; new rock compositions were devised; and elements such as shrubs and stepping stones were characterized by a greater emphasis upon geometric shapes. The latter trend was a continuation of principles begun in the Edo Period at places such as Daichiji Temple, described earlier, with its *karikomi* (clipped hedge) garden.

Contemporary Gardens

The period following World War II saw an explosion of new gardens. In the past, most gardens were built for the mansions and temples of aristocrats, high-ranking warriors and religious élites. In the post-war era, with its booming industrialization and urbanization, gardens were constructed for government buildings, corporate headquarters, restaurants, hotels and the homes of the rising middle class. Because of the scarcity of space in the rapidly expanding cities, gardens were constructed wherever flat areas could be found, including the roofs of buildings. Despite the expansion of gardens into new contexts, many continued to be created in traditional forms, such as dry landscapes, tea *roji* and stroll gardens.

A particularly interesting and appealing trend has been to transform outdoor pools at upper-end hot spring resorts into gardens where one can sit in the steaming water and enjoy the surrounding rock compositions, pruned trees and shrubs, and perhaps even a waterfall. There also is a trend to make greater use of gardens in the interiors of shopping malls and private homes. Sometimes these gardens are solaria that are enclosed by glass walls and illuminated with a skylight. The challenge has been the same as in the Early Modern Era, however, to maintain something of the essence of the traditional Japanese garden while adapting to the needs of modern society. One of the most pressing of those needs is for places where urban dwellers can take a break from the noise and stress of the workplace, make contact with nature and enjoy a little privacy.

New Materials

A hallmark of the Contemporary Era is the experimentation with synthetic materials to cast rocks for areas such as hotel lobbies—materials that are highly realistic without being heavy and are much easier to install. Some claim that this kind of artificiality, while consistent with modern culture, has departed too far from traditional gardening roots. Another criticism is that many modern gardens are not as much landscape scenes as unique sculptural forms intended to bring recognition to their owners and designers. Others, however, feel that such innovations in form and material are a sign that Japanese gardening is vibrant and continues to evolve and adapt to new circumstances and needs.

Top: Modern stone and water garden at the Kyoto International Community Center. In contrast to the use of natural rocks in traditional gardens, rocks used in modern gardens tend to have more of a sculptural quality.

Above: This modern garden at the Kyoto International Exhibition Hall consists of Kiyomizu pottery (made in Kyoto) that borders a watercourse.

Two Meiji Gardens

The Meiji Period (1868–1912) was a time for experimentation with new forms, materials and contexts. There are, however, a number of Meiji gardens that, while showing modern influences, retain a more or less traditional feeling. The best of these successfully combine Western and Eastern influences. Featured below are two notable gardens from the Meiji Period: Murin-an, located in Kyoto, and Sankeien, located in Yokohama.

Murin-an

Murin-an is a Kyoto villa constructed between 1894 and 1896 (Meiji Period) by noted statesman Yamagata Aritomo. In keeping with the times, the relatively small stroll garden is highly naturalistic. A progressive thinker, Yamagata wished to move away from the highly stylized gardens of the past, while retaining the beauty of traditional gardens. He and his designer, Ogawa Jihei, introduced new elements, such as unusual plant specimens and grass. At the east end of the garden, a three-tiered waterfall, modeled after the one at Daigoji's Sambōin, uses water from a canal to feed a stream

Murin-an is built on a gentle slope, borrowing the hills of Higashiyama as its backdrop. Water is brought in by way of a canal to feed a three-tiered waterfall, a pond and a stream.

that runs over rapids into a second pond. Gone are the artistically arranged rock compositions so typical of most traditional Japanese gardens. Instead, the scenery along the stream is an idealized version of what one might expect to find in a wooded meadow. This natural feeling is enhanced through the use of borrowed scenery in which the mountains east of the city can be viewed through a gap in the trees.

There are three structures on the property: the two-storied wooden main house, a teahouse and a two-storied Western style house where a meeting to set foreign policy was held prior to the Russo-Japanese War. The "Murin-an Conference" was attended by Marshal Yamagata Aritomo, Prime Minister Katsura Tarō, Foreign Minister Komura Jutarō and Itō Hirobumi, leader of the Seiyū-kai Party and future prime minister of Japan.

Murin-an villa and gardens were donated to Kyoto City in 1941, and in 1951 the garden was designated by the government as a Place of Scenic Beauty. It is often ranked as one of the finest gardens in Japan.

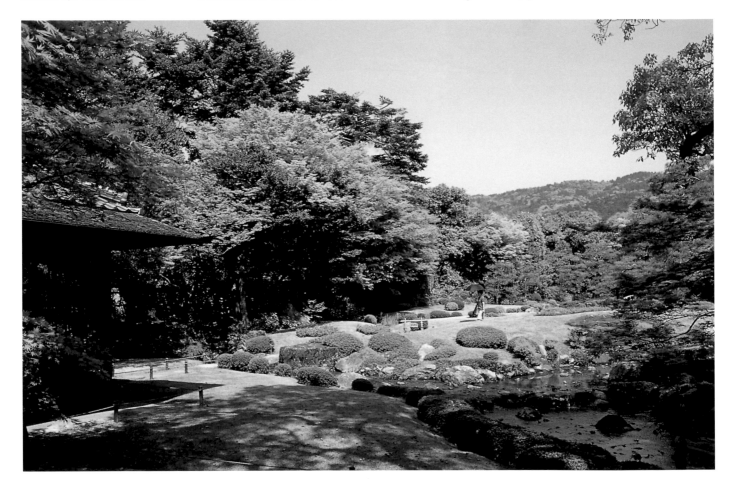

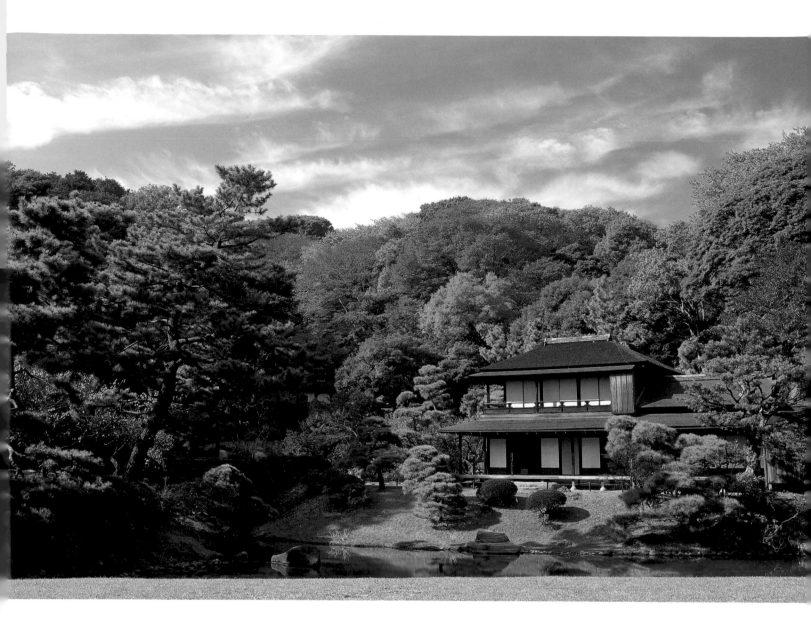

Sankeien

Sankeien, located in Honmoku, Yokohama City, was constructed by Hara Sankei, a Yokohama businessman who made his fortune in silk. It consists of two areas, the Inner and Outer gardens. Until it was opened to the public, the Inner Garden was a private area for the Hara family, which lived in Kakushōkaku, the former family mansion. Hakuuntei, next to it, is a retirement villa constructed by Hara Sankei. The family also moved a number of historic buildings to the site, including Rinshunkaku, an Edo Period warrior mansion originally built in Wakayama for the Kishu branch of the Tokugawa family, three teahouses, old temple structures and buildings from Hideyoshi's Fushimi Momoyama and Nijō castles. Rinshunkaku often has been compared to the Katsura Detached Palace in Kyoto because of its elegant Sukiya style. Rinshunkaku and Hakuuntei are open once a year in August for public viewing.

The Outer Garden is an extension created as a stroll garden for viewing flowers throughout the year. It features seventeen buildings of historic importance, including temple structures, teahouses and traditional farmhouses that Hara dismantled and moved from places such as Kyoto and Kamakura. The relocated buildings are situated in a hilly, wooded area around a large pond. The central feature of the Outer Garden is a three-storied pagoda from Tōmyōji Temple in Kyoto. Originally constructed in 1457, it is the oldest pagoda in the Tokyo area. The Outer Garden was opened to the public in 1909 and the Inner Garden in 1958.

The Second World War caused great damage to Sankeien. In 1953, the property was transferred from the Hara family to the Sankeien Hoshōkai Foundation, which has nearly restored Sankeien to its former appearance.

Rinshunkaku Villa in Sankeien Park and its garden are a successful blend of Western and traditional elements and principles. The simplicity of the lawn and pond contrast with the multicolored foliage of the hills in the background. The building itself is an Edo Period *daimyō* mansion that was moved to Sankeien.

Two Showa Gardens

West (above) and North (below) gardens of the superior's quarters at Tōfukuji Temple in Kyoto—both with a checkerboard theme. In the West Garden, the basic elements are clipped shrubs and gravel, whereas in the North Garden the checkerboard is constructed of moss and cut stones. The fascination with geometric forms is consistent with the Showa Period origins of these modern gardens.

In the Showa Period (1926–89), there was renewed interest in abstract forms and compositions, such as those found in the gardens of Tōfukuji Temple in Kyoto and the Adachi Museum in Shimane Prefecture. This involved a departure from the naturalism of the Meiji Period (1868–1912) and a partial return to ideas explored in Zen gardens of the Kamakura (1185–1333) and Muromachi (1333–1573) periods.

Tōfukuji's Hōjō Garden

Tōfukuji Temple, founded in the Kamakura Period, was once one of the great Zen monasteries of Kyoto, with 101 sub-temples. Over the centuries, the buildings were destroyed by fire, including the Hōjō, which burned in 1880. Though the Hōjō was rebuilt nine years later, it was not until 1939 that Shigemori Mirei, a leading landscape architect of his day, was commissioned to design new gardens for the abbot's quarters. Thus, in contrast to the more common practice of reconstructing or remodeling older gardens, Shigemori was provided with the opportunity to explore new ideas. His goal was to express Kamakura Zen in modern terms. He believed that this would be possible because simplicity was emphasized in both periods. The gardens, which provide a good example of Showa Period trends, do indeed have a modern feel and are elegant in their simplicity, though they are not as easy to appreciate as many of Japan's more traditional landscape gardens.

There are four gardens at Tōfukuji, one on each side of the superior's quarters. The main garden, to the south of the Hōjō, is the most traditional of the four. It is a *karesansui* creation, divided into two parts. In the eastern part are four separate rock groupings that represent *hōrai* islands (where the immortals live). The western part contains five grassy hills representing the five most important Buddhist temples of the Kamakura Period, including Tōfukuji. The two parts are unified by a sea of raked gravel and a white, tile-capped wall that encloses two sides of the complex.

The West Garden is composed of a checkerboard pattern in which the dark squares consist of low trimmed shrubs and the white squares are made of gravel. This theme is picked up in the North Garden where square stones are set in a carpet of moss. In the West Garden, the geometric severity is balanced by an irregularly shaped bed of flowing moss. In the North Garden, a similar softening effect is provided by an adjacent hillside covered with Japanese maples.

The East Garden features seven cylindrical cut rocks, formerly foundation stones for another building. Arranged to represent the Big Dipper, the constellation is surrounded by raked gravel.

The Tōfukuji compound is divided by a valley, which is crossed by three bridges. The most famous of these, Tsūtenkyō, was constructed so that the monks at the temple could walk to the Hondō without descending into the valley. Every autumn, thousands of visitors stand on this bridge to see the colorful foliage of the more than 2000 maple trees planted in the valley.

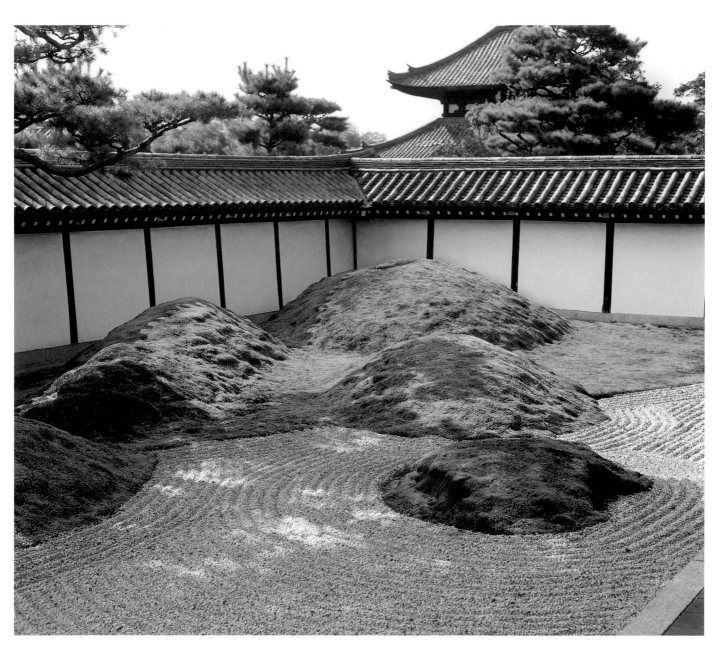

Adachi Museum Garden

In 2003, the Adachi Museum Garden, located in Shimane Prefecture on the Japan Sea side, was ranked as Japan's finest by *The Journal of Japanese Gardening*. The museum houses early modern Japanese paintings, ceramics, wood sculpture and gold lacquer ware and is surrounded by 4 hectares (10 acres) of gardens designed by Nakane Kinsaku in 1970 for the museum's founder, the late Adachi Zenkō. Adachi described the gardens as a picture scroll that unrolls before visitors as they stroll through the wings and corridors of the museum, peering through the large plate glass windows.

There are four principal garden areas: Pond Garden, Dry Landscape Garden, White Gravel and Pine Garden and Moss Garden. To provide

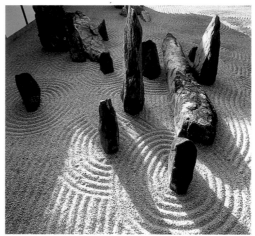

Above: These grassy hills in the western part of the South Garden symbolize the five most important Buddhist temples of the Kamakura Period.

Left: Detail of a raked sand pattern representing a water eddy.

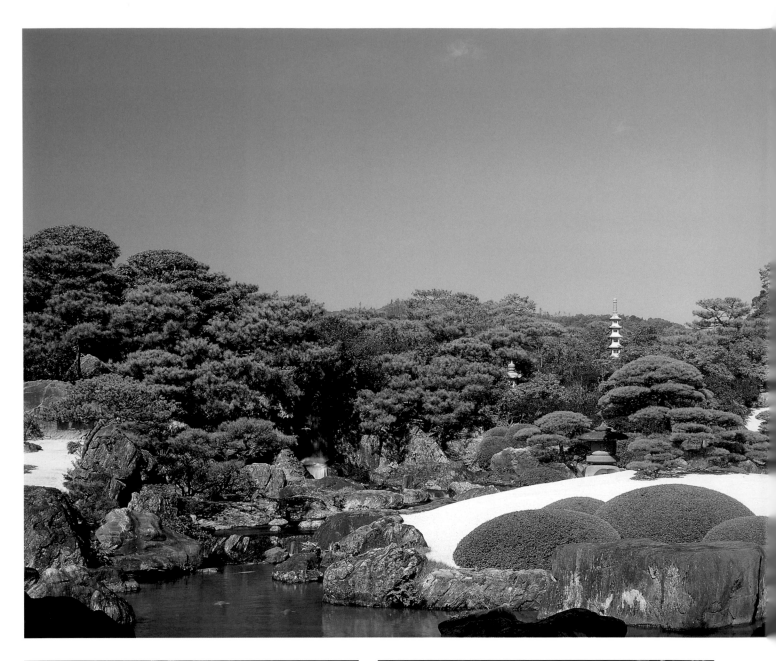

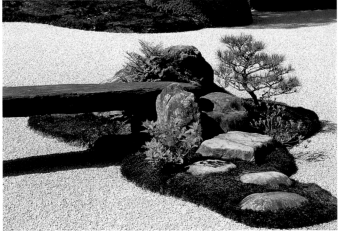

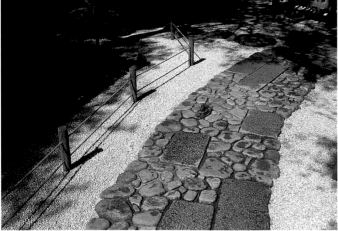

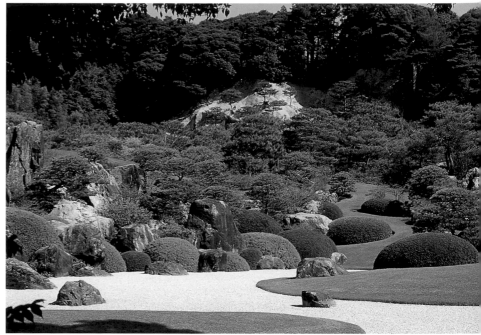

a contrast with the other gardens, which were constructed in a more traditional style, and to harmonize with the Western style buildings of the museum, the Pond Garden was designed in a modern semi-Western style. It consists of a small pond with colorful carp surrounded by trees and rocks and crossed by a slab stone bridge. The clean lines of the museum form a simple backdrop for one side of the pond. On the other side, a "dewy path" leads to Juryū-an Teahouse, nestled in a clump of trees and surrounded by a bamboo fence. Juryū-an is modeled after a famous teahouse at Katsura Rikyū.

The Dry Landscape Garden, viewed from the lobby, is the museum's main garden. It consists of large areas of white raked gravel that flow among grassy slopes and hills, punctuated by rock compositions and trimmed bushes. In summer, the white sand and verdant green of the grass and bushes provide a contrast to the bluish haze of the distant mountains that are skillfully blended into the scene to create a sense of great depth.

The White Gravel and Pine Garden also is partly in the *karesansui* tradition. Trained black pines are interspersed among areas of white gravel, rocks, trimmed azalea bushes and a small pond. In the background is an artificial waterfall that cascades 15 meters down a slope to provide a touch of motion in an otherwise seemingly unchanging environment.

The Moss Garden features a broad river of raked white gravel bordered by undulating moss banks. Growing from the moss are over 800 red pines planted at a slant, as they would grow in the mountains. At the end of the summer, the needles and branches are carefully pruned and the outer bark is stripped from the trunks so the orange colors underneath can be enjoyed by visitors. The moss garden is particularly beautiful after a rain.

Despite their traditional inspiration, the gardens at the Adachi Museum have a surreal quality with a distinctly modern feel. Seen through the large windows of the museum, they are "paintings" to be viewed but not entered. The meticulously maintained landscapes are perfect in every detail. Each morning a small army of employees pick up stray leaves and carefully rake the gravel. The perfection of the Adachi Museum gardens provides an interesting contrast to the intimate atmosphere of a tea *roji*, whose goal was to capture the beauty of impermanence and imperfection.

Above: The Kikaku-no-taki waterfall, seen in the distance, provides a touch of movement to a tranquil scene.

Opposite: A view of the White Gravel and Pine Garden of the Adachi Museum Garden, with the hills in the background used as borrowed scenery.

Opposite below left: Close-up of a rock composition and bridge at the Adachi Museum.

Opposite below right: Natural and cut stone path leading to the Juryū-an Teahouse, a reproduction of Shōkintei at Katsura Rikyū.

Japanese Gardens Outside of Japan

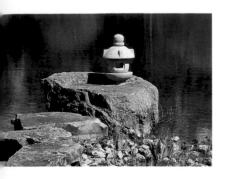

Above: This Misakigata lantern on the pond at the Kurimoto Japanese Garden has no shaft.

Below: Bridge and thirteen-story granite pagoda at the Kurimoto Japanese Garden. The vegetation is all indigenous to Alberta, Canada. The garden was inspired by Murin-an Garden in Kyoto.

Japanese traditional gardens have created considerable interest in foreign countries. There are more than 300 Japanese gardens outside of Japan, as well as a number of societies established to promote the study and creation of Japanese gardens abroad. One of the main challenges facing those who construct Japanese gardens in other countries is how to retain authenticity while making adaptations to other climates and cultures.

Garden Locations

The Journal of Japanese Gardening recently distributed a questionnaire to thirty-nine Japanese garden specialists in Europe, North America and Australia asking them to list the highest quality Japanese gardens located outside of Japan. Respondents were encouraged to focus upon characteristics such as subtleness and natural beauty rather than size and fame. Most of the highest ranking gardens are located in the United States, but there are many noteworthy gardens in other countries as well, such as Canada, Australia, the United Kingdom, Germany, Holland, France, Finland and Poland—to mention only a few.

Resources

A number of Japanese garden societies have been established outside of Japan, such as the Japanese Garden Society of Houston (USA), the Japanese Garden Forum (USA), the Japanese Garden Society (UK), the Vancouver Japanese Gardeners Association (Canada), and the International Association of Japanese Gardens Inc. (USA). The mission of the latter, which publishes *The Journal of Japanese Gardening* (http://www.alcasoft.com/roth/), is "to promote intercultural communications by celebrating and studying Japanese gardens throughout the world." The interactive website, *The Japanese Garden Database* (http://www.jgarden. org) is a major resource for information on Japanese gardens.

International symposia on Japanese gardens are held each year in different parts of the world. The Fourth International Symposium of Japanese Gardens, held in 2004 in Seattle, Washington, dealt with issues such as the innovations that exemplify the process of adapting Japanese gardens to other cultures, and what makes a garden Japanese. Basic to both of these issues is the question of how to maintain authenticity. Maintaining authenticity does not mean copying existing gardens in Japan or importing Japanese shrubs, trees, flowers and stone artifacts. Authenticity is more a matter of using compositional principles and techniques that have proven themselves effective over the centuries in terms of providing inspiration to viewers. Authenticity involves using Japanese training and pruning techniques to transform a shrub or tree into a work of art, even if the plant has never been used in a Japanese garden before. In other words, maintaining authenticity is not in conflict with creativity, experimentation and change.

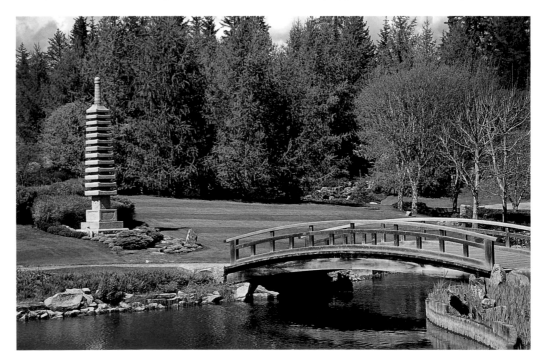

Kurimoto Japanese Garden, Canada

Kurimoto Japanese Garden, belonging to the University of Alberta in Edmonton, Canada, opened in 1990. It was designed by Kubo Associates in Japan and constructed under the supervision of Mitani Kōzō. It is said that when Mitani accompanied a crew to the Rocky Mountains to obtain stones, he saw that the crew was about to use dynamite. He said, "Stop! There is no use constructing a Japanese garden if the *kami* (nature spirits) leave. We have to treat the rocks with respect and handle them gently." When university officials complained that using traditional techniques to obtain and handle rocks would be too expensive, Mitani threatened to resign and return to Japan. The university finally agreed to do things his way, resulting in one of the most authentic and northernmost Japanese gardens in the world.

The garden was inspired by Murin-an Garden in Kyoto, which, interestingly enough, was influenced by Western gardening concepts in the Meiji Period. The Kurimoto Garden, which is a miniature reflection of the varied topography of Alberta, is organized around a pond fed by two streams and surrounded by grassy knolls and indigenous vegetation, such as aspen, spruce, white birch and tamarack. The rocks for the streams and pond took two years to collect and another two years to place. Though planned as a stroll garden, the tranquil atmosphere encourages visitors to stop at one of the many scenic viewpoints for a few minutes of contemplation and self-reflection. The garden is popular throughout the year.

Portland's Japanese Garden, USA

The Japanese Garden of Portland, Oregon, located in Washington Park, is widely considered to be one of the most authentic Japanese gardens outside of Japan. From its beginnings, the garden has been supported by the efforts of civic and political leaders, as well as the Japanese Garden Society of Oregon. It is maintained with the help of volunteers, admissions and gifts.

The garden consists of nine acres featuring five areas: a strolling pond garden, tea garden with a teahouse, natural garden, flat garden and sand-and-stone (*karesansui*) garden. Professor Tōno Takuma, an internationally recognized authority and chair of the Landscape Architecture Department of Tokyo Agricultural University, was commissioned in 1963 to design and supervise development of the garden. It opened in 1967.

The largest area, the strolling pond garden, makes use of traditional "borrowed scenery" and "hide-and-reveal" techniques. In this case, the

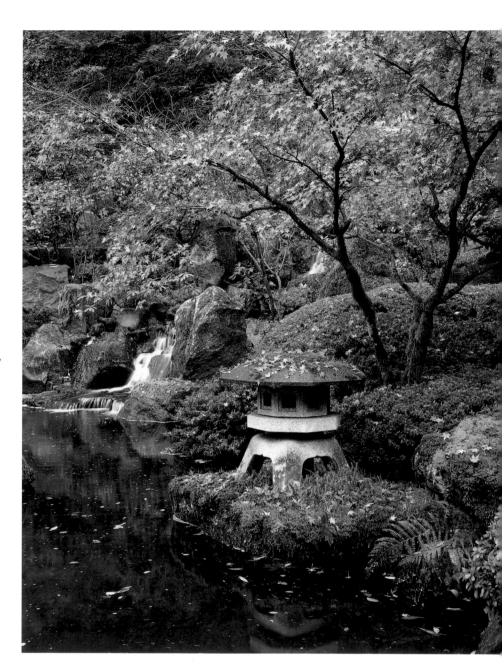

borrowed scenery is the Cascade Range, featuring Mount Hood. Special features of the pond garden include a wisteria arbor, a five-tiered pagoda, a lantern provided by Sapporo, Portland's sister city, picturesque bridges, a waterfall and iris beds that bloom in late June. Also featured is a teahouse that was built in Japan, disassembled and rebuilt in Oregon. In 1963, Yokohama's mayor presented the garden with a peace lantern to commemorate the first landing of a ship on the west coast of the United States after the Second World War.

Yukimigata snow-viewing lantern in the Portland Japanese Garden, Oregon.

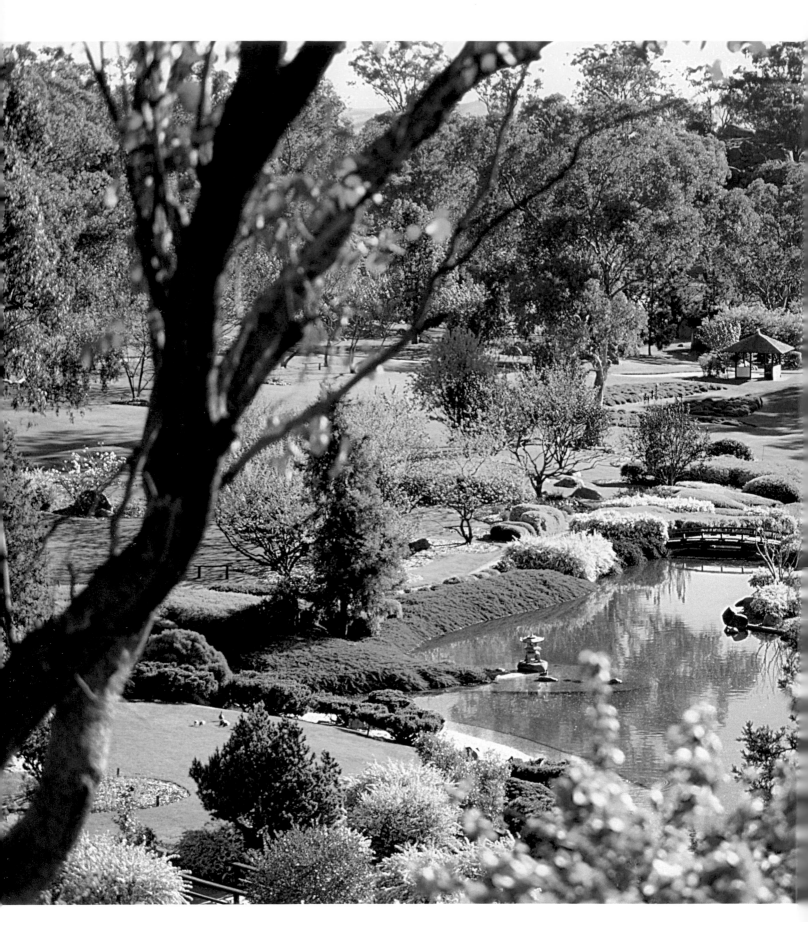

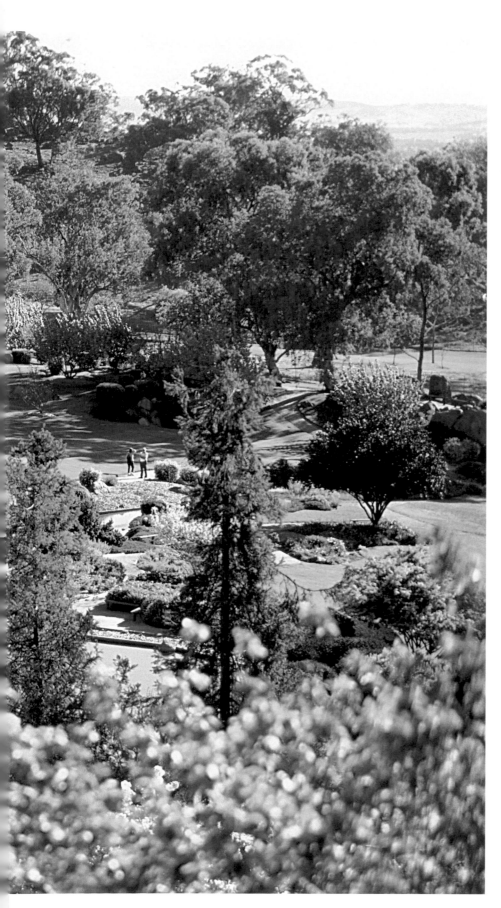

Cowra Japanese Garden, Australia

The Cowra Japanese Garden and Cultural Centre in Cowra, New South Wales, Australia is located on five hectares (approximately 12 acres)—the largest Japanese garden in the southern hemisphere. Cowra was the site of a prisoner-of-war camp where, in 1944, 231 Japanese prisoners were killed in a desperate break for freedom. The Japanese soldiers were buried at Cowra. After the war, Australian veterans decided to forget the past and help maintain the Japanese graves. This action led to friendship between Cowra and Japan and the eventual construction of a Japanese stroll garden with the aid of the Cowra Tourist Development Corporation, the governments of Japan and Australia, and private donors. Construction began in 1978 under the guidance of renowned garden architect Nakajima Ken.

The extensive garden comprises two areas: a *karesansui* garden designed to be viewed from a fixed perspective, and a stroll garden organized around a pond with a *hōrai* island and a curved bridge modeled after the one at Sankeien Garden in Yokohama. Flowing into the pond is a stream that issues from the base of a vertical pointed rock situated on the top of a nearby hill. The presence of this rock, believed by the designer to be a Shugoseki or guardian deity, was the deciding factor in the selection of this site for the garden. Near the Shugoseki is a large flat rock, Yōgōseki. In Japan, such a rock represents the place where *kami* or spirits descend to earth. To Nakajima Ken, the Yōgōseki symbolizes the place where the spirits of Australian and Japanese soldiers come to find peace.

The garden as a whole is designed to represent the varied landscape of Japan and incorporates Japanese trees such as cherry and maple. Indigenous trees were also included, such as eucalyptus, needed to shade underlying vegetation from the hot Australian sun.

Other attractions featured in the garden include a Shinto style *torii* modeled after the famous entrance gate to Itsukushima Shrine at Miyajima, a traditional cottage with *tatami* mats, a teahouse with *roji*, a moon-viewing platform, and a Buddhist bronze bell. Every spring, when visitors come to see the cherry blossoms, the garden sponsors a variety of cultural events, such as flower arranging, calligraphy and tea ceremonies.

Nakajima Ken, whose ashes are buried in the garden, oversaw all aspects of the garden's design and construction. He was proud of the result and often referred to the Cowra Japanese Garden as his favorite garden outside Japan.

Pond at the Cowra Japanese Garden, New South Wales, Australia.

Modern Residential Gardens

Traditional Japanese gardens are expensive to construct and difficult to maintain. Some of the basic principles of traditional gardens, however, can be adapted for the construction of modern residential gardens, even in countries other than Japan. For example, good results can be obtained by keeping things simple, providing balanced asymmetry, and having the patience to wait for the garden to develop the patina of age.

Types of Residential Gardens

Small courtyard (*tsubo*) gardens are best for viewing from inside a house whereas tea style *roji* are more appropriate for creating an interesting approach to the entrance. In some cases, traditional garden elements such as small ponds, rock arrangements and Japanese lanterns are combined with modern elements such as a deck, a barbecue area or a lawn. In situations where there is no room for an outdoor garden, miniature tray gardens (*bonkei*) are becoming popular. *Bonkei* can be constructed entirely of rocks and gravel (*karesansui* style) or a mixture of rocks, gravel and miniature trees (*bonsai*).

Another basic distinction is between "wet" and "dry" gardens. A wet garden generally has a small pond with a waterfall fed by a circulating pump, as well as plants. Wet gardens provide a cool spot on a hot day, but they require a good deal of care and maintenance in terms of tending the plants. Also, in cold climates, pumps must be dismantled and serviced before the freeze-up. Dry gardens composed entirely of rocks and gravel require less maintenance and can be attractive in both rain or snow. But they are too monochromatic and "static" for the needs of many people. A combination of wet and dry elements works well if skillfully done. For example, a waterfall and a stream, constructed without the use of water, can be combined with plants such as ferns and mosses.

Other Considerations

One of the most important considerations in planning a residential garden is the suitability of plants in terms of the growing season for a particular area. In general, it is always safer to use indigenous species. Another consideration is the size of the mature plants selected for the garden. A rock waterfall looks much more convincing flanked by ferns than by large bushes or trees. An alternative is to use potted dwarf trees and shrubs. Though it is difficult to find artifacts such as stone lanterns and pagodas in countries other than Japan, it is possible to use modern substitutes made of concrete or synthetic materials. As the technology improves, synthetic artifacts are becoming more attractive.

Relevance of Traditional Principles

Some of the basic principles of traditional Japanese gardens are relevant to modern residential gardens. For example, the concept of borrowed scenery usually applies to bringing a distant mountain or neighboring hillside into a garden composition. But it can also apply to something as mundane as the stucco wall of a neighbor's house, which can provide a suitable backdrop for shrubs and flowering plants. When carefully considered, extraneous features often can be turned into assets.

The most basic of all traditional principles is to keep things simple—to understate rather than overstate. Despite the considerable resources at their disposal, Japanese warriors (shoguns and

This small residential entrance garden near Shisendō Temple in Kyoto is somewhat unique in that it is outside the gate. A modern touch is provided by incorporating a ceramic pot.

daimyō) usually failed to create first-class gardens because they were overly concerned with a display of wealth and power. As a result, their gardens tended to be too complex and ostentatious. If this was a problem in large warrior gardens, it is even more of an issue in small residential gardens. It is easy to overwhelm a small area with too many rocks, trees and flowers. It is also possible to use too much color. Flowering plum, crabapple or cherry trees are beautiful but if they attract too much attention to themselves, they can diminish the aesthetic value of the garden as a whole.

Creating a Natural Look

What is the essence of a Japanese garden, given the variety of forms gardens have taken over the centuries? This is very difficult to answer. It seems clear, however, that part of the secret of a Japanese garden lies not in the presence or absence of specific elements but in the ability to create something with aesthetic value and yet with a natural feeling. When this is done successfully, the result is a type of beauty that brings a sense of tranquility, whether one is viewing the garden from inside a building or strolling down its pathways.

It is worth emphasizing that a Japanese garden is a work of art. The authors once heard of an individual who attempted to make his garden look natural by writing numbers on pieces of paper that corresponded to the numbered squares on graph paper. He put all of the pieces of numbered paper into a hat, shook them up and pulled out several slips whose numbers were used to indicate where shrubs and trees should be planted. To him, "natural" meant "random." Such attempts rarely are successful as creating a garden with a natural feeling requires considerable attention to composition.

One of the primary principles of composition in traditional gardening is to arrange an uneven number of rocks, shrubs and trees into small groupings. The most favored grouping is a triangle, vertical or horizontal. A vertical arrangement has a triangular shape when viewed from the side, whereas a horizontal arrangement has a triangular shape when viewed from above. In either case, the elements composing the triangle should be of different sizes and shapes. In many cases, they should be of different colors. In other words, the Japanese approach to achieving a natural effect employs the principles of balanced asymmetry and contrast.

A related technique is to use materials and arrangements that provide a refined but rustic look, that have the patina of age. These ideas were inherent in the concept of *wabi-sabi*, used by the tea masters. For example, constructing a path of paving stones with irregular contours is generally more interesting than using paving stones with geometric shapes such as squares or circles. To take another example, rocks covered with lichens or moss are generally more interesting than newly split stones, though there are situations in which the use of split stones is effective. A new residential garden needs time to mature. With careful maintenance and patience, it eventually can come to look as if it is a natural part of the surroundings.

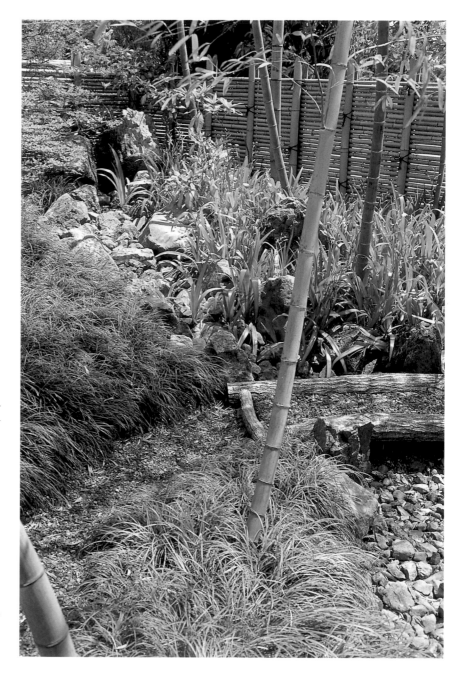

The simple path and bridge in this "dry" garden are made of crushed stones. The stream is represented by pebbles.

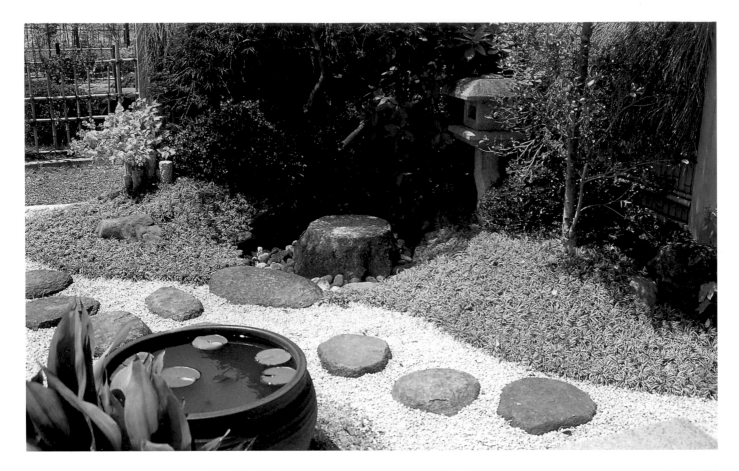

Above: This large pot picks up the other rounded shapes in the garden and serves as a place to plant water lilies and to provide water for birds.

Right: Rock *tsukubai* (water basin) fed by a bamboo pipe.

Far right: This small *yukimigata* (snow-viewing) lantern rests on a rock to raise it above the surrounding vegetation and adjacent path and thereby make it a focal point.

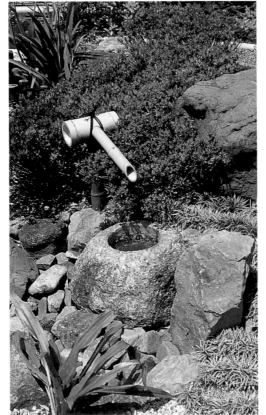

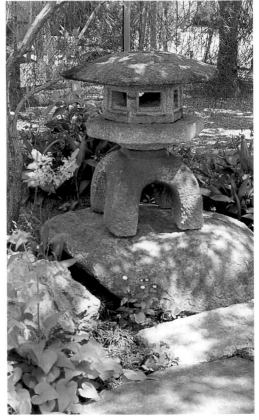

Glossary

bakufu feudal military government

bushidō Way of the Warrior, a code of behavior for samurai

chaniwa tea ceremony garden featuring a *roji* ("dewy path")

chanoyu tea ceremony, often referred to as *sadō*, the Way of Tea

chisen-kaiyū-shiki teien stroll style garden around a pond

chisen shūyū teien pond garden to be enjoyed from a boat

daimyō lord of a feudal domain/castle

dobashi moss- or turf-covered bridge

esoteric Buddhism denominations based upon secret teachings and practices

funa asobi pleasure boating on a pond

haiku short 17-syllable "tone poem"

hinbonseki three rocks that form a horizontal triangle when viewed from above

hōjō abbot's residence within a temple

Hondō main hall of a Buddhist temple; called Kondō in some denominations

hōrai sacred mountain in Chinese legend; a *hōrai* island is a mountainous island in the sea where the immortals live

ishibashi stone bridge

ishi-date-sō stone-setting priests

jari gravel

Jōdo Pure Land (or Western Paradise) of Amida Buddhism

kaiyū shiki teien excursion garden

kakei bamboo pipe that delivers water to a wash basin in a garden

kameshima turtle island

kami divine spirit or Shinto deity

kanshō scene to be contemplated

karedaki (or karetaki) dry waterfall

karesansui dry landscape; flowing water is suggested by rocks and gravel

karikomi clipped hedge often used in *karesansui* gardens

kiriishi cut rock

kuromatsu black pine

kuruma-yose carriage approach attached to a warrior mansion

kyakuden shoin style reception hall in warrior and temple residences

ma interval; the use of empty space in Japanese art and gardens

machiai covered arbor where one waits to be summoned to a tea ceremony

miegakure hide-and-reveal techniques used in stroll gardens

miya early name for a building that served as a shrine/palace

monzeki temple whose head is a member of the imperial family

mu sacred void; potentiality that lies beyond time and space

niwa garden; in early times, a space set aside for special events

Paradise garden Pure Land garden in Jōdo (Amida) Buddhism

rinsen kaiyū teien scenic promenade style garden

roji "dewy path"; stepping-stone walk

found in tea gardens

rōkyō (or kurehashi) covered bridge

sabi the patina that comes with age

Sakuteiki eleventh-century gardening text

sanzonseki arrangement of three rocks representing a Buddhist trinity

shakkei borrowed scenery

shinden main building of a Shinden style mansion

shin-gyō-sō transition from formal to semiformal to informal in a garden

Shinto Japanese indigenous religion

shishi odoshi "deer scare"; originally developed by farmers to frighten off deer and wild boar

shoin originally a small study that later developed into an audience hall

soribashi arched bridge

suna sand

teien modern Japanese term for garden

tokonoma recessed alcove for art objects in a traditional Japanese room

tsuboniwa small courtyard garden

tsukiyama artificial hill garden

tsukubai water basin

tsurushima crane island

wabi austere, ordinary, natural and imperfect

waka classical short poem

yukimigata snow scene lantern

yuniwa consecrated spot; sacred ground

Zen form of Mahayana Buddhism that emphasizes *zazen* (meditation)

Acknowledgments and Photo Credits

We are especially grateful to the Kyoto office of the Imperial Household Agency for their considerable help, as well as Nishi Honganji Temple in Kyoto and Ritsurin Kōen in Takamatsu. Other individuals who have provided us with valuable assistance are Don Springings, Kurimoto Japanese Garden; Sarah Fawcett, Japanese Garden Society of Oregon; Julie Newton, Dietrich Leis Stock Photography; Jennifer Miller, Cowra Japanese Garden and Cultural Centre; and Elizabeth Maloney, Tourism New South Wales. Books in Japanese that have been especially helpful are *Nihon no Niwa, Ishigumi ni Miru Nihon Teien-shi* by Saitō Tadakazu, 1999 and *Nihon Teien no Mikata* by Miyamoto Kenji, 1998. We are indebted to Noor Azlina Yunus, our editor, for her constant support.

a=above; b=below; c=center; l=left; r=right

Dianne Dietrich Leis Photography, 169; **Imperial Household Agency, Kyoto office**, 30–1, 52–3, 60–1, 133a, 134–5, 136, 137b; **Keystone**, back cover, 1, 4–5, 11, 15, 24, 28, 37ar, cr, bl, 43, 50–1, 56–7, 74–5, 83, 85a, 87, 88–9, 91, 93br, 108, 109c, 111a, 113, 124, 125, 127b, 139, 144–5, 149, 163, 165a, 166–7a; **Masano Kawana**, endpapers; **Nishi Honganji Temple**, 115; **Ben Simmons Photography**, front cover, 6, 23, 26b, 29, 37al, br, 45b, 46, 47, 48, 55, 59cl, cr, bl, 63, 65b, 67b, 97, 98, 99b, 118, 121a, 158–9, 165b; **Tourism New South Wales**, 170–1; **David and Michiko Young**, 2–3, 8–9, 12–13, 14, 16, 17, 18–19, 20, 21, 22, 26a, 30l, 32, 34, 36, 37cl, 38, 39, 40, 42, 44–5, 45a, 49, 54, 58, 59al, ar, br, 65a, 67a, 68, 69, 70, 71, 72, 73, 77, 78, 79, 80–1, 81, 82, 85b, 86, 92, 93a, b, 95, 96, 99a, 100, 101, 103, 104–5, 105, 106, 107, 109a, 110, 111b, 116, 117, 119, 120, 121bl, br, 122, 123, 127a, 128–9, 129, 130, 131, 132, 133b, 137a, 140–1, 141, 142, 143, 146–7, 147, 150–1, 152, 153, 155, 156, 157, 160, 161, 162, 166bl, br, 167, 168, 172, 173, 174.

Bibliography

Albright, Bryan and Constance Tinsdale, *A Path Through the Japanese Garden*, Ramsbury, Wiltshire, UK: Crowood Press, 2000.

Berthier, Francois and Graham Parks (translator), *Reading Zen in the Rocks: The Japanese Dry Landscape Garden*, Chicago: University of Chicago Press, 2000.

Bibb, Elizabeth and Michael S. Yamashita (photographer), *In the Japanese Garden*, Golden, Colorado: Fulcrum Publishing, 1996.

Borja, Erik and Paul Maurer, *Zen Gardens*, London: Seven Dials, 2001.

Bring, Mitchell and Josse Wayambergh, *Japanese Gardens: Design and Meaning*, New York: McGraw-Hill, 1988.

Carver, Norman, *Form and Space in Japanese Architecture and Gardens*, Kalamazoo, Maryland: Documan Press, 1991.

Cave, Philip, *Creating Japanese Gardens*, Rutland, VT & Tokyo: Charles E. Tuttle Co., 1993.

Conder, Josiah, *Landscape Gardening in Japan*, Tokyo: Kōdansha International, 2002 [1893].

Du Cane, Ella, *The Flowers and Gardens of Japan*, London: Kegan Paul International, 2004.

Earle, Joe (ed.) and Hibi Sadao (photographer), *Infinite Spaces: The Art and Wisdom of the Japanese Garden* (Based on the *Sakuteiki*), Boston; Rutland, VT & Tokyo: Tuttle Publishing, 2000.

Engel, David, *Japanese Gardens for Today*, Rutland, VT & Tokyo: Charles E. Tuttle, 1959.

Engel, David H., Kudō Masanobu and Seike Kiyoshi, *A Japanese Touch for your Garden*, Tokyo: Kōdansha International, 1980.

Gotō, Seiko, *The Japanese Garden: Gateway to the Human Spirit*, Peter Lang Publishing, 2003.

Harada, Jirō, *Japanese Gardens*, Boston: Charles T. Branford Co., 1956.

Hayakawa, Masao (trans. Richard Gage), *The Garden Art of Japan*, New York & Tokyo: Weatherhill & Heibonsha, 1973.

Hendy, Jenny, *Zen in Your Garden: Creating Sacred Spaces*, Rutland, VT & Tokyo: Charles E. Tuttle, 2001.

Hibi, Sadao, *A Celebration of Japanese Gardens*, Tokyo: Graphic-sha, 1994.

Higuchi, Tadahiko, *The Visual and Spatial Structure of Landscapes*, Cambridge, Mass.: MIT Press, 1983.

Horiguchi, S. and Kōjiro Y., *Tradition of Japanese Gardens*, Tokyo: Kokusai Bunka Shinkōkai, 1962.

Houser, Preston L. and Mizuno Katsuhiko (photographer), *The Courtyard Gardens of Kyoto*, Mitsumura Suiko Shoin, 1996.

_____, *Invitation to Kyoto Gardens*, Kyoto: Mitsumura Suiko Shoin, n.d.

_____, *Invitation to Tea Gardens*, Kyoto: Mitsumura Suiko Shoin, 1992.

Inaji, Toshirō (trans. Pamela Virgilio), *The Garden as Architecture: Form and Spirit in the Gardens of Japan, China and Korea*, Tokyo: Kōdansha International, 1998.

Itō, Teiji (trans. Ralph Fiedrich & Masajiro Shimamura), *Space and Illusion in the Japanese Garden*, New York & Tokyo: Weatherhill & Tankōsha, 1973.

_____, *The Gardens of Japan*, Tokyo: Kōdansha International, 1984.

Keane, Marc P., *Japanese Garden Design*, Rutland, VT & Tokyo: Charles E. Tuttle, 1996.

_____, *Sakuteiki: The Art of Setting Stones*, Rutland, VT & Tokyo: Tuttle Publishing, 2002.

Kitamura, Enginsai, *Tsukiyama Teizōden* (Building Mountains and Making Gardens), Kyoto: Ogawa Tazaemon, 1735.

Klingsick, Judith D., *A Japanese Garden Journey: Through Ancient Stones and Dragon Bones*, Stemmer House Publishers, 1999.

Kōdansha Encyclopedia of Japan, Tokyo, 1993.

Koren, Leonard, *Gardens of Gravel and Sand*, Berkeley: Stone Bridge Press, 2000.

Kuck, Loraine, *The World of the Japanese Garden: From Chinese Origins to Modern Landscape Art*, New York & Tokyo: Weatherhill, 1984.

Kuitert, Wybe, *Themes in the History of Japanese Garden Art*, Honolulu: University of Hawaii Press, 2002.

Main, Alison and Newell Platten, *The Lure of the Japanese Garden*, Kent Town, South Australia: Wakefield Press, 2002.

Mizuno, Katsuhiko and John Bester, *Landscapes for Small Spaces: Japanese Courtyard Gardens*, Tokyo: Kōdansha International, 2002.

Mori, Osamu, *Typical Japanese Gardens*, Tokyo: Shibata Publishing Co., 1962.

Morse, Edward S., *Japanese Homes and Their Surroundings*, New York: Dover Publications, 1961 [1886].

Nakane, Kinsaku, *Kyoto Gardens*, 22nd edn, Osaka: Hoikusha, 1992.

Newsom, S., *Japanese Garden Construction*, Tokyo: Dōmoto, Kumagawa, and Perkins 1939.

Nitschke, Günter, *Japanese Gardens: Right Angle and Natural Form*, Köln: Benedict Taschen Verlag, 2003.

Nose, Michiko Rico, Masuno Shunmyō and Michael Freeman, *The Modern Japanese Garden*, Rutland, VT & Tokyo: Tuttle Publishing, 2002.

Ōhashi, Haruzō, *Japanese Courtyard Gardens*, Tokyo: Graphic-sha, 1988.

_____, *The Japanese Garden: Islands of Serenity*, Tokyo: Graphic-sha, 1986.

Rambach, Pierre and Susanne Rambach, *Gardens of Longevity in China and Japan: The Art of the Stone Raisers*, New York: Skira &Rizzoli, 1987.

Sansom, G. B., *Japan: A Short Cultural History*, New York: Appleton, Century, Crofts, 1962.

Seike, Kiyoshi, Kudō Masanobu and David H. Engel (editorial consultant), *A Japanese Touch for Your Garden*, Tokyo: Kōdansha International, 1980, 1992.

Shigemori, Kanto, *The Japanese Courtyard Garden: Landscapes for Small Spaces*, New York: Weatherhill, 1981.

Slawson, David A., *Secret Teachings in the Art of Japanese Gardens: Design Principles*, Tokyo: Kōdansha International, 1987.

Takakuwa, Gisei and Asano Kiichi (photographer), *Japanese Gardens Revisted*. Rutland, VT & Tokyo: Charles E. Tuttle, 1973.

Takei, Jirō and Marc P. Keane, *Sakuteiki: Visions of the Japanese Garden*, Rutland, VT & Tokyo: Charles E. Tuttle, 2001.

Tamura, Tsuyoshi, *Art of the Landscape Garden in Japan*, Tokyo: Shinkokai, 1935.

Taylor, Mrs Basil (Harriet Osgood), *Japanese Gardens*, New York: Dodd, Mead, 1912.

Treib, Marc and Ron Herman, *A Guide to the Gardens of Kyoto*, revd edn, Tokyo: Kōdansha International, 2003.

Tsunoda, R., W. T. de Bary and D. Keene, *Sources of Japanese Tradition*, New York: Columbia University Press, 1958.

Varley, Paul, *Japanese Culture*, 4th edn, Honolulu: University of Hawaii Press, 2000.

Wright, Tom and Mizuno Katsuhiko (photographer), *Zen Gardens: Kyoto's Nature Enclosed*, Kyoto: Mitsumura Suiko Shoin, 1990.

Yoshikawa, Isao, *The World of Zen Gardens*, Tokyo: Graphic-sha, 1991.